STYLE PEDIA

STYLE

A Guide to Graphic Design Ma

PEDIA

...nerisms, Quirks, and Conceits

Steven Heller and Louise Fili

Sidebars by Dan Nadel

CHRONICLE BOOKS

SAN FRANCISCO

The authors are hugely grateful to our editor at Chronicle, Alan Rapp, whose advice and counsel was invaluable during this long process. Also thanks to Bridget Watson Payne, Jacob Gardner, Doug Ogan, Carrie Bradley, and Beth Steiner at Chronicle for their contributions to the process.

Chad Roberts pored over the pages of this book to create a beautiful design scheme of which we are extremely proud. Thanks also to Jennifer Blanco for her design assistance.

Dan Nadel added an extra level of insight and his sidebars are invaluable and lively additions to this book.

We called upon many friends and colleagues who generously gave information, insight, and visuals for this book. Without them there would be no book. Thanks to Massod Ahmed, Paul Bacon, Michael Barson, Gary Baseman, Michael Bierut, Tom Bodkin, Chris Capouzzo, Art Chantry, Seymour Chwast, Martha Clark, Elaine Lustig Cohen, Michael Dooley, Ed Fella, Pablo Ferro, Marty Fox, Milton Glaser, Steven Guarnaccia, Jim Heimann, David High, Brad Holland, Nigel Holmes, Mirko Ilic, Todd James, Vicki Gold Levi, Paul Lukas, Victor Margolin, Victor Moscoso, Irving Oaklander, Art Paul, Jim Phillips, Jeff Roth, Paula Scher, Rudy VanderLans, James Victore, Chris Ware, Nina Weiner, Zephyr.
— SH & LF

Library of Congress Cataloging-in-Publication Data available.

ISBN-10: 0-8118-3346-1
ISBN-13: 978-0-8118-3346-2

Manufactured in China

Cover and book design by Chad Roberts/Louise Fili Ltd

Distributed in Canada by Raincoast Books
9050 Shaughnessy Street
Vancouver, British Columbia V6P 6E5

10 9 8 7 6 5 4 3 2 1

Chronicle Books LLC
680 Second Street
San Francisco, California 94107

www.chroniclebooks.com

A style is the consequence of recurrent habits, restraints, or rules invented or inherited, written or overheard, intuitive or preconceived.

PAUL RAND

Good Design is Good Will, 1987

INTRODUCTION

At once ephemeral and enduring, style is the graphic imprint of an age. In its historical moment it is a prime marker of cultural accomplishment—or fiasco. Style is often chided as mere veneer (as in that familiar reproach "style over substance"). Yet it can be a substantial manifestation of movements, schools, and individuals, born of philosophies, ideologies, and strategies, endemic to all things crafted by humans, whether ancient or contemporary, indigenous or industrial, folk or commercial.

Radical Dutch artists, who in the early twentieth century founded an art and design movement on strict mathematical principles—believing it was *the* direct path to perfection—called their group De Stijl (the style), asserting theirs was the only *true* style. Before them, in the late nineteenth century, the German avant-garde was called Jugendstil (Youth Style) because progressive naturalistic style was the engine of their creative revolution. In *Treatise on Style* (1928), Surrealist Louis Aragon wrote that style was not a question solely of aesthetics but of ethics. In *Die Neue Typografie* (*The New Typography*, 1928), Modern type pioneer Jan Tschichold promoted a radical typographic style that not only abandoned the past, but also epitomized the future.

The word "style" has resonance beyond commonly accepted prejudices and, therefore, should not be seen as mere superfluity. In graphic design, style is sometimes the look, but more often than not the content, the mechanism by which concepts are communicated and ideas are expressed. Thus many stylists are proponents of distinct mannerisms that define an ethos, creating design entities that propel ideas into the public's consciousness. Style is also a vessel of aesthetics, and one of design history's most illuminating guideposts; histories that focus on decisive events and individual achievement evoke style to shed contextual light. We cannot remember the 1930s without thinking of Streamline and Art Deco, nor can we think of the midcentury without its heroic Modernist style. In each instance style was more than mere skin (as if skin were mere!). "The great art style of any period is that which relates to the true insight of its time," Paul Rand is quoted as saying in *A Designer's Words* (1998).

Style should not be confused with trend, although they are sometimes synonymous. Trends are generally contrivances superimposed on designed objects without functional purpose. They afford a transitory buzz and have more to do with what is "happening" at a particular time than whether or not an object's purpose is enhanced. Trends such as shadowed type, Photoshop collage, or graffiti-like

SILHOUETTES ROUBILLE

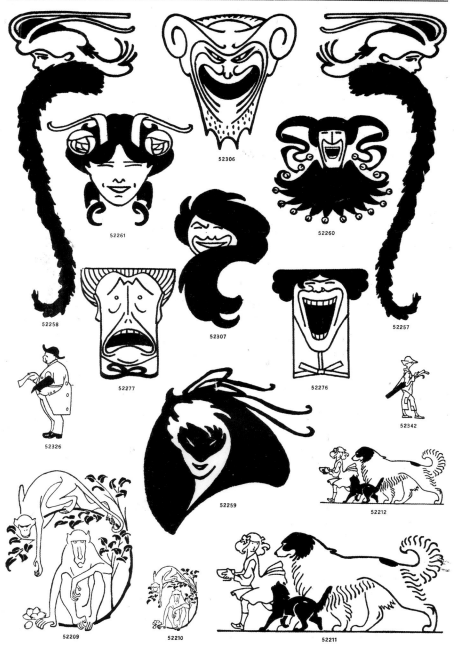

52306

52261

52260

52258

52307

52257

52277

52276

52342

52326

52259

52212

52209

52210

52211

FONDERIES DEBERNY & PEIGNOT, 14, RUE CABANIS, PARIS

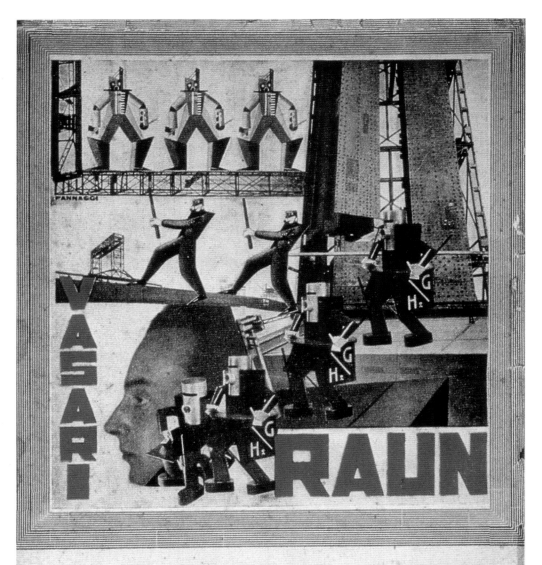

scrawls come and go; they trigger immediate responses, stimulating action or reaction—like buying a product or idea. But once expended, trends are as disposable as all other effluvia and detritus. The widespread fashion in the 1960s for polka dot and paisley patterns, for instance, may have emerged as decorative elements within the larger and ultimately more significant '60s psychedelic style; but those ornaments in themselves were of limited consequence to the design history of that era. Style is certainly the sum of many parts, but when detached from the whole, many of these individual characteristics are often trifling and shallow.

The most important styles have distinct inherent values—some positive, others negative. But not all styles have historical significance. Not all are "authentic" or truly products of their historical moment—as is Gothic, an honest representation of society's desire to reach closer to the ideals of God. Many styles quickly come and go because they are momentary strategies used only to promote or stimulate instant consumption. If they do poorly in the marketplace they are discarded; if they do well they are squeezed and squeezed for all the profit they can produce. In the 1970s the fleeting airbrush style was exploited by countless designers and artists for its contemporary look until it became excruciatingly redundant.

Yet many initially frivolous styles end up as notable in the annals of pop culture because they touched a prevalent raw nerve. Context and timing are everything. If a minor stylistic manifestation turns into a cultural emblem, it must be appreciated for what it reveals about its particular time and place. For instance, the Do-It-Yourself style (D.I.Y.) initially seemed like a momentary fad when it was introduced in the early '70s, yet it became the visual language of '80s and '90s youth culture. Similarly, Deconstruction, which started in the late '80s, appeared as an overly intellectualized fashion with little practical application until its proponents proved it was a valid new means of conveying information. The more styles like these were practiced, the more they represented the aesthetics of the era.

Styles, like viruses, gain potency when they are transmitted from one group to another or one country to another. Style links art to industry and commerce to culture. In the late nineteenth century Art Nouveau spread (and its tendrils wrapped around everything from buildings to furniture to graphics) throughout Europe, the Americas, and parts of Asia, becoming the world's first stylistic pandemic. Its assertiveness was due to such leading entrepreneurs as Siegfried Bing, who propagated the style through publications, exhibitions, and emporia. Art Nouveau was big business and a major design milestone—the precursor of Modernism—because it mutated in various ways yet kept its consistent stylistic persona. This is why it is studied, analyzed, and reprised to this day. But even the most

significant styles were (and are) not inoculated against style-mongers who stole (steal) and exploit their innovative components for profit and fame. Each year marketers grope for the best novelty that might pique consumer interest. In doing so, styles become trends. As soon as the "alternative" culture paves the way for its unique style, retail stylists are often quick to transform it into a craze for consumption.

A good example is Jugendstil, which flew in the face of German propriety during the late nineteenth century, but quickly became a commodity. Likewise, psychedelia rebuked the gray flannel suit generation of the mid-twentieth century, but soon after its introduction became a cool purchase for young fashion-conscious consumers. Each initially connected directly to small constituencies that valued them for their rebellious nature, but eventually the styles leaked out into the general public. And once the genie escaped into the mainstream, it was sold by the bushel or yard to anyone regardless of motive or intent.

In capitalist countries anything that receives excessive popular attention becomes a commodity. And style is the simplest thing to copy, borrow, or steal because it can be easily removed from content and separated from intent. No matter how unique it is, style is not protected by copyright or trademark. To use an information age term, style is open source—a template that can be accessed at will—where anyone can create design in the manner of Victorian, Art Nouveau, Art Deco, or Punk styles, or mix and match. The results of this pastiche are what usually give style its pejorative reputation—and the presumption that it is not about workmanship or quality, but rather surface and showiness.

By the turn of the twentieth century, for example, French Art Nouveau and its international offshoots, Jugendstil (Germany), Modernista (Spain), and Stile Liberty (Italy), which grew out of the handicrafts tradition, had become so shoddily affixed to all types of mass-market products that it quickly became mundane and staid as well as disrespected and passé. Nonetheless when the flower was on Art Nouveau's bloom for the better part of a decade it altered the aesthetics of the industrial and commercial world, until the next dominant style emerged.

Today the time it takes to move from emergence to co-option of a style is exceedingly quick. Sometimes a stylistic fashion vanishes within months of being introduced and many divergent ones emerge at the same time. With the advent of "Style" sections in newspapers and magazines, new looks are splashed on the front pages almost every week. Yet before the twentieth century's dubious ethic of disposability took hold, styles became passé only after lengthy intervals. When mass technologies were not yet available, styles evolved and spread slowly. Gothic

RIGHT
Designer: Unknown
Magazine cover, 1926

FOLLOWING SPREAD
Designer: Johan Thorn Prikker
Poster, 1903

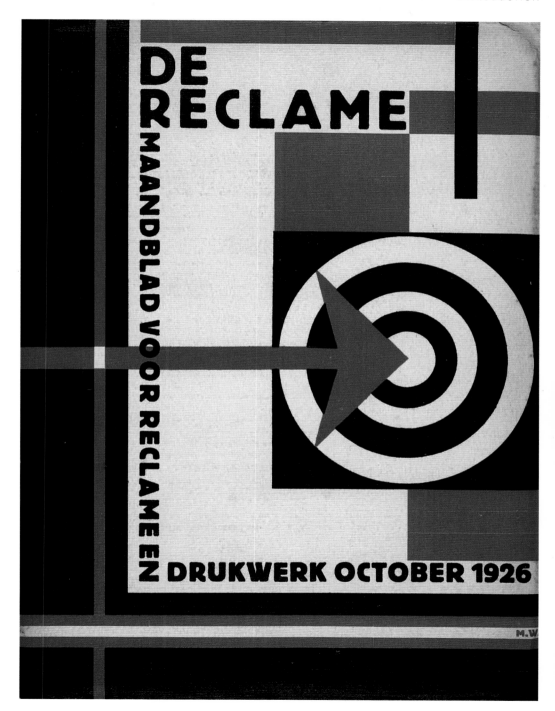

HOLLÄNDISCHE KU

VOM 20 MAI BIS 2 AUGUST

NSTAUSSTELLUNG
N KREFELD
903 IM KAISER WILHELM=MUSEUM

(ca. 1100–1400) and Baroque (ca. 1600–1750) held sway for long periods before the advent of the respective next big thing. Napoleon Bonaparte's introduction of the Egyptian style to France, prompting aesthetic interest in slab serif typefaces, ziggurat motifs, and hieroglyphic symbols, occurred after his Egyptian campaign (1798–1801) was over and lasted beyond the duration of his reign (1799–1814). Yet by the late nineteenth century, in large part owing to increased consumerism pushed along by new transportation and communication methods, the pace of style creation and its consumption accelerated. Styles went out of style at a more vigorous tempo than ever before.

The onset of the Machine Age in the 1920s launched the Marketing Age and the introduction of "obsoletism," whereby a bevy of modern styles were used to give industrial wares and sundry products their contemporary allure. A leading proponent of obsoletism, Earnest Elmo Calkins, legendary director of Calkins and Holden advertising agency in New York, helped promulgate what became known as modernistic (or moderne) commercial style in the United States. Calkins believed that Modernism could be employed to move goods off shelves because consumers desperately wanted to spend their money on the illusion of newness. Modernistic design gave off an aura of freshness.

In its various guises, orthodox Modernism's pioneering artists and designers sought to change the world, coerce their respective nations to embrace more progressive outlooks, and move people away from blindly accepting stagnant, bourgeois aesthetic systems. They developed a visual language that assailed the status quo and attacked entrenched reactionaries. Read any Modernist manifesto— Dada, Bauhaus, Constructivist, Futurist, or Surrealist—and while the methods (and politics) may deviate, each movement called for social revolution. For such deeply political aims, style was their banner, if not their ordnance.

Modernism was created to produce utopia but in the final analysis, despite the continued efforts of the most fervent adherents, politics and commerce conspired against it. The Bauhaus fervently attacked industry's routine reprise of the past and passé, and neo-this-and-that were anathema to the Modernist creed because they not only fostered dreary results, they ensured inequality between the haves and have-nots. The Bauhaus sought to make wares for the masses that were affordable, functional, and beautiful, and unprecedented too. But ultimately few but the wealthy (the enlightened patrons) could really afford the Modernist products.

Nonetheless the Bauhaus fostered desire among those who could not afford the original wares, which gave rise to the need for faux Modernism (also known as conservative Modernism) as a cut-rate commercial style. Progressive veneers

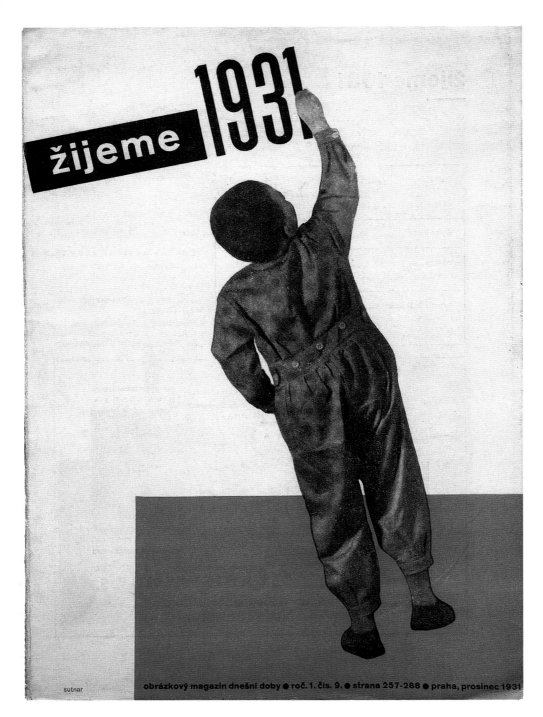

LEFT
Designer: Ladislav Sutnar
Magazine cover, 1931

atop a bourgeois base were referred to in American advertising circles of the '20s as "styling the goods," as in the act of creating contemporary packages and advertising for vintage products, like detergents and sundries. The masses assumed they were getting "new and improved" but instead they were left with "tried and true." Styling was in large part a matter of altering the surface enough to give the illusion of progress. It wasn't what the diehard Moderns had in mind, but it was the introduction of aesthetics as a tool for social engineering. This was not the only instance where marketers dulled the edges of edgy style: It is axiomatic that all risky manifestations are eventually watered down and turned into unthreatening styles. Raymond Loewy coined the term MAYA (most advanced yet acceptable) to describe the level of caution required of adventuresome designers during the 1920s and '30s when introducing progressive ideas to the mainstream. Too vanguard was too shocking to the average system (remember the Ford Edsel?). But MAYA was not simply a '30s phenomenon: The Punk cartoonist Gary Panter, who created a ratty line comics style that was copied by others, refers to '80s New Wave style as "sterilized Punk"—it was still kind of ratty but no longer shocking, just unsurprisingly bland.

Style is kind of a simple pyramid scheme. Truly original, often outrageous manifestations are at the top of a pyramid up in the proverbial clouds away from mainstream culture. Yet when they are adopted, adapted, and "stylistized" for consumption they reside somewhere in the middle of the pyramid, acceptable enough to be marketed to certain demographics. Although they are still not suitable for all the masses, they are no longer cutting edge, either. At the bottom of the pyramid, spreading across a wider base, are the flagrant thefts and copies that are removed from any original philosophical or contextual relevance. Here resides style as fashion.

Over the course of the twentieth century various artists and designers developed personal styles that expressed aesthetic preferences and thematic viewpoints. Some have been adapted for wider use in various media. Picasso and Braque's Cubist practice, for instance, inspired later artists—for example, it was the basis of A. M. Cassandre's legendary advertising posters that, in turn, influenced a major group of graphic stylists from the 1920s to this day. Having synthesized the tenets of Cubism for applied art purposes, Cassandre is the acknowledged pioneer of the Moderne style of poster design. But Louis Aragon, in his 1928 *Treatise on Style,* argued that even the esteemed posterist Cassandre trivialized the original by appropriating and popularizing it. "The intellectual lines of descent from the great man to the poor tumor-filled head are even stranger. The footbridges from

idea to reflex [stretch] from cubism to the [Cassandre] Pivolo poster. From Jeanne Duval, the Black Venus, to the Popular Balls and the golden girls of Paris Casino."

RIGHT
Designer: Fred Deltro
Political illustration, 1920

Still, many original, individual innovations have become broader styles because they triggered universal wants and needs, and at times even touched an emotion or two. Style has no power if people do not respond or consume. Understanding the nuances of graphic style is eternally fascinating for what is revealed about art and design on many levels from look and feel to form and content. Studying styles in relation to other cultural and political phenomena is one means of digging deeper into design history.

Stylepedia is a guide to the most overt, covert, reprised, passé, unpopular, and popular styles in various graphic media, from print to screen. The more than one hundred styles covered herein derive from various times and places—from the nineteenth to the twenty-first centuries, from the United States, Europe, Asia, and South America—by individuals, movements, and schools. Some styles are *out*, others are in, some are pure, others are mongrel mixtures of stylistic breeds. Some may even be debatable because style is a public phenomenon, subject to interpretation. Since not all styles have been codified by scholars, here new typologies and taxonomies are proposed and examined.

Stylepedia is far-reaching but not all-inclusive. The reader may doubtless find that a known style is missing from this encyclopedic format. As editors we determined that some styles were not viable enough to include on graphic design's ever-expanding historical time line. For any oversights we apologize. The reader may also question the inclusion of certain styles, perhaps believing that they are insignificant trends or fashions. Razor Blade style, Chinese Calendar Girl style, and our favorite, Zanol style, will not be found in any of the current respected design histories, but they are, in our opinion, imprints of their times, places, and cultures that held sway over specific fields of graphic production. They may not be as revered or as influential as Futurist, Bauhaus, or Polish Poster styles, but should be recognized for specific contributions made to design and popular culture.

This leads to another potential critique: Are we doing design history a disservice to lump Tijuana Bible, Vegas, and Pulp styles together with the heroic Modernist styles? Perhaps, but with humility, *Stylepedia* is designed to weigh in to the high versus low culture debate. Graphic design is first and foremost popular culture, an intersection of high and low elements that should be equally addressed in an historical forum. In most histories of graphic design certain stylistic manifestations are ignored because they are deemed "bad design" or irrelevant to sophisticated professional practice. We believe that graphic design history should

be more inclusive, if not respectful of, such seemingly marginal but truly pervasive phenomena as Bull's-Eye, Camouflage, Christmas, Halloween, and American Patriotic styles, to name a few.

In addition to canonical styles such as Art Deco, Dada, and De Stijl we present more current design formulated by the likes of Saul Bass, Art Chantry, Ed Fella, Tibor Kalman, and Gary Panter, who have influenced broader stylistic genres. We admit this is murky territory—why these figures and not others? Why not simply fit them into other styles from which they might have emerged (i.e. Bass interprets Expressionism or Chantry follows Dada)? The answer is, in addition to cross-referencing, they each transcend their real and presumed influences to create a style that bears their respective imprints. Certainly this can be said about El Lissitzky or Rodchenko with regards to Constructivism, but their genius, we believe, was a component of the larger Constructivist style—whereas Bass' approach to motion picture title sequence design and Chantry's to Do-It-Yourself were their own, and others followed. Also included are styles that are based more on thematic groupings, such as Conceptual Illustration or Food styles. These comprise various individual stylistic approaches but in our opinion they constitute an overarching style and methodology. There are also styles based on important typographic artifacts, like Futura and Helvetica: Although these two typefaces fit neatly into other styles (Modernist and International Typographic, or Swiss, styles), they have integrity as distinct manifestations on their own.

Stylepedia intends to be more than another foray into defining and presenting graphic design history. It is a supplement to existing narrative histories as well as an alternative. But it is most useful, perhaps, as a guide to the ways in which graphic design is a menu of aesthetic and strategic styles that have been used in the service of mass communication and social change as well as packaging, marketing, advertising, and many other forms of graphic propaganda.

RIGHT
Designer: Leonard Koren
Photographer: Herb Ritts
Lettering: Lynn Robb
Magazine cover, 1978

see Art Deco Type

AGIT RETRO

American poster designer Micah Wright borrows actual vintage posters and retrofits them with caustic new slogans. There's one of Uncle Sam pointing his finger at a flowchart comparing the rise of the rich and decline of the poor, with the headline "Play for the Winning Team . . . Vote Republican!" Another shows Rosie the Riveter in rolled up shirtsleeves with the headline "Up Yours, Congress! I'm Keeping My Right to Choose!" and yet one more shows an heroic-looking GI (in the foreground of nighttime battle) and the words "Hello, AMERICA? Get me THE FUCK out of here! YOUR army THEIR war." Many more featured on Wright's Web site do not simply trigger a nostalgic twinge but hit a raw nerve about homeland security and the Iraq war, and each is more "Wright-on" than the next.

This is not an original conceit: Sampling and parodying of vintage art and design are fairly commonplace. Yet Wright is one of its latest masters. Not only does he coin memorable agitprop slogans, he locates images that are so rare that they seem almost new.

Since Wright started his "propaganda project" on June 10, 2002, he has made close to twenty posters per month. He creates propaganda for a sinister "Ministry of Homeland Security" that,

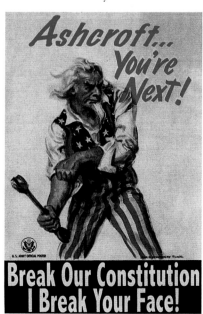

Designer: Micah Wright
Poster, 2003

24

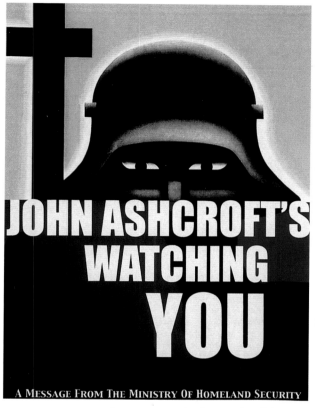

JOHN ASHCROFT'S WATCHING YOU

A MESSAGE FROM THE MINISTRY OF HOMELAND SECURITY

*Designer: Micah Wright
Poster, 2003*

downloaded off the Internet, crops up in the most unexpected locales. Sometimes the images are slightly altered using real paint, but mostly Photoshop. Although it may appear easy to parody a kitsch image, Wright says that "it's never enough to just start with a great poster . . . sometimes I have to struggle with a striking image for weeks to find the perfect news story to attach to it, or it might take a while to wrangle the perfect turn of phrase to substitute on the poster." It took him six months to figure out what to do with his first iteration of the Rosie the Riveter poster. "I just knew I didn't want to waste that poster on a tag line which didn't make me laugh," he recalls, "and a conceptual breakthrough came one day when I was up late and it suddenly struck me that it looks like Rosie is not only rolling up her sleeve, but could also be giving someone the international 'up yours' move. From that realization, it was a short jump to 'Up Yours . . . ! I'm keeping my right to choose!'"

SEE ALSO *American Patriotic, Conceptual Illustration, Fear, Socialist Realist*

AMERICAN PATRIOTIC

Uncle Sam is the most recognizable American icon ever created. He began as a quaint commercial trademark around 1812, based on the self-proclaimed "Uncle" Sam Wilson, a real-life Troy, New York, merchant who owned E. & S. Wilson, which supplied provisions to the American military fighting against the British. As legend goes, Troy's residents assumed that the "U.S." stamped on his shipping sacks and barrels stood for "Uncle Sam," and Wilson exploited the illusion because patriotism and profit were happy bedfellows. His trademark portrait, in which Wilson wears a stovepipe hat, presaged and influenced the typical Uncle Sam image. By the mid-nineteenth century, artists had radically reinterpreted Sam's

face, so little remained of the original. During the Civil War the clean-shaven Sam grew a beard, which made him bear a curious resemblance to Abraham Lincoln. Uncle Sam continued to appear in various iterations until 1917 when illustrator James Montgomery Flagg codified the character with his distinctive rendering for the army's "I Want You" recruitment poster (which was based on earlier British, German, and Russian propaganda poster motifs). Flagg used himself as the model, ensuring his own immortality.

Aside from the ubiquitous dollar sign (the overlapping initials U.S. with the bowl of the U cut through), no other symbol telegraphed the American essence more instantaneously and unambiguously than Uncle Sam. Neither of his two sister icons, Columbia or Liberty, which personified the essential ideals of American life, suggested America's ever-expanding global diplomatic and military influence. Yet as unmodern as his calcified visage may appear today, Sam's craggy features and scraggly goatee spoke directly to the American myth of a classless society baptized in the blood, sweat, and tears of grassroots pioneers. Sam was a composite of the U.S. forefathers, and more: He represented strength, fortitude, and honor. He could also be comical and serious, fatherly and brotherly.

Multinational corporations in today's global economy pay branding specialists (who some critics might argue provide the same pseudo-scientific rhetorical mumbo jumbo today as they did a hundred years ago) billions of dollars to create icons as unmistakably recognizable as Uncle Sam, which is why it is curious that no single government agency or political entity actually owns the trademark registration rights to this valuable American "intellectual property." Any American

Designer: Unknown
Postcard, c. 1920

*Designer: Unknown
Printer's cuts, 1930*

(or foreign) business wanting a patriotic pedigree may freely use Uncle Sam in whatever political or commercial—silly or profound—context and for any purpose they desire, legal or extra-legal. An unwritten law guarantees free and easy access to democracy's symbolic trappings to any individual or institution that desires them. If the government held licensing rights the profits from royalties would pay for major social programs—or would they?—but no one receives anything from the countless Uncle Sam reproductions once sold through type catalogs, clip art books, and printers' stock catalogs.

While America respects its cherished icons, it is more laissez-faire when it comes to their widespread usage. The American colors, for instance, have long been an effective and ubiquitous marketing tool. During the late nineteenth and early twentieth centuries red and blue were among the most popular printing inks after basic black. Whatever the image—even if it had nothing to do with patriotism—printing it in these primary hues produced an unmistakably American style. Today the colors red, white, and blue, stars and stripes, and the American flag itself continue to be used anytime patriotism can generate profit, which is not to imply that red, white, and blue don't evoke a real sense of national pride.

After Independence on July 4, 1776, the U.S. Congress *Resolved that the flag of the thirteen United States be thirteen stripes alternate red and white: that the union be thirteen stars, white on a blue field.* The color symbolism was straightforward: white for purity and innocence; red for hardiness and valor; blue for vigilance, perseverance, and justice. Aside from conventions dictating how a flag must be hung, the U.S. government has never imposed restrictions on how to use the basic form or

*Designer: Unknown
Printer's cuts, 1930*

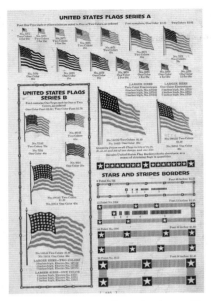

Designer: Unknown
Printer's cuts, 1927

colors—every citizen has a right to "own" a piece of American style. When the South seceded from the Union, the same color scheme was used for the Confederate flag. Congress has never been able to agree on a viable flag desecration bill (paradoxically the accepted way to dispose of a flag is to burn it) because restriction of expression is antithetical to democratic principles. While other nations view as treasonous the desecration of their national symbols, the flag's commodification in the American mix of democracy, capitalism, and free speech is a form of expediency. So, as long as Uncle Sam and the Stars and Stripes are used to sell goods, they will remain unregulated.

Uncle Sam's iconic visage may no longer be as viable as it was a generation ago, his antiquated image usurped by a slew of dynamic corporate logos. Nike's Swoosh, Microsoft's butterfly, and McDonald's Golden Arches do not overtly exude nationalism but are rather signposts (even ambassadors) for businesses that provide American services and collect American profits. Vocal "No Logo" critics in the U.S. and around the world charge that American commercial icons today symbolize the U.S.'s excessively domineering global reach and, like Uncle Sam, they force materialistic American values down the throat of the world. Others argue this is but anti-American claptrap. One thing is certain: Whether political or commercial, American icons trigger strong emotions of desire and revulsion.

S E E A L S O *Agit Retro, Heroic, Socialist Realist*

ART DECO

Art Deco—or Art Moderne as it was originally called—was at once a reaction to the ornamental "floriated madness" of its predecessor Art Nouveau and an integral style that incorporated the aesthetics of the Machine Age. It was something of a compromise with austere, ornament-free Modernist style, and appealed to those drawn to the opulence, if only vicariously. Further, it truly defined a contemporary standard of beauty that appealed to the rich, the nouveau riche, and the masses.

R I G H T
Designer: Unknown
Enamel sign, 1936

During the late nineteenth century France was the world's major exporter of luxury, and she jealously guarded her stylistic innovations. But during the turbulent years before World War I, France's economy was threatened by formidable European competitors. Germany, Italy, and England had produced variants of Art Nouveau and were furiously developing more modern stylized wares and eccentric graphics that toned down naturalism and replaced it with machine veneers. A plan approved in 1912 for an epic trade exposition to be opened in 1915 would have showcased France's great commercial assets but the Great War postponed the event and forced a halt to further innovations. Following the armistice, the French government hoped to reestablish its earlier status as a trade leader with the 1925 Paris *Exposition Internationale des Arts Décoratifs et Industriels Modernes*. Toward this end industrial arts associations who planned the exposition encouraged French craftsmen and designers to engage in a novel way of creating decorative products and enforced rules that governed conception and production.

Members of these associations affirmed that no copies of historical models were allowed and only works of "modern" or unprecedented character were henceforth accepted as worthy of the French imprimatur. This gave rise to an Art Deco

style that stripped away all niggling, Art Nouveau, and other ornamentation in favor of an austere decoration. In graphics, for example, the airbrush was both tool and metaphor for a new machine-driven age and the Deco look evoked a futuristic aura. Sunbursts, lightning bolts, and all manner of stylized power symbols were employed. While these were novel, historical models were not entirely ignored as long as they derived from far-flung antiquity and could be reinterpreted in a futuristic manner. This included Babylonian, Egyptian, or Mayan references, particularly the ziggurats found in ancient architecture. Deco also liberally borrowed from Cubism, Futurism, Constructivism, Purism, and the Bauhaus, which provided various archetypes. Yet rather than Mod-

Designer: Unknown
Sugar package, 1935

ernism's reductive ethos, this so-called modernistic style did not totally eradicate all superfluities. Modernism in its Bauhausian manifestation was too ascetic, but Deco introduced ornamental veneers that ostensibly soothed bourgeois eyes.

Shortly after 1925 Art Deco established itself as the dominant style throughout the industrialized consumer world because it appealed to both the affluent and bourgeois classes; eventually in a mutated form it trickled down to the working class too. In its mass-market form Deco entered the consciousness through advertising as a code for things "new and improved." During the late '20s through the mid-'30s such advertising agencies as New York's Calkins and Holden produced press ads with Modern Art auras to inject freshness into venerable products. Advertising pioneer Earnest Elmo Calkins further proffered a unique strategy called "styling the goods" (which later became known as "forced obsolescence") whereby advertisements, packages, and eventually certain products were regularly spruced up so that consumers could feel they were *au courant*—and feel the need to purchase the latest version.

Designer: Unknown
Advertising fan, 1928

Advertising posters were the most visible graphic artifacts, and magazines featuring posterlike covers spread the Deco gospel. Just as ubiquitous were the point-of-purchase displays for leading department stores as well as for food packages and other goods. But without its emblematic typefaces Deco would not have had its impact. Rectilinear Deco typefaces were the glue that bound all the disparate Moderne conceits together.

As a look of compromise Deco was actually more expandable and inclusive

Designer: Alan Rogers
Poster, 1930

than other venerable styles. Classicism was locked in its prison of time, while Modernism existed behind a wall of dogma. Art Deco further proved adaptable in different cultural contexts, easily incorporating distinctive national traits. Deco had no ideological loyalties though it represented a jaundiced view of the future, and therefore appealed to the forward-leaning youth culture of its time.

The Italians infused their Deco with a Futurist sensibility—mostly found in typography but also in the airbrushed smoothness of imagery—and combined it with a Mediterranean color palette, which through posters, packages, and other printed ephemera appealed to, among others in Italy, young rebels in the Fascist party. Fascist Deco was new, novel, and youthful. German designers mixed pre–World War I Sachplakat (Object Poster style) with Expressionism, particularly in posters, business identities, and various forms of *reklama*, before the Nazis imposed a more turgid neoclassicism as a national design style. The Dutch mixed rigidly geometric De Stijl with raucous Cubism for an eclectic Modernist appearance, while the Spanish and British injected distinct Deco idioms—in posters as well as fashion and furniture—that played off their respective national traditions and tastes. American artists gave birth to the Streamline style, a Machine Age mannerism applied by industrial designers to everything from graphics to automobiles. Streamline was not only a veneer, but also a functional attribute that introduced aerodynamic performance and a futuristic aesthetic.

Art Deco was not an exclusively commercial style: It served the propagandists of warring political parties, factions, and movements on both sides of the ideological divide. At the same time it was employed in poster campaigns by right-wing Italian Fascists, so too it was used by the left-wing Republican loyalists during the Spanish civil war fighting in 1936 against Fascist (Falangist) rebels. The monumental aura of Art Deco—sleek airbrushed renderings of heroic, neoclassical figures—served all factions in their efforts to win hearts and minds. Art Deco had no partisan underpinning, but rather belonged to

Designer: Unknown
Counter display, c. 1930

whichever group embraced it, good and bad, right and wrong, left and right.

SEE ALSO *Art Deco Type, Art Nouveau, Bauhaus, Constructivist, De Stijl, Expressionist, Fascist, Futurist, Modernist, Object Poster, Streamline*

WILLY POGANY'S *MOTHER GOOSE*, 1928

sing a song of sixpence,
a pocket full of rye;
four-and-twenty blackbirds
baked in a pie;
when the pie was opened,
the birds began to sing;
was not that a dainty dish
to set before the king ?

This exceptional children's book was designed and illustrated by Hungarian émigré Willy Pogany. A fine example of Deco's slightly regressive ornamentalism, Pogany's pages are sometimes festooned with Art Nouveau–esque border motifs, from floral patterns to Egyptian-style starbursts. But the illustration's clean, elongated lines are resolutely Modern, right down to a ribbon's lightning bolt attack on a Streamline cat. The children are idealized Deco caricatures—all clean lines and well-framed skips, hops, and jumps. Pogany's lettering is a Modern approach to medieval and Victorian themes, ultimately resembling a kind of new urban Gothic. Deco, so prevalent in children's books at the time, is given a more complete voice in Pogany's work. Rather than merely over-stylized type or pictures, he strikes a balance between the flair of Deco and the playful whimsy of a child's imagination. —D.N.

ART DECO TYPE

Every nation that adopted Deco produced its own unique typefaces in its own type foundries, but many faces were modeled on the inventions of the leading French foundry, Deberny & Peignot. Its signature font, Peignot, designed by A. M. Cassandre in 1937 and named after type impresario Charles Peignot, became one of the most familiar and emblematic faces of the Deco era. This and other popular Deco typefaces reproduced separately and on artifacts were readily available to advertising artists everywhere, giving them the opportunity to project

Designer: Unknown
Type specimen, 1932

contemporary auras for timely and fashionable products.

Typefaces defined Art Deco exuberance during the '20s and '30s every bit as much as cubistic fashions, Streamline furniture, setback skyscrapers, and aerodynamic automobiles. Stylish display types were the seals of modernity in advertisements for contemporary products. Type designers may not have entered the higher echelons of industry, but they were in the trenches of the consumer revolution.

With the power to influence popular perceptions, new type designs were released with great fanfare. Type specimen sheets from the mid-1920s through the early 1930s were enticing displays of alluring designs. Advertising artists demanded stylish faces with Jazz Age conceit; with the widespread availability of print advertising during the early twentieth century, novel and novelty letter forms—some revivals of historical faces, others contemporary inventions— appealed to printers and designers. Scores of new typefaces and complementary ornaments and dingbats with futuristic names like Vulcan, Metropolis, Modernistic, and Cubist Bold heralded Machine Age progress.

Modernity was the "fatal dart," as A. Tollmer, the French advertising expert, referred to it in *Mise en page* (*The Studio*, 1931). A typical Art Deco typeface—such as Broadway or Streamline—announced the new and improved; the type framed a stage on which anything from boot polish to automobiles were sold. Stylish type was more than a graphic accent on page or poster; it was the pitchman's most useful prop. Contemporary commercial typographic styles were defined

ABOVE
Designer: Otto Heim
Type specimens, 1933

LEFT
Designer: K. Sommer
Type specimen, 1929

RIGHT
Designer: R. Schaffer
Magazine cover, 1926

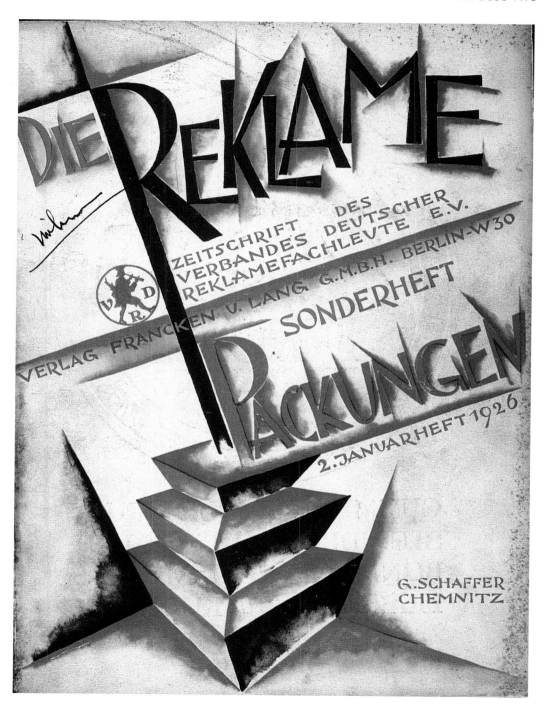

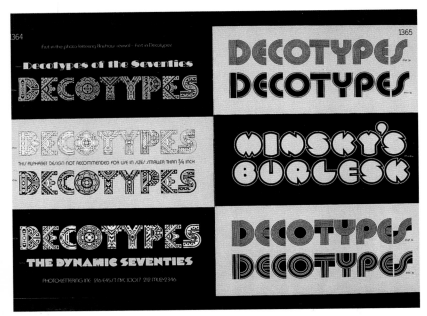

Designer: Ed Benguiat
Type specimen, 1970

by a marriage of austere mannerisms and ostentatious ornament. The sharp edges of radically geometric Constructivist and De Stijl design were smoothed out through the addition of modernistic ornament. Modern serifless letters, which some critics argued were too forbidding for the reader, were made accessible through an appliqué of shadows, squiggles, and motion lines. The advertising trade magazines of the day, including *Printed Salesmanship* in America, *Reklama* in Holland, *Commercial Art* in England, *La Pubblicità* in Italy, *Gebrausgraphik* in Germany, and *Publicité Modial* in France, promoted decorative commercial type-play.

Deco typefaces were influenced by two intersecting trends: the typographic reform movement known as the New Typography, codified by German type master Jan Tschichold in 1925, and the decorative or ornamental practices of the late nineteenth century, which were

Designer: Otto Heim
Type specimen, c. 1933

predominant in posters. The former was a rejection of antiquated nineteenth-century rules of composition; the latter was an update of commercial job printing techniques void of any philosophical rationale.

In the purest sense Modern typography is rooted in the rightness of certain basic forms: the circularity of a circle, the squareness of a square. "It revolted against the flabby sentimentalist, the weaver of legends, the exponent of meaningless platitudes," wrote Faber Birren in *The American Printer* (April, 1929). Modern typography further reflected the tempo of modern times—speed. Deco type was born out of the need to be modern and at the same time retain certain traditional values. "Modernism in typography, unfortunately, lends itself readily to the derivation of unintelligent formulas," chided type historian Douglas C. McMurtrie, in *American Printer*. The concept of "going modern" in the advertising industry signified "an axis off the center of the layout, with sans serif types in square blocks disposed to the right or the left of this axis."

The production of Deco types ceased during the austerity binge of the 1940s, but the typefaces that signaled the opulent style of the preceding decade retain the luster of that time and place in history.

S E E A L S O *Art Deco, Constructivist, De Stijl, Modernist, New Typography, Push Pin, Streamline*

NORAKURO BY SUIHO TAGAWA

Norakuro by Suiho Tagawa was a hugely popular Japanese comic imbued with the Japanese Deco-Modern design aesthetic. From 1923 to 1941 it followed the funny animal adventures of a dog in the (all-dog) Imperial army. The drawings are certainly in the lineage of late nineteenth- and early twentieth-century pictorial prints, with figures and backgrounds flattened into carefully delineated shapes. But those shapes, lines, and character designs are equally the products of graphic design style exemplified in the packaging of Shiseido Cosmetics that had long since absorbed Art Deco and other Modernist influences. Like much Deco illustration, Norakuro and his fellow pooches are all angular outline, seemingly drawn by one continuous clean line, and they battle against the backdrop of crisply decorative cities and landscapes. Each of the ten hardcover, slipcased books features the cute animals arrayed on strict, thick grids with Japanese characters in what looks like the Japanese version of Bodoni. Norakuro's adventures in war were eventually stopped by World War II itself, as the comic, and Japanese design, were put on hold for the duration of the hostilities between Japan and the United States. — D.N.

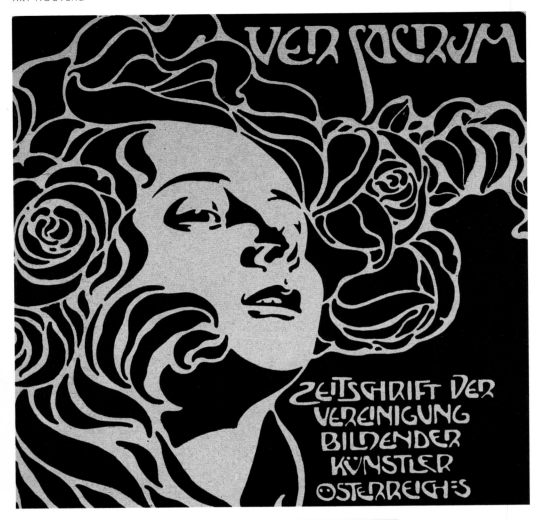

ART NOUVEAU

By the early 1890s academic realism was under attack by an army of young artists and designers who marched throughout Europe and the United States under a common banner. Although their movement was known by different names in the various countries—L'Art Nouveau in France, La Libre Esthetique in Belgium, Stile Liberty (or Stile Inglese) in Italy, Secession in Austria, Modernista in Spain, Jugendstil in Germany, The Glasgow School in Scotland, and the Bohemian Secession in Czechoslovakia—it was a tightly knit, radical sensibility that transformed fashion, furniture, architecture, graphics, and all manner of decorative arts.

Designer: Koloman Moser
Magazine cover, 1899

Each nation invested the overall style with its distinct cultural tics and quirks, but with a shared visual language. Art Nouveau inveighed against parochial nationalistic movements while promoting the international exchange of ideas. Although it did not evolve into a politically ideological movement (like other schools or styles comprising the twentieth-century avant-garde), Art Nouveau signaled a social and cultural realignment that focused on creating a "new modern living environment." Its practitioners were linked by their

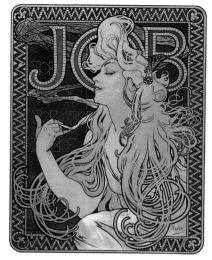

shared belief that "the total work of art" (or *Gesamtkunstwerk* as it was known in Germany) was not merely found on canvas or sculpted out of marble but rather extended to a range of functional products residing in all realms of daily life—the cornerstone of modern design.

The ethic (and aesthetics) of Art Nouveau was born in England, a direct descendant of William Morris' Arts and Crafts movement, and migrated to the Continent. Originally it was practiced by the likes of Englishmen Arthur H. Mackmurdo, who wed Pre-Raphaelite symbolism to a naturalistic mannerism in his book cover for *Wren's City Churches*, and illustrator Aubrey Beardsley, master of eccentric eroticism. But by 1894 Art Nouveau in France and Belgium crystallized into a distinct, unprecedented curvilinear stylistic manifestation derived in part from a popular interest in traditional, naturalistic Japanese design, which emerged in France under the rubric *Japonisme* (the term for aesthetic fascination with all things Japanese coined by French art critic Philippe Burty).

Japonisme's enthusiasts obsessively purchased exotic trinkets and curios, including paper lanterns, parasols, and fans. Entrepreneurs, in turn, sought to capitalize on this newfound consumer instinct by inventing exciting forms and more costly objects that fused into a fashionable allure. Siegfried Bing, one of the leading impresarios of Art

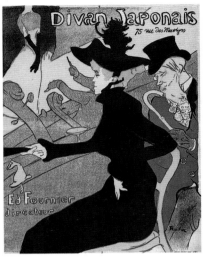

Nouveau in Europe (Louis Comfort Tiffany was his counterpart in the United States), launched the monthly magazine *Le Japon Artistique*, which promoted and reported on the craze for Japanese objects available in the West after Commodore Matthew C. Perry opened commercial trade with Japan in 1853. The magazine was a tonic for artists and designers, many of whom imitated and were inspired by the great Japanese woodcut artists Hokusai, Utamaro, and Kuniyoshi. Indeed much early Art Nouveau graphics were created as woodcut as well as lithography. But Japonisme was only one component of a broader inspirational pool. Art Nouveau drew inspiration from Byzantine art and the Pre-Raphaelites, as well as Symbolist painting that fixated on the spiritual and sensual. Art Nouveau was symbolism personified.

Yet despite these historical roots, Art Nouveau's break from the chains of historical precedent was important not only in its own evolution, but in the development of modern art and design. Artistic cross-fertilization from one country to the next was necessary to build a viable beachhead against the fortress of official art. The key philosophical underpinning of Art Nouveau was the radical idea (though one that extended back to pre-history) that *art* was imbued in everything functional and applied, from advertisement to architecture. This was expressed through common visual mannerisms employed in all these objects: curvilinear forms drawn directly from natural surroundings.

In reaction to rigid academic painters' slavish re-creation (and romanticizing) of natural beauty, Art Nouveau's progenitors—among them designers

Designer: Henri de Toulouse-Lautrec
Poster, 1893

Designer: A.I. Rich
Logo, 1898

Designer: Unknown
Type specimen, 1909

Henri de Toulouse-Lautrec, Georges Auriol, Eugène Grasset, Alfons Mucha, Walter Crane, Koloman Moser, and Otto Eckmann—fostered an abstracted interpretation of nature with sometimes agonizingly intricate forms incorporated into a decidedly modern aesthetic sensibility. Owing to what became its typical, sinuously organic ornament, the terms "floriated madness" and "linear hysteria" were used to describe Art Nouveau's more extreme oddities.

Like the roots and tendrils of the flora (and occasional fauna) that comprised its design scheme, Art Nouveau spread to most industrialized nations. Its ornaments covered buildings in Paris, Brussels, Barcelona, and other cities where adherents established practices and businesses. Art Nouveau

*Designer: Unknown
Magazine cover, 1915*

was the first decidedly commercial style that was applied to (and enhanced the appeal of) industrial products. Ubiquitous were the spirited, illustrative posters that adorned hoardings and package labels in merchants' display cases.

Typeface design cannot be overlooked in Art Nouveau's ascendancy. Posters filled the streets with colorful lithographic renderings and the hand-lettered headlines on these *affiches* developed into a style of French type that conformed to the new architecture, furniture, textiles, and other designs. Curvilinear typefaces—often custom-designed for individual posters—were mass-produced in font families and used by printers and designers for the myriad products that sought to project a contemporary veneer. In addition

*Designer: Alfred Roller
Magazine cover, 1899*

to French *affichistes* Jules Chéret and
Henri de Toulouse-Lautrec, the Czech
Alphonse Mucha (who worked in
Paris) helped define the obsessive
French style. Type was manufactured to
serve the huge needs of commerce on the
one hand, and popular culture on the
other. Almost immediately after an art-
ist concocted a lettering style for a poster,
a foundry such as Deberny & Cie would
manufacture a complete font of all let-
ters and ornaments for commercial use.
Sometimes the original designer was
employed; other times the unprotected
work was simply appropriated. During
the heyday of the style, artists, graphic
designers, architects, and typographers
developed a surfeit of stylishly distinc-
tive wood and metal typefaces that
complemented architectural and inte-
rior motifs, and so defined the style
and movement. These were delight-
fully eccentric typefaces that tested the
tenets of legibility, but were nonethe-
less rooted in the fundamentals of type
design—balance, harmony, and color.
A few of the faces have survived the
test of time (many were seen in psyche-
delic posters), but most were so inextri-
cably tied to the era in which they were
designed that they have been lost.

Art Nouveau was a big business.
Siegfried Bing's Maison L'Art Nouveau
galleries in Paris and Brussels were
wellsprings for everything from chairs
and lamps to wallpaper and stained
glass. Thanks to Bing, Émile Galle, and

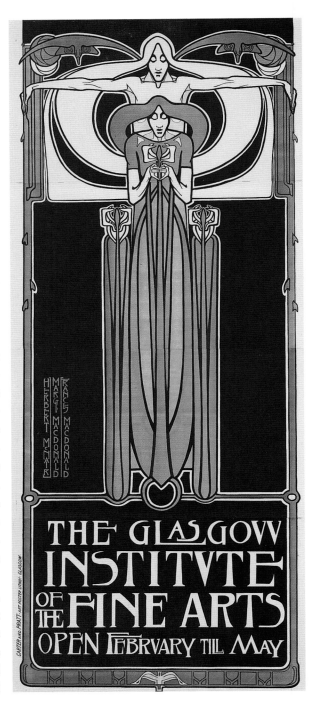

other entrepreneurial cohorts it seemed the world would be covered in Art Nouveau for a long time to come. But in little over a decade Art Nouveau had run its natural course: By the early twentieth century Art Nouveau was, well, no longer nouveau. It had become such an incredibly popular mass conceit so flagrantly applied to even the most inappropriate objects that its uniqueness was lost. While it continued to appear in advertising manuals and as motifs for furniture, wallpaper, and even architecture, it was old-fashioned. Finally, World War I put an abrupt end to all forms of ephemeral excess. After the war, other styles that had emerged as alternatives to Art Nouveau began to flourish.

SEE ALSO *Arts and Crafts, Beardsley, Psychedelic Poster, Push Pin, Victorian*

THE KIN-DER-KIDS AND WEE WILLIE WINKIE'S WORLD BY LYONEL FEININGER

Lyonel Feininger, later to join the Bauhaus and make a career as a painter, completed a remarkable run of comic strips from 1906 to 1907. Both the style and content of *Kin-der-Kids* and *Wee Willie Winkie's World* reflected then prevalent Jugendstil trends. Feininger's stories detailed adventures set in a bathtub and a little boy's anthropocentric world, respectively. His drawings were done in the exaggerated style of the day: all long limbs, distorted perspectives, and static shapes filled with flat colors. The shape of the strip itself was often designed to Jugendstil (German Art Nouveau) standards, with elaborate borders and occasionally signature Nouveau objects rimming the panels: a devil's mask, archly geometric clocks, and the tall, grinning form of a cat. With his comic strips, Feininger brought Jugendstil drawing to its ideal subject matter: the fantastic, whimsical, and surreal. — D.N.

ARTS AND CRAFTS

The Arts and Crafts movement began in England in the 1880s and promoted, in journals such as *The Century Guild Hobby Horse*, the common goal of inspiring higher quality in the book arts. Groups like the Century Guild, the Arts and Crafts Society, and the Art-Worker's Guild fought to return enfeebled British craftsmanship, as they saw it, to a state of excellence in the world. In doing so they wed all fine and applied arts into a single endeavor. The movement began with many voices until William Morris—social reformer, poet, philosopher, and furniture, textile, wallpaper, stained-glass, and type designer—became the de facto

leader. His Kelmscott Press (founded in 1891) became the vanguard of this medieval-inspired sensibility, which was anti-industrial in its rejection of mass production.

Morris was influenced by John Ruskin's celebration of Gothic architecture as the only pure stylistic form, and later was inspired by book designer Sir Emery Walker, who lectured on the history of type. Morris designed his own "Golden Type" in 1890 and pushed for the total reformation of printing types by basing them on historical tradition.

Morris and kindred artists and craftsmen, who despised the dehumanizing effects of Victorian industrialism and commercialism, established an alternative aesthetic based on quality handwork. The style, developed in collaborative workshops or guilds, was found in architecture, textiles, furniture, and the book arts. In reprising a romanticized past, Morris developed a language that appealed to and was clearly understood by those who feared the homogenizing effects of industrialization and mass production. Morris advocated greater control over the means of production as well as attention to aesthetic standards.

In England, some Arts and Crafts members eventually veered toward Art Nouveau, others embraced a purist Gothic aesthetic. In the United States, Arts and Crafts took other paths for practical reasons. The standards of commercial printing varied, so a movement began among printers and designers to proffer higher standards. Influenced by the Arts and Crafts movement a few fine printers working private presses ventured into areas that bucked convention, and ultimately set new standards for type design and composition. The American Arts and Crafts

THE NATIVITY OF OUR LORD, OR THE BIRTHDAY OF CHRIST, COMMONLY CALLED CHRISTMAS·DAY.

ALMIGHTY God, who hast given us thy only·begotten Son to take our nature upon him, and as at this time to be born of a pure virgin; Grant that we being regenerate, and made thy children by adoption and grace, may daily be renewed by thy Holy Spirit; through the same our Lord Jesus Christ, who liveth and reigneth with thee and the same Spirit ever, one God, world without end.

Heb. i. 1.

GOD, who at sundry times and in divers manners spake in time past unto the fathers by the pro·phets, hath in these last days spoken unto us by his Son, whom he hath appointed heir of all things, by whom also he made the worlds; who being the brightness of his glory, and the express image of his person, and upholding all things by the word of his power, when he had by himself purged our sins, sat down on the right hand of the Majesty on high; being made so much better than the angels, as he hath by inheritance obtained a more excellent name than they. For unto which of the angels said he at any time, Thou art my Son, this day have I begotten thee? And again, I will be to him a Father, and he shall be to me a Son? And again, when he bringeth in the firstbegotten into the world, he saith, And let all the angels of God worship him. And of the an· gels he saith, Who maketh his angels spirits, and his ministers a flame of fire. But unto the Son he saith, Thy throne, O God, is for ever and ever: a sceptre of righteousness is the sceptre of thy kingdom. Thou hast loved righteousness, and hated iniquity; therefore God, even thy God, hath anointed thee with the oil of gladness above thy fel· lows. And, Thou, Lord, in the beginning hast laid the foundation of the earth; and the heavens are the works of thine hands: they shall

ADAM·PROTOPLAS· TVS·ABRAHAM·PAT· RIARCHA·MOYSES·LEG· ISLATOR·DAVID·REX

ISAIAS·PROPHETA IEREMIAS·PROPHETA DANIEL·PROPHETA EZECHIEL·PROPHETA

SIBYLLA·PERSICA SIBYLLA·LYBICA SIBYLLA·ERYTHRÆA SIBYLLA·DELPHICA SIBYLLA·CVMANA

Designer: Dard Hunter
Book cover, 1904

movement emerged through small workshops, which wed furniture, textiles, and printing.

By the late 1890s the offshoot Aesthetic Movement in the U.S. comprised a loose-knit group of book builders and typographers, with the goal of reviving historical models for contemporary application. They reprised Old Style typefaces, including Italians, Gothics, and Caslons, as well as Moderns. Decoration was adopted that revisited medieval and Rococo sensibilities; and this approach continued well into the 1920s through influential designers including Will Bradley, Thomas Maitland Cleland, Daniel Berkeley Updike, and Bruce Rogers. But the most hard-core Morris acolyte attempted to re-create the guild system and develop a style unique to his workshop. Elbert Hubbard established a crafts community called the Roycrofters in East Aurora, New York, where he published books and periodicals using custom typefaces and ornament. While his work did not completely mimic the Kelmscott Press, and was criticized by purists for its lack of fealty, he came as close to the Arts and Crafts ideal as any American artisan. Commerce was of growing importance, and most type designers attempted to reform commercial printing rather than retire into craft utopias.

SEE ALSO *Art Nouveau, Beardsley, Victorian*

ARTZYBASHEFF

The graphic art of Boris Artzybasheff (1899–1965), a painter and illustrator, presents a personal style with broader implications for other illustrators of his era.

Artzybasheff's baroquely detailed and realistically rendered work is so rich in graphic detail that it seems like a layer cake of imagery. Though his palette was high contrast, he left nothing in the shadows, no questions went unanswered, no mysteries were unrevealed. His work exuded style born of his keen ability to render the minutest detail with such flair that the viewer was compelled to read the picture like a page of hieroglyphs.

In the 1940s *Life* magazine said of Artzybasheff: "The measure of his ability to put his point across in paint is that the more closely the paintings are examined,

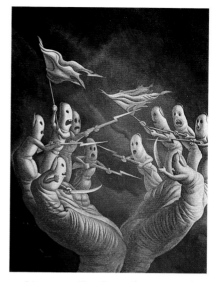

the more clever their details become." He objected to being labeled a Surrealist, as some called him, although his fantasies might be categorized as such. What he called his "burlesque or grotesque" style was introduced long before Surrealism became popular. He communicated unambiguous messages through the mass media, not contrived renditions of dreams. "I get irritated with those damn Freudians," he once wrote. "They try to see something in everything. I think there is something wrong with their minds!" But one can't blame them, really; he mastered double entendre through his satirical anthropomorphic personifications of, among other things, machines that symbolically cautioned against man's increasing dependence on mechanical devices. And his content was a commentary on modern life; rather than give his drawn machines humanity, he used human characteristics to invest them with monstrous proportions.

Artzybasheff instinctively knew how far to push the imagery while remaining "realistic." He was a precursor of the "conceptual illustration" that blossomed in the mid-1950s with Robert Weaver, Tom Allen, and Robert Andrew Parker, and later exploded with the likes of David Levine, Ed Sorel, Robert Grossman, Brad Holland, and Marshall Arisman throughout the 1960s and on to the present. Clarity was a part of Artzybasheff's success, but his ability to hold the audience's attention through intricate, visually provocative inventions—and not confuse them in the bargain—was key.

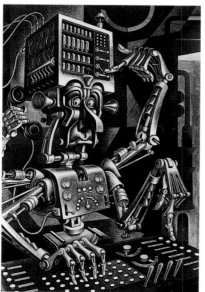

SEE ALSO *Conceptual Illustration, Expressionist, Surrealist*

see Black Letter

BASS

By 1959, when *Anatomy of a Murder* was released, Saul Bass had already hit his stride as the pioneer American title sequence designer-director. Four years earlier, the poster and opening titles for *The Man with the Golden Arm* marked his first attempt at the German Expressionist–inspired film titles that became his signature style, subsequently adopted by others making film titles at the time. Director Otto Preminger's gritty films about murder and drugs revealed society's underbelly; there was no better way to express the noir side of life than through raw images based on black-and-white silhouettes.

Bass was a fan of German and African art and had an uncanny way of incorporating them in a contemporaneous manner. The *Anatomy* sequence builds directly on two charged visual ideas: the typical coroner's outline of a corpse, and a dis-

Designer: Saul Bass
Poster, 1959

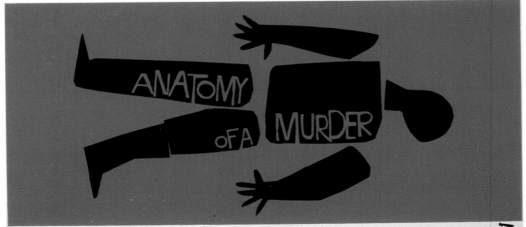

Starring James Stewart/Lee Remick/Ben Gazzara/Arthur O'Connell/Eve Arden/Kathryn Grant and Joseph N. Welch as Judge Weaver/With George C. Scott/Orson Bean/Murray Hamilton
Screenplay by Wendell Mayes/Photography by Sam Leavitt/Production designed by Boris Leven/Music by Duke Ellington/Produced and Directed by Otto Preminger/A Columbia release

Designer: Saul Bass
Poster, 1966

embodied human form—both disconcerting images in their own right. Yet Bass stylized them just enough to avoid being grotesque. Nothing says "murder" to the film-going public more instantly or eloquently.

The splayed *Anatomy* body, recalling police outlines of homicide victims, is a natural logo. The animated screen version is a serial construction of the mark, and as a puzzle it serves as a metaphor for how the police piece together a murder case. The *Anatomy* sequence, like *The Man with the Golden Arm* before it, is also a complete entity—a film within a film, a story that introduces the story. Bass was a master of short introductory allegory. Over time this sequence is arguably more memorable than the film itself. It certainly made an impact on the poster designer who copied it almost verbatim for Spike Lee's 1995 film, *Clockers*.

SEE ALSO *Expressionist, Kinetic Type, Modernist, New Typography*

BAUHAUS

The Bauhaus was established in 1923 as a state-run school in Weimar to train artists who would, in turn, bolster the flagging postwar German economy by creating distinctive, high-quality national wares. Industrialization had a profound impact on society and culture, but the Great War had squelched achievement. Bauhaus director Walter Gropius sought to end the alienation of the designer/craftsman from labor, and was fervently dedicated to the idea of the "unified work of art—the great structure, bringing together the artist, producer, and consumer in holy union," as he wrote. Thus the Bauhaus resolved to democratize art by removing the distinction between "fine" and "applied," and by making it responsive to rather than detached from the public's needs.

The so-called "spiritual" stage of the early Bauhaus lasted until 1923, replaced during its second phase (1923–1925) by new teaching methods based on quasi-scientific ideas and a Machine Age ethic. The third phase began in 1925 when the Weimar government withdrew financial support, forcing the school to relocate in Dessau. Here Gropius built his Bauhaus school building—a temple to

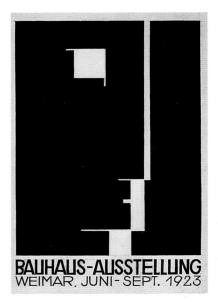

BAUHAUS-AUSSTELLUNG
WEIMAR, JUNI - SEPT. 1923

LEFT
Designer: Herbert Bayer
Poster, 1923

functionalism in which outward visual form is organically related to its internal function. In Dessau the Bauhaus launched its workshop pedagogical system. Gropius retired in 1928 and Hannes Meyer (a devout Socialist) assumed the directorship. He was removed in 1931, succeeded by Mies van der Rohe, who moved the school one more time to an old telephone factory in Berlin before its permanent closing by the Nazis in 1933. Before its demise, the Bauhaus was one of the most influential design institutions in the world in the fields of architecture, furniture, fixtures, textiles, scenic design, typography, and advertising. Its students were taught to be integral members of society.

The Bauhaus typography workshop, headed by László Moholy-Nagy (and later Herbert Bayer), developed the concept of typographic asymmetry codified in 1928 by Jan Tschichold as the New Typography (*Die Neue Typografie*). A philosophy expressing that form follows function led to a typography that was a machine for communication. "The essence of the New Typography is clarity," wrote Tschichold in *The New Typography: A Handbook for Modern Designers*. "This puts it into deliberate opposition to the old typography whose aim was 'beauty' and whose clarity did not attain the high level we require today." The Bauhaus reconciled contemporary and classical values by rejecting timeworn verities in favor of timeless utility. Functionalism was the hallmark of Bauhaus typography.

Similarly, Moholy-Nagy wrote in *Staatliches Bauhaus in Weimar 1919–23* (Munich, 1923), "Typography is a tool of communication. It must be communication in its most intense form. The emphasis must be on absolute clarity since this distinguishes the character of our own writing from that of ancient pictographic forms." As a Bauhaus master Moholy-Nagy proselytized for a movement that attacked visual redundancy. His doctrine of asymmetry stood type on its ear in an effort to garner greater freedom and less reliance on ornamentation to capture the reader. His predilection for sans serif faces as typefaces of "our time" was not based on slippery fashion conceits but arose from the same tendencies as seen in Modern architecture.

RIGHT
Designer: Joost Schmidt
Poster, 1923

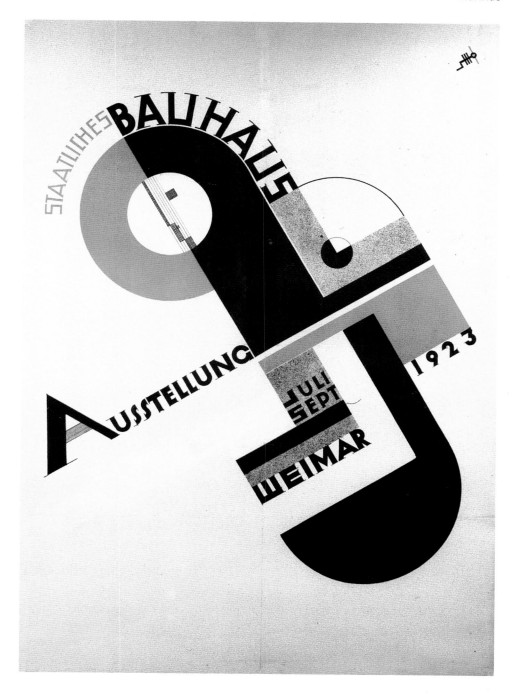

DIE
FORM

ZEITSCHRIFT FÜR GESTALTENDE ARBEIT

VERLAG HERMANN RECKENDORF, BERLIN W35

JULI : 1926
HEFT : 10
JAHRGANG : I

Designer: Joost Schmidt
Magazine cover, 1926

The Bauhaus broke conventions of placement and layout as it eliminated ornament and eschewed symmetrical composition. In place of the classical page "constructed" sans serif typefaces and bold black and red rules were designed to fragment the page and control the eye. In the 1920s it was viewed as an extraordinary departure from conventional design, but ultimately even the New Typography became yet another set of dogmatic rules against which to rebel.

SEE ALSO *Constructivist, De Stijl, Modernist, New Typography*

BAUHAUS SNAPSHOTS

Photography was not a part of the Bauhaus curriculum until 1930. But beginning with László Moholy-Nagy's appointment to the school in 1923, the medium was a vital, if independent, part of its creative life. For the young students at the Bauhaus, photography was a form of play, and where Moholy-Nagy's work tended towards formal experimentation, that of his students was more lighthearted and spontaneous. Indeed, they used smaller cameras and emphasized daily life, with a twist. The snapshots taken at the Bauhaus, particularly those by Lux Feininger (the son of Bauhaus member Lyonel Feininger), showcase the formal influence of the movement let loose on daily life. Lux photographed jumping students against the clean lines of the buildings, the curves of a saxophone, and his professors in quiet moments at striking angles. The Bauhaus complex is given new life through witty interaction with the camera; the members are humanized, caught unguarded and quiet. And yet these photographs are unmistakably of the time: spontaneous, yes, but never sloppy. The compositions are perfectly realized, the experimentation honest and forthright. The viewer gets a glimpse of how the Bauhaus style can exist in daily life. Because of the combination of the subjects themselves and the style of the work, Bauhaus style pours out of these photographs. — D.N.

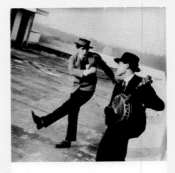

DANCING ON THE ROOF
PHOTOGRAPHY AND
THE BAUHAUS (1923–29)

JUNE 5–AUGUST 26, 2001
THE METROPOLITAN MUSEUM OF ART

THE HOWARD GILMAN GALLERY

BEARDSLEY

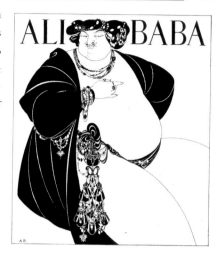

During the psychedelic '60s, when graphic artists reprised past styles from Victorian to Art Nouveau to Deco, the English *graphiste* and erotic *symboliste* Aubrey Vincent Beardsley (1872–1898)—the so-called "dandy of the grotesque"—was posthumously returned from his exile in the artistic wilderness. His excessive curvilinear style and chiaroscuro sexual fantasies were a potent antidote to austere Modernist design, and an apt influence on drug-inspired hippie aesthetics of the day.

Beardsley had an obsession with the darker side of life and his representations of men and women were macabre. He ignored proportion and perspective, which brought considerable criticism from academic art circles. His signature style involved working with the single line and masses of black—in part influenced by Japanese printmaking. His figures were symbolic but he was primarily an ornamentalist. His frontispiece to *Volpone* is considered a tour de force from a purely technical standpoint, one of the best pen drawings of the age. His posters for the Avenue Theatre and for Mr. Fisher Unwin were among the first of the modern cult of that art. With the decline of Art Nouveau's eccentricities, Beardsley's work fell out of favor.

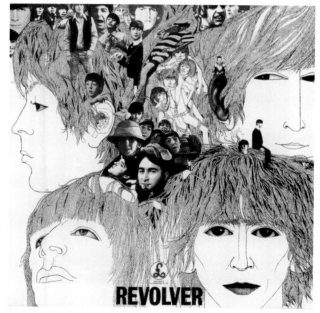

The 1966 release of the Beatles' landmark album *Revolver* featured a quirky cover portrait of the group by Klaus Voormann that combined Beardsley-esque linear styling (especially the obsessive lines that comprised the Beatles' hair) with silhouetted photos pasted

ISSN 1721-4904

9 771721 490005

on. This single piece of art altered the way LP sleeves would be designed for the next decade. Beatles fans (and Beatle-ologists) dissected every aspect of the cover for hidden meanings. The black-and-white cover was at once haunting and comforting, polished and raw, yet decidedly unlike any preceding pop record sleeves (usually straight photographic portraits of bands). Soon afterward Beardsley reprints and Beardsley-inspired illustrations cropped up in abundance on rock posters, underground newspapers, and hippie ephemera. But Beardsley veneration was short-lived. While his life and work continue to interest scholars and collectors, by the mid-seventies it was passé to copy the style. As recently as 2005, a Milan-based online periodical called *This Is a Magazine* (www.thisisamagazine .com) published a cover influenced by *Revolver*, if not Beardsley himself.
S E E A L S O *Art Deco, Art Nouveau, Psychedelic Poster, Victorian*

BIG BOOK

The "Big Book Look"—a large title, large author's name, small symbolic image—had its inception in 1956 when designer Paul Bacon was commissioned by Simon & Schuster to design the jacket for *Compulsion*, a *roman à clef* by Meyer Levin about two young men who cold-bloodedly plan and carry out the murder of a young neighbor boy to see if they can get away with the crime. The publisher knew that the highly publicized killing of Bobby Franks by Nathan Leopold and Richard Loeb would popularize the novel, but was uncertain how to devise a

jacket that would be suggestive though not crass and evoke a mystery without clichés. Bacon sketched out a number of ideas until he came up with the rough, hand-scrawled word "Compulsion," which he positioned at the top of the jacket, taking up a fifth of the space; below it an empty rectangle bled off the field, and below that, at the bottom, was scrawled "a novel by Meyer Levin." The combination of enormous title and large byline signaled the book was a bestseller; the fact that the book did well helped solidify the Big Book style. In fact, Bacon's Big Book approach was

immediately copied throughout the trade book world, although the designer sub-ordinated ego to function, saying in an interview, "I'd always tell myself, 'You're not the star of the show. The author took three-and-a-half years to write the god-damn thing and the publisher is spending a fortune on it, so just back off.'"

As design matured in the 1960s, publishers liked the idea of using an icon or a logo on a jacket as opposed to the conventional type or literal illustration. And Bacon was good at "finding something that would be a synthesis graphically of what the story was about." Moreover "I was not encumbered by having to work from models," he says. "Many of the things I did, I just did strictly from memory and without any reference at all. Unless I needed something specific, like a German airplane or something—then I'd look it up. But it was very liberating to realize that I didn't have to do something that looked like Norman Rockwell did it."

He was not Rockwellian, but neither was he an orthodox Modernist like Paul Rand, Alvin Lustig, and Leo Lionni, who were influenced by European Mod-ern art. Bacon certainly admired these designers, but his book jackets were generally not for "heady" works of criticism, analysis, and literature with small print runs, but rather reso-lutely commercial books with massive exposure.

Designer: Paul Bacon
Book jacket, 1980

Bacon didn't do multiple sketches to show clients, but he was accommodat-ing. "If people didn't like something about a Cole Porter tune he just tore it up," he says. "And I did the same thing with the jackets." For the 1961 publica-tion of Joseph Heller's classic *Catch-22*, Bacon did eleven versions, including one that just said *Catch-22* in very large lettering and one that had the protago-nist Yossarian bull's-ass naked from the back, saluting as a flight of bombers went over. Then at some point "I came up with the little guy that I tore out of a piece of paper, representing Yossar-ian in full flight from everything." The

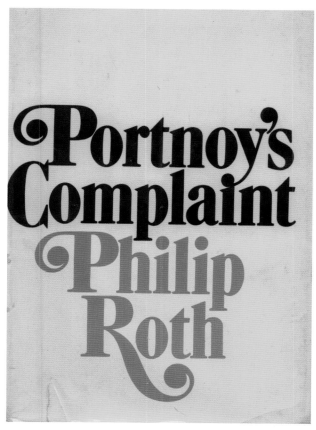

Designer: Paul Bacon
Book jacket, 1969

finished cover doesn't conform to any of Bacon's other jackets, but with the book it became one of the most successful bestsellers.

The jacket for Philip Roth's *Portnoy's Complaint* (1969) was characteristically uncharacteristic. Though the vast majority of Bacon's jackets are built on some conceptual idea, this one consisted solely of pure type against a yellow background; no fancy touches, except for the swash capitals in the title and author's name. Asked why he avoided his signature conceptual image, Bacon said it was because of the difficulty in portraying the book's most prominent element: masturbation. But also, "In color, it was just so simple and raw. I started to do this for books like *Sophie's Choice* that were strictly lettering covers, which in some ways I suppose was a coward's way out. But it just seemed appropriate for these enormously complicated books." Bacon felt that attempting to do anything other than a solution that proclaimed this was an "important book—read it!" would not work.

SEE ALSO *Commercial Modern, Conceptual Illustration*

BIG IDEA

The early to mid-1960s were known as a golden age of print advertising because creative teams of art directors and copywriters worked in harmony for a common goal. With the barriers between word people and picture people torn down, advertisements no longer looked like a patchwork quilt. Just as critical, television had not yet become the dominant advertising medium, hence many of the best art directors—George Lois, Bill Taubman, Gene Federico, Bob Ga—were also dyed-in-the-wool graphic designers who understood the nuances of type and made ideas come alive through its intelligent handling. Creative

Andy Warhol and Sonny Liston fly on Braniff. (When you got it-flaunt it.)

Designer: George Lois
Advertisement, 1967

advertising experienced a revolution that launched a unique slogan: the Big Idea.

Big Idea advertising was startlingly witty, intelligent conceptual thinking combined with simple typography and straightforward Modernist principles. Advertisements didn't all look the same: Clean graphics allowed ideas to thrive. One crucial campaign epitomized this aesthetic more than any other.

"In the beginning, there was Volkswagen," wrote the adman Jerry Della Femina in his best-selling memoir of the ad business, *From Those Wonderful Folks Who Gave You Pearl Harbor* (1970). "That's the first campaign to which everyone can trace back and say, 'This is where the changeover began.'" The changeover was the 1959 Volkswagen "Think Small" campaign art directed by Helmut Krone for Doyle Dane Bernbach. At a time when conventional advertising accentuated mythic perfection, this was the first time that an advertiser—a conservative automobile advertiser—admitted the possibility of imperfection. Not only that, but given the Promethean American car mentality, the Volkswagen started as an underdog. The copy said that once in a while VW turns out a lemon, and when they do they get rid of it. "No one had ever called his product a lemon before," Della Femina wrote. "It was the first time anyone took a realistic approach to advertising. It was the first time the advertiser ever talked to the consumer as though he was a grown-up instead of a baby."

Designer: George Lois
Advertisement, 1964

The campaign was also graphically distinctive because Krone allowed ample white space to frame the modest Futura Bold headline, and the seductively matter-of-fact photography dispelled the preconception that automobile photography should necessarily be hyperrealistic to sell the product. It was also the first time that formal advertising copy was conversational and not puffed-up. Copy blocks routinely contained widows to avoid artificially filling out lines. And perhaps anticipating some residual ill feeling from World War II, the VW logo was kept small.

During the era of Big Ideas virtually everything Doyle Dane Bernbach touched turned to gold. Another momentous campaign—for Levy's Rye Bread—art directed by William Taubman, transformed this local ethnic product into a national staple. Although the difference in the taste of rye breads may be negligible at best, the sudden rash of subway posters showing alternately an African American or Chinese American child, a Native American or Chinese American adult happily munching on a sandwich under the headline "You Don't Have to Be Jewish to Love Levy's" is as memorable today as Doyle Dane's classic 1960s "We Try Harder" campaign for Avis.

Designer: Louis Silverstein
Advertisement, 1965

Endearing trade characters had long been the mainstay of advertising practice. By the 1960s some of these friendly pixies and gnomes were replaced by more sophisticated concepts. About one seminal change Della Femina recalled, "they were trying to sell Alka-Seltzer with this little Speedy creep. Well one day they moved the account over to Jack Tinker and the first thing Tinker did was to kill off Speedy. . . . And they came up with a great campaign, 'Alka

"I got my job through The New York Times."

Social Worker

Seltzer on the Rocks.'" To make a chalky tasting medicine into a refreshing cock-tail was a stroke of brilliance. So was Mary Wells' inspired Alexander Calder paint job on Braniff's planes. In the days when the public was more conscious of novelty than safety, Wells' refurbishing gave Braniff the kind of visibility that put them on the map. This was the age of smart ideas *and* great execution.

Public service advertising promoted further innovation: Since the advertising business communicated directly to the American mainstream, it accomplished more than the counterculture to raise the consciousness of the white middle class to the problems of those Americans being discriminated against in housing, edu-cation, and the workplace. Harnessing commercial advertising techniques, Young and Rubicam's "Give a Damn" campaign for the Urban Coalition was exemplary of the new confrontational public service message. It was bold yet did not scare off its audience. It also conditioned viewers to relate to public service ads with even more startling imagery. Advertising had indeed flexed its muscle.

S E E A L S O *Commercial Modern*

BLACK LETTER

Black letter was long shrouded in mystique and nationalism. The polar opposite of the geometrically based Roman, black letter is often misleadingly referred to as Old English or Gothic, all-encompassing terms used to describe the scripts of the Middle Ages in which the darkness of the characters overpowers the white-ness of the page. It was based on the liturgical scripts found in Gutenberg's 1455

Mainz Bible and precedes Nicolas Jen-son's earliest Roman alphabet by fifteen years. Black letter developed through-out German-speaking Europe during the fifteenth century in four basic styles: Textura (*gotisch*), Rotunda (*rund-gotisch*), Schwabacher, and Fraktur, reinterpreted in various manifestations and stylistic variants.

Prior to the Napoleonic wars ten-sions between the German states and France inflamed virulent nationalism, which encouraged official recogni-tion of Fraktur as *the* German type,

Designer: Unknown
Magazine cover, 1925

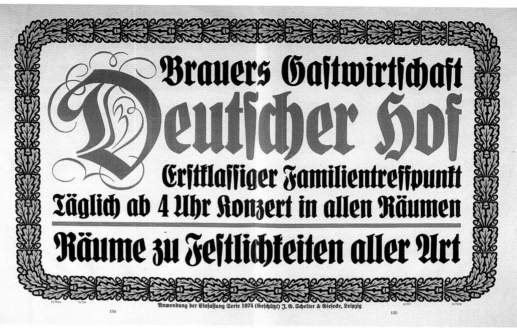

Anwendung der Einfassung Serie 1074 (Geschützt) J. G. Schelter & Giesecke, Leipzig

bestowing upon it the same passionate allegiance as a national flag. Throughout the nineteenth and twentieth centuries black letter symbolized the best and worst attributes of the German states and nation. In the twenties Jan Tschichold (a leftist who briefly changed his name to Ivan in solidarity with the Bolsheviks) denounced "broken type" as nationalistic. Rudolf Koch, who also designed the sans serif Kabel as well as his own version of Fraktur, supported "the German Way of Being," which manifested itself in the "German Way of Writing." Other considerations, such as rationalism versus romanticism, later entered the debate for and against black letter. Nevertheless, the German Left used Fraktur almost as much as the Right, yet the type has been criticized most for being "Nazi letters."

"Lettering is an active and vitally needful civilizing factor and must from henceforth play a much greater part in

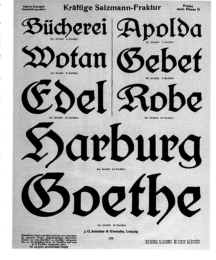

our life. . . . It will help to vitalize indi-
vidual capacities and hence further the
development of the whole of our future
civilization," proclaimed a 1936 editor-
ial titled "Writing and Lettering in the
Service of the New State" in *Die Zeit-
gemässe Schrift*, a magazine devoted to
lettering and calligraphy. The state was
the Third Reich and the lettering was
Fraktur, the traditional German black
letter that had lost favor during the
Weimar Republic years when Bauhaus
style and the New Typography chal-
lenged its dominance. Yet by 1933 the
Nazis, who assailed some Modern sans
serif type as "Judenlettern," returned
Fraktur back with a vengeance as the national type style.

Designer: Lucian Bernhard
Advertisement, 1912–22

Josef Goebbels, Nazi minister of Propaganda and Enlightenment, decreed that
black letter be returned to its rightful place representing German *Volk Kultur*. In
the early years of the Reich black letter became the official *Volksschrift* (lettering
of the German people). To honor the five-hundredth anniversary of Gutenberg's
invention in 1940, the Germanisches Nationalmusuem in Nuremberg held the
exhibition "Writings as German Art." But then suddenly on January 3, 1941,
Deputy Führer Martin Bormann issued the following directive:

> *The following is brought to general attention by order of the Führer: To consider
> or to designate the so-called Gothic script as a German script is wrong. In reality the
> so-called Gothic script consists of Schwabacher-Jewish letters. Exactly as they later
> on took possession of the newspapers, so the Jews residing in Germany took posses-
> sion of the printing shops when printing was introduced and thus came about in
> Germany the strong introduction of the Schwabacher-Jewish letters.*

> *On this day in a conference with Reichsleiter Amann and printing plant owner
> Adolf Mueller the Führer has decided that Roman type from now on shall be des-
> ignated as the normal type. Gradually all printing products shall be adjusted to this
> normal type. As soon as this is possible textbook-wise, in the village schools and the
> elementary schools only Roman shall be taught.*

> *By order of the Führer Reichsleiter Amann will proceed to change over to normal
> script those newspapers and magazines which already have a foreign circulation or*

[for which] foreign circulation is desirable (quoted from *Art Under Dictatorship,* by Helmut Lehmann-Haupt, Oxford, 1954).

Given the negative perception of black letter, one might presume that after the Nazi's defeat in 1945 the type would forever fall into disrepute. But the type was not only retained by those businesses for whom conservative or traditional values could best be symbolized through Fraktur (including beer advertising, gastronomy, and newspaper mastheads), but as a fetish for those loyal to neo-Nazi ideologies. Since German Federal law forbids any display of the swastika, black letter continues to serve a ritualistic and symbolic role for extremists. At the same time, not all black letter revivals are the property of skins or neo-fascists. Contemporary typographers from Jonathan Barnbrook to Zuzana Licko to Michael Worthington have reinterpreted black letter in a variety of ways and their quirky alphabets adorn Gothic novels, heavy metal CDs, and countless magazine and television advertisements for hip and hip-hop products.

S E E A L S O *Bauhaus, Fear, Object Poster*

BONEHEAD

Bonehead style, the creation of Minneapolis graphic designer Charles Spencer Anderson, revels in goofy cartoon characters derived from 1930s and 1940s stock commercial art sample books. Yet Anderson's design is anything but goofy. This highly polished ironic graphic style has evolved into a distinct dialect that draws on a lexicon of quotidian images, typefaces, and dingbats—the ephemera (some call the detritus) of popular visual culture.

By the 1960s the corny printer's cuts and trade characters that were once so ubiquitous had sunk to the nadir of graphic achievement, repudiated by Modernists whose mission was to obliterate such blight from design. In the Postmodern eighties what began as a parody of these forms was eventually raised to an integral art, as when pop artists of the 1960s elevated the artifacts

Designer:
Charles Spencer Anderson
Book cover, 1995

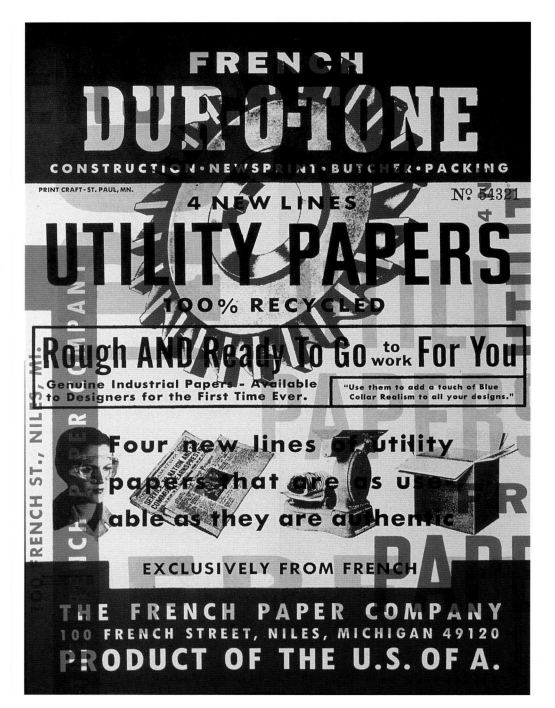

of commercial culture to revered icons. Anderson's long-running (1980s through '90s) campaign for the French Paper Company borrowed the iconography of early commercial printing and incorporated it into witty rebus-like compositions that critiqued the mindless ubiquity of these once anonymous materials by giving them a contemporary comic reinterpretation.

The quotation of common visual advertising clichés and sampling of Gothic commercial typography uncovers a lost aesthetic dismissed as artless. Anderson discovered graphic integrity in the crude innocence of timeworn vernacular images. He appreciated them for their nonsensical qualities and for entertainment value. He launched Bonehead style through the French Paper campaign, including paper specimens that were developed as toys, playing cards, and other graphic playthings, exploiting the more camp characteristics for the purpose of engaging the viewer in a distinct visual world.

It was no coincidence that Bonehead style began during the Reagan '80s, a time when, as critic Natalia Ilyin writes, "nostalgia twisted truth out of its socket" by forcing the public to accept the false simplification of a vague, mythic past. The earliest iterations of Anderson's design were consistent with retro trends like the nostalgic TV show *Happy Days*. Then again, much like the folklorist who discovers lost and forgotten stories, Anderson's images became the basis for multiple narratives for various commercial purposes. While the style was used to promote the wares of companies like French Paper, Urban Outfitters, and Turner Classic Movie Network, it also fostered appreciation among graphic designers for nascent commercial art. In popularizing these forms Anderson contributed to the continuum of design by building on what designer Art Chantry refers to as American commercial folk art, the anonymous artifacts of the commercial era.

SEE ALSO *Chantry, Generic, Matchbox, Postmodern, Razor Blade, Tijuana Bible, Vernacular*

BULL'S-EYE

One does not have to be a crack marksman to appreciate the sheer eloquence and simple beauty of the classic bull's-eye. For function and utility it is the most perfectly designed of all graphic forms; nothing is more economical than the black concentric circles surrounding the target mark. If the archetypal target did not date to antiquity it would epitomize the Modern marriage of form and function. In ancient times the *targe* was a light circular shield protecting the foot soldier from an enemy's attacks. The shooting target, based on that shield, was a bundle of wood painted with circles and hung from a tree or pole.

By the early twentieth century, targets were recurring motifs in various posters and illustrations. In the 1920s the target was used as an eye-catching device in Russian Constructivist advertisements and posters. Other Modernist schools adopted it as functional ornamentation. In the 1930s commercial advertising arts magazines referred to "scoring a bull's-eye" with bold graphics, and literally used the concentric circles to underscore the point. Such mainstream consumables as Odol, Tide, and Lucky Strike have targets on packages as startling mnemonics. The practice of targeting household products continued well into the '50s. In the 1960s Jasper Johns transformed the target into a pop art icon. In the '90s Target stores appropriated the bull's-eye as its primary logo.

Bull's-eye targets are designed to be shot to smithereens, a purpose that is difficult to separate from their material graphic grace and elegance. Yet it is this very tension between the target's form and function that makes it so intriguing, stylish, indeed hypnotic.

SEE ALSO *Constructivist, Generic, Kodalith, Vernacular*

ABOVE
Designer: Unknown
Advertisement, 1928

RIGHT
(top and bottom right)
Designers unknown
Shooting targets, 1990s

(bottom left)
Designer: Alexey Brodovitch
Magazine cover, 1931

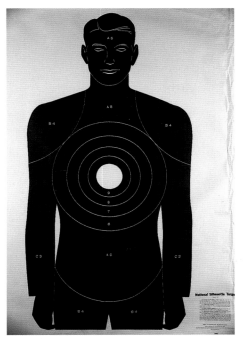

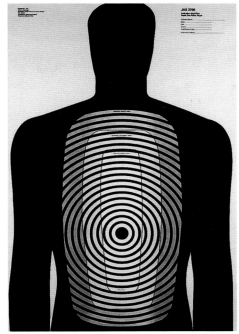

see Cooper

CAMOUFLAGE

How well a piece of camouflage is designed can mean the difference between life and death for soldiers on the battlefield. Long considered one of the most indispensable tactical tools, camo has been perfected for all kinds of environmental venues from jungles to deserts to cities. It was only a matter of time, in the tradition of the T-shirt, Spam, and aviator glasses, that camo, once exclusively used by the military, would become one of the hottest high (and low) fashion trends.

Long before Old Navy stores popularized cheap chic, army and navy surplus stores provided civilians with inexpensive, durable off-the-rack clothing. It was only a short leap from functional apparel to groovy accessories. In the late 1980s and early '90s camo and other martial materiel, like holsters and bullets, were co-opted by stylists. Today camo is used by the military more than ever before (and by hunters and militia types), but for most civilians it is a decorative style, void of functionality or symbolism. The use of camo patterns on everything including automobiles, furniture, leisure wear, and graphics suggests that connoisseurs needn't be gung-ho militarists to embrace military aesthetics. The abstract shapes and complementary color combinations, contrary to camo's original purpose, are eye-catching. The mere sight of camouflage cannot but trigger unsettling images of guerrilla warfare, forced occupation, even ethnic cleansing. Military symbols are not meant to be ambiguous nor benign. But camo's stylistic surges are more about

Designer: Mary Beth McIlhinney
Patent drawing, 1989

Designer: Unknown
Flyer, c. 1941

flaunt than deception, which not only goes counter to original intent but flies in the face of Modernist design principles as well.

"Camouflage attracts modernists raised to believe that ornament is crime," wrote Phil Patton in *AIGA VOICE* (2005). Artists and fashion designers have long played off camouflage, and many fashionistas ironically apply camo bikinis as "a play on concealment and revelation," says Patton.

Camouflage has long been associated with artists who were employed during World War I to camouflage equipment and installations. Gertrude Stein quoted Picasso and Braque after they viewed camouflaged military equipment on parade in Paris at the beginning World War I. "We did that. That is cubism," Picasso said. British military ship camouflage was akin to Futurist or vorticist painting, with its angular slashes and zigzags. And as Patton writes, "That an apparently functionalist thing had so many stylistic and cultural variants was a lesson modernism would have to learn again and again." Currently, an extraordinary variety of camo is in use in life-saving, life-ending, and life-diverting applications.
SEE ALSO *Futurist, Modernist, Vernacular*

CAPPIELLO

Leonetto Cappiello's advertising posters project an aura of quaintness born of commercial innocence when, during the turn of the nineteenth to the twentieth century, the nascent advertising industry relied on fantasy and romantic art to sell products such as liquor, cars, sundries, and medicines. However, at the dawn of mass marketing, Cappiello, the "father of the modern poster," made radical advertising with reportedly over one thousand original designs. You will not see many designers today borrowing Cappiello's illustrative method because unlike Constructivism or the Bauhaus, this work does not have a cool Machine-Age veneer.

Mass marketing in Europe coincided with the increase of traffic on broad boulevards and the introduction of large poster hoardings showcasing colorful images designed to grab the eyes of passersby. The Italian-born (Livorno, 1875) Cappiello,

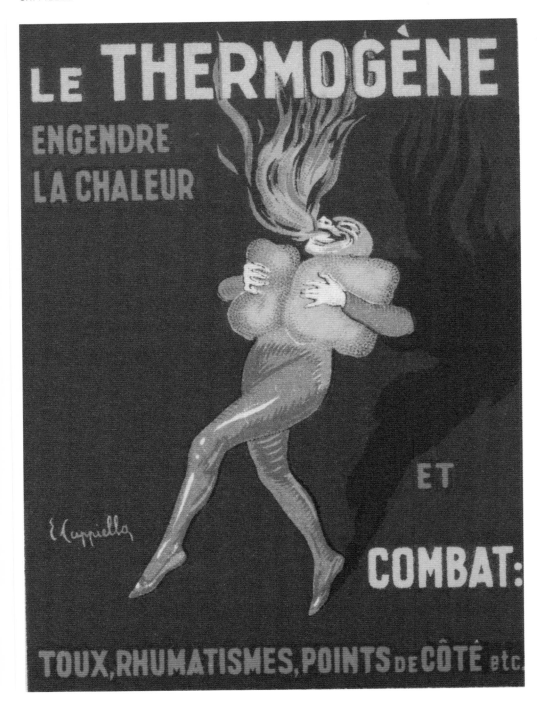

who produced the majority of his work in Paris from 1898 to 1936, believed that simplicity was paramount. Hence he always focused on a single image, usually a mascot of some kind, accompanied by a line of starkly rendered hand-drawn type—usually a brand name. He once said that color "makes us notice," while action "makes us remember." His posters were carefully composed to make lasting impressions, and they are unforgettable even today.

The images of clowns, mimes, animals, and sensual women in bouffant hairdos are classic. His most famous and monumental trade characters (now a staple of poster exhibitions and galleries), the Cinzano zebra, Fernet Branca king, Thermogene fire breather, and Bitter Campari lamppost climber, are as startling as they ever were—even in this era of relentless image bombardment.

Cappiello began as a caricaturist for the leading humor periodicals of the late nineteenth and early twentieth centuries, *Le Rire*, *Le Cri de Paris*, and *L'Assiette au Beurre* (the most politically controversial of the bunch). He was a frequent contributor to *Le Figaro* for which he perfected a fluid line that captured simplified likenesses. He was a bridge between the Art Nouveau and Impressionist styles that dominated French and Italian advertising of the time. He dabbled in book illustration, and in 1916 made drawings for poet Guillaume Apollinaire's "Le Poète Assassiné," but commercial art, not storming the cultural barricades, was his goal. In fact some critics blasted his style as "bourgeois realism."

In 1900 he signed a contract with Pierre Vercasson, a printer and advertising agent, for whom he evolved a signature approach of contrasting brilliant flat colors off dark backgrounds. One of his seminal posters for Chocolat Klaus was a bold stroke that smashed "through the barriers of traditional Victorian restraint," writes Jack Rennert, who argues that Cappiello's work penetrated the viewer's subconscious, "to conjure up images that remain indelibly associated with the advertised product." Cappiello's fanciful trade characters were indeed friendly mnemonics that firmly established an idealized view of the most quotidian of wares. In 1916 Cappiello left Vercasson (who hired other artists

to copy his style) and three years later associated himself with Devambez, an agent and broker who sold his work until 1936. During this period the Cappiello style reached its zenith: Posters from that period are prized collectibles today. His Bitter Campari clown climbing out of an unfurling orange peel and the Pâtes Barconi levitated Pierrot consuming a plate of spaghetti have mouthwatering power.

His masterful work for the umbrella manufacturer Parapluie-Revel of Lyon is abstract and yet perfectly accessible. The viewer sees the tops of three umbrellas that look like a ship's black sails covering the users. Against a field of sienna (an anomalous color for a rainstorm) the trio braves the suggested but unseen wind and rain with as much selling allure as any more realistic image. The style may seem a little musty today, but the formal brilliance of Cappiello's illustrative advertising remains timely.

SEE ALSO *Art Deco, Art Nouveau, Bauhaus, Constructivist*

CHANTRY

Despite Art Chantry's prestigious retrospectives at the Seattle Art Museum and MoMA's P.S. 1, he resides in a kind of wilderness on the margins of graphic design. He is not a trendy stylist, clever conceptualist, or hip theorist. For over three decades he remained true to his own vision, out of which emerged an idiosyncratic Chantry style, that falls under the Postmodern banner yet sits uncomfort-

Designer: Art Chantry
Record sleeve, 1999

ably alongside Vernacular, Punk (Do-It-Yourself, or D.I.Y.), and Grunge. While the style projects these various looks it is not really any of these. Chantry's method is beyond eclectic, perhaps best described as a kind of folk art—a "commercial folk art style."

Although fashion embraced his method for a time, it also rejected it. Chantry hasn't been fazed nor has he changed direction just to be on or ahead of the curve. True to the basic principle that graphic design is itself a form of folk art that reveals as much about the ambient culture as it does about a client's message, Chantry's goal has

Designer: Art Chantry
Record covers, 1992–98

always been to create work that speaks to and about the culture in which he lives.

When Chantry began practicing in the late 1970s, a time when corporate design budgets were high and designers wallowed in glossiness, he preferred using found materials and printing on cheap paper stocks for both cost saving and demonstrative results. This wasn't a new idea—sampling vernacular iconography dates back to '20s Dada and was practiced during the '60s psychedelic period—but as a fan of hot-rod graphics and psychedelic posters, Chantry distilled these counterculture methods into a unique language.

Traditionally schooled, he understood the tenets of type and principles of composition all too well, but rejected mannerisms that did not offer any real

challenges. Before vernacularism dev-
olved into a neat official style and before
some design academies established the-
ories of anticanonical design, Chantry
had already broken rules of legibility
and readability. He accepted that his
ostensibly low-budget theater, music,
and book clients would not be best
served by a neutral style, and so he tested
the limits of visual communication.

Enter the computer: "One of my
great professional sorrows is the loss
of the typographer/typesetter to con-
temporary graphic design," Chantry
once opined in an interview about the
advent of the computer and the death

of the type shop. "I learned that graphic designers are not typographers. The mere

Designer: Art Chantry
Record cover, 1999

fact that all graphic designers have to now act as their own typographers has in
effect tossed out 500 years of expertise and replaced it with a level of amateurism
and experimentation that is going to take decades to absorb. Computers are such
powerful design tools that it may take many decades to get past the 'bad type/bad
design' learning phase. Typeface design has almost nothing to do with design or
function at this early stage, but everything to do with decoration and fad."

Reacting to this state of affairs Chantry quit doing typography. He stepped
backwards: "If you examine my work—it becomes apparent to me that I have
become a letterer. I no longer even attempt to create what I used to consider 'qual-
ity designed typography,' I just make the words fit my ideas—however that may
be achieved." The Chantry style is about carving words out of whatever seems
appropriate to the idea. Chantry could have adopted the tricks of the computer
trade, but instead followed another impulse and has produced a wealth of printed
matter that defines a time and place.

SEE ALSO *Dada, Do-It-Yourself, Grunge, Postmodern, Vernacular*

CHEAP CHIC

In the 1930s and '40s fees for commercial art were pretty low, even by the stan-
dards back then. Book jackets, for example, paid between $10 and $25, which

included type and imagery (typically a painting or drawing). Advertisements, posters, and Show-Cards went for $5 to $10, depending on size. Layout people earned $5 to $15 per job in an economy where a blue-plate special cost two bits, and a weekly rent averaged $5 to $10. With such paltry budgets, most graphic artists created their own lettering and ornament rather than share such meager fees with typesetters; since photostats were usually costly, they often drew whatever images they needed by hand in pen, ink, or gouache. For a freelancer

to make a livable wage, high volume work, production shortcuts, and being a jack-of-all-trades were necessities of a successful professional life.

Of course, relative destitution in commercial art can spawn innovation. Members of Europe's early twentieth-century avant-garde design movements were more concerned with expression than budgets. Radical Dadaists, Futurists, and Constructivists traded wealth for freedom to serve their cultural-political agendas. The rule-breaking asymmetrical design that defined the New Typography of the 1920s has been characterized as a rebellion against antiquated bourgeois notions of acceptability; it was also innovation born of necessity from monetary constraints linked to oppositional fervor.

In post–World War I Europe, hot-metal typesetting was expensive; in post-revolutionary Russia, paper and ink were extremely scarce; young activists had to find alternative ways to convey messages to the masses. What better way than to recycle print shop leftovers, old printing cuts, and discarded type slugs—it was akin to smoking old cigarette butts. The

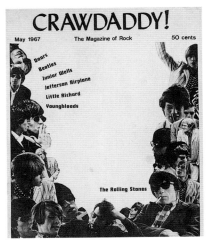

Designer: Miriam Linna
Magazine cover, 1967

anarchic Dada aesthetic relied on disparate letters appearing in the same lines of type—as much to rub salt in the eyes of the bourgeoisie as to redefine taste—but it was also economical to make letters and ornaments from random typecase "furniture." Radical artists would have challenged convention even if printing and typesetting were free, but graphic radicalisms were spurred in untold ways by economic constraints.

In the 1960s, a cheap style emerged once again as an alternative to professionalism, and this time the radical idea was to fill the printed page with as much minutia as possible—contrary to the Modern dictum the hippie or underground aesthetic was "more for less." Like the avant-gardists before them, lack of funds forced '60s designers to borrow, co-opt, and steal. This was the age of the flea-market aesthetic, in which old type and ornament from Victoriana and Art Nouveau, pictorial wood engravings, and decoupage clippings were crammed together in cluttered compositions. Cheap techniques such as split fountain inking (blending two or more colors on a single roller or screen to give the illusion of more),

solarization (a darkroom technique giving the illusion of three dimensions), and Kodalith high-contrast pictures produced graphic power at little cost. Graphic artists also routinely used Transfer-type, Typositor, or Address-O-Graph lettering, and cartoonists and illustrators often drew the headlines to give '60s graphics a homemade veneer.

In the early 1970s, Punk emerged as the next generational aesthetic to exploit frugality. Punk was dreary, cruddy, and untidy—in short, amateurish. Taking Dada a step further, Punk was so contemptuous of conventional beauty that it rose to haute-ugly. There

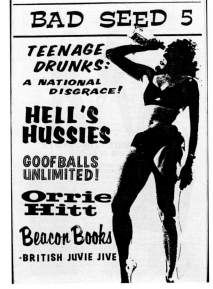

Designer: Miriam Linna
Magazine cover, 1990

was little temptation for mainstream trendsetters to mine Punk for profit. To the astute observer, the primitive torn-and-tattered style, especially the ransom note typography and anarchic collages on publications, record covers, and posters, suggested a usable, indeed, a co-optable style. What began as an inexpensive means to address an exclusive audience became shorthand for youth culture. In fact, precisely because the visual materials and design tools were so cheaply accessible to anyone with a pair of scissors and a glue pot, Punk, so tied to sampling, became a prime target for sampling itself. And the most flagrant samplers were Condé Nast's fashion magazines in the early 1980s under Alexander Liberman, a publication designer who believed that elegant design had become too froufrou. He spent millions making the magazines under his control—*Vogue, Self, Mademoiselle*, among others—look cheap, or at least cheap chic. The result, however, was disingenuous.

SEE ALSO *Chantry, Club Flyer, Constructivist, Dada, Do-It-Yourself, Futurist, Handlettering, Kodalith, New Typography, Show-Card*

CHINESE CALENDAR GIRL

Artist Kwan Chuk Lam (also known as Lamqua) settled in Hong Kong in 1845, where he established the "Handsome Face Painter" shop that produced advertisements for the China Trade, and a style that dominated Chinese advertising for decades. These were mostly portraits of a generic quality created in the romantic style of his teacher, the English Mannerist painter G. Chinnery, and used to promote a wide range of imports and exports. The flourishing business was carried on by Kwan Chuk Lam's descendants. The most notable was Kwan Wai Nung, who during the 1920s was hailed as "The King of Calendar Art" for his distinctive portraits, mostly of beautiful women, that combined traditional Chinese brush painting with European Modern stylizing. He learned his craft from Western sources as well as the "Mustard

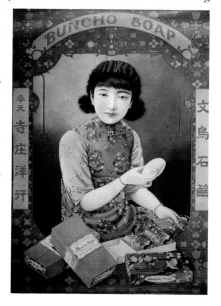

*Designer: Unknown
Poster, c. 1930*

Seed Garden Manual," an eighteenth-century Chinese guide that taught artists drawing and composition.

Prolific is not a precise enough word to characterize Kwan Wai Nung's immense output. Over a twenty-year period by his own hand or under his direction Kwan produced thousands of images. Each conformed to a similar formula. Every model was elegantly dressed, purposefully posed, and colorfully painted in a romantically realistic manner. The models' demure yet sultry eyes rarely looked directly at the viewer. Kwan preferred three motifs: the single woman (known as "calendar girls"), two women suggestively together, and a woman and child. Men were rarely present. Unlike most Western posters, the products being advertised were not incorporated into the main image; rather, blank spaces were left above and

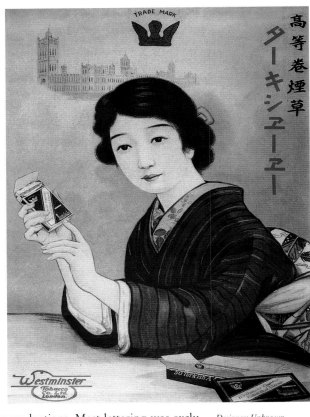

Designer: Unknown
Advertising poster, c. 1930

below for the typography and package reproductions. Most lettering was exclusively Chinese, except brand designations for the Western imports.

Kwan Wai Nung catered to a wide range of clients from a San Francisco medicine firm to the first Hong Kong government's antismoking poster. He also produced images for use by cigarette, liquor, cosmetic, confection, and even insecticide companies. It was not uncommon to find his images, which were either sold or stolen, used on packages or promotions for very different products created by other printing establishments. In fact, Kwan's sons and nephews established competing companies (and used many of the King's original designs), including the Mercantile Printing Co., Tin Chun Lithographic Press, and the Paramount Advertising Co. During the 1930s Kwan Wai Nung passed on his honorific as King to Cheung Yat Luen, a poster artist who continued painting calendar girls until the 1950s. These images continued to be used for another decade until they were replaced by photographic pinups.

S E E A L S O *Art Deco, Vernacular*

CHRISTMAS

Illustrator: Thomas Nast
Book illustration, 1869

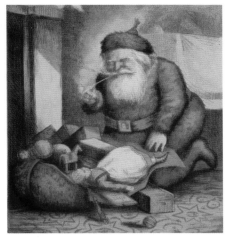

In 1841 the Philadelphia merchant J.W. Parkinson hired a man to dress in a crimson suit and repeatedly climb in and out of a makeshift chimney outside his shop. The advertising ploy worked, but Santa did not truly become the quintessential Christmas icon until 1862, when American political cartoonist Thomas Nast (creator of the Democrat donkey and Republican elephant) rendered him in pen and ink while working for New York's *Harper's Weekly*. It was an attempt to lift the spirits of Union Army soldiers and their families during the darkest days of the Civil War. Nast was inspired by his own childhood memories of images of Saint Nicholas, a fourth-century Byzantine bishop known for kindness and generosity, who traveled from village to town wearing a tall miter, flowing robe, and long white beard, dispensing gifts as he went. Saint Nicholas Day in Europe (December 6) was traditionally devoted to gift giving. In 1866 Nast's drawing entitled "Santa Claus and His Works" established Santa as a toy maker par excellence, and in his 1869 book of collected drawings, with a poem by George P. Webster, Nast established the mysterious North Pole as home of Santa's bustling workshop.

Designer: Unknown
Greeting card, 1934

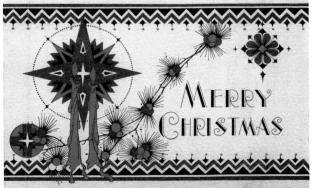

Norman Rockwell's 1920 Santa Claus cover for the *Saturday Evening Post* became a veritable trademark that contributed to the modern Santa "brand." The most popular image of all was introduced in 1931 when Haddon Sundblom painted a rotund, rosy-cheeked Santa to promote the sales of Coca-Cola. Using himself as model, Sundblom painted a new version every year for thirty-three seasons. Santa became more recognizable than any comparable commercial trade character and

when combined in advertisements with other secular Christmas personae, such as snowmen and reindeer, Coca-Cola totally dominated the holiday market—and isn't marketing what Christmas is all about?

SEE ALSO *Generic, Vernacular*

CLUB FLYER

For party people caught up in that movable feast known as the late twentieth-century club scene, rave and club flyers were passports to all-night cavorting. These usually full-color, postcard-sized missives printed on ultra-thick stock with UV coating began as announcements for after-hours nightclubs in Manchester, England, in the late 1980s. But soon the club phenomenon spread across Europe, Japan, and the United States. Disco was dead but clandestine raves were hot. They were collages of sights, sounds, lights, and movement, and crowds of partygoers, white, black, Latino, Asian, from late teens to early twenties, wearing the gear of the moment—everything from baggy urban threads to trash glamour outfits—swirled and pulsed with self-absorbed abandon. Flyers mirrored the exuberance, and the design, a mélange of glowing and pulsing type and imagery, evolved into a unique style that underscored the rave scene's moment, much in the same way that psychedelics defined the sixties concert scene.

Club flyer designs varied according to club and artist. Many of the artists were raw and untutored, yet skilled. Some designs were festooned with spirited carnival-like comic strip graphics; others had aggressive industrial images that represented the rapid assembly-line anvil-pounding rhythms of techno music; still others employed religious iconography that reflected the curious gospel undertones of some acid

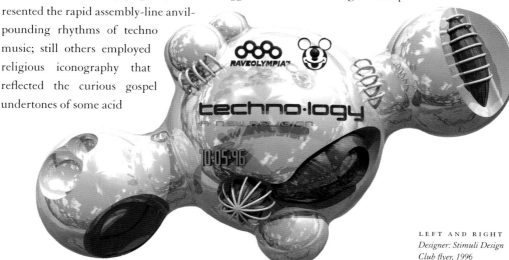

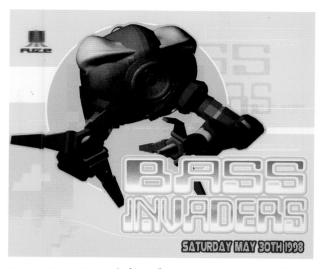

*Designer: Elemental Design
Club flyer, 1998*

house music. Covert and overt drug symbols—like those carved into Ecstasy tablets—included smiley faces, Mickey Mouse heads, and iconic Xs.

Intricate flyer graphics would have been impossible to achieve without the essential computer software Adobe Photoshop, which enabled designers to recycle images and create layered, dimensional high-tech concoctions wherein type and picture were integrated into seamless, often phantasmagoric assemblages. The late eighties and early nineties marked the height of digital typeface experimentation, and a bevy of original fonts were created specifically for use on flyers and became integral to club culture iconography. Old and new reigned simultaneously, yet designers were not slaves to styles from the past, present, or the future (even though techno called for futuristic imagery). Rules did not exist; the style claimed only one common trait—improvisation. While lettering for some flyers quoted futurist tech and science fiction, others reprised the Modernist typography of '50s Blue Note jazz album covers. Shadows, outlines, and tubular lettering were common and designers skewed them around, made them dance, or rendered them in monumental 3D. The ultimate goal was to announce where and when the next big rave was happening, and who among the various club entrepreneurs was throwing the party.

SEE ALSO *Comics Lettering, Do-It-Yourself, Psychedelic Poster*

COMICS LETTERING

Comic strip typography has been inspired by, and is the inspiration for, myriad visual artifacts from billboards to film titles. And yet, comics lettering's origins date back to illuminated manuscripts. A comic strip is a kind of sequential manuscript in which word and picture have equal weight. Comics lettering also has roots in nineteenth-century sign painting, known for contoured letters with colorful dramatic drop shadows, and circus poster alphabets made from ornamented Tuscans and Egyptians. Vintage twentieth-century film title cards and movie foyer posters are among comics lettering's forbears insofar as the hand-wrought typography was flashy, bold, and dramatic in the same way as comic splash panels. In 1936 Howard Trafton designed the brush-letter Cartoon, long accepted as the quintessential comics typeface. With easy access to digital typefaces, today comic

Designers: Chris Capuozzo, Todd James
Business card, 1990

book style lettering is a dynamic alternative to standard typography.

The introductory frame of a comic strip, known as the splash panel, is a marquee designed to dramatically announce the visual narrative and is invested with more graphic bravado than, say, a common book title page. Elegant typographic nuances found in book type composition are negligible in comics; there is, nonetheless, a quirky bookishness in comics lettering insofar as it establishes a visual tone for the strip or comic book. Comics lettering, usually designed to echo either the drawing style or thematic thrust of the strip, is perfectly complementary and purposely composed. Comics lettering evokes mood. While splashy words illuminate the stage on which a comic strip drama, comedy, or fantasy takes place, speech balloon lettering underscores the narrative's timbre and verbal identity.

In the world of traditional strips, superhero comics have their own style suited to the subject matter—loud, demonstrative, and masculine. The same is true for war, horror, and sci-fi, while romance comics use "feminine" letters with swashes and curlicues. Certain lettering styles are emblematic of their themes, but since the advent of Underground Comix in the late '60s there is even more to comics lettering than obvious, metaphoric relationships. The lettering is indeed art.

Designer: Unknown
Comic book cover, 1955

Looking back to antique forms of typography, the San Francisco Underground artists, including R. Crumb, Rick Griffin, and Victor Moscoso, were passionate for slab-serif wood type and curvilinear Art Nouveau motifs. These applications were not simply copied

verbatim, but were manipulated and massaged into a comics form. Rick Griffin was among the most innovative of all the Underground letterers. In addition to designing the original psychedelic curlicue swash logo for *Rolling Stone* (no longer used), he developed hand-drawn typography that was more beautifully eccentric than most of the recent crop of expressive digital alphabets. Griffin was a master of what might be called the Rorschach school of calligraphy, with page after page of letter drawings that have mysterious, multiple meanings.

The stylistic range of comics lettering is as diverse and personal as the comics artists are idiosyncratic. Some sage once said that comics artists who cannot letter should not draw comics; lettering is endemic to the art form, and the lettering-challenged have no business in the business. This may be true but not all comics lettering is sinuous or freehand. Chris Ware's extraordinary typographic homage to turn-of-the-century novelty and mail-order catalogs also falls into the realm of tightly rendered verisimilitude. Ware's Acme Novelty lettering could fill a veritable catalog of boisterous display or Show-Card writing. He lovingly re-creates a world of *now* from the visual lexicon of the past through letters that complement his sublime drawing style. As imperfect handlettering makes a comeback to offset digital perfection, comics-derived typefaces will become increasingly more available to anyone looking for a quirky individual character. But the quirkiness will never come bundled or straight from the box, it has got to be challenged through the hand.

SEE ALSO *Handlettering, Show-Card, Underground Press, Ware Lettering*

COMMERCIAL MODERN

In the early 1920s American products were either nondescript or laden with Beaux Arts ornament to camouflage a mass-produced look. Although mass production was the foundation on which the modern American economy was built, many cultural critics felt that items coming off the assembly line lacked good taste. While the Bauhaus, Constructivism, and other European Modernist avant-gardes had already embraced the machine and proffered the integration of Modern art and industry, American industrialists, who could easily afford to aesthetically improve their products, were usually apathetic if not resistant to the idea. What they did not resist, however, were marketing strategies that would insure greater profits. So following a brief economic downturn in the early '20s and subsequent boom, industry frantically tried to find a new means of stimulating sales. It was the profit motive, not any transcendent utopian ethic or aesthetic ideal, that

paved the way for Commercial Modernism in the United States, which was introduced to American advertising by Earnest Elmo Calkins (1868–1964), an advertising pioneer, design reformer, and founder of Calkins and Holden Advertising Co.

After seeing an array of Cubistic and Futuristic graphics, packages, and point-of-purchase displays in the pavilions of the 1925 Paris Exposition *Internationale des Arts Décoratifs et Industriels Modernes*, Calkins wrote to his staff in New York: "It is extremely 'new art' and some of it too bizarre, but it achieves a certain exciting harmony, and in detail is entertaining to a degree. [Everything is] arranged with an eye to display, a vast piece of consummate window dressing." What was so different from most American advertising art was the noticeable rejection of realism in favor of abstraction. Illustration was not representational but through symbols, metaphors, and allegories exuded a "magical" atmosphere. Boxes and bottles were no longer mere utilitarian vessels for their contents, but rather represented the essence of what the product symbolized to the consumer. Calkins summarized the development this way: "Modernism offered the opportunity of expressing the inexpressible, of suggesting not so much a motor car as speed, not so much a gown as style, not so much a compact as beauty."

For most advertising art directors Modernism was a bottomless bag of tricks the artist could use to set an ordinary product apart. And advertising artists were indeed quick to appreciate the possibilities of Modernism since realistic art had reached what Calkins termed a "dead level of excellence." It was no longer possible to make an advertisement striking, conspicuous, and attractive by still pictures and realistic groups. Spearheaded by Calkins and Holden, and later adopted by such progressive New York agencies as N. W. Ayer and Kenyon and Eckart, commonplace objects—toasters, refrigerators, coffee tins—were presented against new

patterns and at skewed angles; contemporary industrial wares were shown in Surrealist- and Futurist-inspired settings accented by contemporary typefaces with contempo names like Cubist Bold, Broadway, Metropolis, and more. Layout inspired by the European New Typography also became more dynamic in its asymmetry. Modernism offered an aura of cosmopolitan culture and avant-garde style and signaled the spread of an aesthetic coming-of-age of American advertising.

Designer: Unknown
Storefront schematic, 1932

Color, comparatively rare in magazine advertisements in the mid-1920s, was another critical aspect of Commercial Modern—or Department Store Modernism—introduced as a raucously decorative component in windows, which until then had been prosaic displays of products. The new windows borrowed primaries from De Stijl and the Bauhaus and combined them with bright purples, greens, and oranges. "Modernism to the general public came to mean silver and black," Frederic Ehrlich wrote in his *New Typography and Modern Layout* (Frederic A. Stokes, 1934), one of the most astutely written critiques (posing as an instructional manual) of Modern practice published in America at that time. Ehrlich was referring to the metallic silver papers and black silhouettes that were ubiquitous in window displays as well as later in magazine advertisements, menus, and the like. Silver-colored aluminum symbolized the Machine Age as vividly as pictures of factories, crucibles, and gears.

True Modernism is good taste! And here is the key distinction between the radical forms of European Modernism that are heroicized and romanticized today, and the commercial application introduced in the 1920s: The former was intended to violently disrupt the status quo and improve the visual environment, while the latter had no loftier purpose than to revolutionize the buying habits of the American public and so stimulate the economy.

SEE ALSO *Bauhaus, Constructivist, De Stijl, Futura, Futurist, Modernist, New Typography, Postmodern, Streamline, Surrealist, Zanol*

CONCEPTUAL ILLUSTRATION

The "new" American illustration launched during the mid-1950s can be summed up in one word: Conceptual. Illustration evolved from what-you-see-is-what-you-get realism to conceptual symbolism because the issues and themes covered in magazines were becoming more complex, more critical. Although illustrations in the Rockwellian tradition of realism were rooted in broad ideas, the illustrators rejected illusion, metaphor, and symbolism in favor of explicit vignettes. Physical detail was more important than psychological enigma. Even Rockwell's own paintings, which were influenced by Renaissance allegorical painting, were scenes void of the ambiguity that invites a viewer's deep interpretation. By the late 1950s photographers had vividly captured the surface of things, leaving depiction of the interior world to illustrators. So the younger artists of the 1950s, among them Robert Weaver, Robert Andrew Parker, Phil Hayes, Al Parker, and Tom Allen, not only painted in an automatic manner akin to the Expressionists, their images were intended to be deconstructed—like poetry.

As TV usurped the primacy of magazines, expressive illustration offered alternative editorial dimension. Illustrators were given a key role in the phenomenon known as "the Big Idea," which was an extraordinary confluence of rational graphic design and acute visual thinking. The rise of Conceptual Illustration

Illustrator:
Christoph Niemann
Editorial illustration, 2005

during the 1960s, furthermore, was marked by an unprecedented collaboration between illustrator and art director-designer because illustration was viewed as an element of design—but design was not only about making special effects on a page, it was about making messages. In the Rockwellian era, the art director would position the painting in a layout near the appropriate text. In the new scheme, art directors worked with illustrators on concept, composition, and layout as well. Either an illustration was integrated into a format or given its own page adjacent to an elegantly and sometimes metaphorically composed block of text. Conceptual Illustration served two purposes: It provided meaning, even commentary, and gave visual personality to a publication.

Neo-Rockwellian obsolescence helped spawn Conceptual Illustration but there was also a natural evolution by iconoclastic artists instinctively bucking trends and fashions. Among the innovators, Saul Steinberg, Boris Artzybasheff, and Robert Osborn invested illustration with wit and satire, Expressionism and Surrealism. They rejected turgid realism in favor of allusion. Their graphic commentaries on a broad range of social and cultural issues energized the covers and pages of,

Illustrator:
Christoph Niemann
Editorial illustration, 2004

respectively, *The New Yorker*, *Life*, and *The New Republic*, proving that illustration could influence opinion as well as illuminate text. The relative success of these artists in capturing a popular following gave impetus to editors and art directors—notably Cipe Pineles at *Seventeen*, Leo Lionni at *Fortune*, Henry Wolf at *Esquire*, Frank Zachary at *Holiday*, and Richard Gangel at *Sports Illustrated*—to pursue other conceptualists. And a growing number were indeed waiting for their turn to be published in the big magazines.

Influenced by Cubism, German Expressionism, Dada, Surrealism, and Abstract Expressionism, the Conceptual illustrators also found kinship in nineteenth-century cartoonists (Honoré Daumier, J. J. Grandville, Thomas Nast), comic strips, primitive art, and

*Illustrator: Eugene Mihaesco
Editorial illustration, 1972*

various other eclectic forms. Where Neo-Rockwellians lagged behind contemporary advances in fine art, the new Conceptual illustrators blatantly borrowed from the Modernists. René Magritte, the Belgian Surrealist, had perhaps the most profound influence on American illustration during the 1960s, exemplified by the work of then Push Pin Studio artist Paul Davis. Unlike Salvador Dalí, Magritte's Surrealism was less rooted in Freudian dream interpretations than ironic juxtapositions that tested accepted perception. He further built a clear, though mysterious, symbolic language that illustrators discovered could be applied to commonplace editorial themes. A gigantic boulder floating in space, a cloudburst of bowler-hatted men, a train coming through a brick fireplace as from a tunnel, and other bizarre situations formed the basis of a vocabulary that was used to visually comment on the economy, politics, and society. And what better way to cover such complex issues than through metaphors that transcended the commonplace.

In the late 1960s and early 1970s magazines that practiced "the new journalism" (a unique form of editorialized reportage pioneered by Tom Wolfe, Jimmy Breslin, Pete Hamill, and others) also promulgated the new illustration. *Esquire, Evergreen, Ramparts,* and *New York Magazine* were among the wellsprings, giving regular outlet to leading Conceptualists such as Paul Davis, R. O. Blechman, Milton Glaser, Seymour Chwast, James McMullan, and Brad Holland, among others. By the early 1970s the *New York Times* op-ed page—art-directed by illustrator J. C. Suares and established as a outlet within the newspaper (opposite the official editorials) for independent opinion through text and art—opened a floodgate for artists who practiced linear, Dada- and Surrealist-inspired illustration. These drawings complemented or commented upon the texts being "illustrated." Illustrators were encouraged to reflect upon the essence

*Illustrator: Brad Holland
Editorial illustration, 1999*

89

or underlying concept of a text rather than specific passages. They were hired to translate verbal ideas into visual ones, and therefore became virtual coauthors, as integral to the page as any writer. They were also told to avoid universally recognized symbols, such as dollar signs, Uncle Sams, or flags, in favor of more personal icons drawn from the subconscious, which invited the reader to interact with the art. Because op-ed art emerged as an archetype of illustration during the 1970s and 1980s, imitators sprang up like mushrooms, and this form of Conceptual art became almost as hackneyed as neo-Rockwellian realism.

Illustrator:
Christoph Niemann,
Editorial illustration, 2003

During the intervening years American illustration decidedly expanded its conceptual and stylistic range. It was very much alive in the 1980s, as evidenced in the *American Illustration* annuals, which like the earlier *European Illustration* annuals celebrated diversity while emphasizing common roots. Although a Marshall Arisman was miles apart from a Brad Holland painting, which was leagues apart from a Christoph Niemann drawing, each eschewed decorative tendencies in favor of conceptual thinking and expressive painterly methods. They were drawn together not by a Rockwellian style guide but a need to be individual yet communicative. As a group the artists in *American Illustration* both followed and led fine art. And compared to the (then) predictable annuals of the Society of Illustrators, the 100-year-old establishment based in New York City, *American Illustration* personified the unpredictability that had for years been percolating, but had never been assembled as a "movement," loosely knit or otherwise.

SEE ALSO *Artzybasheff, Big Idea, Dada, Deconstruction, Expressionist, Modernist, Polish Poster, Push Pin, Surrealist*

CONSTRUCTIVIST

In the early twentieth century Russian Constructivists believed that a designed object should not have a discernable style but rather be a pure product of industrial creation. Constructivism called for the technical mastery and organization of materials according to three principles: tectonic (act of creation), factura (man-

ner of creation), and construction. Constructivist artists considered themselves to be engineers, embodying all that this vocation implies; they oversaw the total creation and manufacture of a product and therefore were masters of production from start to finish. In addition, Constructivism developed a formal language born of radicalism and pragmatism that was mitigated by the Russian Revolution.

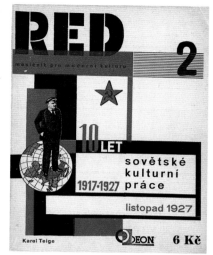

In 1913 the painter Kasimir Malevich invented Suprematism, a nonobjective style of art characterized by the juxtaposition of squares and rectangles framed by negative space. Under his influence younger artists took the nonobjective aesthetic further into the province of commercial art. In 1915 Vladimir Tatlin experimented with what he called "machine art" or "product art," collages and montages constructed from industrial products. What soon became known as Constructivism had various exemplars, including designer Alexander Rodchenko and poet Vladimir Mayakovski, who experimented with collage and montage, and Lazar (El) Lissitzky, who combined Suprematist and Constructivist elements into experimental designs that he called "Prouns" that were neither traditional painting nor graphics.

Lissitzky's compositions were striking abstract assemblages of geometric shapes that symbolized Bolshevism's triumph over the former power structure. Underlying his radical form-making was always a political-social agenda. Unprecedented in the annals of polemical graphics, Lissitzky's 1923 typography for Mayakovski's book of poetry, *For Reading Out Loud*, is a paradigm of nonobjective avant-garde design, the marriage of functional typography and symbolic decoration. Following

Designers: L. Kassak and Rolf Lange
Advertisement, 1928

the Bolshevik Revolution many avant-garde artists applied their experiments to utilitarian graphic design or what was called Productivism. Constructivism and Productivism were taught at the Vkhutemas art school and quickly evolved into a typographic style that at once imbued the printed page with dynamism and encouraged a largely illiterate population.

This distinctly Russian typographic discordance was the visual expression of the revolutionary times. Constructivist typography developed its distinctive look—letters and words at sharp angles intersecting other letters and words, framed by bold rules and borders printed in one or two primary colors—in part because limited printing and typographic materials prevented all but the reductive approaches. Moreover, garish ornamentation was associated with Czarist indulgences. The avant-garde artist-designers also looked to Holland and Germany for inspiration, and through publications that promoted the Modern avant-garde found kindred sensibilities in Dada, Neoplasticism, Futurism, Cubism, and other -isms. Typographer Solomon Telingater, for one, stressed the dynamics of functional typography, and what he called the "cinematographicity" of motion on concurrent pages.

Berlin was an entry point in the early twenties for Russian progressives who made pilgrimages to Weimar. El Lissitzky, who taught at the design school in

Designer:
Solomon Telingater
Book cover, 1925

Vitebsk, had developed an innovative graphic design language utilizing circles, squares, and triangles in dynamic juxtapositions, and during an extended stay in Berlin he devoted more attention to typography, prodigiously experimenting with metal typecase materials (rules, bars, leads) to construct typographic compositions. Despite severe bouts of pulmonary tuberculosis he was a ubiquitous presence in the capitals of Modernity—Germany, Switzerland, Holland, France, and Poland—and helped catapult Constructivism as both design philosophy and method.

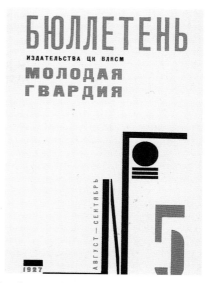

Modernism's adherents promoted an idea that graphic tension and drama could coexist with clarity and accessibility. The manipulation of form in space, and the interplay of type and image were more rational than ad hoc, more constructed than haphazardly splayed out on a page, nonetheless, what gave Constructivism its defining visual identity was improvisation. When typefaces were not available designers constructed them out of wood or metal "furniture" found in printers' typecases. Making do and making new with available material ultimately defined the entire genre and ultimately inspired professional type designers to produce novel typefaces that echoed Modernist concepts.

Designer: Alexander
Rodchenko
Advertisement, 1923

Alexander Rodchenko, who significantly contributed to the Modern lexicon of printed visual form, saw the page as an organic entity, and introduced extreme geometrical forms as a substitute for literal illustration and as a symbolic hallmark of mass production. As a teacher at Moscow's avant-garde Vkhutemas art school in 1920 he introduced a course devoted to Productivism with the goal of creating a cadre of artist-engineers who designed functional, utilitarian, indeed commercial

wares to serve the Soviet economy. In this new society pure art was a luxury that the revolution could ill afford.

Rodchenko also collaborated with Mayakovski to create advertising for the GUM department store, Mospoligraf, a government publishing house, and other commercial businesses, as well as propaganda posters promoting literacy and attacking enemies of the Soviet Revolution. These missives were hung in post office windows, painted on railway cars, and served as the first significant popular art of the revolution. From 1923 to 1925 he collaborated on the design of *Lef* (*Levyi front iskusstv*—Left Front of the Arts), with Mayakovski as editor, to create a series of emblematic covers that both characterized the magazine and bolstered the aesthetics of Constructivism. Through-

out the twenties Rodchenko experimented further with typography and photography and fused these forms into a Modernist idiom.

SEE ALSO *Bauhaus, Dada, Futurist, Modernist, Sutnar*

ABOVE
Designer: László Moholy-Nagy
Magazine cover, 1922

CONTAINER CORPORATION OF AMERICA

The Container Corporation of America, the largest manufacturer of packaging materials—boxes, cans, and so forth—was a major and early patron of Modern design in America. The CCA's design identity and advertising campaigns reflect the goal of Modernist design and progressive business to make the environment more accessible. Design by the CCA reflected the growing consumer culture fueled by new attention to the aesthetic shaping of products and advertising. In following its mission—and especially through its advertisements—CCA founded a style of institutional communications that influenced the field and prefigured contemporary socially oriented campaigns. Walter Paepcke (1896–1960), founder of the CCA, first initiated a progressive design program in 1935 under the direction

RIGHT
Designer: Herbert Bayer
Advertisement, 1952

Ralph Waldo Emerson on a civilized nation

If there be a country which cannot stand any one of these tests—

a country where *knowledge* cannot be *diffused* without perils of mob law and statute law;

where *speech* is not *free;*

where the *post office* is *violated,* mail bags opened, and letters tampered with;

where *public debts* and *private debts* outside of the state are *repudiated;*

where *liberty* is attacked in the primary institution of social life...

where the *laborer* is not *secured* in the earnings of his own hand;

where *suffrage* is not *free* or *equal*—

that country is, in all these respects, not civil, but barbarous; and no advantage of soil, climate, or coast can resist these suicidal mischiefs.
(Civilization, 1862)

R. Waldo Emerson

Artist: herbert bayer

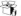 **CONTAINER CORPORATION OF AMERICA**

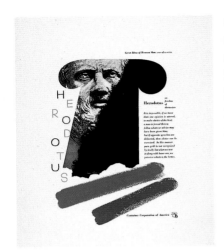

of Egbert Jacobson (1890–1966), who created a cohesive visual appearance from the company trucks to the letterhead (the identity program would later be managed by John Massey and Herbert Bayer). Initially, the company hoped to gain a competitive edge on the market and overcome a Depression-era mistrust of big business by portraying the company as a patron of "good design," intelligence, and taste aimed at making the business world a better place. Beginning in 1937 a seminal series of ads directed by Charles T. Coiner (1898–1989) of the Philadelphia agency N. W. Ayer and Son used the illustrations of such European vanguard artists and designers as A. M. Cassandre, Jean Carlu, Leo Lionni, Herbert Bayer, and Herbert Matter. This marked a unique integration of progressive art into the bowels of otherwise crass commercial promotion. But Paepcke deepened his impact on Modernism in America when he became the friend and financial supporter of Bauhaus émigré László Moholy-Nagy, who came to Chicago in 1937 to launch the New Bauhaus. Paepcke also became the patron of Bauhaus alumnus Herbert Bayer, who profoundly aided him in his goal of bettering humanity through his commercial products and advertising.

The CCA's influential advertising campaigns were organized under such themes as wartime service and patriotism, the United Nations, the states of the Union, and finally the most influential "Great Ideas of Western Man," which employed pioneering artists and

Designer: Paul Rand
Advertisement, 1950

Designer: A. M. Cassandre
Advertisement, 1937

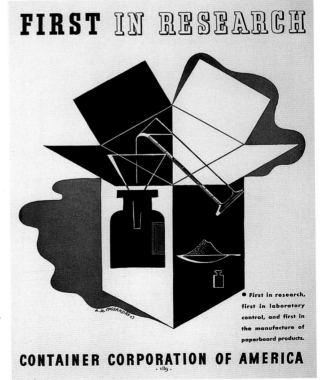

designers to visually interpret quotations from philosophers to politicians. Beginning in 1945 Paepcke began redeveloping the resort town of Aspen, Colorado, with design direction provided by Herbert Bayer, who moved there that year. Bayer designed many projects for CCA including his groundbreaking *World Geo-Graphic Atlas* in 1953.

SEE ALSO *Bauhaus, Geo-Graphic, Modernist*

COOPER

Cooper Black was once as emblematic in its day as Futura or Univers. While not the first type to have rounded serifs, it was the most authoritative of the so-called fat faces. Used for advertising and editorial display, Cooper Black was as demonstrative as a charging bull or a carnival barker.

Oswald Cooper (1879–1940) created the Cooper style. A native of Coffeeville, Kansas, in his teens he settled in Chicago to pursue illustration. He eventually became one of the leading practitioners of "The Chicago Style." In the early 1920s and '30s American design was comprised of regional dialects, each emanating from a big city under the influence of one person's mannerism or the confluence of a few. The Chicago style wed calligraphic and typographic mannerisms in advertisements that were purportedly modern in character and classic in form. And Cooper, while respecting tradition, flawlessly understood the needs of a mass commercial market.

At eighteen Cooper studied at the famous Frank Holme School of Illustration. His lettering teacher, Frederic W. Goudy, most famous of all American type designers and director of Holme's typographic department, helped him earn his tuition by assigning him jobs lettering for correspondence course booklets. The quality of Cooper's lettering was high. His letterforms were not simply novelties, but "lessons in structural form, in free and friendly balance," wrote his friend Paul Standard in a testimonial. Cooper created as many new designs as he could. Yet he had an instinctual distrust of things superficially modish and conceptually strained. "Types too dexterous, like tunes too luscious," he once waxed, "are pre-destinated [sic] to short careers."

Cooper stumbled into type design. His first was cut in 1913 by one of Morris Fuller Benton's staff artists at American Type Founders (ATF), unbeknownst to Cooper and without his permission. Cooper routinely made customized lettering that appeared in advertisements for the Packard Motor Car Company. One of these caught Benton's keen eye, and since type pirating was a fact of life and

ads were not signed nor attributed to any artist, Benton innocently ordered Cooper's to be redrawn—he called it Packard. But when Benton learned that the original was actually designed by Cooper, he paid him a fee and renamed it Cooper (it was later renamed Cooper Old Style).

In the early 1900s typefaces were vigorously marketed to printers and type shops, often through ambitious type specimen sheets. Barnhart Brothers & Spindler Type Foundry was particularly aggressive at sales and succeeded at popularizing Cooper's first normal weight roman ("Cooper") and made it the basis for a continuing family. A style was on its way to being born. The second in the series was Cooper Black, the most novel of early twentieth-century super-bolds. BB&S declared Cooper Black was "the selling type supreme, the multibillionaire sales type, it made big advertisements out of insignificant little ones." Cooper responded that his invention was "for far-sighted printers with near-sighted customers." Owing to its ostentatious novelty, it caused commotion in certain conservative printing circles.

Then came "the black blitz." First was Cooper Italic ("much closer to its parent pen form than the roman . . ."). Cooper Hilite was made by the simple expedient of painting a white highlight on a black proof of Cooper Black, with patterns cut and matrices engraved accordingly. Cooper Black Italic was completed in 1926 to cash in on the swell in sales of Cooper Black. Cooper Black Condensed was designed shortly afterward and had 20 percent less heft. A complete metal font of Cooper Black weighed almost eighty-three pounds and lifting it strained the back of many a typesetter.

Cooper's designs initiated trends, but he refused to take part in what he called "the itch of the times." Nor was he a fan of what in 1928 he called "the balmy

Designer: Oswald Cooper
Type specimen, 1921

wing of modernism." However, his last face designed in 1929 for BB&S (originally called Cooper Fullface and later changed in ATF catalogs to Cooper Modern), was in fact, consistent with the dominant styles. Of this face Cooper wrote, "This style, lately revived by the practitioners of the 'modernistic' typography, has created a demand for display letters that comport well with it—letters that reflect the sparkling contrasts of Bodoni, and that carry weight to meet the needs of advertisers, Cooper Fullface is such a letter."

SEE ALSO *Art Deco Type, Art Nouveau, Futura, Generic*

CUBA

The festive Cuban graphic style of the 1940s and '50s—projecting a sun-drenched tropical carnival oblivious to the poverty and discontent in the country and the region—was influenced by U.S. popular culture. Everything from Hollywood

Designer: Olga Perez
Brochure cover, 1949

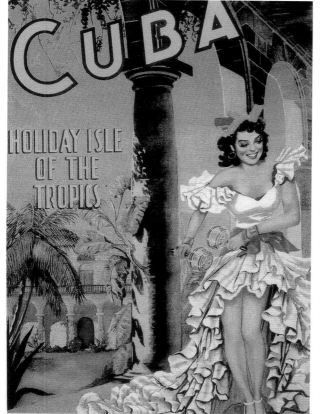

movies to nightclub society gave this Caribbean island its visual character—at least in print. Before Fidel Castro's 1959 revolution, Cuba did not have its own graphic persona—certainly not in cosmopolitan Havana, a city that dutifully catered to the fantasies and desires of wealthy Americans.

A marriage of Art Deco elegance and carnival gaudiness fused into a distinctly Cuban style with the aim of attracting vacationers, gamblers, and businessmen. This Yankee age of Cuban graphic style, which flourished during the first half of the twentieth century, was remarkable for its almost seamless melding of both sophisticated and crass decorative trappings. Such diverse artifacts as posters, menus, travel brochures, record albums, and magazine covers recall what was once a commercially exuberant and culturally electrifying environment.

The first inkling of a Cuban graphic style emerged following the Spanish-American War in 1898 when Cuba became a vast business opportunity for American entrepreneurs. Havana had already experienced a profound European influence but after the short period of American occupation, from 1899 to 1902, the graphics changed. Throughout the early 1900s Cuba teemed with soldiers, settlers, developers, and businessmen of all kinds who stimulated the need for new merchandise and large emporia in which to sell it. Consequently more businesses, including hotels, restaurants, bars, carriage rentals, tailors, and pharmacies were founded to serve the new clientele. Owing to increased competition among businesses the American advertising industry attacked the island in a manner that would have put Teddy Roosevelt's Rough Riders to shame.

In Havana signs of all descriptions were painted on brick walls in bright colors with realistic representations of the new commodities. Along the roads poster hoardings with striking graphics sprouted like weeds and huge, bilingual billboards with pitches for North American brand-name products from beer to condensed milk gave Cuba the appearance of a parallel world.

Advertising had two missions: To sell as many goods as possible to a large Cuban bourgeoisie *and* to sell Cuba to North American tourists and investors. The former was handled in a typically American manner through hard-sell product pitches with insidiously memorable slogans. Ads in the United States had always relied more on word than image, although for Spanish-speakers pictures of brands played an increasingly greater role. Travel promotion aimed at wealthy North Americans was extremely image- and style-oriented, emphasizing glamour, chic, and current fashion.

The Cuban myth was based on a combination of ideals and realities symbolized, among other graphic traits, by tropical colors and jovial patterns

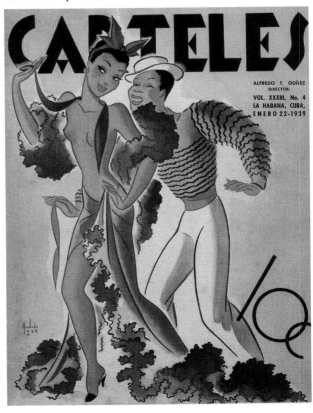

Designer: Andres Garcia
Magazine cover, 1939

*Designer: Corrado Massaguer
Magazine cover, 1929*

wed to familiar stylistic veneers, such as Art Deco. This international decorative style of the 1920s through the '30s was typified by sunburst patterns, pastel hues, and stark geometry. The Modernist style signaled that Cuba was decidedly a civilized oasis.

Cuban graphic style also serviced the dominant industries. The cigar business was among the most graphically endowed. Although many cigar labels were actually designed and printed in the United States for Cuban imports, Cuban printers created a fair share as well for their own exports. Various liquors and wines distilled in Cuba had labels created exclusively by Cuban printers and designers. By the early '50s, Latin music had become remarkably popular throughout North America, resulting in a huge demand for live performances and records. While most of the recordings were packaged, if not also produced, in the United States, Cuba produced some of the record sleeves, albeit on an American model.

On January 1, 1959 the nation as a whole was totally upended when the armed resistance to Batista turned into a bona fide revolution as Fidel Castro's *barbudos* (bearded guerrillas) took control of the presidential palace. Although Castro promised democratic social reforms, he radically altered the entire Cuban way of life and with it this age of Cuban graphic style abruptly ceased, replaced by revolutionary graphics that served the state.

SEE ALSO *Art Deco, Modernist, Show-Card, Vernacular*

see De Stijl

DADA

Dada was a nonsense word on which an anti-art/art movement, which lasted from 1916 to 1924, was predicated. Dada was a critical mass of dissonant ideas embraced and rejected and embraced again by a group of artists who waged war against other groups, structures, conventions—in short, the status quo. When coined in 1915 (or 1916 depending on which Dadaist one believes) the word *Dada* (which means hobby horse, among other definitions) was affixed to acts of cultural disruption that fused into a revolution of young intellectuals initially brought together in Zurich, Switzerland, from all over war-torn Europe, and then later in Berlin, Paris, and New York. Dada developed its own metalanguage, which only Dadaists could understand.

Dada began as a kind of theater and performance. Hugo Ball opened Cabaret Voltaire in 1916 as a stage for artists and writers who flocked to Zurich. Spontaneous combustion occurred within the tight quarters of Meierei Café where Cabaret Voltaire was housed. Along with the star performers, Tzara, Marcel Janco, Hülsenbeck, and Arp, the cabaret became a playground of intoxication for those liberated from war's horrors by music, poetry, performance, and plastic art. Although the creative energies did not fuse into a unique Dada style precisely at that time, it marked the early

Designer:
Theo Van Doesburg
Magazine cover, 1923

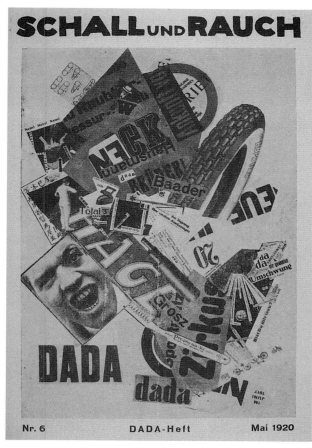

Designer: John Heartfield
Progam cover, 1920

contractions of Dada's official birth.

The influence of the cabaret was transitory, so an international review was conceived to publish the words and pictures that expressed the nonesense Dada gospel. Ball proposed the name *Dada* for the review's masthead and suggested that his colleagues take turns editing individual issues. The new periodical was a rambunctious display of Expressionism, Futurism, and Cubism, experimental poetry, anarchic imagery, and confrontational manifestos. But ultimately the overarching character of Dada was forged through its chaotic and raucous typography.

The most distinctive effect of cultural disruption and social havoc ignited by Dada was the act of forcing the eye to see differently. It changed the common perception of the written word in ways unimaginable; it attacked the rectilinear conventions of the printed page and broke apart the sequential order of typeset lines. Italics were thrown in haphazardly, capitals and miniscules were applied at random—all to achieve a disruptive jolt. Dada crusaded against the sanctioned conveyance of meaning, by shouting and screaming and thus imitating sound through printed words.

But this was not entirely a Dada invention. Decades earlier, the advertising industry discovered that loud, flashy, and vulgar typography could attract consumers. As tools for moving goods, different styles of grotesque wood-block typefaces were frequently jumbled together in ads and posters to draw the eye away from complacent reading patterns. Demonstrative typography was, in fact, more in demand as the accelerated pace of city life gave passersby less time to casually ponder the barrage of advertising messages.

Another Dada influence was experimental poetry that disrupted the rules of writing. Stéphane Mallarmé's 1897 poem "Un coup de dés jamais n'aborlira le

hasard" (A throw of the dice will never abolish chance), published in the British magazine *Cosmopolis*, was an early example, as was Lewis Carroll's 1895 fanciful description of the mouse's tail in *Alice's Adventures in Wonderland*, purposefully written and typeset so it curled off the end of a paragraph to appear like the animal's tail described in the text. In Guillaume Apollinaire's calligrammatic poem "Il Pleut" (It Rains), which appeared in the journal *SIC*, a typographic display of ingenuity streamed down the page as though rivulets of water.

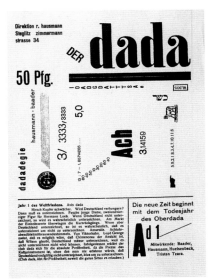

Designer: Raoul Hausmann
Magazine cover, 1919

These typographic transgressions inspired and gave license to Dada's innovators. Since type was used to approximate noise, toward this aim it was necessary to increase and decrease the size of type numerous times on the same page—and often within the same paragraph. The densely packed kinetic typography was meant to agitate and confuse the public. For Dadaists there could be no uniformity. And yet there was consensus that conventional art and language represented the bourgeois elite.

Dada hijacked gaudy mass-market typography as a means to attack the established order. It borrowed from advertising, was influenced by Futurism, and went even further in its symbolic and conceptual application of Cubist typographic fragmentation. Rejecting sanctimonious concerns over what is high and low art, Dada employed vernacular visual language to underscore its own rebellion. Periodicals were the prime examples of this typographical revolution. And there was no better display of the Dada page than in the periodicals issued from Berlin.

Weiland Herzfeld, a leading Dadaist and publisher of the Berlin-based Malik Verlag, said, "'Dadaism' was its layout." He was talking about the art direction of his brother John Heartfield, who in Berlin Dada circles sparked a typographic revolution by using the old and making it new. "The sovereign, fascinating way in which he conjured up something unprecedented from old type, plates, leadbars, and rings reveals the artist who—almost overnight—had found his own unmistakable style," wrote Herzfeld admiringly in his biography of John Heartfield.

Heartfield's typography for radical newspapers like *Neue Jugend* as well as book

covers and jackets signaled a rejection of conventional design tenets. It involved the playful use of variegated typefaces composed in an asymmetrical manner with numerous cliché cuts found in job printer's typecases. Metal typecase furniture was used as graphic elements, prefiguring El Lissitzky's and Rodchenko's symbolic Constructivist type-graphics. Visually, *Neue Jugend* was true to its name. It was not the typical, staid political manifesto nor was it decorous commercial art. Rather the type summoned the reader to action. Dada was indeed a call to action. SEE ALSO *Constructivist, Do-It-Yourself, Expressionist, Futurist, Underground Press, Vernacular*

DE STIJL

"God made the World, the Dutch made Holland." The Dutch landscape is almost entirely man-made, reclaimed from the sea and fortified by a system of rectangular dikes, where right angles and straight lines define the topography. Not surprisingly De Stijl, the Dutch avant-garde design movement, treated such geometry as sacred. In 1917 Theo van Doesburg (born Christian E. M. Kupper), Vilmos Huszar, Antony Kok, Bart van der Leck, Piet Mondrian, and J. J. P. Oud founded the group they called de Stijl (the Style). Rectilinearity was common to all Modern movements, but for the Dutch artists it was a matter of faith. Van Doesburg and cofounder Piet Mondrian believed that the rectangle was the Holy Grail of modernity because it introduced natural order to art. The other key element of De Stijl painting and design was the use of black, white, and gray and the primary colors red, blue, and yellow. Simplicity was divine.

Designer: Piet Zwart
Magazine cover, 1932

Van Doesburg founded, edited, and designed the journal *De Stijl* in 1917 (he originally wanted to call it *The Straight Line*, but instead agreed to *De Stijl*), and through its frequently mutating format he helped innovate Modern graphic design. The logo for the early issues of *De Stijl* was designed from rectangular patterns arranged on a strict grid, contributing to its blocky appearance. The interior typography was less overtly geometric, yet it was void of ornament of any kind. The layout

was without flourish, allowing the illustrations of paintings and photographs of architecture to take center stage.

In 1924 Theo van Doesburg moved to Paris and began working on paintings in which he introduced oblique rectangles for dynamic effect. This asymmetrical arrangement invested more energy yet departed from orthodox De Stijl principles, which forced a split with Mondrian, who vociferously argued that it unhinged the "cosmic equilibrium" he had sought to achieve with his own art. Mondrian quit the movement but van Doesburg remained as the spiritual head of De Stijl and editor of the journal for fifteen years, seventy-six issues (ninety numbers).

As an international revue, with publishing outlets in Warsaw, Leiden, Hannover, Paris, Brno, and Vienna, *De Stijl* was a document of Modern art. In issue no. 9 (1924–25) van Doesburg published his own historical critique on the doctrines of Futurism, Cubism, Expressionism, Dadaism, Purism, and Constructivism. In 1926 he produced an extended, annotated listing of all the extant avant-garde periodicals as a means of binding together the diverse factions of the movement. But above all, Modernism and Modern innovators found an unprecedented outlet in *De Stijl* that validated their positions in twentieth-century art history.

De Stijl was an anti-art art movement and in a 1926 manifesto published in *De Stijl* titled "The End of Art," van Doesburg declared that "Art, whose function nobody knows, hinders the function of life. For the sake of progress we must destroy Art." Ironically, the results of his rebellion against art are today considered exemplary artifacts of the Modern period. In his crusade against outmoded and failed ideas, van Doesburg became a vociferous advocate of a total union of fine and applied arts, and thus brought type design and typography into De Stijl,

consistent with the idea of straight lines and rectilinear geometry.

SEE ALSO *Constructivist, Dada, Expressionist, Futurist, Modernist*

DECONSTRUCTION

The Futurist F. T. Marinetti proposed a revolution against status quo text composition when he announced, "My revolution is aimed at the so-called typographical harmony of the page, which is contrary to the flux and reflux, the leaps and bursts of style that run through the page. On the same page, therefore, we will use three or four colors of ink, or even twenty different typefaces if necessary." The relevance of this statement to graphic designers in the late twentieth century is as obvious as the posters, book covers, and magazine pages created in the Deconstruction style. While traceable back to the early Modernists, deconstruction was not a wholesale reprise of that revolution but a synthesis of various cultural theories. In literary terms deconstruction connotes an intellectual method of analyzing texts proffered by post-Structuralist critic Jacques Derrida in his book *Of Grammatology*, published in France in 1967 and translated into English in 1976. Deconstruction rejected Platonic and Socratic approaches to learning, as well as the goal of modern criticism to uncover the meaning of a literary work by studying the way its form and content communicate essential humanistic messages. Like Marxist, feminist, and semiotic critiques, Derrida did not address themes and imagery

Designer: Hamish Muir/8Vo
Magazine spread, 1988

Designer: Robert Nakata
Degree project, 1985

but rather linguistic and institutional systems—the contexts in which works were produced. With similar motivation, Deconstruction style was applied to architecture. The resulting structures were rooted in transparency, in effect turning the buildings inside out. In both literature and architecture the aim is for the receiver of the message to fully embrace the complexity of meaning, and view it through contemporary social and political lenses.

Theories of semiotics, linguistics, and semantics were introduced to graphic design teaching in the New Bauhaus (brought to Chicago by László Moholy-Nagy in 1937) and at Yale as early as the late 1960s to bolster problem-solving intelligence. But in the late 1980s graphic design graduate students at Cranbrook Academy in Bloomfield, Michigan, were taught Derrida's deconstruction theory as a means to evaluate their content and design compositions where tried-and-true formulas were no longer viable, so that form and content were forced into new relationships. The result was a style of design that eschewed typographical hierarchies in favor of chaotic display, which in turn was a critical commentary of corporate culture.

However, even some of the proponents of Deconstruction style, notably former Cranbrook design cochairperson Katherine McCoy, admitted that some of these theoretical linguiustic concepts are better suited to art than to a client-driven message. Yet the principles on which Deconstruction style was based were applicable when conveying a certain kind of message to this information-saturated society. The idea of multiple layers of type and image forces readers to scan in bites, rather than in traditional linear fashion, which parallels the visual bombardment on the street and airwaves. Deconstruction argued that the linear narrative was not the only way to navigate a printed page (or a Web site for that matter). And for those able to navigate the layers, comprehension is not difficult, and actually often more memorable. The Cranbrook (and later Cal Arts) students who accepted the fundamental idea that meaning is rooted in complex histories and that therefore typography should reveal multiple access points, were seeking ways to project new codes. For some, Deconstruction style was a way to approach the printed page (or

screen) anew, for others layering, distortion, and density were typographic characteristics designed as much to emote as to be read. And then for even others it was another fashionable style.

SEE ALSO *Container Corporation of America, Futurist, Me-Too, Modernist, Postmodern, Sutnar, Vernacular*

DO-IT-YOURSELF

Guitar-powered rock 'n' roll and angst-laden lyrics defined Punk rock; periodicals such as *Punk, Slash, Sniffin Glue, Search and Destroy,* and *The Rocker,* as well as countless Quick Copy missives, also propagated Punk poetry, aesthetics, and celebrity. Punk zines established the Do-It-Yourself (D.I.Y.) style, the "Anyone can do it! You don't need them!" attitude in graphics, typified by torn paper edges and misspelled typewriter typography—the visual equivalent of a loud out-of-tune slashing power chord or vomit-stained thrift store tatters.

Punk magazine, the first of the D.I.Y. zines, premiered in New York in January 1976. *Punk*'s cofounder and designer, John Holmstrom, a former comics student at the School of Visual Arts in New York, says the magazine coined the term *Punk,* which denoted petty thugs and jailhouse paramours, to distinguish its music from syrupy pseudo-psychedelic hippie pop of the post–Sgt. Pepper era. He claims that without *Punk* magazine there probably would have been no

Designer: Jamie Reid Record cover, 1977

Punk rock and no Punk movement. Holmstrom's partner Eddie (a.k.a. Legs) McNeil coined *Punk* because he liked the gangster association. English punks will argue that on their side of the ocean Malcolm Maclaren and Vivienne Westwood caused a stir with the Punk Mecca, the Sex Shop, as early as 1974. But in America *Punk* was the glue that brought the disparate traits together under one banner. *Punk* was quintessential D.I.Y., produced for less than nothing and fueled by the sweat of its founders. The premier issue came together during November and early December 1975.

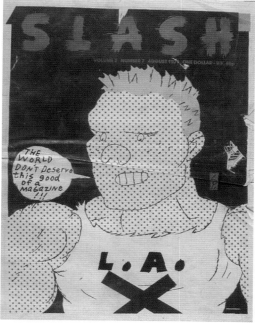

VOLUME 1 NUMBER 9 APRIL 1978 FIFTY CENTS

ABOVE *(left)*
Designer: Unknown
Magazine cover, 1979

(right)
Illustrator: Gary Panter,
Magazine cover, 1979

Harvey Kurtzman, founder of *MAD* magazine, and Will Eisner, creator of the
"Spirit," with whom Holmstrom studied at SVA, were mentors for *Punk*. They
cemented ideas about the viability of producing an underground rock 'n' roll com-
ics zine, and since they could not afford typesetting, the lettering was methodically
rendered by hand—every word in every article, caption, and advertisement—in
a comic book style. The hand-scrawled editorial in *Punk* #1 announcing "Death
to Disco Shit! Long Live the Rock," with its satirically indignant tone, had the
graphic allure of a newly drawn tattoo. The magazine also launched the first of
many "photoplay" comic strips (movielike storyboards) as a defining visual fea-
ture—the first one starred Legs McNeil in his search for "Cars and Girls." Articles
on Marlon Brando ("the Original Punk"), the Ramones and Lou Reed, and origi-
nal comic strips (including "Joe," a character who pals around with an anthro-
pomorphic piece of turd) shared space with Robert Romagnoli's hand-scrawled
Punk poetry. Romagnoli's "Do-It-Yourself Sixties Protest Song" was a sarcastic
lampoon of the hippie ethos that *Punk* detested.

Holmstrom rejected designed elements that defined the hippie look. Hippie
style involved lots of color and detail. Instead he preferred a stark, simple, black-
and-white look. Hippie magazines used flowery lettering, so *Punk* looked like

urban graffiti. Hippie illustrations were airbrushed, over-rendered and silly—naked women with butterfly wings and caterpillars sucking hookahs on top of mushrooms, so as counterpoint Holmstrom's crude drawings contributed to what he called a "crummy-looking" magazine. Nonetheless, he did not sacrifice legibility and used "a lot of straight lines" in layouts to make the handlettering look orderly. He insisted that the magazine could not look like anything was done unintentionally. And most important, the magazine had to echo the music: fast, primitive, pounding, and loud.

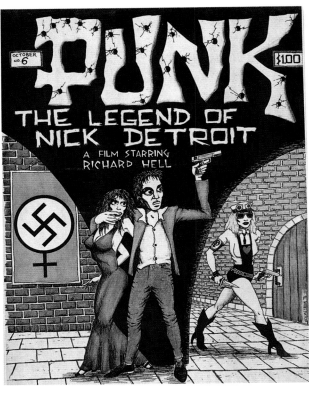

Designer: John Holmstrom
Magazine cover, 1975

Punk continued the tradition of alternative magazines that dates back to early twentieth-century Dada and Surrealism, and its direct antecedents were '60s Underground papers where D.I.Y. really began. However, since reaction is frequently the mother of reinvention, it was not surprising that Holmstrom referred to *Punk* (the magazine *and* the movement) as reactionary at least in its rejection of left-wing politics. Although all the punk magazines took an antiestablishment stance, the politics of Punk were antipolitics. American Punk was somewhat analogous to '20s Swiss Dada—more cultural than political—while British Punk echoes Berlin Dadaists who steered the German faction toward the hardcore Left.

A month after *Punk*'s first issue, *The Rocker* was launched, published by Alan Betrock (who died of cancer in 2000). Betrock's early issues established a template that was a lot less slick and "old hippie" than *Rolling Stone* but more artistic and professional than most Do-It fanzines. About *Rocker*'s design, Elizabeth van Italie, an illustrator who became art director in 1980, explains, "It was a seat-of-your-pants thing. I farmed almost everything out. I thought it would be a good thing if every page looked different from the next. I didn't know what I was doing. I had no design background; but I admired all the cool things of the day: *Slash*, *WET*, *The Face* . . . and record covers, everyone was putting out cool singles with colored

vinyl and beautiful packaging. I also admired [Russian Constructivist] Rodchenko as well as '50s and '60s retro stuff. I don't think it was a very Punk-looking magazine. The devices that gave Punk its look, like cut-out letters, rips, safety pins, and Day-Glo, quickly became design clichés. But it was very homemade looking, an energetic and uneven grab-bag, and in a lot of ways it did accurately reflect the scene as it was—which by then was less 'Punk' and more New Wave/no wave and beyond." Yet still raw and unpretentious.

Other contemporary magazines contained strands of Punk DNA: *Sniffin Glue*, published in England in 1974, is an archetype of Punk style because it was resolutely unprofessional, completely handwritten in a raw, scratchy scrawl without any of the tutored nuances that Holmstrom invested in *Punk*. *Sniffin Glue*'s pages were haphazardly laid out, produced essentially on a photocopier, without an iota of concern for legibility. Similarly, the San Francisco–based *Search and Destroy: New Wave Cultural Research* (which eventually evolved into *RE:Search*), edited by V. Vale from 1977 to 1979, reveled in its total disregard for design tenets. Its pages, composed using an IBM Selectric typewriter, looked similar to the broadsheets posted on lampposts and mailboxes raving about government conspiracies and UFOs. *Slash*, published by Steve Samioff, was Los Angeles' first Punk paper and began a year and a half after *WET*. Though *WET* didn't inform *Slash*'s aesthetic, which was more akin to *The Rocker*'s seat-of-the pants design, in an interview Leonard Koren said that *WET* performed "a kind of cultural road paving that contributed to Samioff's decision to go off in the publishing direction." The antidesign of '60s Underground papers pervaded *Slash*, and to any outsider whose reference is from the '60s it appeared to be a less political offshoot. It even included its own underground comic strip, *Jimbo* by Gary Panter, who by virtue of this venue established his "ratty line" as the quintessential Punk comic style.

S E E A L S O *Constructivist, Dada, Hip Hop, New Wave, Surrealist, Underground Press, Vernacular*

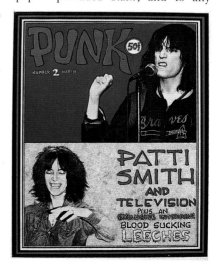

Photographer: Roberta Bayley
Magazine cover, 1976

DESTROY ALL MONSTERS: GEISHA THIS

Destroy All Monsters magazine ran six issues from 1975 to 1979, and was the creation of the Detroit band by the same name, comprised of Cary Loren, Niagara, and future art world stars Mike Kelley and Jim Shaw. Like the polished rock they responded to with noise, their printed product was a loud blast of chaotic and destructive graphics. By its very name, *Destroy All Monsters* seemed to summon up two of the primary Punk obsessions: B-movies and destruction. Each issue was a nonsensical set of pages devoted to collaged images of monsters, robots, and other degraded pop culture fare, along with drawings by all four members, found imagery, and disintegrated photographs. All of this was laid out haphazardly, crooked, often printed from stacks of leaflets and printed detritus the group could scrounge for free. This was both an aesthetic and moral necessity: Like their compatriots, *Destroy All Monsters* believed in "doing it yourself," right down to the copying, binding, and even stealing involved in making the zine. The Geisha compilation duplicates the magazine but adds an art slant. Multiple paper types are used, from rag to heavy varnished. But the effect is the same, if not more so for the variety: a sustained burst of Punk obsessions in perfect Punk form. It was sloppy, dirty, and fiercely D.I.Y. — D.N.

DWIGGINS

W. A. (William Addison) Dwiggins—a.k.a. WAD, Dwig, or Bill—(1880–1956) grew up in Cambridge, Ohio. At nineteen he studied lettering with Frederic Goudy at the Frank Holme School of Illustration in Chicago, Illinois. He was weaned on the ideals of the Aesthetic Movement, whose proponents imitated fine printing of the past. But Dwig did not follow the rules. His longtime friend and collaborator Dorothy Abbe once said that he had arrived at his own determination of fine printing, and it differed very considerably from that of Goudy, Daniel Berkeley Updike, and Bruce Rogers. While these stalwart keepers of the classical rejected mass production as anathema to fine design, during the course of his life Dwig witnessed the passing of individual craftsmanship, and the substitution of bigger and faster machines in all phases of typesetting and printing. He saw no reason why new technologies should not produce quality work, and proposed that photoengraving, for example, made calligraphy more widely available, which would increase popular appreciation of good design.

Dwiggins practiced advertising design, type design, book design, and marionette design. He created a working puppet theater in his clapboard studio in Hingham, Massachusetts. But to appreciate Dwig's obsession for work one must understand that he was driven to accomplish more than humanly possible before succumbing to the dire prediction of an early death. "He was handicapped by the clock and the calendar," says a biographical notation in a Typofiles chapbook. In 1922, diagnosed with diabetes, at that time a usually fatal disease, Dwiggins was motivated to get on with life. "Me I am a happy invalid and it has revolutionized my whole attack. My back is turned on the more banal kind of advertising and I have canceled all commissions and am resolutely set on starving. . . . I will produce art on paper and wood after my own heart with no heed to any market," he once wrote. Fate intervened and insulin soon became available, giving Dwiggins another thirty-three years.

Tossing aside his lucrative advertising accounts, he concentrated on the not-so-profitable business of book design and page ornament—with an unprecedented calligraphic style that wed Mayan and Asian influences to Western forms. His earliest book commissions were for Harvard University Press, for which he designed a now rare volume, *Modern Color* (1923), and Alfred A. Knopf, for whom, beginning in 1924 and continuing for almost two decades, he designed 280 books of fiction and nonfiction, as well as almost 50 book jackets. "Bill enabled us to produce a long series of trade books that for interest and originality of design are unequaled," wrote Mr. Knopf.

Designer: W. A. Dwiggins
Ticket, 1937

In addition to his calligraphically composed and sometimes illustrated book title pages, two features characterized his design: The text was always readable and the bindings were adorned with his calligraphic handlettering and neo-Mayan ornament. Every piece of lettering and typography—down to the minutest graphic detail—was rendered by hand; and given the extant physical evidence, many were done without a single mistake (or he simply redrew them rather than touch up the errors). Dwiggins' calligraphic display letters, a marriage of classical typefaces and invented scripts, set the standard for Knopf's books, and influenced many

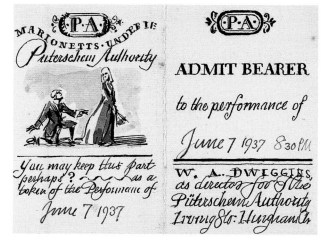

On spine: THE ARCHITECT AND THE INDUSTRIAL ARTS · THE METROPOLITAN MUSEUM OF ART · 1929

Type ornament, with landscape attached

WAD

LINOTYPE

Electra

THE SERIES COMPRISES:

Electra *Electra Italic* *Electra Cursive*
and **Electra Bold**

THE Old Beauty And Others

by Willa Cather

THE
Old
Beauty
and
Others
BY
WILLA
CATHER

BORZOI
BOOKS

KNOPF

The last three stories
of a writer who has given us some of the greatest
literary creations of our time

other publishers, who employed various imitators.

Dwiggins initially wanted to avoid designing dust jackets because he saw them as crass advertisements. Yet owing to his special relationship with Mr. Knopf, when asked, he did them—scores of them. Nevertheless, his method was a form of denial. He refused to pictorially illustrate most covers, as was the common practice, but rather applied Dwigginsian ornament and calligraphic lettering, contributing to a formal similarity between all his jackets. The image area of his most common jacket format was cut in half, with the title on top and a subtitle or other type below. Sometimes he used an excessive amount of ornamentation, but only with his own self-authored books did he ever use a drawing. A typical approach specifically found with his jacket for *The Old Beauty and Others* by Willa Cather, which includes a hand-lettered title and byline and characteristic ornament printed in pink, green, and brown, is something like a souped-up title page. The jackets never evoked the plot or theme of the book, but were "dust wrappers" in the literal sense of the word—designed to protect not to illuminate.

"There are few American designers whose work can be revisited after decades with more pleasure and instruction," an admirer wrote about Dwiggins a decade after his death in a Typofiles chapbook. When viewing examples of his printed work or the original drawings that surface at exhibitions, Dwig's work stands up not as nostalgia, but as invention. Even the book jackets, which are stylistically locked in time, could with some typographic modifications be used today. By the

fifties, however, with the advent of the International style and the sweeping success of Corporate Modernism, Dwig was virtually ignored. The tendency among Modernists to disclaim as crass commercial art anything that preceded Modernism was reason why Dwiggins was falsely accused of being passé.

S E E A L S O *Art Deco, Art Deco Type, Show-Card*

see Emigre

EMIGRE

A year before the introduction of the Apple Macintosh computer in 1983, Rudy VanderLans and Zuzana Licko founded *Emigre* magazine. Within a few years it developed into the clarion and experimental wellspring of digital typography and design. As pioneer users of early Macintosh, Licko designed custom bit-mapped typefaces for the magazine, which VanderLans used in layouts that rejected Modernist rigidity in favor of Postmodern improvisation. By exploiting the quirks and defaults of the computer they developed a typographic language that challenged many other sacred tenets of legibility.

Realizing the power of the personal computer and the ultimate shift from photo lettering to digital type, they founded a type business, Emigre Graphics (later Emigre Fonts), featuring original typeface designs that exploited computer technology while reflecting the gestalt of the times. Among the innovative dot-matrix fonts were Bitmap Oblique, Oakland Six, and early high-resolution digital typefaces including Modula Serif and Democratica Bold. *Emigre* further showcased other leading inventors and practitioners of the new typography and sold their experiments in the practical arena.

The most emblematic of the early '90s and therefore the most stylistic too, Template Gothic (1990), designed by Barry Deck, was influenced by a handmade sign in a laundromat. Ironically it came to epitomize digital era typography. Timing might explain why Deck's face became the most commonly used font for everything from posters to periodicals. At the time universality was becoming the hobgoblin of cultural diversity. Template Gothic ventured into areas of type design deemed taboo. "The design of these fonts came out of my desire to move beyond the traditional concerns of type designers," Deck explained in *EYE* #6, "such as elegance and legibility, and to produce typographical forms that bring

RIGHT *(top)*
Designer: Rudy VanderLans
Catalog covers, 1992–93

(bottom)
Designer: Rudy VanderLans
Magazine covers, 2003–04

to language additional levels of meaning." After twenty years of gridlocked design, reappraisal was inevitable.

Conceptually playful, experimentally serious, and purposefully imperfect Template Gothic was a discourse on the standards and values of typographic form. Template Gothic was literally ripped off the wall. "The sign was done with lettering templates and it was exquisite," Deck said. Although the original stencil was professionally manufactured and commonly sold in stationery stores, the untutored rendering of the sign exemplified a colloquial graphic idiom that heretofore designers viewed as a gutter language. So, perhaps the best reason for Template Gothic's success was that it did not invoke nostalgia or retro. It also captured the conscious and unconscious needs of young designers to reject the recent past.

Manson (a.k.a. Mason) designed by

Designer: Rudy VanderLans
Magazine cover, 1986

Jonathan Barnbrook was another charged face launched by Emigre Fonts that propelled the new digital style. On the surface the spiky Roman typeface (named after killer Charles Manson) recalls medieval inscriptions. With crucifix-ated Ts and Os it exudes a symbolic air well suited as a display face for spine-chilling thriller and mystery books. But shortly after it was introduced, Manson was criticized not for its form, but its name. A letter to Emigre Graphics, the foundry that released the face, read: "In a time of random violence . . . why are you naming a typeface after Charles Manson? As part of our media culture, in fact a well-respected one, what kind of humor are you projecting? What kind of responsibility are you neglecting? This is no subtle joke. We are shocked at your inhumanity and callousness." In 1995 Emigre Fonts renamed the face Mason, suggesting the stonemason who inscribed the original letters. Yet despite revisionist nomenclature the name "Manson" stuck, and gave the face an aura of menace.

Emigre was known for triggering controversy. And as the magazine and type

foundry became a touchstone for progress, they also axiomatically provided templates for mimicry. What *Emigre* initiated was co-opted by the new mainstream—from fashion magazines to MTV. Stylistically *Emigre* was not just the standard bearer, it was the bearer of standards for experimental digital typography.

S E E A L S O *Club Flyer, Kinetic Type, Me-Too, Modernist, Postmodern*

EXPRESSIONIST

German Expressionism emerged in 1905, a movement of rebellious painters repudiating the academic strictures placed on German art. Two Expressionist groups, Die Brücke founded in 1905 and Der Blaue Reiter in 1912, held sway. Fauvist color principles influenced both and each produced exhibitions and publications that promulgated opposition to the tenets of classical beauty. The offspring of their collective radicalism was a visual language that drew upon new discoveries of primitive iconography, not the least of which were African totems and masks.

Expressionists favored the woodcut, a medium that resists perfection. Woodblocks require that artists gouge the wood to make their marks—the Expressionists made this struggle visible, which in turn allowed the artists to reveal their emotions, resulting in rawness that stripped the respective subjects to their primal states. Deformation of the figure was employed to heighten the intensity of expression. Prior to World War I, Expressionism attacked the status quo mostly in metaphysical terms. But after 1918, following the November revolution that installed a republic in war-ravaged Imperial Germany, many in the movement became more fervently political, allying themselves with Socialist and Communist parties.

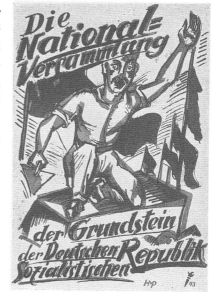

Expressionists broke into distinct factions: One such was the radical Novembergruppe, which produced polemical posters, newspapers, and other propaganda for the Left between street battles with right-wing nationalists. The raw graphic style the group adopted from Expressionism stripped away both artifice and propriety with

*Designer: Max Pechstein
Poster, 1918–19*

Die Aktion

IX. JAHR. HERAUSGEGEBEN VON FRANZ PFEMFERT NR. $\frac{45}{46}$

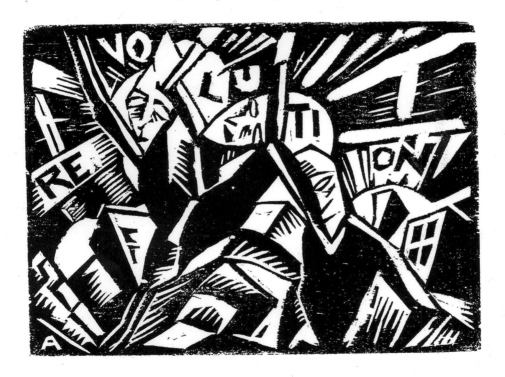

VERLAG · DIE AKTION · BERLIN-WILMERSDORF

HEFT EINE MARK

the goal of creating formal visual language of the revolution.

These postwar Expressionists delved further into graphic design to reach a greater mass audience. They introduced rigid woodcut lettering that gave the style its signature look. Usually the letters were not based on existing models but grew out of the unforgiving woodcut medium. The Expressionists did not produce commercial typefaces, but they did influence others even after the art movement ended around 1922. In 1937 the Nazis lumped all Expressionist art and design (even work by artists who joined the Nazis) into the category Degenerate Art, displayed in the so-named exhibition (*Entartete Kunst*), which showed only work that was anathema to the new German State.

SEE ALSO *Art Deco, Artzybasheff, Bass, Conceptual Illustration, Dada, Futurist, Push Pin, Wendingen*

FRANS MASEREEL'S PICTURE NOVELS

Frans Masereel (1889–1972) drew inspiration from Expressionist design and illustration in the 1920s. Born in Belgium, based in Switzerland and then France, he is best known for his picture novels, proto-graphic novels but with one image per page and no words. Published in inexpensive and widely available editions by his German publisher, Kurt Wolff, his books include *The Passionate Journey*, *The Sun*, and *The Idea*. In his narratives idyllic forests give way to factories, hellish cities of jagged alleys, and terrible buildings, thus echoing the themes of industrialization, war, and the new modern life with which designers and illustrators from Karel Tiege to El Lissitzky to George Grosz and Käthe Kollwitz were grappling. Masereel's stark black-and-white geometric figurations were departures from the stylistically looser, more impressionistic drawings of Grosz and Kollwitz, but his ideas and the visceral power of his images tie them. Indeed, his innovation was to demonstrate contemporary concerns through long-form visual narratives, telling book-length stories in the Expressionist vocabulary of elongated limbs, looming, plasticine structures, and skewed perspective. Masereel was able to assimilate all of these elements into stories that depict a world, and an art form, on the verge. — D.N.

see Futura

FASCIST

In Fascist Italy during the 1920s and '30s "the cult of the cradle" was an aggressive official doctrine determined to inculcate in male youngsters the mythology of the omnipotent regime in order to transform so-called "flowers of faith" into soldiers of empire. Relentless propaganda campaigns printed and published with an evolving "heroic" design language, and the embrace of Fascist doctrine in schools and youth groups were designed to breed a new cultural order.

In the fall of 1921 Benito Mussolini consolidated Fascist bands of *squadristi* into *Fasci Italiani di Comattimento* that ultimately evolved into the *Partito Nazionale Fascista* (PNF), which took for its emblem the fasces (rods bound together with an axe handle) of ancient Rome. In fall 1922 this upstart party formed Italy's dictatorial government, and a few months later Il Duce (the leader) Mussolini proclaimed with characteristic bravado, "Today in Italy is not the time for history . . . it is the time for myths. . . . Only the myth can give strength and energy to a people about to hammer out its own destiny."

Mussolini knew for Fascism to permeate society every facet of Italian life needed to be revamped. Myths of a new empire, a third Rome, were planted deep in the fertile minds of the most malleable Italian citizens—youth—in part through print campaigns conveyed in a distinct graphic style that replaced antiquated bourgeois typography and

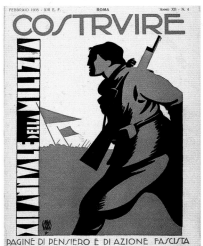

LEFT
Designer: Unknown
Magazine cover, 1935

RIGHT
Designer: Mario Sironi
Almanac cover, 1936

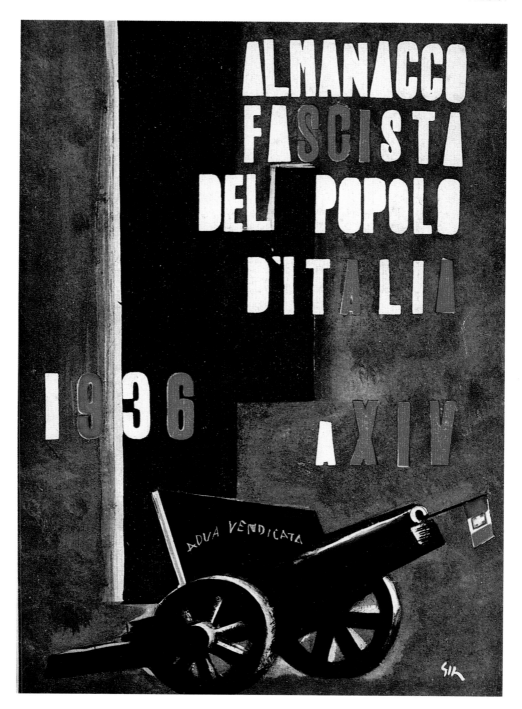

ornament with revolutionary symbols and icons. The Roman calendar was changed to make 1922 into Anno I. The linguistic system changed so that the formal third person singular *Lei* was abolished and replaced by the second person singular *tu* or plural *voi*. Dialects were outlawed as remnants of past occupations. The "effeminate" handshake was eliminated in favor of the masculine straight-armed Roman salute. And above all the national symbols of Italy were substituted for new Fascist icons. The visage of a lock-jawed Il Duce was the most ubiquitous of these icons. Mussolinian style, propagated through the Ministry of Public Instruction, was enforced in all media, from advertising to architecture.

Mussolini devoted more time to publicity than to policy. The job of the new regime was to weave Fascism through the fabric of Italian society. It was essential to capture the minds and secure the loyalty of compliant youngsters by creating an enticingly conformist culture that established youth as the most valuable asset of the state. The mystique of youth was a Fascist obsession that played out in propaganda built upon the manufactured youthful image of Il Duce (news

Designer: Unknown
Catalog cover, 1933

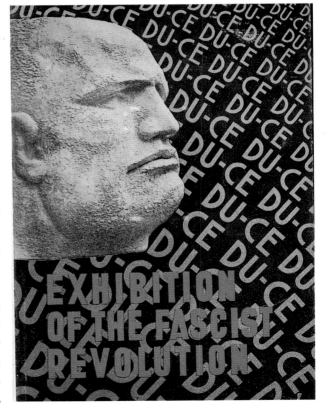

media were prohibited from discussing his grandchildren but countless photographs of the vain bare-chested Mussolini were published in newspapers and magazines). Mussolini created youth groups that emphasized sports and martial training in order that members be fit enough to carry the baton of the Fascist movement into the future. The shock troops of Fascism were originally gangs of youth—a generation of combatants storming through Italy wearing black shirts, jackboots, carrying death's head flags, and wielding batons against an enemy that represented social decay and cultural elitism.

The Fascist Grand Council, whose orders were implemented by the *Milizia Volontaria per la Sicurezza Nazionale* (MVSN) was manned by twenty-something and older members known collectively as the Black Shirt Militia,

Designer: Unknown
Diploma, 1933

who personally pledged obedience to Mussolini. In the spirit of revolution and to infuse fresh blood into the MVSN the Grand Council instituted youth organizations that included eight- to twenty-one-year-olds. The first such group, founded in 1920, was the *Avant-guardia Studentesca dei Fasci Italiani di Combattimento* (under the control of the Milan *fascio*), which published a magazine titled *Giovinezza* (Youth). In 1921 the original group became the *Avanguardia Giovanile Fascista* (or *Vanguardisti*) for boys from fifteen to eighteen years old. Within a few years the original journal evolved into a more startlingly designed and expensively produced *Gioventù Fascista* that through its posterlike covers of young *Vanguardisti* rendered in a streamlined manner defined an Art Deco–styled Fascist graphic youth style.

The Fascists tightened their hold on youth in part through alluring ideological images rooted in the most visible of symbols: the uniform, which was paramount in establishing conformity yet underscored an elite within Italian society. Uniforms were designed with careful attention to detail and style and with each incremental age level the regalia (including various shiny badges and insignia) increased in direct proportion to completed indoctrination. Wearing of uniforms was required during all official gatherings (of which there were many) as well as all rites and celebrations. Countless posters commemorated the new youth in the new state through heroic, airbrushed images of uniformed boys and men (and sometimes girls).

The airbrush became an ideological tool in the making of myths. Fascist artists used the airbrush to streamline human figures into Modernist effigies and this mythic image of the *Giovanili* symbolized obedience and allegiance. In contrast to the stiff heroic realism of Nazi iconography, portrayals of Fascist youth involved Futurist nuance that reduced the human figure essentially to a sleek logo.

Designer: Unknown
Magazine cover, 1928

"Believe, Obey, Fight" (the motto of the MVSN) were "action" words chosen by Mussolini. The Fascists worshiped might and celebrated speed, which were duly represented in Modernist graphics and typography. Antiquated, central-axis page composition was replaced by more dynamic aesthetics that wed Futurism to Art Deco. Typefaces with sharp edges and contoured right angles expressing velocity replaced classic Roman alphabets (at least in propaganda aimed at the young) that were considered old-fashioned. Often these newly designed letters were set tightly in blocks reminiscent of monumental stone inscriptions (and formations of Roman soldiers), exuding a contemporary appearance with an aura of classical virtue. When the Fascists changed the linguistic system it was supported by a radical typographic restyling that rejected humanist serifs for demonstrative Gothics. Language drove the look of type and Mussolinian words such as those meaning *struggle*, *courage*, *death*, *glory*, *discipline*, *martyr*, and *sacrifice* were appropriately spelled out in letters that seemed to speak loudly and bombastically.

The Nazis are routinely credited with producing the twentieth century's most effective graphic identity program, but the Fascist campaign to inspire and manipulate Italian youth was as arresting if not more remarkable. While the swastika proved to be a more hypnotic symbol than the fasces, the installation of a total propaganda program created through the critical mass of icons, images, and ornaments comprising Italian Fascist style was an essential precursor.

S E E A L S O *Art Deco, Futurist, Heroic, Modernist*

FEAR

Although the aesthetic of enmity may not be based on any particular typeface or color, the visual rhetoric is obvious, the style is clear. It includes lies and hyperbole, caricature and stereotype, threat and agitation. Fearsome messages are not only the product of extremist groups; the vast majority is government-sanctioned and professionally produced. And it is one of the most universal of graphic styles.

"In the beginning we create the enemy," writes historian Sam Keen in *Faces of the Enemy: Reflections of the Hostile Imagination* (Harper and Row, 1986), about state coercion. "We think others to death and then invent the battle-axe or ballistic missiles with which to kill them."

Propaganda precedes technology as a means to soften otherwise rational minds into malleable clay. Therefore, the process of demonic manufacture, wherein the object of abhorrence must be thoroughly stripped of its human characteristics, is essential in securing mass hostility toward one group or another. "The war of icons, or the eroding of the collective countenance of one's rivals," noted Marshall McLuhan in *Understanding Media*, "has long been under way. Ink and photo are supplanting soldiery and tanks. The pen daily becomes mightier than the sword."

During World War I, U.S. artists and designers under the watchful art direction of Charles Dana Gibson at the Committee on Public Information invented images

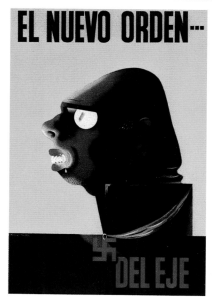

bolstered by rumors of German savagery against civilians. The "Hun," an apelike beast with blood-soaked fangs clutching young female hostages (implying that rape was an instrument of policy), was a fearsome poster child.

In the process of demonization, stylized repetition becomes the artist's primary conceit. The more an image or epithet is repeated the more indelible it becomes. The big lie can be created by synthetic truth. But real truth bolsters extreme exaggeration. So purveyors of Fear style routinely latch on to the lowest denominator and over-generalize a particular people on the basis of a

long-lived stereotype or for a manipulative political agenda—as in all Jews are rapacious or all Arabs are terrorists. In U.S. propaganda of the '50s, Joseph Stalin, a real scoundrel, represented not merely the regime over which he lorded but all Soviets. Not surprisingly, in Soviet propaganda all Americans were portrayed as corrupt, corpulent money-grubbers often given the composite features of fat, cigar-smoking, avaricious capitalists. In the litany of hate, everyone, irrespective of individual persona, is tarred with the same brush. When seen only as a mass of faceless types the enemy becomes even more terrifying.

At the outset of World War II, U.S. propagandists, including designers and illustrators from the advertising industry, were drafted into the paper war against Axis Germany, Japan, and Italy to create and propagate odious stereotypes that subverted tenets of peacetime civility. The Office of War Information in Washington, D.C., created many of the negative depictions including bucktoothed Japs and fang-toothed Nazis that were fed civilians at home and soldiers overseas. Civilians had to be constantly reminded of the ruthlessness of the enemy, while soldiers had to be encouraged to kill them without remorse. This was only accomplished through a program of media dehumanization—the ends justified relentless graphic means.

Photographer: Unknown
Magazine cover, 1942

"Civilization is a constant struggle to hold back the forces of barbarism," writes Keen in *Faces of the Enemy*. "The barbarian, the giant running amok, the uncivilized enemy, symbolize power divorced from intelligence. . . ." So the graphic lexicon of hate abounds with metaphor and allegory in which the barbarism of any opponent is made concrete through images of vicious anthropomorphic beasts—polemical werewolves—the embodiment of bloodthirsty wickedness and unbridled savagery. Never mind that in wars each side resorts to barbarism to achieve its aims. Never mind that the vocabulary of hate invariably deploys barbarism to "fight" barbarism. In the propaganda war, the victor is the nation that

invents the most blisteringly horrific image of its satanic enemy.

War is not the sole rationale for institutional, graphic hatred. In other lethal power struggles there is no greater motivator than apprehension of "otherness," and no more effective imagery, than ethnic and racial stereotypes that exacerbate the suspicions of insecure people. Absurd racial stereotypes have historically been (and still are) used as commercial symbols in comics, advertisements, and packages, even logos, but when similar caricatures are tweaked with just a hint of menace, such as a lustful gaze or dramatic shadow, they switch from unenlightened farce into vengeful attack.

Psychological warfare has long been employed in hot and cold conflicts, its purpose to instill paralytic fear that will severely reduce an enemy's fighting capabilities. Aggressors drop leaflets warning civilian and soldier alike to capitulate before the onset of massive destruction. Paper bombs are not as cagey as more sophisticated propaganda, but they are powerful at conveying a straightforward message without artifice or conceit—and the message proposes only two viable options: Live or die. Be afraid or succumb to an overwhelming force. When the Fear style really works, it instills terror of a massive kind.

S E E A L S O *Halloween, Mushroom Cloud, Red Scared*

FELLA

In the 1980s, after decades working as a commercial artist in a Detroit studio primarily servicing the auto industry, Ed Fella enrolled as a graduate student at Cranbrook Academy of Art in Bloomington, Michigan. After graduating with an MFA, he became one of its most popular teachers. Cranbrook took the vanguard of "the New Theory," a blend of deconstructionist literary concepts wed to typographic practice that gave birth to a wave of young designers and design educators. Fella reveled in this hothouse environment. In fact, the risks that he had avoided in his younger days while producing illustrations and

Designer: Ed Fella
Poster, 2003

practice and preach and/or theorize and teach!

brochures for conservative commercial clients seemed to pour out of him after "retiring" to academia. He produced an astonishing array of expressively raw, misshapen, hand-lettered type compositions that were used as posters and invitations for eclectic art galleries and nonprofit cultural institutions in the Detroit area.

The prolific and prodigious Fella arguably revived hand-drawn typography and turned it into a period style and made it acceptable to do in the digital age. When Fella started making contorted hand-hewn typography that echoed the earlier "words in freedom" practiced by avant-garde Dadaist, Futurist, and Surrealist designers, he swore never to do a "straight job" again.

What typifies the Fella style is a boundless curiosity and effortless rule busting. The former took him on an odyssey around the United States photographing ad hoc and amateur signs—ultimately collected in the book *Letters on America* (Princeton Architectural Press, 2000)—and making signs of his own. The latter gave him license to create his own typographic systems that are part illustration, part scribble, and entirely expressive art.

During the late 1980s and '90s Fella's free-form, serendipitous approach to typographic design earned him exposure in the pioneering experimental type magazine *Emigre*, which saw in Fella's handwork inspiration for new expressive digital compositions. The era of late Modernism with its emphasis on transparency, clarity, and the grid had fallen out of favor. Fella's work rejected impersonal universality, and his matter-of-fact disregard for the strictures adhered to throughout his professional life appealed to many young designers who saw graphic design as an expressive medium.

Fella made a huge impact with his quirky typeface Outwest with characters that look like cactus wearing cowboy hats, and his comic dingbats Fella Parts, nonsensical abstract designs—both distributed through Emigre Fonts. Fella always worked as though the hand is mightier than the pixel, still, each of his fonts was digitized for widespread sales. Although he turned his back on the commercial

life these fonts found their way into the design mainstream. For Fella primitive style is an antidote to slick professionalism, though he is aware that his brand of primitivism has evolved into a professional style too.

SEE ALSO *Dada, Deconstruction, Emigre, Futurist, Surrealist*

FOOD

The modern commercial package was introduced about a century ago with quaint labels, yet its key conventions—used to achieve "appetite appeal"—remain in place. The most common element involves hyperrealistic illustrations of food. A well-executed stack of pancakes soaked in butter and syrup, a steaming bowl of soup, and a plate of spaghetti topped with a delectable sauce excite the salivary glands more than the powder, liquid, or goo found in the packages. Reproductions of fruits and vegetables—a glistening apple, orange, or pear on a juice container, or dew-soaked berries on a jar of jelly—have incalculable overt *and* subliminal powers. Transforming the contents of a box or tin into a feast does not take genius, but it does take talent. Which is why specialists called "food stylists" work closely with still-life photographers to create the ideal representation.

In the absence of actual aroma—no one has dared use scratch 'n' sniff packages, yet —perfectionist imagery, like a wedge of chocolate layer cake on a cake mix box or smiling sunny-side-up eggs on a powdered egg package, are convincing substi-

Designer: Unknown
Label, c. 1905

Designer: Unknown
Label, c. 1925

tutes. The fact is, without these pictorial representations the supermarket would be little more than a warehouse of generic staples. With them, it is a cafeteria of tasty displays.

Food packages do not, however, show only cooked foods or nature's bounty. Contemporary packages appeal to the shopper's lifestyle and, notably, health concerns. These days a product cannot be mouthwatering or thirst-quenching alone, the package must announce that it is *indispensable* for the body, mind, and soul. Food is much more than mere sustenance: It is culture. It is also a code for class and social strata, for the masses or the classes. Decades ago it was said, "We are what we eat." Today the sentiment motivates the food packaging industry.

Supermarkets around the country have had face-lifts to look more stylish. Now they offer more shelf space to a wider variety of "food for the masses *and* food for the classes." In addition, specialty food shops have increased demand for premium and "fancy" foods, which are not only prepared with more attention to fashion, they are packaged in more atypical ways. The combination of a general upgrade of mass products and the introduction of more upscale products, not to mention the addition of food-style magazines, radio, and cable food programming, have increased the status of food in contemporary culture.

Advertisements for average bottled waters claim to quench thirst, but packages for the premium brands presume to satisfy social tastes. To impress one's guests, seltzer is just too plebeian, but a bottle of *aqua minerale* will stand regally alongside a decanter of the choicest Beaujolais Nouveau. With its elegant cobalt blue bottle, Tynant water,

Designer: Unknown
Label, c. 1940

for example, looks perhaps as stylish as fine wine. In the eighties specialty foods, once the province of small, exclusive caterers and food boutiques, found their way into the supermarket where shoppers must often choose between the common and premium, economical and costly.

Packaging is key. The majority of foodstuffs are packaged to be unpackaged, but increasingly more packages are saved. Food tins, boxes, and jars are not only designed to distinguish themselves in a crowded market, but to be displayed in private homes. Like vintage advertising posters, artsy food packaging is designed to be instant artifact.

In the 1950s virtually all supermarket brands, regardless of the product, looked basically the same: Bold Gothic type or custom script lettering, loud primary colors, and friendly trade characters on a label or box. Some of the best-known packages, like Hershey's chocolate or Golden Blossom honey, were not altered for decades and many are still packaged more or less with the same design as when they were first introduced. Change came slowly to food packaging because manufacturers and retailers were terrified of confusing their loyal consumers.

In the '80s, graphic designers who were more concerned with the aesthetic value of their design than market-tested truths turned from eye-catching Gothic and sans serif types to classical or even New Wave typefaces; loud primary colors were replaced by quieter pastels; and trade characters were either streamlined or retired. Yet despite stylistic changes, food packaging is still the most conservative of any graphic medium. Consumers may say that they want novelty as a respite from daily routines, yet an analysis of the average shopping cart reveals that only a few purchases are impulsive. Consistency is the watchword of food style.

SEE ALSO *Generic, Show-Card, Vernacular*

FUTURA

Paul Renner's name may not be a household word, but his face—rather his typeface, Futura—is one of the best known of the twentieth century. Renner, a type designer and teacher at the Munich Meisterschule für Deutschlands Buchdrucker (Master School of German Book Printing) designed Futura as an alternative to the traditional German spiky black letter, which was Germany's national lettering style since the days of Gutenberg. Released a year after it was designed in 1925, Futura, dubbed "the type of today and tomorrow," became the most ubiquitous "grotesk" or sans serif typeface of its day. Yet owing to Renner's outspoken criticism of black letter, which the Nazis briefly celebrated as the letter of the German

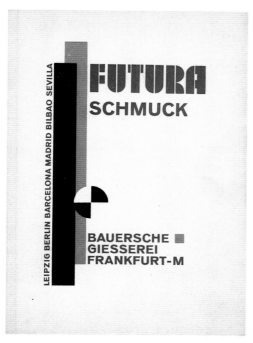

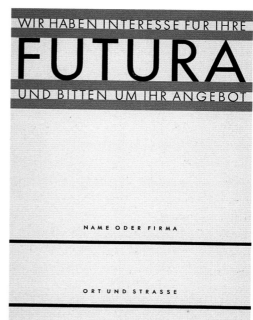

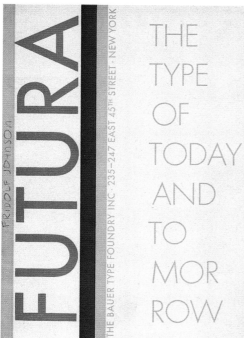

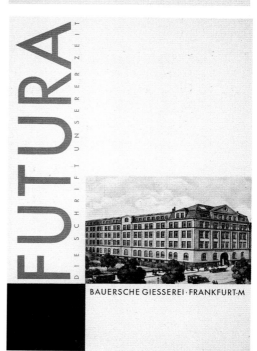

people, he was persecuted and dismissed from the university without his pension. Ironically, a short time later, a version of black letter was deemed to be *Juden-lettern* (Jewish type) and serif roman and sans serif were returned to currency, but Renner was still prohibited from practicing his craft.

Renner was influenced by Edward Johnston's typeface designed (and still used) for the London Underground. Renner's Futura (touted in specimen sales sheets as "the typeface of the future") was unique for its perfect geometry and crystalline clarity. It symbolized the transition from handicrafts to the Industrial Age, and became an emblem of *Die Neue Typographie* (the New Typography), a style employed by progressive advertising designers and typographers who, influenced by twentieth-century avant-garde art, sought to liberate commercial art from its antiquated verities. Rejecting rigid central-axis composition, the New Typography proffered more dynamic asymmetrical alignments of type and image, the avoidance of unnecessary ornamentation, and the introduction of bold, economical alphabets. Futura was not only the most emblematic sans serif—since it was produced in numerous weights and sizes it was also one of the most versatile. Today Futura is still widely used in advertising and magazine design.

S E E A L S O *Art Deco Type, Black Letter, Helvetica, International Typographic, New Typography*

FUTURIST

By 1900 in Europe utopian philosophies held that art was not entertainment for an elite, but rather a revolution aimed at altering society, culture, and politics. The artist was a soldier in this revolution and influenced all aspects of life, through all arts including graphic design and advertising. Art Nouveau wed applied to fine

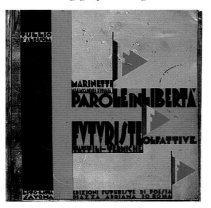

art, but the most radical experiment began in 1909 when F. T. Marinetti produced the first of many typographic manifestos, called "words in freedom." Marinetti, a rebellious young poet and playwright, was the father of Italian Futurism, a cultural insurgency that advanced the idea that art and design were inextricably linked to modern technology, particularly the machine. The graphic style that best expressed

Designer: Tulia d'Albisola
Book cover, 1932

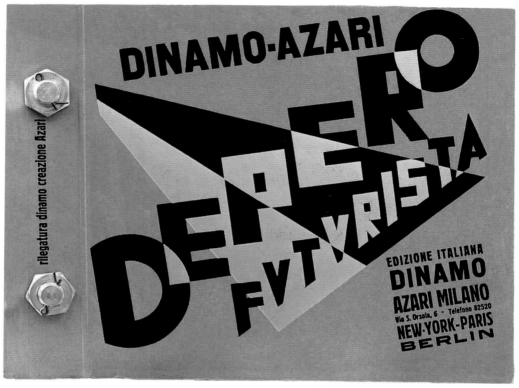

Designer: Fortunato Depero
Catalog cover, 1927

the Futurists' ideology—a dissonant cacophony of letters, types, and words—was a curious mixture of the archaic (nineteenth-century letterforms) with futuristic, unprecedented compositions. Futurists claimed that art could no longer be aloof from the social and political forces that forged it, and as civilization advanced into the future, art would lead the charge.

Filippo T. Marinetti's "First Futurist Manifesto" published in 1909 in, paradoxically, the most respected Parisian newspaper, *Le Figaro*, was a paean to "progress" and a cry for vehemence—the first of many calls to arms that inducted art and artists into the service of cultural politics. Futurist manifestos were written in impassioned prose and composed in bombastic layouts with type that exploded on the printed page. Marinetti accused a somnambulant culture mired in antiquated classicism of stultifying progress. In his seminal manifesto he wrote:

We affirm that the world's magnificence has been enriched by a new beauty: the beauty of speed. A racing car whose hood is adorned with great pipes, like serpents of explosive breath—a roaring car that seems to ride on grapeshot is more beautiful than the Victory of Samothrace.

We will glorify war—the world's only hygiene—militarism, patriotism, the destructive gesture of freedom-bringers, beautiful ideas worth dying for, and scorn for woman.

We will destroy the museums, libraries, academies of every kind, will fight moralism, feminism, every opportunistic or utilitarian cowardice (F. T. Marinetti, *The Founding and Manifesto of Futurism*).

Although the "First Futurist Manifesto" was typographically bland in light of its militancy and compared to later proclamations, it nonetheless presaged the antibourgeois aspects of the Italian Fascist revolution and its leader Benito Mussolini, who embraced Marinetti as a valued propagandist.

Futurism marked a radical shift in the attitudes of youth in particular, expressed through all cultural forms. But its contribution to design perhaps had greater influence than any of its other manifestations. Futurism changed type and layout from the old-fashioned reliance on staid central-axis composition to dynamic asymmetry. Typeset and hand-drawn letterforms were no longer quietly or elegantly printed on a page, they were transformed into vibrant onomatopoeia: Some typographic compositions were turned into images on the page.

On May 11, 1912, Marinetti published the "Technical Manifesto of Futurist Literature" (and three months later a supplement) in which he outlined the visual principles of Futurist poetry—as well as his disgust with accepted notions of intelligence. The goal was to recast written and spoken language by eliminating conventional grammar and syntax, and this was manifest in the invention of his most emblematic visual-verbal poetic form, *parole in libertà*—or *liberta*, as he might have it—(words-in-freedom), which he created specifically to express notions of speed through a compositional economy of means.

All punctuation and nonessential verbiage, like adjectives and adverbs, were rejected. Verbs and nouns were exaggerated, repeated, and forced to collide through madcap typographical compositions that quite literally flew around the page. The combination of onomatopoeia phrases and expressive typography effectively simulated the

LEFT
Designer: Ardengo Soffici
Book cover, 1915

RIGHT
Designer: Unknown
Newspaper, 1933

[233]

esce ogni domenica (settimanale) 15 gennaio 1933-XI

FUTURISMO

a. II° n. 19 cent. 50

settimanale del futurismo italiano e mondiale · via delle tre madonne 14 · roma · telefono 871285

IL TEATRO TOTALE FUTURISTA

Il palcoscenico fisso e girante del teatri contemporanei è più o meno simile ai teatrini dei bambini. Adatto alle marionette più che agli attori vivi, evoca sempre il cosinetto istoriato del caminetto borghese con castelli medioevali e semplicemente la gabbia dei morti, imprigionati dal fondale e dalle quinte e illusoriamente liberi dalla parte anteriore.

Noi futuristi abbiamo quindi ideato un teatro TOTALE con risultati architetturali originalissimo.

Vi sono stati molti tentativi ma troppo moderati ed insufficienti per correggere la monotonia della scena unica e della azione unica. Occorre coraggiosamente liberare lo spettatore dalla sua immobilità servile e sottomessa e metterlo in movimento.

Da ventitre anni noi propagandiamo lo luoge di simultaneità nelle teatro che condanna il concetto di scena unica e stabilisce che ogni episodio della vita ha infiniti altri episodi contemporanei contrastanti e favorevoli e adatti sempre ad arricchirlo di significato e drammaticità.

Noi facciamo circolare gli spettatori intorno a molti palcoscenici tondi su cui si svolgono simultaneamente e azioni diverse con una vasta graduatoria di intensità con una perfetta organizzazione collaborante di cinematografia - radiofonia - telefono - luce elettrica - luce neon - aeropittura - aeroposia - tattilismo - umorismo e profumo.

ARCHITETTURA E MECCANISMO DEL TEATRO TOTALE.

(sintetico polisensazionale e multanno polisensorico aeropittorico aeropoetico cinematografico radiofonico olfattivo tattile rumorista).

Il teatro costruito con le sue masse ascensionali secondo i principii del grande futurista Sant'Elia (padre della nuova architettura, di Aeropittura, di Aeropittura, è aerospittura, è di Aeropittura.

S. E. Marinetti ha illustrato come egli sola sa fare l'importanza e il pregio artistico di questa Mostra futurista, certa una delle più grandiose e delle più complete organizzate fino a a Firenze, ed ha messo in rilievo il travolgente risveglio della nostra Arte, oramai etorna e d, e costano della quale a sua volta si riferisce a altre dozzine di consorelle e così d'il seguito di anno in anno dal '70 ad oggi.

Tutto ciò è antistorico, antifascista, pedanteria, confusionismo impigrimento delle energie spaziate: la vigilata del passato del passato.

S. E. Marinetti ha anche accennato alla Mostra della Rivoluzione, ma ex questa viva ed intensa Mostra che è a intrattenità più a lungo in una interessante conferenza.

CONFERENZE MARINETTI A FIRENZE

Nel magnifico salone della Galleria Ferrari, dinanzi a un pubblico numeroso e scelto mo nel quale figuravano le più eminenti personalità del mondo artistico e politico fiorentino, S. E. Marinetti ha tenuto la prima delle sue annunciate conferenze, è servita d'inaugurazione alla grandiosa Mostra d'Arte Sacra futurista e di Aeropittura.

a voltarsi tutto invaso dello triangolazione di un corteo di squadristi di Toto sopravveniente nello scherno di sinistra. Le orchestre e i cori invisibili fistano ogni tanto con musica sintetica fuori del suolo. Opportuni dialoghi di sette otto secondi permettono il necessario riordinarsi della fantasia agitata dello spettatore.

Il crescendo emozionante dei diversi spettacoli culminano nel grande palcoscenico centrale su cui a picco all'altezza di 100 m. lo zenit della cupola celestiale del teatro meccanizza tutte sue orbite metalliche il movimento meccanico a basso prezzo nelle città, cittadi di teatro e a nazionale autori e sopra re e di montagna, libri e biblioteche di insegnamento elementare politico fascista. Il Capo del Governo ha molto elogiato l'important sinistra fascista di questa iniziativa dovuta al Sindaca e il suo appoggio diretto.

F. T. MARINETTI

PROPOSTA FUTURISTA PER IL RINNOVAMENTO QUINQUENNALE DI TUTTE LE LEGGI E DECRETI DELLO STATO

Non so quante migliaia di leggi e decreti oggi sieno in vigore per fare la fortuna professionale dei competenti i possessori di indici sistematici ed altri espedienti bibliografici atti alla pronta ricerca del tale o tale articolo di legge. Non so quante leggi e decreti tutt'ora siano in piedi giuridicamente benché in pratica non abbiano alcuna applicazione utile salvo quella di inceppare e contrastare i rapporti e gli equilibri che la vita, più sapiente delle leggi, ha creato.

Non so quante leggi e decreti bisogna consultare per applicarne una promulgata e pubblicata nell'anno undicimo col solito sistema di riferirsi a qualche dozzina di leggi precedenti, ciascuna delle quali a sua volta si riferisce ad altre dozzine di consorelle e così d'il seguito di anno in anno dal '70 ad oggi.

Tutto ciò è antistorico, antifascista, pedanteria, confusionismo impigrimento delle energie spaziate: la vigilata del passato.

Articolo Unico

Tutte le leggi e, cominciare dallo Statuto, decadono ogni 5 anni dalla data in entrata in vigore.

Un mese prima della decadenza di ciascuna legge, ne è pubblicata la nuova legge. Se la parte ancora necessaria, modifiche che l'esperienza, la tecnica e le esigenze della burocrazia avranno consigliato.

Le leggi dovranno dire in linguaggio tutto quanto dispongono col più assoluto divieto di riferimenti numerici a antecedenti ma che se per ciò dovranno essere certe righe più esplicite.

Con questa legge ci quanto disposto in essa si otterrà:

1) Un'adeguazione logica, umana, intelligente fra le realtà e le esigenze della burocrazia invadente.

2) L'orientamento della burocrazia e della cultura verso la ricerca del nuovo del meglio del perfetto, invece dell'intiachimento che le macerie del passato.

3) La possibilità che i cittadini prendano interesse alla conoscenza delle leggi facilitandone l'applicazione.

4) Finalmente la morte della falsa cultura della dantoria del padreterno, cosmopolitico. La vita viva, novo, veloce in tutto è per tale degna del suo animatore.

5) La creazione di una legislazione viva, palpitante, presente ai tempi e nostri futura.

F. T. MARINETTI

COMUNICATO

Fanno parte del Movimento Futurista Italiano il pittore DIULGHEROFF, il pittore P. A. SALADIN, il pittore scultore ERNESTO MICHAHELLES (THAYAHT), il pittore scultore RUGGERO MICHAHELLES (RAM).

Il primo è di nazionalità bulgara, il secondo, il terzo e il quarto di nazionalità svizzera. Tutti e quattro italiani di passione.

Da molto tempo tutt'ora e creano al nostro fianco.

Il titolo di futuristi che meritano e portano con fierezza è assoluta indiscutibile garanzia di italianità fascista.

GIORGIO MACRY

ra d'una aeropittura di Balla, Benedetta, Dottori e di Fillia, proiettata. Lo spettatore ne gode immediato in adatte a contrastanti atmosfere luminose.

Così anche domina la azioni simultanee nei diversi palcoscenici degli schermi e delle celine celesti e rotta dall'intervento creativo improvvisato degli spettatori e del palcoscenico Marinetti ha esposto il programma del l'Autoteatro del Libro, organizzazione nazionale di Autocarri-Libreria, editrice e originalmente colori che si venderanno a basso prezzo nelle città, cittadi e specialmente nei più remoti centri di comunicazione di massa plastico che danno oggi alla Mostra della Rivoluzione un tipico carattere futurista alla turbinosa vita dei grandi centri americani, delle belle aeropitture e le proposte lanciate in questi giorni col forte policromo e sorprendente giornale «Futurismo» di Mino Somenzi alla sterminata esplosione del futurismo spettatore.

Il passato non esiste la noi militarista a vista, viva il teatro Totale.

SONO TUTTI FASCISTI BENISSIMO!

I.

Sorgono giornalisti fogli stampati a piccola o grande tiratura. Tutti hanno diritto alla vita perché sono a quello, su Tizio o su Caio.

Nascono, peggio dei funghi, pedreterni e padreterni fedeli alla gloriazato carpita, in un danaroso scatto dall'intervento creativo improvvisato degli spettatori e del palcoscenico.

Bazzecole!

Fortuna per noi il fascismo e i suoi autentici gerarchi non sentono il prurito di questi anti imberbi petaloni al, melconsistenti, i quali sembra che vivano solo per combinazioni di qualche dito e a orientato del signor A è il signor B.

Occorre però tener d'occhio questo difetto che si va facendo strada; meglio anzi sarebbe troncarlo alle origini.

Ritorniamo in questo periodo alla mania del «puro» del «primo» dell'«eroe» ad ogni costo. Il più delle volte si tratta di venteniti.

Son tutti prefascisti fascisti fascistissimi al cento per cento. Anzitutto, criticano, obbottano con i cento sapulteli coi quali pare impossibile discutere.

Taluni, in divisa di milite, sottolineano l'autorità della persona e... col grado che portano molto spesso ostentano il millantale credito contenuto nei loro discorsi.

Nel campo artistico si son tanti anticipi di fede e di purezza di affascare il cielo, è tanti parlano in più su persona.

La qui, è là!

Presi in blocco, un po' di muoche, ben intese, di chi vivono e speculano a favore che apale il Duce stesso lo giacinterzo e in quanto dove riuscano a sente un per iva il Duce perfetto.

Parlando a scrivendo come anche delle verità delle verità così "sular" di troppo tempo tutti gli italiani.

Quindi inutili a ricordare l'arte sentrice dio un artistela, il più comunque o un perdere di petto o crea etessita.

Bella trovata quella esplicisre il passato per A ottenere del signor A del signor B.

Siccome oggi a conti tutti i fessi si gradano agradare il prossimo, ciamo paolo e baolo. Necessariamente il fasismo ha perfato con al Capi colore e l'opare mentalità, correnti artistici in attitera con lo spirito della Rivoluzione.

Probabilmente dovere sere così a man ottenersi masti noi siti autentici ani perottori del 19, noi futuristi, l'Italia rebbe dominata da un'esue genza, anche se forte o terminesima, non non ecolebra un Regime "bibliotario".

Totalitario io generio, se, vel nome d'Italia, rivo indistintamente gli itali Italia, e di passione e chiamano spiaco le Italia.

Si distribu che io sono concedendo autorità di dire a spiriti troppo proponosi, perche in futurtanti artifici col essere piano, in, ine, pas dove l'archestati pare della giu sul della gra perciebili sulla grande colo luminoso del Regime to al Capo, sinca da luino rosamente tollerate so perclemn o dentro lo stesso.

E da escludersi infatti e il Duce possa antreclibe pere a uomini in quanto stridure con la sua gratila sensibilità futurista.

Se il fatto avviene ne i ultimi tempi avegnano i uomini intesa per ternuli a deri tenuli e rivela di mediocri e a preguidui e preste sissi subo col at mente di a futurismo e turnoco Quello che conta è d'il Italia.

Lo spazio non si d'riv rità di diritti e di dovere. Benissimo!

MINO SOMENZI

"DINAMO FUTURISTA" "ELETTRONI"

Due nuove interessantissime pubblicazioni si annunciano nel nostro campo.

L'una «Dinamo Futurista» di Fortunato Depero che vedrà quanto prima la luce a Rovereto: l'altra Elettroni di Mino Caracciolo che si pubblicherà a Napoli.

Dice di Fortunato Depero si sembra superfluo: il troppo noto su di lui e del suo nome e la sua artistica di questo tempo, perché a perché il debba fare ai nostri lettori il torto di ricordarlo. I seguito e i disegni di Depero, illustratori di New York e delle migliori riviste continentali di giornalistica, di più complesso, di più dinamico, di più vibrante ai nostri tempi. La viva vivente, che ha racchiuso nel tista una solarità nostra una sensibilità futurista e moderna.

I campo artistico si premiazione la vivacità ed preminenza la viviità giordinale Elettroni che Ma Caracciolo dirigera o mette a propio futurista napoletana esserà con quella passione è la caratteristica più origine delle nature meridionali.

Alle due nuove pubblicazioni i nostri auguri per la nuova vittoria nella bella battaglia.

141

sounds of both street and machine.

In 1914 Marinetti published the milestone book *Zang Tumb Tumb*, which further illustrated the concept of words in freedom. It was an account of the 1912 battle of Adrianopolis (Turkey), where the author volunteered as a "Futurist-soldier." The words and type set in different typefaces at various sizes in jarring juxtapositions simulated the sounds of grenade blasts and machinegun fire. A seminal document in terms of Futurism's formal attributes, the book further underscored one of the movement's key guiding principles: glorification of war as a cleansing apparatus.

The leading designer of Futurism's so-called second phase was Fortunato Depero, master of Futurist advertising art and design and possibly the greatest con-

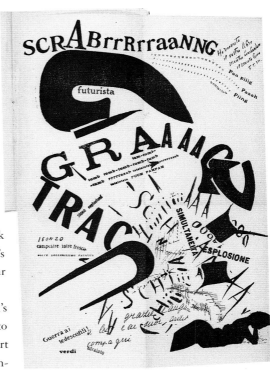

Designer: Filippo Marinetti
Book, 1919

tributor of the Futurist style spirit to the mainstream. Depero's distinctive rectilinear, vibrantly Mediterranean style was accepted by commerce and industry, and established a Futurist presence throughout Italian popular culture with his decorative covers for general and lifestyle magazines (*Vogue*, *Emporium*, and *La Rivista*) and businesses, such as Campari, for which he created a prodigious number of advertisements and trademarks. In 1932 he coauthored the "Futurist Manifesto of Advertising Art," and celebrated the future of Futurist publicity in *Numero unico futurista Campari* (1931) and *Depero Futurista* (1927). The latter was also known as the "bolted book" because this collection of typographic experiments and freeword poems was bound together with two industrial-strength bolts.

Depero developed theories of art and design and coined Futurist terms, such as "the plastic-architectonic use of writing," "typographic architecture," and "advertising architecture." In 1932 he published his own magazine, *Dinamo Futurista* (the logo on a few covers was line drawings of a dynamo engine), wherein he incorporated many of the Futurist ideas of type and image that can be found in his manifestos and catalogs. The journal was both an advertisement for his work (notably for Campari) and a model for new methods of graphic design. Depero

was the most fervently committed to making publicity through frenetic word compositions and he defined the Italian Futurist commercial style of graphic design, which ended in the early 1940s when the Fascist government was overthrown.

Futurism was not, however, limited to Italy. Russian artists were influenced by Marinetti's ideas, and his Futurist manifesto was published in St. Petersburg a month after it appeared in Paris. Russian Futurism was something of a composite of the Western avant-garde: the fragmentation of plastic forms (from Cubism), focus on kinetics (from Italian Futurism), bold colors and lines (from neoprimitivism), and a departure from objectivity (prevalent in various quarters). Cubo-Futurism was a full-fledged movement with its own visual grammar. Similarly, Vorticism was a Futurist offshoot and originated as an English alternative to Cubism and Expressionism. The term Vorticism, from *vortex,* or core of energy, was coined in 1914 by American expatriate poet Ezra Pound, and represents the concept of greatest mechanical efficiency.

The various Futurist sects diverged in many ways, yet the machine, engine, or turbo, and the art these marvels inspired, served as a common trait that defined a style that was an influence on Dada, Constructivism, and even the Bauhaus.
S E E A L S O *Bauhaus, Constructivist, Dada, Do-It-Yourself, Fascist*

ANTONIO RUBINO

Antonio Rubino (1880–1964) was an Italian Futurist illustrator and designer whose work found its way into the hands of children and the general public. Best known for his comic strip *Quadratino* ("Little Square-Head"), which ran in the publication *Corriere dei Piccoli* throughout the 1910s and '20s, Rubino was a pop version of the Futurist designer Fortunato Depero. Rubino shared with that more famous exponent of Futurism a gift for rendering form and shape in the new, mechanized style while retaining a fanciful, almost Deco flair for ornament. In *Quadratino* a boy with a square head encounters various obstacles in the world which inevitably deform his head into some other geometric shape. Quadratino tumbles down stairs, falls from stilts, and climbs through octagonal holes, but in the end his head is carefully measured and put aright. The strip is about the play of geometric forms in space and amongst other objects. Accidents, chaos, and then motion and conflict continually transform Quadratino's head, but there is always a solution, and it is one in keeping with strict principals of mechanics and geometry. *Quadratino* reflects both what Futurism was reacting against and how it attempted solutions, giving adults and children a weekly dose of Futurist practice via the head of a little boy. — D.N.

see Grunge

GENERIC

Most mass-market product packages are graphically designed to conform to specific codes or "trade dress" established by leading companies, then copied by all others within that genre until the next big thing emerges. All cereal boxes look like cereal boxes; all pain-relievers look like pain-relievers; all laundry detergents look like laundry detergents, and all lottery tickets look like lottery tickets because producers agree that Pavlov was right—dogs and consumers are behaviorally conditioned to respond to recognizable stimuli.

Major alterations to mass-market packages are cautiously watched because new and novel tropes could easily disrupt consumers' mass buying habits. This means that we should not underestimate the power of graphic design and typography in moving the masses, yet it also underscores that innovation in consumer culture is not always welcome.

Most consumer products are market-tested to the hilt before being released into the nation's malls. In the 1950s the Container Corporation of America, duly celebrated for producing some of the most progressively Modernist institutional advertising in the country, was also largely responsible for establishing some of the mass graphic codes still used today. Its researchers developed pseudoscientific devices for testing an average consumer's ability to recognize packages at certain distances, identify and distinguish logos, and retain various visual impressions of a product's identity. One such invention was a

Designer: Unknown
Coffee cup, 2005

Designer: Unknown
Brochure cover, c. 1923

shadow box that opened and closed at varying speeds to test the time needed to hook a customer with a particular product image. Since this required considerable amounts of time and money it was obvious to less enterprising companies that the cheaper route was to simply copy CCA's research rather than invest in its own. Widespread genre code mimicry started with the rationale that spending research and development money was unnecessary when the product was already a knockoff. Those same dollars would be better spent promoting the brand instead.

Inventing a brand mythology is essential to the success of any product, which means a knockoff could easily be touted as an original through an effective ad campaign. Whether, for example, Tostitos, Chipitos, or Nachos lead the salsa chips marketing bonanza is ultimately unimportant. Whoever and whichever company initially designed the colorful Mexican rectilinear motifs and stereotypical cha-cha lettering imprinted on the originator's bags may have understood that all the other products in the genre would ultimately adopt the same look. Customers might ask for a brand by name, but are easily duped into buying whatever looks similar and familiar. Redundant design is a strategy that enables rivals to trespass on another's market share. Although promotion blitzes emphasize unique qualities of each chip, using common graphic characteristics on packages will doubtless confuse most consumers at the point of sale.

Confusion is, therefore, one of many strategies for capturing buyers' hearts and minds. Here is another classic example: At most supermarket check-out counters buyers are confronted with the confluence of bold headlines in colored boxes colliding with and overprinting photographs of celebrities. The tabloid weeklies, *The Star*, *Globe*, *Examiner*, and *Enquirer* come off as a congealed blob of typefaces and imagery, and even their mastheads are ostensibly the same—set in Gothic faces, either as white dropped out of red or red on white. Each periodical is also bathed in yellow, which on newsprint has apparently the same allure for Homo sapiens as bananas for monkeys. This sameness rests on the idea that while waiting on a supermarket line customers in a weakened state don't really care which one

or how many of these periodicals they buy—one is as good as the next and all are better than one.

Nonetheless, unique brands should theoretically maximize their uniqueness to corner their respective markets. But try telling that to the makers of all those pregnancy tests. A clever TV commercial for one of the leading tests showed a woman at home waiting for her test results; sitting next to her on the couch is presumably her husband, but he is actually a delivery boy who she hugs profusely upon learning she is pregnant. Okay, so I don't remember the brand, but the point is that it was more distinctive than the package itself, which follows rather lackluster conventions: white box with a red or pink airbrushed hue overall with a photograph of two or more of the testing devices situated in the lower right-hand corner of the box. The logos for E.P.T., First Response, and Confirm are set in different typefaces but the general "trade dress" takes generic to a new level of homogenized sameness.

Why are babies totally absent on a product devoted to confirming or denying them? Perhaps it is because the baby is a big "if" at the point of purchase—but also it might be because they appear in abundance on many leading brands of toilet tissue. Charmin, SoftPak, Quilted Northern, and Angel Soft packages all use different colors and typeface combinations but each features an infant or

No. 1148-A

No. 1917-A

No. 2068

No. 1413-A

No. 1923-A

LEFT
Designer: Unknown
Printer's cuts, 1928

toddler to suggest the quintessential softness of this essential product. Of course, there are dedicated wipes for babies (on which infants are also featured) but the heated battle for toilet tissue market share demands that these young combatants appear as an ersatz seal of approval—and anyone who has ever used the sandpaper-coarse Scott Tissue knows why a baby is not on that particular package.

Nowhere is generic style more obvious than blue jean design. Aside from the denim material itself the single most familiar design characteristic on all popular brands is the leather label with the brand's "branded" logo. Originally created by Levi's in the late nineteenth century this piece of real or ersatz cowhide is such a common genre accessory that every manufacturer from Armani to Old Navy wouldn't think of producing jeans excluding the identifying accoutrement. And customers are so used to this as endemic to the jean gestalt that unless they are antisocial (or antibranding) snobs, they would not buy a pair without the label.

But what does the law say about this plethora of mimicry? While trademark infringement is frowned upon, trade dress conventions are accepted. No other fast-food restaurant, for example, can use McDonald's Golden Arches yet another can refashion its red and orange color palette or secondary typefaces in ways that might be similar yet not the same as the original (even the name could be changed to McDoodles as long as it is over six degrees removed from the original). In the land of free markets and mandatory competition companies are allowed considerable leeway in how they conform to the trade dress of a particular genre. This does not only apply to major mass-market goods. The more sophisticated or subtle design of so-called boutique products like specialty bottled waters and expensive packaged foods are continually impinged (but not infringed) upon. Although designers and design competitions celebrate originality, the fact is that many producers couldn't care less. Indeed how often have you heard a client say, "I want my product to look just like this one"?

SEE ALSO *Bonehead, Matchbox, Razor Blade, Show-Card, Vernacular*

GEO-GRAPHIC

Atlases had been around for centuries, but most were maps pure and simple. Former Bauhaus master Herbert Bayer's unique contribution (as designer and author) was to show that maps did more than illustrate space and place—they were a record of time and perhaps could even be a tool of prognostication. His *World Geo-Graphic Atlas*, published in 1953 by Walter Paepcke's Container Corporation of America (CCA), is a monument to Bayer's singular vision, as a precursor

to current trends in information design, and an example of how complex data can be made accessible. Arguably it launched a style that "information architects" are currently applying to maps, charts, and other quantitative data.

Despite recent advances in information graphics there is nothing that measures up to the sublime complexity and relentless functionality of Bayer's *Atlas*. Although some data has changed since 1953, the fundamental form and overarching concept—to chart the impact of natural phenomena on the planet—is as valid today as when it was first conceived.

Bayer supervised a team of three designers (Martin Rosenzweig, Henry Gardiner, and Masato Nakagawa) over a three-year period. The atlas was designed to address the geopolitical landscape of post-WWII life. The graphics were straightforward, but the research was complex. Bayer traveled throughout Europe to find maps and data that would help him reinvent the classic map. Drawing on Bauhaus methods, Bayer advocated the concept of a total work of art—painting, typography, indeed information design were interconnected. All art, even the most muse-driven, served a purpose—to inspire, inform, or both. In undertaking the *Atlas* Bayer addressed environmental concerns that he addressed in his series of "Mountains and Convolutions" paintings (1944–1953) that artistically explored the earth's mutability.

Designer: Herbert Bayer
Book spreads, 1953

With the *Atlas* he was much more concrete in visualizing the earth's surface as influenced by millions of years of climatic and geological forces. Building on the foundation of his painting, the *Atlas* was a means to vividly show the awesome impact of environment, as well as express his own deep concern for climatic conditions and topographic change. The data was conveyed in a Modernist idiom and the style of *Atlas* was adopted by other map designers for decades after.

SEE ALSO *Bauhaus, Container Corporation of America, Modernist*

GRUNGE

The word *grunge*, which began with hard-rocking, post-Punk music originating in garages all over Seattle, Washington, signifies the disorderly, unruly, and antisocial appearance of its practitioners. As a graphic design style Grunge signifies the inversion of Modernist tidiness, and indicates a mannerist appliqué of functionally dysfunctional typefaces that are either distressed or decayed, or look as though they were scrawled in dirt for the distinct purpose of making orthodox type connoisseurs apoplectic.

Grunge graphic style was born from the desktop computer, specifically the Macintosh, and particularly the software program Fontographer, which made custom font-making as easy as moving a mouse. Although quirky handlettering had been around for ages, Grunge could never have occurred when type designing was the sole provenance of skilled draftsmen—they would kill before allowing it. But with the new software individualistic and expressionistic urges that emerged through Postmodernism became as simple as scanning, copying, and redrawing. In this souped-up technological milieu designing all kinds of letterforms was possible, and the allure was incredible. Emigre's Rudy VanderLans and Zuzana Licko helped launch the Grunge phase by publishing (and thus codifying) current experiments from the United States and Europe. Shortly after, *Ray Gun*'s David Carson became the most renowned of the Grunge designers for developing off-the-wall type arrangements that transformed taboos into virtues. His early experiments in *Beach Culture* magazine during the late '80s and with *Ray Gun* in the

Art director: Art Chantry
Illustrator: Ed Fotheringham
Poster, 1994

'90s, where he set computer type using default settings and ludicrous spacing options, opened the floodgates for a new wave of anarchic, free-form composition. His seemingly unstructured pages were decidedly anarchic, however, in the way that Jackson Pollock or Franz Kline's abstract paintings busted the grid (or backbone) of academic art. Modernist Massimo Vignelli once said that Carson's work was like "painting with type on canvas."

Grunge was also a critical commentary on the tasteless and tasteful visual

environment. On one hand it celebrated the strip mall vernacular, on the other it decried Modernism's blandness. Grunge denounced the formality of official letterforms and declared that anything could be a typeface as long as it contained twenty-six letters (in fact, some Grunge faces had more and others had less). With the advent of digital type foundries, including Emigre, T-26, Garage Fonts, and Plazm Fonts, which produce and license designs from professionals and novices alike, the field was open to all kinds of typographic tomfoolery, so in walked artist-designers who, simply because they mastered the programs, produced a wide variety of demented expressionistic concoctions.

"Against the backdrop of defaults and prepackaged templates," wrote type designer Tobias Frere Jones (*Zed*,

ABOVE
Art director: Art Chantry
Illustrator: Friese Undine
Poster, 1990

1994), "grunge stands as a rebellion against the default of the computer." Grunge used the computer to attack the computer, and used graphic design to condemn professional design. Grunge degraded notions of purity as it guffawed in the face of conformity. But while the Grunge designer teased the profession with unorthodoxy, its practitioners also sought legitimacy for what they were doing. Grunge layouts were quickly accepted into art director and AIGA competitions, and once it became a code signifying cool-youthful-rebellion it began its inevitable absorption into the mainstream.

SEE ALSO *Chantry, Do-It-Yourself, Emigre, Handlettering, Kodalith, Postmodern, Ray Gun*

RIGHT
Designer: Carlos Segura
Poster, 1997

see Helvetica

HALLOWEEN

Halloween is one of the most theatrically exuberant and visually spectacular of all annual festivities with many extravagantly bizarre icons—ghosts, goblins, skeletons, black cats, and jack-o'-lanterns—each intended to spike fears and raise hackles for the collective good. Despite its contemporary libertine connotations, the celebration originates in superstition and religion—early Christian and ancient Druid. Halloween combines the Christian All Hallows' Day and the Celtic celebration of Samhain, which both take place on the first of November. In pagan Celtic culture, Samhain marks the end of summer and eve of the New

Year. In Catholic countries, November 1 is All Hallows' Day or All Saints' Day, a solemn observance to honor saints. October 31 in European folklore is the day when the separation between this world and the next is the thinnest. People would form boisterous parades through their villages on the night of October 31, dressed in ghoulish garb, eerily wailing to frighten away insidious spirits. Ultimately, wearing scary costumes and carrying out irritating pranks became ritualized into common and secular custom.

The ubiquitous jack-o'-lantern derives from an old Irish tale. A nasty drunkard named Jack slyly tricked Satan into

Designer: Unknown
Greeting card, c. 1905

climbing a tree. Jack then carved an image of a cross in the trunk, trapping the devil. To be set free old Satan was forced to agree never to tempt Jack again. But after Jack died and was denied entrance to Heaven for his past misdeeds, he was also denied access to Hell because of his trickery. As a consolation Satan gave him a single ember to light his way through a cold and bleak eternity. The ember was placed inside a freshly hollowed-out turnip. The Irish called turnips "Jack's lanterns," but when Irish immigrants came to America, they substituted the far more plentiful pumpkin.

Halloween is also known for the ominous black cat, companion or "familiar" of witches. A slew of homemade and mass-produced monsters—vampires, werewolves, mummies, and ghouls—join the Halloween cast of characters, roaming with presidents, ninjas, and toy terrorists. A fount of mystique and lore annually finds its way into Halloween graphics in all the nations where it is celebrated—by adults as well as children. The basic design conventions rarely change and the spooky styles remain fairly constant. The graphics are used to celebrate the holiday but, more important, sell hundreds of related products. In fact, the style is itself the commodity it is selling.

SEE ALSO *Fear, Vernacular*

HANDLETTERING

Typesetting is official; handlettering is informal. Typesetting is mechanical; handlettering is expressive. Because the computer ensures tidiness and orderliness sometimes leading to blandness, the hand has been making a comeback in profound ways that draw on both past and present. Yet for inspiration designers need not go as far back as medieval times when scribes laboriously composed ornate manuscripts in cloistered towers for church and king.

During the early twentieth century typographers and type designers produced precisionist lettering by hand aided by templates and grids because time, technology, and economy demanded it. When photostats were too

Designer: Christoph Niemann
Magazine cover, 1996

expensive or slow, handlettering was the cheapest and quickest way to create a custom headline for a book jacket, poster, or point-of-purchase display. Show-Card lettering, as the practice of creating one-of-a-kind quotidian advertisements was known, demanded of its practitioners a decidedly high degree of craft and invention—not just copying existing traditional alphabets but devising novel and novelty scripts, Gothics, and hybrids. American designer William Addison Dwiggins in the 1920s and '30s designed exquisite lettering for book spines and title pages. Other designers engaged in ad hoc writing simply as a respite from the rigor of traditional typography and to loosen up their work. During the late 1930s it was fairly common for designers to use brush and pen scrawls as display lettering-cum-personal signature. Paul Rand used a light-line hand-drawn script instead of conventional type to give certain advertisements the informality necessary to intimately engage the audience. Handwriting was something of an antidote to the hard-sell Gothic type conventions that prevailed with most newspaper ads. In the late 1930s, Alex Steinweiss was the first graphic designer to create original artwork for 78 rpm and later 33⅓ LP record album covers: in the '50s he developed the "Steinweiss Scrawl" as a means to inject quirky character traits into his illustrative album designs. Steinweiss' curlicue script was later licensed to PhotoLettering Inc., sold as a standard typeface, and was used by those who wanted a more colloquial sensibility in their design. Similarly, graphic, interior, and product designer Alvin Lustig used handwriting on book jackets to complement expressionistic collage and montage.

These designers rejected conventional calligraphy as too decorous and stiff. Handwriting was more natural and, therefore, consonant with the anti-ornamental tenets of Modernism. By the mid-'60s handlettering became something of a socio-

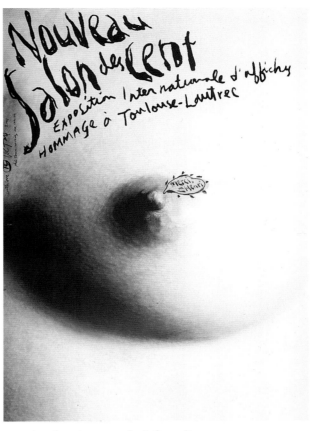

Designer: James Victore
Poster, 2003

Designer: Paul Rand
Book cover, 1959

political statement, an antidote to the Swiss-inspired corporate Modernism prevalent at the time.

With the American Underground Press, the clarion of the antiwar, civil rights, and sex-drugs-and-rock-and-roll alternative cultures, graphic styles radically changed from precisionist to ad hoc or do-it-yourself in reaction to the real and symbolic implications of professionalism. In the design language of the time purposefully artless hand-lettering intensified the schism between alternative and mainstream methods (and was a subtle protest against the

latter's authority). Words scrawled in an untutored raw way with Magic Marker were used as headlines in Underground papers and on posters that critiqued the establishment's social, cultural, and economic stance on war, race, and gender. Meanwhile, psychedelic poster artists fashioned a meticulous hand-rendered lettering language based on resurrections of old Victorian wood and Art Nouveau metal types. Victor Moscoso, who helped mastermind psychedelic alphabetics, rendered the negative spaces between letters rather than the positive letters themselves as a means to create vibrating sensations. Every detail was achieved by hand because it was necessary to maintain total control to achieve the typographic optical illusions that he invented.

Illustrator: Maira Kalman
Book, 1991

By the '90s, with the help of the computer, a unique phenomenon arose that married handlettering concepts together with high-tech digitizing software. Many

designers who never designed a typeface before used font-making programs to transform otherwise one-of-a-kind hand-lettered beauties *and* monstrosities into downloadable font packages available to anyone. Thus the age of ersatz handlettering began. The most popular (and ubiquitously reused) of all the digital handlettering alphabets was Frank Heine's 1991 Remedy (published

and distributed by Emigre Fonts). With its happy-go-lucky curlicue conceits it recalled the Steinweiss Scrawl and soon became one of the most emblematic fonts of the period. Many other hand-lettered-looking fonts soon followed and throughout the '90s graphic designers used these simulated hand-faces to express jocularity. The upsurge in handwork in magazines, packages, and CDs, however, prompted an antidigital reaction (not to be confused with a rash) that arguably has inspired some designers to return to the one-of-a-kind Show-Card-inspired quirky handlettering that is, in fact, actually done by hand one time and never made into a font for continued consumption.

Designer: Jonathan Gray
Book jacket, 2002

SEE ALSO *Do-It-Yourself, Dwiggins, Emigre, International Typographic, Psychedelic Poster, Record Cover, Show-Card, Underground Press*

HELVETICA

Few other typefaces have triggered the same intense feelings among designers as Helvetica. It prompts paroxysms of joy and fits of rage because the face represents a clear Platonic ideal *and* a turgid generic sterility. Helvetica was the answer to the unsatisfactory optical imperfections found in earlier sans serifs or grotesques. Designed in 1956–57 by Edouard Hoffman and Max Miedinger (who named it Neue Haas Grotesk, for the Haas type foundry in Switzerland), it was renamed after the Latin name for Switzerland with new production of the type in 1961 by the D. Stempel A. G. Typefoundry in Germany. "Conceived in the Swiss typographic idiom, the new Helvetica offers an excitingly different tool to the American graphic designer and

ABCDEFGHI
JKLMNOPQR
STUVWXYZ
ÆŒÇØŞ
1234567890
£$&/!?%

Designer: Edouard Hoffman and Max Miedinger
Type specimen, 1956–57

Designer: Max Miedinger
Type specimen, 1956–57

typographer," reads promotional text in a specimen sheet from Stempel. "Here is not simply another sans serif type but a carefully and judiciously considered refinement of the [sans serif] letter form." Helvetica embodied the Modern mission to democratize visual communication, and was better at it than Futura (the fabled "type of tomorrow"). It is readable, versatile, and modest. Following its introduction, first in

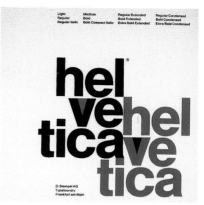

Europe and then in the United States, Helvetica emerged as the typeface of choice for business throughout the multinational world. When the Soviet Ministry of Commerce needed to put a Western gloss on its "for export only" publications and advertisements, Helvetica was used. When New York City's Sanitation Department wanted to clean up its typographic image, it specified Helvetica. When the civil rights advocacy group the Urban League wanted to appeal to white middle-class donors, Helvetica came to the fore. Helvetica is Esperanto. Yet even though it has successfully broken down national boundaries and exudes a democratic air, Helvetica is also used to obfuscate corrupt corporate messages. Such is neutrality's double-edged sword.

SEE ALSO *Futura, International Typographic, Modernist*

"All media work us over completely. They are so pervasive in their personal, political, economic, aesthetic, psychological, moral, ethical, and social consequences that they leave no part of us untouched, unaffected, unaltered. The medium is the massage. Any understanding of social and

Designer: Quentin Fiore
Magazine, 1964

HEROIC

The true hero is born with or acquires real virtues while the false one is a fraudulent composite of ideal attributes. But in either case, the heroic image has considerable sway over public perception, which makes it such a commanding propaganda tool. Paradoxically, a real hero is not always ideally heroic in appearance or stature, so designing heroes (and an heroic style) necessitates creating symbolic beings that are bigger and bolder than life.

In heroic art the diminutive Napoleon was depicted as taller while the impuissant Hitler was stronger than nature had originally intended. The exaggerating lens is routinely used to elevate rulers and warriors, as well as sports and media stars. Indeed filmmakers routinely create larger-than-life live-action characters whose heroic personas the public unquestioningly embraces simply because of a few special effects. The grandest fictional heroes—the super comics variety—are not made of flesh and blood at all, but paper, ink, and myth. Take Superman, created in 1939 by Jerry Siegel and Joe Shuster, a pair of Depression-era American Jews who, having learned about the Aryan Superman, wanted to show that not all supermen were Nazis. By imbuing him with otherworldly super-human powers to defeat evil and bullies (not unlike those Nordic myths that gave rise to Nazism), they tapped into the universal desire for invincible heroes to uphold, in this case, "Truth, Justice, and the American Way."

"The chief business of the nation, as a nation," wrote H. L. Mencken, the petulant American critic and journalist, "is the setting up of heroes, mainly bogus." And the job of the illustrator and graphic designer in this particular business is to bolster false heroes with graphic façades.

A heroic figure must at once prompt recognition, engender response, and forge indelible bonds with the viewer. Whether in the service of democracy or dictatorship, during the twentieth century artists and graphic designers have been responsible for the lion's share of hero-mongering. They have designed the icons that impress a leader's likeness on mass consciousness. Nations use heroic representation to unite its citizenry behind an idea or ruler. Democracies heroicize common man; dictatorships worship leaders. Both engage in necromancy through representations of fallen heroes—there is no better way to truly capture hearts and minds than promote heroic martyrs.

In Nazi Germany "the fallen become part of the 'eternal German,'" wrote historian George L. Mosse in *Masses and Man* (Howard Fertig, 1980), "those who preserve their basic nature from all contamination with the passage of time." The

RIGHT (Clockwise from top left)
Designer: Achille Mauzan
Poster, 1917

Illustrator: James
Montgomery Flagg
Poster, 1917

Designer: Joseph Binder
Poster, 1941

Designer: Dengel
Poster, 1928

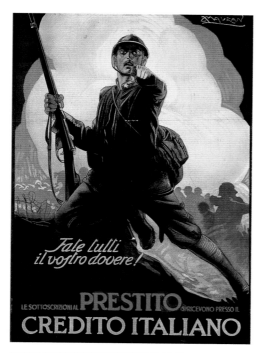

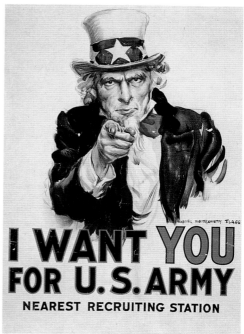

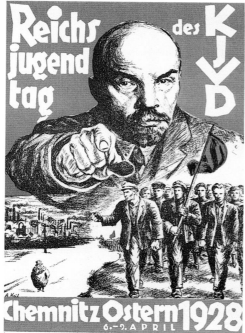

Nazis called this "heroic sacrifice," and idealized images of men and boys giving their lives for the leader were almost as common as the swastika itself.

Realism is the primary method of rendering heroes; this approach involves romanticizing and ultimately beautifying those depicted in such a way that after the warts are removed and the muscles are fleshed out, what remains is a heroic shell. Soviet Socialist Realism was, however, more than a shell—it was a shroud. Instituted in the late 1920s as a reaction to abstract revolutionary art, which was deemed suspiciously perplexing to the masses, it became the official language for representation of a system based on a sacrificing proletariat. Official images—realistic painting or photomontage—showed an elevated stature and forward-looking visage. At the 1939 New York World's Fair, "Joe Worker," as he was known to Americans—a huge statue of a laborer with muscular, rolled-up-shirt-sleeved left arm raised to the heavens, holding a red star—stood atop the monolithic Soviet pavilion representing the heroism of the state and its people. Inside the pavilion hung scores of blemish-free portraits of Marx, Engels, and Lenin, and the most omnipresent of all, the nation's absolute leader, Joseph Stalin. Yet in the annals of heroic depictions, the ogre Joe Stalin was clearly outdone by Adolf Hitler, Benito Mussolini, and later, Mao Tse-tung.

Illustrator: Unknown
Magazine cover, 1939

The master German poster artist Ludwig Hohlwein, whose Munich style (or *Hohlweinstil*) dominated German advertising in the late 1920s, '30s, and into the '40s, created the most effective heroic realism. His depictions of Nazi youth and SS police were given monumental stances and lit to accentuate their presumed grandeur. He did not engage in negative stereotypes, preferring to mythologize rather than demonize. But he did set a standard against which Nazi poster iconography must be judged. It is difficult to say definitively that Hohlwein invented National Socialist (or Nazi) Realism, but his work was the paradigm. In a 1933

issue of *Gebrausgraphik* he also stated how such art must operate in the service of the nation:

Today, art, as a cultural factor, is more than ever called upon to take a leading place in building up and conserving cultural values. It must take its place in the front ranks of the legion, which Europa has gathered to preserve her individuality against the onslaughts from the East. Art is the best possible distributing agent for ideas and intellectual tendencies. Commercial art is doubly effective in this sense for it stands in the very forefront, giving form and expression to the daily panorama and forcibly dominating even those who would ordinarily remain impervious to artistic influences. May the best among us realize fully the significance of what is at stake and their own responsibility and may [they] labor creatively and with conviction [in] the preservation of our cultural civilization and its restoration to perfectly healthy conditions.

Whether called Socialist Realism, National Socialist Realism, Heroic Realism, or just plain Realism, the design of heroic imagery is carried out with similar components for the same effect. While the Chinese certainly have a unique visual culture, when Mao's regime prevailed over the Nationalists, the official art of Communist China was Socialist Realism. On the one hand, Mao appeared on everything, glowing like a beacon of hope, the father of his nation. On the other hand, soldier, worker, peasant—men and women—were cleansed of every blemish in sanctified posters and banners that heralded the glories of the nation. Chinese propaganda art also transformed people of all third-world nations—from Cuba to Africa—into heroes of an international people's revolution.

In the '60s the Christ-like visage of the Argentine-born revolutionary Ernesto "Che" Guevara adorned stamps and posters, flags and billboards. Even in the United States the Che myth was perpetuated by the Left through iconography, notably American illustrator

Designer: Julius Englehard
Poster, 1915

Paul Davis' 1968 portrait of Che as cover and poster for the left-wing magazine *Evergreen Review* (which prompted the bombing of the magazine's offices by anti-Castro loyalists).

Artists and designers filter heroism through a subjective lens. Elbert Hubbard, the founder of the Roycrofters Arts and Crafts community, wrote over one hundred years ago, "The heroic man does not pose; he leaves that for the man who wishes to be thought heroic."

S E E A L S O *Fascist, Hohlwein, Kodalith, Socialist Realist*

HIP HOP

Hip Hop is arguably the most widespread global style. As music and fashion, from graffiti to bling, starting in the 1970s Hip Hop invaded the cultural circulatory system and infected everything from language to image. With MTV's opening of the airwaves, Hip Hop—originally an African-American ghetto attitude—reached out to countless sub- and mainstream cultures. Owing to the constant barrage of music video clips Hip Hop stars achieved huge audiences and many have become fashion icons.

In a way Hip Hop continues the "total work of art" concept promulgated by early twentieth-century Modernists insofar as it embraces fine and applied art as one commercial entity. From its early stages graffiti led the Hip Hop visual vocabulary. "Wild Style" was the New York term given to the huge interlocking bulbous letter-forms and block letters—the tags or aliases of graffiti writers like Zephyr—that appeared on subway and freight trains and wall murals, and they influenced the event flyers which further propagated the style.

These D.I.Y. (Do-It-Yourself) flyers, made with rubdown type and traced letters with crude comics illustrations, announced the clubs and parties where rap and DJ competitions were performed. The main designers were graffiti artists like Phase 2, who designed many of the cheaply printed missives. As Jim Fricke and Charlie Ahearn state in *Yes Yes Y'all, An Oral History of Hip-Hop's First Decade* (Perseus Books Group, 2003), sometimes the performers themselves designed their own flyers—it was very amateur, but also the start of an indigenous graphic language.

The influences for the style of lettering and illustrations were comic books, cartoons, and video games (even pinball machines). Similarly the names of the usually teenage graffiti artists—the Furious 5, Fantastic 4, Klark Kent, and the Fab 5—are taken from the comics. The early graphics were ham-fisted but distinctive, yet as time wore on they became more professional looking.

RIGHT
Designer: Revolt and Zephyr
Photographer: Martha Cooper
Graffiti, 1983

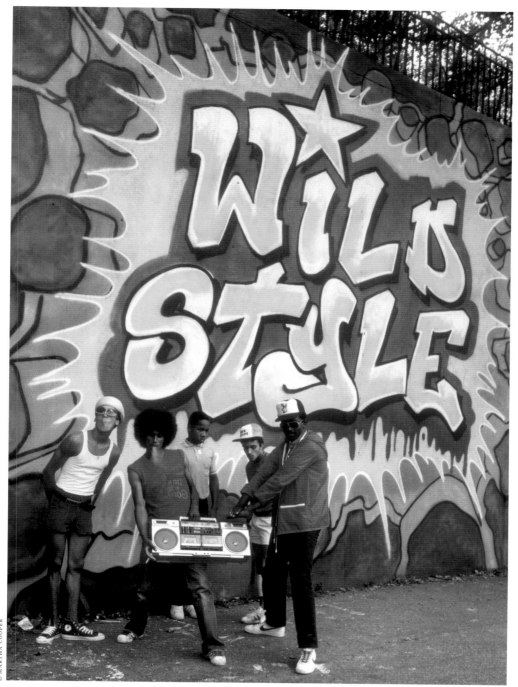

The flyers covered in *Yes Yes Y'all* are a far cry from the Hip Hop conceits that emerged during the more refined graphics of the late 1980s. The flyers borrowed from graffiti pioneers who created monumental train markings using 3D airbrush lettering as early as 1973. Graffiti historian and producer of the documentary *Style Wars* Henry Chalfont describes the Hip Hop graffiti scene as "like a mini art world." As the flyers got more sophisticated, the influence of graffiti and train-writing on the design is seamless. The letterforms are more decorative and audacious, serifs grow to mammoth size, typefaces become more ornamented.

"Old school" Hip Hop album sleeve design from the late 1970s to the mid-'80s derived from the visual and audio cultures of rapping, deejaying, and break-dancing. Photographs, drawings, and graffiti were the main media through which the "old school" look developed. Everything, however, was interconnected. Graffiti artists designed covers, but they also recorded if they had something more to say. One of the more ubiquitous early designers for Mo' Wax and Celluloid Records was Futura 2000, the tag for an artist who, armed with cans of Krylon spray paint, helped create the quintessential fluid graffiti lettering. When Hip Hop went electric in the mid-'80s the visual language became more futuristic-comic—Tommy Boy records led the competition with the most otherworldly images. By the early '90s CD covers showed rappers in bracingly photographed covers. One of the principal stylists was art director–photographer George Dubose, who shot the rappers as the kings of bling.

Artist: Size
Graffiti, 2003

Artists: Sen and Size
Graffiti, 1996

Ultimately the graphic style associated with Hip Hop turned into a marketable aesthetic—a multimillion-dollar industry—and most of the original tag writers failed to benefit monetarily when Hip Hop migrated from subculture to pop culture. Rap mogul Russell Simmons, founder of Def Jam Records, was the first to understand the equation of fashion + rap = celebrity and produced the iconic Phat Farm, Baby Phat, and FUBU fashion lines, each exuding a clearly identifiable graphic style that built on a Hip Hop language as one of its attributes. "Hip Hop is all about attitude. It helps a lot if you have the fashion *cred* to go with it, but that doesn't mean you have to be a copycat," said Simmons in an interview.

In addition to Simmons, famous rappers who have jumped on the rag trade wagon include Snoop Dogg, Missy Elliot, Eve, and P. Diddy (Sean Combs); the latter is known for "bringin' the bling" into the public sphere. Graphically these fashionistas have transformed a gaudy look into a valued pop culture by making it totally cool. Just as graffiti—once the bane of urban dwellers and sanitation enforcers and an art form of the disaffected—has become mainstreamed, Hip Hop has sampled its way into becoming a distinct all-around language of the age.

S E E A L S O *Club Flyer, Comics Lettering, Do-It-Yourself*

HOHLWEIN

Decades before Germany was carved into East and West, in the rivalry between North and South the graphic arts were as different as the accents of the northern Berliner from the southern Münchener. Around 1906 *Gebrausgraphikers* (commercial artists) in Berlin, led by Lucian Bernhard, spearheaded Germany's revolutionary Sachplakat, or object poster, which eliminated visual and textual superfluities in favor of a single object. Meanwhile, in the Bavarian capital Munich, Ludwig Hohlwein, a former architect turned *Graphiker*, was in the vanguard of a parallel revolution that rejected such austere simplicity in favor of anecdotal realism based on the human form. At a time when the poster was the most ubiquitous medium, advertising agents in Berlin and Munich feverishly competed for the nation's leading accounts. But it was the prolific Hohlwein whose Munich style, or *Hohlweinstil,* eventually dominated the German advertising scene from the late 1930s through the '40s.

*Designer: Ludwig Hohlwein
Poster, 1926*

Poster artists wielded considerable power to influence the buying habits of the public. A popular artist was the virtual spokesperson for a particular brand. The public anticipated the release of that artist's new poster as if it were a new book or play. To underestimate its commercial—indeed entertainment—value is to miss a key aspect of the consumer revolution, not just in greater Germany but throughout industrialized Europe.

Hohlwein, who was born in Wiesbaden on July 26, 1874, entered the limelight after winning his first graphic arts competition in 1905 with what might today appear to be a prosaic hunting poster featuring an antler-crowned stag. An avid huntsman, Hohlwein adroitly depicted this sacrificial creature. As a young architect he designed the interiors of many a hunting lodge,

Designer: Ludwig Hohlwein
Poster, 1926

and as a poster artist he captured the interior life of the hunter. He was an amazingly skilled though totally self-taught painter of animals.

In 1906, when the health food trend that underscores today's lifestyle was prefigured in Germany, Hohlwein was commissioned to create posters for so-called "Alcohol-Free Restaurants" and to promote unprocessed foods. His skill at rendering made him the perfect choice for representing the natural bounty that zealots hoped would convince Germans to embrace nutritional purity over the heavily advertised packaged foodstuffs on the market. Soon he became the acknowledged maestro of animal and food illustration.

Hohlwein did not eschew either period or personal styles—looking at the posters today one can easily identify the epoch when they were created. But neither did he resort to graphic tricks or tropes endemic to Art Moderne, which was current at the time. *Hohlweinstil* defined the period rather than followed it. And while many lesser advertising artists rendered their themes with obvious indifference to stylistic dictates and templates, Hohlwein was totally absorbed in whatever the subject matter was.

Working exclusively from models (often his wife and children), Hohlwein sought the perfect representation. Precision was his hallmark. His work was not strictly academic, but his imagination was used for conceptual matters only, not to impose on the figure or form itself. Truth was paramount. After making sketches that were very faithful to nature, he created the anecdotal compositions he was known for. In contrast to many leading commercial artists of the day whose assistants rendered their work, Hohlwein was perpetually unaided. Every commission was handled personally from start to finish. He took pride in being a loner.

Not all critics were convinced of the rightness of Hohlwein's method. His technical virtuosity aside, rivals in and out of the Sachplakat group argued that he did

DER OFFSETDRUCK-FACHMANN WÄHLT

NUR
GESTRICHENE
OFFSET-PAPIERE
UND
GESTRICHENE
OFFSET-CARTONS
MARKE NAJORK

LEFT
*Designer: Ludwig Hohlwein
Poster, 1926*

not always emphasize the object being advertised. That the commodity was not in the center of some pictures caused one such pundit to rail that "Hohlwein advertises himself, not his client." But Hohlwein was sought after throughout Europe and the United States. In 1923 a New York exhibition of his posters introduced him to the American advertising industry and earned him commissions for Camel and Fatima cigarettes.

During World War I Hohlwein had made posters supporting the "fatherland." These were not the typically gruesome depictions of war or venal assaults on the enemy, but rather graphic reminders of home front concerns rendered with characteristic precision. Hohlwein was not a Prussian militarist but he was a Bavarian patriot. After the war, when the nationalists of the South opposed the republicans of the North, Hohlwein took a decidedly nationalist stance. For his poster promoting the Stahlhelm (Steel Helmet) paramilitary (or Freikorp) group of former German soldiers, he was made an honorary member. The poster itself was a masterpiece of persuasion: He captured the powerful presence of the steel-helmeted officer in a bull's-eye of color that also serves as a halo, suggesting a righteous crusader. This marked the first of a long series of work in support of the nationalist cause that evolved into the Nazi movement.

Hohlwein's Nazi-era posters hold a place in propaganda history. At this mature stage in his career he had jettisoned some of the more decorative tendencies in his work for pure painting, which while decidedly recognizable as Hohlwein's art, was even more traditional in its heroic realism. It is difficult to say definitively that Hohlwein invented National Socialist (or Nazi) Realism, but his work was certainly the paradigm.

After the war Hohlwein was "denazified," not charged with engaging in felonious Nazi activities, and allowed to continue working. Despite the economic devastation that followed Germany's surrender, he continued to make some advertising art until his death from a stroke in 1948.

SEE ALSO *Fascist, Heroic, Object Poster, Socialist Realist*

RIGHT
*Designer: Ludwig Hohlwein
Poster, 1926*

see International Typographic

INSTRUCTIONAL GUIDE

You just bought a newfangled kite that resembles a World War I Sopwith Camel biplane. The color photograph printed on the label, which shows the replica replete with stunning graphic markings, is so beautiful that you can't wait to get it airborne. But when you open the box, instead of a plane there are pieces of wood, string, plastic, and fabric. Oh yes, and a small, folded piece of white paper on which are poorly printed (as if it has gone through the photocopier for the fiftieth time) assembly instructions. As you scan the schematic your heart sinks as you realize that this is not designed for the ten-year-old inside of you, but the quantum physics postgraduate that you never were, nor will ever be. So you begin to experience IDR (instructional diagram rage).

No matter what you buy these days, virtually everything—from milk cartons to condoms to LEGOs—come with diagrammatic instructions, often mandated by law, which are designed to help understanding, though more commonly confuse. Of course, the idea that eight out of ten products must be assembled in the home is a twentieth-century nightmare made worse by the fact that the instruction "designers" are sadists. They cannot really believe that all those arrows, numerals, dotted lines, and pointing fingers are useful wayfinders.

Still, the world needs instructional guides. How else would one know how to change a tire, turn on a Cuisinart, or avoid placing fingers in electrical sockets? Without information of this

RIGHT
Designer: Nigel Holmes
Illustration, 2005

BELOW
Illustrator: George E. Block
Information graphic, 1931

Fig. 24. Hydroelectric Power Plant.

A TEAM EFFORT

Conventional cars greatly underuse the potential power of their engines. The power of a big engine is only tapped during sudden acceleration, and that happens just 1% of the time we drive.* In a typical hybrid, the combination of an electric motor and a smaller-than-normal internal-combustion engine produces the appropriate amount of power for all driving conditions. In other words, a hybrid car is tailored to the way people actually drive.

1 When the gas engine is off—typically if the car is going less than 15 mph—the electric motor powers the wheels. During braking, the kinetic energy released flows back to the battery, recharging it.

A hybrid car produces fewer emissions than a conventional car because it uses less gas.

25 KW BATTERY PACK

GAS TANK
Holds enough fuel to go 500 miles.

Using tires that are smoother and inflated to a higher pressure reduces drag. This allows the car to be powered by a smaller engine, consuming less gas.

Having an onboard generator means that hybrid cars never need to be plugged in for recharging, as do all-electric cars.

cable

cable

GENERATOR

shaft

44 HP ELECTRIC MOTOR

POWER SPLIT DEVICE

70 HP GAS ENGINE

2 3

The key element of the hybrid car is the power split device. This sends the gas engine's power either to the wheels **2** or to the generator (which in turn recharges the batteries). **3** The device also engages the electric motor when added power is necessary.*

For instance, when you are passing?

* Yes, let's say you are traveling at 50 mph. At that speed, the gas engine is powering the wheels. But since it's smaller than the usual gas engine, the electric motor kicks in to give you a quick burst of acceleration needed to pass another car.

kind, most of us are doomed to trial and error (with emphasis on error). So there is no shortage of how-tos, where-ares, and what-nots bombarding us daily. As a consumer, I muddle through most instructions as best I can. But as a graphic designer I am often disturbed by the lack of design intelligence.

Instructional guides help us navigate complex information in digestible units. But it is not easy. Actually, it is even more difficult than most navigation on the Web because unless in the minority of people who enjoy following instructions, one is predisposed to resent having to assemble anything. Therefore, if instructions appear too complex on the surface, even if they are perfectly logical, they are rejected out of hand.

Instructional style comes in two varieties: the purposeful guides and the parodies of surface mannerisms. Both look the same, both are prevalent graphic styles—ostensibly line art with simple flat colors replete with navigational guides. Nigel Holmes was the master of the purposeful diagram when on a weekly basis in the late '80s and '90s he contributed information graphics to *Time* magazine. But they are also found on everything from toys to medical equipment. The second kind is a late nineties ironic illustrative approach that uses the deadpan style as a humorous conceit.

S E E A L S O *International Typographic, Modernist, Pictogram*

COMPTON PICTOGRAPHS BOOKLET

This odd 1939 booklet is a clear example of Otto Neurath's innovative system of graphics, ISOTYPE (International System of Typographic Picture Education). Neurath's goal, incubated in the Viennese Positivist philosophical circle, was a universal language of pictorial symbols to represent information of all kinds—people, objects, directions—in order to disseminate, gather, and display data. Neurath's communication tool was put to good use in the 1939 edition of *Compton's Pictured Encyclopedia*, of which this booklet is an abstract. The booklet was produced to publicize what was then the landmark incorporation of Neurath's ISOTYPE system into the encyclopedia. It reprints the Industrial Revolution chapter, which makes use of pictographs developed especially for the encyclopedia. To determine the success of the new system, the authors suggest that one question a student *"before* and *after* showing him the pictograph on page 74-n of the article....By its very nature this new 'language' does more than merely give information. It suggests to the student new and clearer ways to think for himself." Needless to say, said article does indeed visualize information, the pictographs especially noticeable as against the body text's drab black-and-white graphics. Neurath's achievement was not only informational and aesthetic, but also populist. By placing it in the context of a common encyclopedia, available to and in use for a huge American audience, Neurath made the design and implicit philosophy of ISOTYPE into a viable and widely seen language for the masses. — D.N.

Pages from the 1939 Edition of Compton's Pictured Encyclopedia showing the new method for visualizing facts and ideas invented by Dr. OTTO NEURATH, Director of The International Foundation for Visual Education at The Hague

INTERNATIONAL TYPOGRAPHIC

The Swiss School or International Typographic style of the early 1950s evolved directly from De Stijl, the Bauhaus, and the New Typography. Its leaders, Theo Ballmer (1902–1965) and Max Bill (1908–1994), studied typography at the Bauhaus. After the Bauhaus was closed in 1933 by the Nazis, Ballmer and Bill went to Switzerland to continue their philosophical search to achieve objective clarity rather than individualistic style through graphic design. Their work of the late 1930s and early 1940s, before the Swiss style was truly internationalized, prefigured the reductive functionality that characterized the style, which ultimately evolved into a common graphic language of businesses worldwide.

Ballmer and Bill's basic principle was that layouts be constructed of pure

Designer: Carlo Vivarelli
Poster, 1949

geometric elements and organized mathematically on a grid. Earlier, in the late '20s, Theo van Doesburg, cofounder and editor of *De Stijl*, issued the *Manifesto of Concrete Art,* which called for a universal art of absolute clarity based on mathematical exactitude. Accordingly, geometric spatial divisions (the grid), Akzidenz Grotesk type (a well-proportioned late-nineteenth-century sans serif typeface), flush left–rag right settings, and paragraphs indicated by an "interval space" instead of the conventional paragraph indent were key components in Ballmer and Bill's early efforts. Along

with the grid the International Typographic style was guided by clear typographic hierarchies and spatial considerations wherein only one type style (in one or two weights) served all the basic informational and navigational needs in the same layout. Relative importance was shown through changes in point size or weight and the position of the type on the grid. Invisible grids had long been present in classical design, but in the International Typographic style the overt application of modular units, geometric progressions, and mathematical sequences laid down strict rules.

The International Typographic style was more restrained than Moholy-Nagy and Herbert Bayer's Bauhaus typography: Bill was such a fervent minimalist that he removed all the red and black bars and borders found in typical Bauhausian layout. And after Jan Tschichold renounced the New Typography for being too rigidly opposed to anything but its own standards, in a letter reprinted in *Print Magazine*, Bill vociferously argued he betrayed the movement. "Fortunately there are young,

Designer: Unknown
Type specimen, 1956

forward-looking people, who do not blindly accept arguments like these," he wrote. Bill's ultrapurist standards of Swiss typography were followed religiously. But there was another approach involving complexity, which challenged the stereotype that Swiss design was fervently one-dimensional. Max Huber (1919–1992) added levels of visual information on the printed page through transparent colors and photographic and montage juxtapositions. The density of graphic material did not detract from the basic rule of clarity and transparency but rather provided the viewer with more visual entry points. While the grid was adhered to he seemed to burst its confines.

Sans serif type was the most emblematic component of the International Typographic style. In 1954 Adrian Frutiger designed Univers, a mathematically constructed and visually programmed family with twenty-one variations (expanded, bold, condensed, and so on, indicated by number). Originally produced in metal by

Designer: Josef Müller Brockmann Poster, 1955

Deberny & Peignot in Paris, it was the first type family to have as many integral variations designed in each height, allowing greater visual harmony. In 1956 Edouard Hoffman decided that it was time to refine Akzidenz Grotesk and collaborated with Max Miedinger on a well-defined sans serif known as Neue Haas Grotesk (so named for the Haas type foundry in Switzerland). When it was produced in Germany by D. Stempel foundry in 1961 the name was changed to Helvetica (the Latin name for Switzerland) and became the most ubiquitous typeface in the world.

The Swiss style is no more monolithic than Switzerland is home to one linguistic group. The differences are apparent in two cities, Basel and Zurich, and their two design schools, where the International Typographic style developed. At the Gewerbeschule in Basel, Emil Ruder taught a typography class that experimented with contrasts,

Designer: Karl Gerstner
Poster, 1960

textures, and scale using Univers. In 1967 he wrote *Typography: A Manual of Design* that addressed achieving a wide range of texture variations while limited to this single font. Armin Hofmann, another Basel school faculty member, evolved a philosophy based on the elements of point measurement, line, and plane. Hofmann's posters uniquely bridged the divide between representation and abstraction. His 1954 "Die Gute Form" (Good Design) is perhaps the designer's quintessential contribution to the poster field. This stark typographic design is at once concrete and abstract, simple and complex, conventional and radical. The headline "Die Gute Form" is, in fact, a picture and the picture is a headline that can be read either as words or symbols—or both at a single glance. To make this poster indelible Hofmann designed geometrically precise yet thoroughly novel letterforms that are so harmonious when composed into the three words and then partially obliterated, that they retain their readability. Hofmann's 1965 book, *Graphic Design Manual*, was a key manifesto of elementary principles. In Zurich, teachers of the Kunstgewerbeschule, including Josef Müller Brockmann and Carlo Vivarelli, used vivid photographs to convey a message but framed them with stark, rational typographic treatments in what Brockmann called "universal graphic expression."

Neue Grafik (New Graphic Design), a short-lived, though internationally influential magazine founded in Zurich in 1958 by Richard P. Lohse, Hans Neuburg, Müller Brockmann, and Vivarelli, showcased (almost only) Swiss accomplishments in interior, industrial, and graphic design. The magazine was written in three languages composed in parallel on a grid format. *Neue Grafik* not only expressed the rational quintessence of the International Typographic style, it did so with such a fervent belief that this was the right and most effective means of presenting information to an international audience that little room was left for doubt. For the better part of the postwar twentieth century, multinational corporations practiced a form of Swiss-inspired dynamic neutrality in their corporate communications.

S E E A L S O *Bauhaus, De Stijl, Helvetica, Modernist, New Typography, Peignot*

175

JUNK MAIL

Most Americans learned that whales needed saving from a white #10 envelope
with the phrase "Save the Whales" on the front, one of the most effective direct
mail (DM) campaigns of the past three decades. Few could ignore the plain-
tive plea and poignant picture of the mighty mammal struggling to survive in a
callous world. But even if 98 percent of all recipients were heartless enough to
have trashed the envelope, the donation campaign would still have been trium-
phant. Whether designed to save whales or sell magazines the direct response
mail industry measures its success by a paltry 2 percent. Yet it takes saturating
the mails with millions of unsolicited letters to get that result, which is why it is
called junk mail—and why it is a style (and convention) all its own.

Most purveyors of DM—including copywriters and designers—recoil at that
term even though they concede that junk mail is out there. To them DM is as
legitimate and creative as magazine advertisements, TV commercials, and out-
door billboards. DM also eats up as much as 55 percent of the average overall

Designer: Unknown
Direct mail, 1999

annual American advertising budget,
and some agencies call it "customer
relationship management." Whatever
it's called, DM has three primary goals:
Acquisition—acquiring new business
or soliciting donations; retention—
offering existing customers special
attractions or attempting to "up-sell"
to new products; and fulfillment—
responding to requests from consum-
ers seeking information solicited from

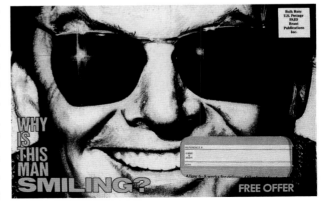

176

other advertisements. While this sounds legitimate enough, DM is nonetheless perceived of as intrusive.

Regardless of how well designed or expensively produced the material or how segmented the audience, usually 98 percent of the recipients of all direct mail campaigns look upon what fills their mailboxes as junk and reflexively throw it away. Direct mail fosters almost as much hostility as e-mail spam (which is shunned by the majority of mainstream advertisers).

The derogatory term "junk mail" reflects that mail solicitations are viewed as an intrusion and invasion of privacy. Owing to this bad rap, in part because of obtrusive and deceptive design, the public is not conditioned to embrace even so-called "good" DM—useful information and announcements. For most of us unwanted mail is junk.

"Good" is relative when compared to

TOP
Designer: Unknown
Direct mail, 1999

ABOVE
Designer: Alexander Ross
Direct mail, 1948

other forms of advertising and graphic design. What ultimately attracts the recipient in a second is less about smart graphic design than manipulative illusions of intimacy. So forget about fine cuts of Times Roman or Garamond typefaces. The big thing today is computer-generated handwriting. People respond better to fake intimacy (often referred to as "personalized" letters) because this makes a person feel less like a number. Quality of design tethered to a great offer or clever slogan, certain logos or images can make the difference between saving or trashing.

SEE ALSO *Generic, Vernacular*

see Kruger

KINETIC TYPE

Back in the early '60s BC (before computer) American designer Herb Lubalin predicted that since type was rapidly moving off the page and onto the television screen typographers needed to rethink design. Abandon delicate Bodonis, the subtleties of which were lost on the cathode ray tube, and rely instead on bold, more readable sans serifs. He further argued that large-print advertisements on the sides of moving vehicles explained why passersby had become conditioned to reading fleeting messages. With the public's eyes pulled in different directions on message-laden streets it was incumbent on graphic designers to devise new kinetic reading methods that were at once legible, eye-catching, and stylish.

But Lubalin's prognostication was not exactly news. Package designers and advertising art directors had learned years before that TV altered the practice of conventional typography, and before that, sign graphics had adapted to the speed of the automobile. Products like laundry detergent and breakfast cereal, which were regularly promoted on TV commercials, required more direct graphic intensity —more style—to push them off the screen and into homemakers' consciousness. Passive typography—the kind that quietly and sometimes elegantly sat on a page—was not viable in a telekinetic world. Like the screaming headlines on tabloid newspapers, television demanded increasingly more dramatic type displays.

The trademark for the American detergent Tide is an example of type specifically designed for the screen. A large Gothic italic *Tide* overprinting a radiating orange and yellow sunburst was deliberately designed to avoid being slashed by television scan-lines. Bold sans serifs were less likely to be distorted in a medium that was subject to the vicissitudes of transmission and reception. Whatever the flaw—vertical and horizontal fluctuation or ghosted images—the word *Tide* was unimpaired and unmistakable.

Designer: Pablo Ferro
Movie titles, 1998

Technology had been influencing typographic aesthetics since the days of Gutenberg, but the act of moving typefaces around in telekinetic space demanded that typographers reappraise the essential cultural role of type: Was it still a neutral vessel for words and ideas, or a component of—indeed a player in—a larger communications drama? One thing was certain: type in motion could never be entirely neutral. It was not until a decade after Lubalin's death in 1981 that the Apple Macintosh enabled graphic designers to make type move without the benefit of

Designers: Kyle Cooper,
Jenny Shainin
Movie titles, 1995

complex optical effects and high-end computer programs like Paintbox. Another few years passed before programs like Flash and After Effects gave design-ers the power to create animation on their own computers. Prior to the Macin-tosh motion typography was so costly and time-consuming that only designers with patience and ambition even attempted to make type perform on the screen.

In the 1960s, film title sequence designer Pablo Ferro laboriously experimented with dancing type for eccentric TV commercials that combined cartoon lettering with Victorian circus type for improvisational compositions. By utilizing quick-cut editing, stop-frame animation, and simultaneously projected images, he helped condition viewers to receive multiple graphics and produced typographic tours de force. He also developed a style of dancing type and fast-cut images that became a standard trope for title sequences and TV commercials.

By the late 1980s kinetic type on film and TV was fairly common (Robert Brownjohn's 1964 titles for Ian Fleming's *Goldfinger* was a prime example of com-

bining type with image), though it was still relatively difficult to achieve without considerable investment. Moving type was more the province of film production experts than graphic designers until Tibor Kalman, principal of M&Co, New York, introduced expressive motion typography to the 1988 Talking Heads environmentalist paean "Nothing But Flowers" music video. Kalman actually took a cue from those quaint old follow-the-bouncing-ball "sing-along" films of the '40s and '50s where song lyrics were displayed at the bottom of the screen, below the moving images, allowing viewers to read the words and lip-sync to the tune (a precursor of karaoke) as they watched the film. For the Talking Heads video each lyrical phrase was conceptually composed in different sans serif typefaces underscoring the lyric's meaning. When rain was mentioned type fell vertically down from the sky. When cars were mentioned type sped horizontally back and forth as though on a highway. The purpose, Kalman said, was to add more dimensions to the listening-viewing experience, and make something dynamic happen on screen beyond the typical performance scenes that were clichés.

The feat was impressive because it was accomplished with predigital tools. Although it was not the first time this was tried, when it was done, it was a significant bridge between old and new technologies. The type was cut from repro galleys by hand, fanned out, letter-spaced, made to jigger and shimmy, and was carefully pasted onto boards that were then filmed and optically superimposed on the original performance footage (which was framed and shot to accommodate the typographic compositions).

By the time MTV premiered as the music video network in 1981 the medium was already changing how people heard and saw music, and certain filmmakers welcomed this as a fertile experimental form. Music videos were also a playground where graphic designers could play with image, sound, and, of course, typography in ways theretofore rare. When in the late '80s digital programs like After Effects and Final Cut Pro became widely available it was inescapable that sooner or later kinetic typography would be a common graphic design genre and taught as a requisite class in art and design schools. By the time Kyle Cooper designed the edgy title sequence for David Fincher's *Se7en* in 1995, motion graphics and kinetic type had come of age. This coalescence of cinema and typography was destined to expand graphic design practice.

SEE ALSO *Bass, Lubalin, Tibor*

FLASH

Macromedia Flash is a motion graphics program developed for the Web. It offers interactive animation through compact, fast-loading files. Because its browser plug-in is readily available for free, it has become the most common animated display program online. Its initial purpose as a package was to enhance the user experience through interactive motion (much like a video game), but when the promise of infinite bandwidth seemed just around the corner, companies began mounting very heavy sites, and a Flash aesthetic soon emerged.

The hallmark of the style is movement. Spinning logos were just the start; full motion was and is the real goal. Barneys.com, the site for the New York–based clothing store, uses a typical Flash conceit: navigation through sliding images and animated menus. The style amounts to feeling like one is skating through the store, clothing and options whizzing by. Because the files are compressed in order to load faster, the image quality in Flash is often slightly grainy, giving the impression of a slightly out-of-focus photograph moving quickly past the viewer. Flash sites are marked by menus that are sensitive to the touch of the cursor, and multiple rollovers: images, that, when passed over by the cursor, reveal an image underneath. Like other Flash sites, images and graphics tend to move across the screen or fade in and out when choosing or dismissing them; the experience is both tactile and spatial.

There are multiple uses for Flash, and its style is slippery. But it allows users to affect their interface environment like no other tool, and comes the closest of any online experience to replicating how we feel when proceeding through the Web. Hillman Curtis's "Are You a Bodeist?" (right) comes the closest to replicating the film experience through the expert employ of Flash. — D.N.

KODALITH

During the late 1960s, when cheaply printed offset alternative newspapers, posters, and flyers were the media by which the sex, drugs, and rock 'n' roll generation spread their counterculture gospel, an old photographic printing technique greatly increased the ability of graphic artists to make startling pictorial messages. So widespread was its use that the look it produced became known, at least among its proponents, as the Kodalith style.

Eastman Kodak's eponymous Kodalith photographic paper (and printing plates), invented in 1931 to facilitate the reproduction of ultra high-contrast images (or "line art"), removed all the middle tones in conventional photographs, leaving only the darkest masses and brightest highlights. The dark areas could then be subtly manipulated or radically distorted using either darkroom methods or brush and ink, which eliminated the need for costly and time-consuming airbrush retouching. "Kodalithing," as it was also called (much to the delight of Kodak's brand-masters), made even mediocre artwork or stock photography more dramatic. In fact, Kodalith paper enabled anyone with a stat camera to make ersatz art, just as Photoshop now enables neophytes to make artsy collages.

Although Kodalithing was initially used to hold down production expenses, during the late '60s it spawned a counterculture aesthetic. At first it was simply a decorative conceit—a means to goose up a layout with bold graphics. But in a charged era when politics was endemic to the visual culture, Kodalith was synonymous with polemical communications—the politics of black and white—associated almost entirely with left-wing issues (just as litho or grease

Designer: Ivan Chermayeff
Book cover, 1969

crayon–rendered illustration was considered the foremost medium of Socialists and Communists two generations before). It was common to see portraits of such heroes of the Left as Black Panther leader Eldridge Cleaver or Latin American revolutionary Ernesto "Che" Guevara as Kodaliths on stickers, posters, and T-shirts. It was easy to transform any recognizable photograph into a graphic icon.

Kodalith encouraged subversion. High-contrast images often veiled contraband by effectively masking obscene or lurid parts of halftone photographs. High-contrast reproduction made blatant sexuality more ambiguous and libelous depictions more intangible. Removing all tonal information transformed realism into abstraction. Truth could be fiction and fiction could be mistaken for fact. The pure photograph was fodder for the manipulating artist. Indeed Kodalith made mundane imagery more "artistic." Other screen techniques, including mezzotint, scratch, and continuous line, might render a halftone into line art, but only pure Kodalith had the power to totally transform.

The Pop artists of the '60s, many trained as commercial artists, appreciated the power of Kodalith. Andy Warhol's famous portrait series of Marilyn Monroe, Elvis Presley, and Elizabeth Taylor were rooted in Kodaliths; by virtue of their monumentality on large canvas the images were elevated to cultural icons. Instead of painstakingly painting true likenesses from photographs, as Norman Rockwell would have done, Warhol Kodalithed portraits and applied them to canvas, then added often garish color. Some critics argued that Kodalith-made art was faux art—a shortcut that bypassed painterly craft. Others believed it was the next evolutionary stage in art—a consequence of mechanical reproduction that obviated the need for tedious painterly process. Much like the Expressionist woodcut, the Kodalith enabled artists to capture the primitive spirit on paper. Just as the Expressionists built a new art on the foundation of naïf arts, Kodalith

RIGHT
Designer: Quentin Fiore
Book jacket, 1967

BELOW
Designer: Unknown
Political caricature, 1968

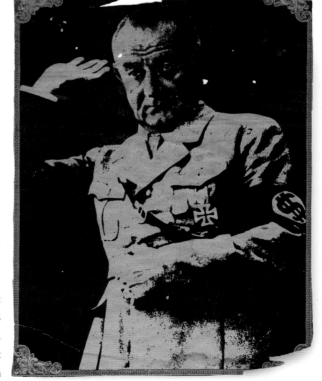

Marshall McLuhan
Quentin Fiore
The Medium
is the
Massage

An Inventory of Effects

built a new Expressionism out of naïf technology.

In the '60s Kodalith was further used for countless collage and montage—both black-and-white and color—that opened the floodgates for the graphic tomfoolery so prevalent during this transitory time in graphic arts history. One classic example involved combining Kodalith prints of President Lyndon B. Johnson and Adolf Hitler into a single figure. It was done in 1965 by an anonymous graphic artist for the New York underground newspaper the *East Village Other* that vociferously and regularly protested against the leader of the free world and his unpopular Vietnam War policies. Through the reduction of iconic forms to bold black masses the viewer was invited to be party to the subterfuge. In reality the viewer knew that the infamous Heil Hitler pose and Johnson's head were artificially grafted together, but both figures in the resulting collage were so simultaneously recognizable that reality was suspended. The image was certainly surprising, but it was also more believable than if the manipulation been done with a conventional halftone image.

Designer: Rudolf de Harak Book cover, 1965

Designer Quentin Fiore also used Kodalith to heighten graphic intensity in his collaborative books with media philosopher Marshall McLuhan, *War and Peace in the Global Village* and *The Medium Is the Massage*. Similarly his design of former Youth International Party (Yippie) founder Jerry Rubin's *Do-It!* combined high-contrast and halftone photography in a veritable orgy of counterculture images. The most dramatic use was Fiore's cover of *The Medium Is the Massage*, a high-contrast depiction of a tormented face, which, in fact, is the head and torso of a burned Vietnamese child. At first glance it appears abstract, with but a few identifiable physical characteristics signaling a human form, but as the viewer's eyes begin to better absorb the visual information the tortured visage becomes more vivid. A conventional halftone might be more easily recognizable, but not as

dramatic once it is perceived. This high-contrast form actually forces the viewer to pause before opening the book, and in that split second in which the image is revealed the viewer comprehends the critical essence of the message about how images are mentally (and often mistakenly) processed in a media-glutted information age. Throughout each of the Fiore books Kodalith imagery serves as stop signs forcing the reader to dwell on images that otherwise might fleet on by.

Not all Kodalith applications were politically motivated or polemically intended. Among the most exemplary uses to bridge fine and applied art was the application of Kodalith as artistic tool in French book designer Massin's 1965 radical "typographic interpretation" of Eugène Ionesco's *The Bald Soprano*. Massin utilizes high-contrast photographs of all the characters in Ionesco's absurdist play as visual substitutes for stage directions with their respective lines typographically emerging from their bodies and faces as in a comic strip. The Kodaliths were startling against the pure white paper, and the physical and facial characteristics that remained after the middle tones were removed vividly represented each actor's distinctive personality.

Kodalith also became a stylistic mannerism in film and on television because the black masses were easy to animate (and to colorize). The pioneering effort that prompted a slew of copies was the 1962 film title sequence for *Women of Straw* designed by Pablo Ferro, wherein each actor's high-contrast portrait was bleached of all tone and then bathed in primary colors that faded in and out on the screen. Ultimately various TV drama series applied the same technique to stylistically introduce characters and theme in an artful way.

But Kodalith style is not time-specific. With the advent of easy-access photocopiers, making high-contrast images became *de rigueur* in D.I.Y. (Do-It-Yourself) graphic movements, including 1970s Punk and '80s and '90s Grunge. With Photoshop, making high-contrast imagery is as easy as a keystroke, and is just as frequently used.

S E E A L S O *Do-It-Yourself, Expressionist, Grunge, Massin, Underground Press*

KRUGER

In the late 1970s Barbara Kruger intercepted popular media—from matchbooks to advertisements to movies—to critique art, society, and assumptions of power portrayed in the media. Her style derived from Modern advertising, and, solidly built on the foundation of mass communication, is meant to quash certain art historical taboos in terms of the unholy union between fine and applied art.

Kruger's style is directly influenced by reductive Modernist graphic design, the kind that has dominated corporate identity, and so-called "Big Idea" or "Creative Revolution" advertising of the sixties that was characterized by clever slogans and ironic imagery. Her signature use of Futura Bold type, often dropped out of red bands, is both a Modern trope and a common trait in sensationalist design. Her stylistic mannerisms can be traced back to her job as an art director for *Mademoiselle* and later as a freelance book jacket designer.

In melding art and graphic design Kruger made an art that was more populist, enabling a broad audience to consume social and cultural dynamics that in other art might be more inaccessible. Which is not to say that Kruger's art is transparent. It is anything but. Her pictures and words are almost like teaser advertisements (in fact, she arguably influenced the current trend in teasers) that hint at a

Artist: Barbara Kruger
Poster, 1990

We don't need another hero

Artist: Barbara Kruger
Poster, 1987

message and stimulate attention by prompting curiosity. The parts that she leaves out—ideas tucked in between the picture and the words—demand viewer participation and interpretation.

Like Fluxus, the loose-knit collective of artists who produced reams of art in print media, including typography, Kruger critiques the power of mass media with its own conceits. She uses the language of commercial art and its media—advertisements, postcards, shopping bags, posters, billboards, bus shelters, and film—to address heretofore taboo art subjects, like those of gender, racial, cultural, and economic stereotypes promoted by mass media.

In addition to communicating her ideas to a gallery and museum audience, Kruger's adoption of commercial art has had an impact on the graphic designers too. Designers have always looked to art for inspiration, but they have rarely found so many common formal characteristics. The intensity of commitment is weighted more towards the artist who retains more freedom than the client-driven designer, yet sharing visual forms suggests that at least superficially the once formidable boundaries between art and graphic design have temporarily blurred.

Kruger rejects the terms graphic design and advertising to describe her work: "I'm someone who works with pictures and words, and people can take that to mean anything they like," she says. But by using the graphic and typographic languages she reveals how graphic and advertising styles inveigle their way into public consciousness, and uncovering the corrosive effects of mass media is a goal of her distinctive style.

SEE ALSO *Agit Retro, Big Idea, Futura, Modernist*

see Lubalin

LESS IS MORE

The tendency during the mid-1980s through the late '90s, largely among younger designers, to practice layered or More Is More graphic design was a rebellion by one generation who sought to disrupt the status quo. Graphic clutter—multiple layers of type and image—was partially a metaphor (or a mirror) for the bombardment of data on television, computer, and even the urban street. It was also a critical response to the clean and sterile late Modern or corporate modern formulae. The mantra was "Down with Helvetica" and all it stood for. Complexity would probably have occurred whether computer technology existed or not,

RIGHT
Designer: Rudolf de Harak
Book cover, 1963

BELOW
Designer: Michael Bierut
Advertisement, 1999

Light Years The Architectural League of New York's 1999 Beaux Arts Ball at the Starrett-Lehigh Building, Saturday March 13, 1999. For tickets please call (212) 753 1722. Corporate Sponsor Artemide

Anthropology and Human Nature

Ashley Montagu

$2.75

McGRAW-HILL PAPERBACKS

Rudolph deHarak

but the Macintosh tipped the scales and stimulated action by giving designers a powerful tool to achieve both elegant and convoluted complexity (as represented by such stylistic manifestations as New Wave, Deconstruction, Punk, and Retro). More Is More became a generational code.

But for every action there is usually a proverbial reaction. Schools of thought and practice passionately debated the philosophy and aesthetics of the "new design." Condemning illegibility and clutter, a new movement emerged in the mid-nineties that sought to eradicate More Is More. Graphic simplicity, economy, and reduction were not merely rejections of fashion, but means to ensure effective, unambiguous communication. Excess, once a protest against conformity later embraced by countless young designers, became a design cliché.

Yet the presumption that Less Is More was based solely on functionalism is wrong. The new simplicity may have been the absence of unnecessary complexity, but it was not as austere as was orthodox Modernism. Those who practiced Less Is More techniques retained decorative design tropes when appropriate to the message. In fact Less Is More was never a style based on predetermined tenets, but rather was comprised of various points of view. Certain common characteristics prevailed, such as the generous use of white space and preference for classical serif and Modern sans serif typefaces, but this did not preclude considerable variety.

At the time it was introduced, coming off a period of almost slavish layering and increased illegibility, Less Is More was fresh enough to catch the eye and excite the senses. But it was anything but retro. When the progressive *Emigre* magazine published its own radically austere looking "Graphic Design: the Next Big Thing" issue (#39), after thirty-eight issues devoted to digital excess, it was tacitly putting the lid on complexity (for a while at least) while offering economy as a new direction. As it turned out, Less Is More was not a new wave replacing the old ones, but it offered at least as many variations for stimulating design solutions as did complexity.

SEE ALSO *Deconstruction, Emigre, Helvetica, Modernist, New Wave*

Designer: Michael Bierut
Logo, 2002

Hip: the history John Leland

Designer: High Design
Book cover, 2006

THE *MCSWEENEY'S* STYLE: VICTORIAN/NEOCLASSICAL MEETS SARCASTIC/IRONIC

Dave Eggers' literary journal *McSweeney's* launched in 1998 in a flurry of minimal, type-specific pages. Layouts were simple paragraphs of Garamond captured in thin borders. Story titles were set in larger Garamond, occasionally decorated by Eggers' own idiosyncratic line drawings resembling the objective merchandise depictions in Victorian and turn-of-the-century product catalogs. The first two covers were

broadsheet-style, all type was centered, and though sizes varied, few other graphic devices were used. The third issue featured an elaborate chart that would've fit snugly between one's collection of Victorian star charts and medical journals, except for the text, which was both scatological fun ("We, You Are a Monster") and revolutionary manifesto ("Editing for Space Is Too Easy to Be Moral"). Type also overran the spines—the third issue audaciously held a complete David Foster Wallace story. Abruptly switching formats, the fourth issue was a box of booklets, each with a cover designed by its author.

Both the visual and the editorial voices seemed like a cheeky adaptation of Victorian styles, which in part they were. But as became clear in a pamphlet from issue four, "The Author's and Book Enjoyer's Bill of Rights, at Least Insofar as the Book Jacket is Concerned," a function of Eggers' desire was to make something pleasing but not design based. That is, what design was there would only clear the way for the author's voice and the identity of the journal. Furthermore, this was a style that was uncluttered and, though self-referential, not self-consciously designed, with graphics attempting to substitute for content. Every decision either brought the author to the fore (standardized type; allowing the authors to choose their own cover images) or provided yet more writing for the reader (the spines and covers).

It didn't take long for other designers to swipe the look. The cover to IBM's 2000 annual report sports centered Garamond and text written in much the same tone as *McSweeney's*. Save the logo, it could be mistaken for a much less clever issue of the journal itself. Likewise, the arts journal *Parkett* took up the overcrowded spin motif. Neither project looked or read well. Like a prose style separated from its generative content, the *McSweeney's* look seems hollow. Eggers' concern in his "Bill of Rights" was to give authors correct and well-meaning visual representations. As his own designer, then, he was successful: He produced work that fit *McSweeney's*, and nothing else, just right. According to the principles, that is just as it should have been. — D.N.

LUBALIN

Herb Lubalin was a type basher. He respected the integrity of letterforms but realized that there was more to good typography than purity. During the 1960s, type was ready to explode off the page, so by bashing faces Lubalin smashed taboos of type design and composition and imbued words with personality. Like the rockers of the era, he turned up the volume and made his design sing. In the process a Lubalin style emerged, a pervasive eclectic sensibility that informed advertising, editorial, and package design.

Lubalin built a bridge linking the austere Swiss Modern (International Typographic) and eclectic methods. Considered the father of conceptual typography, he not only made letters do tricks, he enabled words to emote. His "experimental" type and page design became so thoroughly embraced by the profession, first in advertising and then publication design, that it's hard to imagine that Lubalin's style was truly radical.

Even when his typography was comparatively quiet, it was never neutral. His illuminated display headlines forced the reader to halt, read, and experience the entire page before being absorbed by the message. He was meticulous when it came to manipulating letters to make striking compositions. The graphic strength of "No More War"—an advertisement for the magazine he art-directed, *Avant Garde*—featuring block letters forming the pattern of an American flag with a bold black exclamation point at the end, was one of the most iconic statements of the Vietnam War era.

Lubalin's type was a hybrid form of concrete poetry, yet critics sometimes recoiled from his bashing, smashing, and overlapping because it seemed contrived. At times it was, and eventually the conceit did become overly self-conscious. Even Lubalin winced at the way others copied his work. But in his hands the style was brilliantly applied because he was the quintessential basher.

SEE ALSO *International Typographic, Kinetic Type*

Designer: Herb Lubalin
Advertisement, 1968

Designer: Herb Lubalin
Magazine cover, 1970

Designer: Herb Lubalin
Magazine cover, 1970

see Modernist

MAGAZINE CLICHÉ

Magazines are sometimes like teenagers. No, they don't get acne, but they do go through stages where an entire generation of them shares the same stylistic tropes—or clichés—that ultimately define their respective moments in time and history. Peer pressure among magazines and magazine designers is intense. Sometimes these tropes are typographic: in the fifties an abundance of small, bold Akzidenz Grotesk type atop blocks of line-spaced Century or Garamond italic, or in the sixties a surfeit of smashed and overlapping typefaces. Sometimes they are illustrative: in the '70s Surrealistic paintings (à la Magritte) were the rage, and in the '80s conceptual photographs (that looked like Magritte) overtook the paintings. The early '90s became known for intense page clutter with layered, disparate, and degraded typefaces (in part owing to the computer's capacity to make such monstrosities happen), while the late '90s were more minimalist, though not exactly mimicking the Swiss Modernist austerity of the '50s. Sometimes clichés become convention. In the late '60s *New York Magazine*, design-directed by Milton Glaser, introduced small images as a regular feature in its table of contents (the first time this was done), and shortly afterward and to this day virtually every magazine uses small images in this manner. Today there is a whole new assortment of clichés—some uniquely twenty-first century, others carryovers from the late twentieth. An increase in leader dots in headlines has not yet reached cliché proportions. These are eleven of the most recurring design clichés:

1. Asterisks (*) and {brackets} that only serve as decoration and otherwise have no intended purpose. Thanks *Wallpaper** and *Surface**!
2. Rules or lines used to separate information, as in "we have a pull quote here, let's wrap it with 25 lines so everyone, and I mean everyone, knows we are separating

> **What was difficult was people automatically assumed I smoked. You'd never say 'How'd you get it?' to someone with breast cancer.**
>
> —MELISSA ZAGON, 37, NONSMOKER WITH LUNG CANCER

As the perfect best girlfriend, you're responsible for throwing the perfect bridal shower, baby shower, birthday—or even breakup party—for your gal pals. Relax! What better way to celebrate than with some decadent pampering. Light some candles, get out the double chocolate truffles, some nail polish and you've got a blissful Pamper Party. Add personalized invites, album pages and party bags and you'll have the girls gushing. Read on for projects, invitation ideas and fun celebration ideas free from HP.

MAKE IT UNIQUE
The first step to any great party is an invitation. Customize and print stylish pink invites right at home, then send! You'll also find printable party bags perfect for bath salts or sweet treats, adhesive labels to personalize soaps or nail polish, and much more. Just go to www.hp.com/go/getcreative6 and get started. Another great idea: Greet guests at the door with comfy

SHARE YOUR BEST
Whether it's a photo greeting card, custom menu or personal invitation, HP inks and papers are designed to work with your HP printer to bring out the absolute best in everything you print. Which, in turn, brings out the absolute best in you. Who says science and beauty don't mix?

✳ Special Kitchen Section

Dangerous Knowledge

How to Break into Your Girlfriend's E-mail (And why you probably shouldn't)

< Leather Trim Optional

303 REVIEWS · Summer 2005's HOTTEST Movies DVD Music TV Games

GIANT

THE COOLEST IN ENTERTAINMENT

KATIE HOLMES "I'm not as sweet as you think."

WATCH! LISTEN! PLAY!

900 family members of fallen American soldiers have met with the commander in chief

5 Women Who Make Us Want to Be a Better Man

[People]

Hyatt Named Nelson CEO
Michael Hyatt has been appointed CEO of Thomas Nelson, succeeding Sam Moore, who will remain chairman. Hyatt served two stints with Nelson, rejoining the company in 1998,

RAZOR
SEX & SAND & SWIMSUITS

aspiring cr

enter your best work today.

Lemon Curd Mousse Cake

38 R.S.V.P.
Readers' favorite restaurant recipes.

47 >> New Column: Party Improv
It's all about big results with little effort.
THIS MONTH: A casual steakhouse menu that comes together almost instantly.

update · STRATEGIES

Shoulder Seasons

May is an ideal time to catch a destination during shoulder season—those few weeks when rates are low and the weather is (almost) perfect. To help you find the right place at the right time, we've highlighted off-peak destinations around the world all year long.

246 FREE EVENTS INSIDE

STYLE SHEET

Peak-season rates often reflect when an island is overrun rather than when it's best to visit

What Makes A Good Art/Design School?

Dancing chickens and yak-
Break out your "Kraut accent" and read along with the director's wit and wisdom

the information from the text," plus other graphic devices to frame quotes.

3. Transparency and translucency. Now that magazine designers are switching to Adobe's InDesign, over-printing text on a screened background over a picture that would otherwise be too dark or dense, has been used and misused.

4. Small silhouette headshots in margins or quotes or blurbs. These were originally introduced in the '20s and '30s in gossipy film "confidential" magazines, and then satirically reintroduced in the '80s in the American magazine *SPY*. Now they crop up like mushrooms after a storm in fashion, entertainment, and news magazines.

5. Hyper-short, 150-word, snappy items in front-of-the-book sections, often boxed or over-printed with a color tint, usually accompanied by a silhouetted photograph or illustration. This is so obligatory at this point it has almost gone from being a cliché to a reflexive piece of design furniture.

6. The oversized carrot (>>), neither bracket nor parenthesis, suggests motion or dynamism. Like the also-clichéd big arrow or the bloated question mark, the carrot is supposed to direct the eye to something profound, but instead usually leads to a dead end.

7. Illusionistic depth, a clichéd signifier of "naturalism," whereby the page is a screen or window onto another space. Thanks to Photoshop the ability to shadow in faux dimension is a click away. It is even a feature in PowerPoint.

8. Smirking male and female celebrities photographed against white or colored seamless, used on covers. In recent years the number of magazines featuring these clones has increased exponentially. The theory, of course, is that gazing stars will grab the stargazer's short attention better than any other cover image. It helps if the celebrity's breast or chest is visible too.

9. CYMK as a color for headlines, page tints, and other applications. Once cyan, yellow, and magenta seemed too cheesy, reserved only for slimy tabloids. Now it's self-referentially Postmodern to play with the raw materials of printing.

10. Cartoon speech balloons have taken the place of quotation marks. Perhaps the rise of graphic novels has contributed to this trend, but more likely it is easy to signal speech through this vernacular device.

11. And do not forget drop shadows on type. Once used only for novelty purposes the Macintosh has made it too easy to transform any typeface—even the most beautiful cut of Garamond—into a 3D eyesore. Of course, there are good reasons for adding drop shadows, in-lines, and outlines to type, but just make sure it is not an indiscriminate application.

SEE ALSO *Commercial Modern, Modernist, Playboy*

MASSIN

With his radically kinetic page layouts for a volume of Eugène Ionesco's absurdist "anti-play" *La Cantatrice Chauve* (1964), known in its American edition as *The Bald Soprano* (1965) and in the English edition as *The Bald Prima Donna* (1966), French book designer Massin pioneered a form of expressive typography that two decades later would be common and easy to achieve with the aid of digital type and layout programs. In 1964 Massin only had the ten digits on his two hands to work with. Influenced by the metaphoric and kinetic words in *Parole in Libertà* ("words in freedom," in which various type styles are jumbled together to approximate the sound of speech) of Futurism, Dada, and Constructivism, *The Bald Soprano* was Massin's attempt to capture the dynamism of the theater within the static confines of the book.

Massin saw Ionesco's play over twenty times; in the print version he wanted to project all the nuances, inflections, and tics that the actors experienced on stage. He assigned to each character a specific typeface representing a personal voice. The type was combined with high-contrast Kodalith photos of the actors and through this process they were transformed into black-and-white symbols that replaced their typewritten names in the original script. The layouts of the book are like a large storyboard used to block out a movie, but rather than typing the dialogue neatly underneath the images, the text was integrated into the picture frame. This gives it something of the look of a comic strip, but without speech balloons. Stage directions were replaced by the actual gestures and movements of the actor-icons and dialogue actually flowed from their respective personages across the pages in varying type sizes and configurations. Dueling or battling dialogue became increasingly chaotic as more actors appeared on the stage/page.

Designer: Massin
Book cover, 1964

Massin's graphic interpretation was in sync with Ionesco's existential satire of language and logic, but technically speaking it was a big mess that was not easy to achieve—or copy. Each graphic element was not only arduously composed and pasted up, it was produced in three different versions for the French, English, and American editions. Even more extraordinary was the way Massin

*Designer: Massin
Book design, 1964*

distorted the type to distinguish soft and loud conversation. He stretched the text by transferring the type onto soft rubber—three dozen condoms, to be exact—that he pulled and tugged to bend and warp, then photographed the end product on high-contrast film. It was hard enough doing this for the original French edition, but he also had to do iterations for two separate English-language translations. The end result, however, was a tour de force of interpretative typography.

At the time it was published and for almost a decade thereafter *The Bald Soprano* was a veritable textbook that influenced many designers, especially those working with small budgets. The Kodalith film and plate eliminated the need for costly halftones because veloxes (or paper prints) could be directly pasted upon the mechanical, reducing the expense of negative stripping. Stylistically speaking, Massin's method further introduced both a noir aesthetic to eclectic design and a kinetic dynamism found in the purposeful, if messy, clash of type and image on a single page.

S E E A L S O *Constructivist, Dada, Futurist, Kinetic Type, Kodalith*

MATCHBOX

Collecting matchbox labels is called phillumeny; its obsessive proponents are phillumenists. One reason there are so many phillumenists is because there are untold matchbox (and matchbook) graphics that can be found in virtually all corners of the globe, and many are quite striking.

Modern matchbox labels follow the invention of the safety match, in 1844, when Swedish chemist Gustaf Erik Pasch developed a phosphorous compound that was stable, but would combust when friction was applied on contact. The first matchbox was designed with a small strip of striking material on the box's narrow side. Pasted on the box's wider top was a relatively intricate woodblock design, or an illustration printed with the brand name and reference to the country of origin. Matches became profitable export businesses for Sweden, Thailand, Russia, Italy, and Japan, to name a few, as each country produced its own graphic styles that

were both unique to their respective cultures and curiously universal, too.

During the early 1900s, matchbox art from around the world began to share many of the same graphic conceits, among them comic animals, imaginary coats of arms, intricate ornamentation, and portraits of real and mythical beings. These were common naturalistic images for a good many packages before the age of pseudo-scientific branding. The matchboxes used English as the common language, indicating the broad scope of international trade. But each nation also maintained a distinct iconographic accent that revealed its unique visual heritage and national preoccupations, such as samurai or Mt. Fuji for Japan.

Among the industry leaders Japan was exceptionally prodigious, and the designs produced were various, plentiful, and consistent with the early twentieth-century expansion of the nation's heavy industries. Commercial art played an important role, in general, as it developed brand recognition and sales for new industrial products. It put Japanese graphic designers at the forefront of what is now called "branding." The designers were seriously influenced by imported European styles such as Victorian and Art Nouveau, which is evident on these matchboxes (and later by Art Deco and the Bauhaus, introduced through Japanese graphic arts trade magazines, and incorporated into the design of matchbox labels during the late 1920s and '30s). Western graphic mannerisms were harmoniously combined with traditional Japanese styles and geometries from the Meiji

period (1868–1912), exemplified by both their simple and complex ornamental compositions. Since matches were a big export industry, and the Japanese dominated the markets in the United States, Australia, England, France, and even India, matchbox design exhibited a hybrid typography that wed Western and Japanese styles into an intricate mélange. The domestic brands, however, were routinely designed in a more reductive—though typically Japanese—manner solely using Kanji characters.

In Japan, matchboxes were a mainstay of daily, vernacular culture. Safety matches became important staples in

Designer: Unknown
Label, c. 1930

202

part because they satisfied a primal social need (fire), and because of the nation's substantial lumber industry that supplied a near endless supply of material. The largest Japanese match manufacturers, including Shungen & Co., Mitsui & Co., Seiryukwan, and Koyoukan Binnaka Seizo, from Osaka, Koshi, and Himeji, were all well known, but the artists who created their respective designs were purposely kept in the shadows—like most commercial artisans in other quotidian fields. Anonymity was the fate of those who produced the most vibrant, as well as the most ephemeral, products of the Japanese popular arts. Nonetheless certain manufacturers were known for certain styles designed to appeal to different aesthetic tastes. Nisshinsha's labels often featured a central "trade mark" (a rabbit suggesting good luck) or a vignette (two-winged cherubs framing a globe), while Shiyosegumi Seizo's labels were heavily typographic with tiny images integrated into the overall design. But for the most part, the labels followed a standard template that was developed in the late nineteenth century and was maintained for decades.

Phillumenists explain that the extraordinarily large number of diverse matchbox labels had to do with the marketing ruse of cultivating a collector's mentality among consumers. This kind of thinking is not unlike the strategy for selling razor blades (where one "brand" issued various collectible packages and wrappers) or cigarettes (where serially collectible cards were incentives). During this period, matchboxes were sold indiscriminately through all kinds of stores and vendors as a necessity, not just for lighting the ubiquitous smoking materials, but also for routinely igniting fires in ovens, grills, and heaters. Not until the 1930s were matchboxes and matchbooks—the newer, compact invention—produced as vehicles specifically to promote and advertise restaurants, shops, and businesses.
SEE ALSO *Bonehead, Chantry, Generic, Show-Card, Vernacular*

ME-TOO

Graphic design of the 1990s began to evolve in the early '80s when a rebellion against sterile corporate Modernism and slick opulent professionalism erupted. Designers attacked the Swiss style—the International Typographic style—that

ordered and clarified information, which had come to symbolize corporations in the '60s and '70s through iconic logo design. Once sacrosanct rules of form and function were expunged through the use of distressed or distorted letterforms, the result was a plethora of dissonant compositions where type and image collided on a single page. So-called Postmodern graphic designers from progressive design schools in Holland, Switzerland, England, and the United States borrowed the language of Poststructuralism from French literary critics. This allowed them to "talk about themselves, expose their own mechanics, and hold a dialog or discourse about their own constructs," explained Katherine McCoy, the former cochair of Cranbrook Academy of Art, once a fount of graphic design's Deconstruction movement.

Deconstruction theorists at Cranbrook and elsewhere proposed to transform graphic design from a mere commercial tool to a rich cultural language. They believed that a participatory audience interpreted information in an individual way. Therefore, everyday messages were not to be taken at face value simply because they were set in official typefaces and printed on fine papers. Deconstruction questioned the authority and morality of all kinds of propaganda— a worthwhile goal, although somewhat detached from design problems for common businesses, such as annual reports, catsup labels, or mail-order catalogs.

Deconstruction would probably have remained behind the academy's walls if not for the almost simultaneous introduction of the designers' best friend, the Macintosh, in the mid-'80s, which caused the most profound stylistic *and* attitudinal changes since the 1920s when European Modernists put forth the notion of design universality and formal purity. Digitization was the first major revolution in graphic arts, particularly in how graphic design is produced and distributed—if not conceived—since old man Gutenberg moved his earliest type slugs around in fifteenth-century Mainz. Even the shift from hot metal to cold type during the sixties did not give individual graphic designers the same opportunity to directly control the setting and printing of content while dabbling with form. Faceless technology, paradoxically, made personal expression possible for everyone.

In the print arena *Emigre* magazine, the clarion of digital typography, led a charge that inspired the likes of *Beach Culture*, *Ray Gun*, *Bikini*, *Blur*, *Speak*, and scores of other outlets of "new design" where digital type jockeys galloped over the status quo. Similarly, *Fuse*, founded by Neville Brody and John Wozencroft, was a petri dish of type culture—a digital "magazine" and an international conference that encouraged conceptual type-play around such themes as politics, sexism, and pornography. *Fuse*'s conceptual, digital alphabets expressed burning

LET'S SEE WHAT'S OUT THERE...

Newsstand
Price $2.00

zoot capri

[THE MAGAZINE]

Big Reader Fiction Feature

Who's Hot?

Meet Freddy's Father

Seen Heard and Read

THE

Odd

ISSUE

Designer: Unknown
Advertisement, c. 1999

social and cultural issues, rather than simply address the functional demands of type. Experimental type became difficult to decipher and a metaphor for whatever issue required metaphors.

Emigre's Rudy VanderLans and Zuzana Licko created unprecedented typefaces and layouts that pushed the limits of traditional design into that otherworld between art and functionality. They intuitively understood the potential power of the new tools, and they were not afraid to take risks that annoyed orthodox Modernists like Massimo Vignelli, one of their more vocal critics. But their influence was first on other designers rather than on the mass market. Following close on their heels, David Carson, art director of *Ray Gun*, introduced typographic antics that evolved into the more widespread code of nineties youth culture. He exploited the computer's mistakes to make abstracted design rather than readable pages. Computer programming glitches provided an endless supply of legibility-challenging graphic conceits.

Although illegibility was not entirely new—having been done before in the 1920s under the banners of Futurism, Dada, Merz, and Surrealism—when revived for the digital age it was symbolic of a new rebellion against the status quo. Digital freedom, which meant everything that could never be done because it was too difficult prior to the computer, was the nineties designers' license to be "me," and for others a free pass to be "me too."

With so much power on the desktop a wave of narcissism and self-indulgence hit the shore. Although individual personality routinely plays a key role in visual communication, confusion ensues when everyone is conducting experiments yet just following fashion.

Experimentation became a fashionable style. Carson's work, as idiosyncratic as it was, fostered the self-titled "End of Print" style (also the title of Carson's first

monograph). Cranbrook's grads spawned a style of layered typography, and even VanderLans' efforts resulted in an "Emigre Style." It was unavoidably predictable. *Emigre* was, however, the first to question its own role in this vortex of style, and by the mid-'90s admitted that its methods were being mimicked by acolytes. VanderLans refined his work by shifting over to a more uncluttered manner built around *Emigre*'s signature typefaces, proving that behind all his experimentation was a skillful designer. Nonetheless the controlled chaos that had been unleashed was now tried, true, and stylish too. The herd of me-too-ers could be seen in design competitions and showcase books. Anything with smashed, blurred, or contorted type was a shoo-in and Me-Too style ruled.

S E E A L S O *Dada, Deconstruction, Emigre, International Typographic, Modernist, Postmodern, Ray Gun, Surrealist*

MINI-MANNEQUIN

Vintage mannequins such as those from the 1920s and '30s have elegance and grace. And despite the patina of age they never seem to grow decrepitly old. Designed to embody ideal beauty, they are the Greco-Roman statuary of the Machine Age, twentieth-century sculptures of commercial culture whose seductively stylized forms beckon the consumer to buy.

Designer: Unknown
Mini-mannequin, c. 1935

Scale reductions of floor-model mannequins were designed for utility. In clothing emporia mini-mannequins were armatures for the latest women's dresses, men's suits, and intimate apparel; in pharmacies they showcased trusses, bandages, and cosmetics. In hardware stores they promoted industrial wares and tools. Miniaturization was the key to grabbing the consumer's browsing eye. Store-window and countertop figures subconsciously appealed to susceptible consumers in ways that print ads could not. Window displays with life-size or miniature mannequins comprised serial tableaux that told stories about the merchandise. Once inside the store pristine countertop mannequins wearing Lilliputian garments created added incentive to purchase the merchandise.

Produced in multiples of hundreds, mini-mannequins came in distinct personality types with names often derived from thirties and forties movie stars: Clark, Cary, Barrymore, Mae, Greta, and Ava. They were mainly produced in Chicago, Los Angeles, and New York, in dusty display studios and workshops, formed in clay molds and then reproduced in plaster, hard rubber, or other composite materials. The basic forms, commonly offered in

Ladies, Men, Junior-Miss, and Boys-Prep, were stockpiled in warehouses until such time when trademarks and logos were stamped or embossed onto them. For more expensive custom models, a logo or slogan was designed as a seamless part of the figure. Sometimes a fully clothed figure would be cast, and the patterns and colors of the garments meticulously painted on, as was common with drugstore miniatures that advertised support and prosthetic devices. The majority, however, came into the world solely in their birthday suits, minus the genitalia.

Mini-mannequins wore scale-model clothes crafted by skilled seamstresses, with an attention to detail that was far superior to any lavished upon most children's dolls. The bra and girdle ensemble for Camp and the bra for Grenier were exact replicas of the actual versions, down to the zippers and catches. Slips, suits, and dresses were equally authentic. Some studios offered a choice of real, sculpted, or silk-chenille hair. Some designed their mini-mannequins with joints that enabled them to strike poses. As with life-size mannequins, the basic facial features of the miniatures were drawn from live artist's models. New models were introduced every September and eagerly awaited by display men. The display studios either opened their showrooms or mounted installations at the annual convention of the National Association of Display Men in New York. Miniatures sold for $25 to $50, depending upon their degree of articulation. They continued as an accepted style of advertising until the late 1950s, when cardboard and other economical materials became more common.

SEE ALSO *Art Deco, Commercial Modern, Streamline*

Designer: Unknown
Mini-mannequin, c. 1940

MODERNIST

Modernism developed early in the second decade of the twentieth century, a movement of kindred artists, designers, and writers from throughout Europe who believed that a wave of industrial mass production and technological progress had caused profound social repercussions in all realms of society. Art and design had to aggressively lead the culture into the new century. Outmoded styles were replaced with new, reductive formal languages in everything from painting to typography. A movement that addressed ethics and aesthetics ultimately gave rise to a stylistic manifestation.

Modern movements with common traits were founded in Holland (De Stijl), Germany (the Bauhaus), and Russia (Constructivism). Composites and variations of these ideas took root in Czechoslovakia, Yugoslavia, Poland, Romania,

and Hungary, incorporating design languages unique to their respective cultures. These ideas were exported through emblematic reviews, newspapers, and magazines in Europe, the United States, and Japan.

Periodical journals shared and promoted Modernism's universal language. A few of these magazines were bilingual and others were trilingual, such as *Veshch/Gegenstand/Objet*, produced by El Lissitzky and Ilya Ehrenburg, which published in Russian, German, and French. Cross-pollination between foreign artists was encouraged: Ideas of

FORTSCHRITT-STUHL

Dutch artists influenced Germans, which in turn impacted Russians, and so on. Theo van Doesburg helped found De Stijl and its journal of the same name that influenced the content and look of certain Bauhaus and Bauhaus-inspired periodicals. By the mid-1920s the Bauhaus was the most recognized of Modern pedagogical institutions. It was not the sole magnet for international students, but it was the most publicized owing to its copious publication program, which inspired other periodicals throughout the network.

In its critical rejection of archaic central-axis type composition and ornamental design the New Typography was presented as a tool of artistic revolution.

Elementary typography incorporated radical thought into quotidian communications and was constructed on the armature of geometric grids with prescribed typefaces as an alternative to the status quo. Although there were some exceptions to the basic tenets, sans serif typefaces, bold horizontal and vertical bars arranged like a Mondrian painting, masses of geometric shapes, and often the color red were the superficial manifestations that gave the phenomenon a graphic identity. But the Modern

movement's vanguard typographic language is more importantly related to upheavals in twentieth-century painting, architecture, and poetry.

Although the Nazis closed the Bauhaus and laid waste to the wellsprings of Modernism, the ethic and aesthetic continued to simmer and came to a boil after the war. In Switzerland, Max Bill, a former Bauhaus student—among other exponents—promoted Modernist thinking and contributed greatly to the Swiss style, or International Typographic style, the next generation of European Modernism. SEE ALSO *Art Deco, Art Deco Type, Bauhaus, Constructivist, De Stijl, Futura, Helvetica, International Typographic, New Typography*

Designer: Lester Beall
Magazine cover, 1937

WILLIAM SANDBERG: *KEYWORDS*

Keywords is a 1965 collaboration between Dutch designer William Sandberg and editor Jurriaan Schrofer to honor their elder contemporary, Piet Zwart. The idea of the project was to publish many of Zwart's "keywords" and phrases that defined the theory and practice of his work.

Sandberg worked in a modified version of New Typography, his text sans serif, unjustified, and boldly floating in a sea of white space. Anchoring the type, though, are his colorful cut paper letterforms and abstractions. *Keywords* begins with a cut paper key above a "w" punning on the title and winking at Zwart, whose playful design work was, if not echoed in Sandberg's sparseness, certainly related to its wit.

Throughout the book Sandberg uses large cut paper letters as compositional tools, creating a lower case "t" to rudely break a page devoted to rebellion. Or once again winking at Zwart by spelling out the master's name in three-color cut paper letters across from a quote from Zwart that "I have nothing against color, but everything against flirting with color." Another design mode in *Keywords* is abstract illustration. Next to Zwart's thoughts on the "tasks of functional typography" Sandberg has constructed a picture that could be cuneiform, a glyph, or a simple abstraction. Other abstractions more closely resemble the pithy geometric compositions of his Bauhaus forebears, though the rough edges of the cut paper put the stark shapes into a soft relief. Here his cut paper works evoke the spiritual qualities that frequently underlay the Bauhaus pioneers. The essentialism of sans serif type in a broad white space is well accentuated by mysterious blue shapes, cut from rough, grainy paper.

Sandberg's use of the New Typography points up its most elegant traits: free use of white space, word spacing, unjustified lines, and essential forms. With *Keywords*, the game is one of contrast—hard-edged Modernism against soft paper, each pointing up the singular qualities of the other. It is a fine object lesson in the very virtues embodied in the New Typography. — D.N.

MUSHROOM CLOUD

Fearsome imagery is not always based entirely on the depiction of subhuman stereotypes or frightened human beings. Indeed the most terrifying graphic image of the second half of the twentieth century was not a monster but a cloud.

Spectators described the first atomic bomb blast on July 16, 1945, as "unprec-
edented," "terrifying," "magnificent," "brutal," "beautiful," and "stupendous."
Words failed to truly convey the spectacle; Thomas F. Farrell, an official of the
Los Alamos Laboratory, later said to the press, "it is that beauty the great poets
dream about but describe most poorly and inadequately." And what the inarticu-
late scientists and military personnel in attendance had witnessed was an unparal-
leled event: a thermal flash of blinding light visible for more than 250 miles from
ground zero; a blast wave of bone-melting heat; and the formation of a huge ball
of swirling flame and mushrooming smoke climbing towards the heavens. While
the world had known staggering volcanic eruptions and devastating man-made
explosions, and often throughout history similar menacing shapes have risen into
the sky from catastrophes below, this mushroom cloud was a demonic plume that
soon became civilization's most foul and awesome visual symbol—the logo of
annihilation—the style of the nuclear age.

The mushroom cloud was nightmarishly ubiquitous, especially for young chil-
dren growing up during the late 1940s and early to late '50s, the relentless testing
period of the nuclear age when the United States and the Soviet Union ran their
arms race on ocean atolls and in deserts and underground caverns. The U.S. govern-
ment issued scores of official cautionary pamphlets and the mass media published
countless histrionic paperbacks, pulp magazines, comic books, and other periodi-
cals that fanned the flames of thermonuclear anxiety. The bomb itself (in its vari-
ous unexceptional physical manifestations) was not iconic enough for widespread

use as a modern emblem. But the
mushroom cloud initially represented
superhuman accomplishment. It sym-
bolized righteousness rather than
wickedness. Not everyone embraced
this view. Only a few months after the
end of war one early opponent, former
U.S. Navy Lieutenant Robert Osborn,
an artist whose wartime assignment
was to draw cartoons for training and
safety brochures, published a caution-
ary manual of a different kind. This
time rather than teach sailors and
pilots survival techniques under battle
conditions, his book, titled *War Is No*

Artist: Robert Osborn
Cartoon, 1946

Damn Good, condemned man's incessant and insatiable passion for war.

Osborn created the first protest image of the nuclear age—a drawing of a smirking skull face on a mushroom cloud, which transformed this atomic marvel into a symbol of death. But even Osborn's satirical apocalyptic vision pales before actual photographs and films of A-bomb and H-bomb blasts that were prodigiously made of the many tests over land and under sea. Yet early into the atomic age the mushroom cloud devolved into kitsch. Government and industry promoted "our friend the atom" with a variety of molecular-looking trade characters and mascots. Comic book publishers made hay out of mushroom mania. Atomic blasts, like auto accidents, caught the eye of many comic readers and horror aficionados. Just as real photos and films of atomic tests seduced viewers, fantastic pictorial representations of doomsday bombs blowing up large chunks of earth tweaked the imagination.

The sheer enormity of these fictional blasts, especially when seen on earth from space, raised the level of terror many notches. Similarly B movies in the nuke genre with all those empty cities made barren by radioactive poison exploited the "what if" voyeurism that people still find so appealing. Books and magazine stories covered a wide nuclear swath. Novels such as *Fail Safe* and *On the Beach* (both made into films) speculated on the aftermath of nuclear attack and thus triggered fear (though perhaps secretly promoted disarmament too). But to sell these books, paintings of mushroom clouds were used in ridiculous ways. The cover for *On the Beach*, for example, is absurdly prosaic, showing a woman standing on a seaside cliff directly facing a mushroom cloud while waiting for her lover to return from his submarine voyage to no-man's land. By current standards—even for mass-market paperback covers—this is silly yet effective because the cloud is so incredibly horrific. In actuality, if it can snap us out of mass denial, the mushroom cloud is no less frightening today than it ever was, an indelible sign of terror.

SEE ALSO *Fear*

see Neuland

NEULAND

Neuland, designed in 1923 by Rudolf Koch, is a family of convex-shaped capitals reminiscent of German Expressionist woodcut lettering. Reportedly, Koch did not make any preliminary drawings, which accounts for an informal quality that "expresses an atmosphere of exotic 'flavor,'" as proclaimed in a type specimen brochure distributed by Superior Typography, Inc. (ca. 1923); there is an "unusual expressiveness; a subtle harmony of . . . ruggedness and delicacy of design." Neuland was recommended for advertisements promoting airplanes, boats, books, coffee, gifts, lacquers, rugs, tea, and tours, and was widely used until the thirties, when it was sidelined like so many novelty typefaces. But in 1993 Neuland was revived for the logo for Steven Spielberg's *Jurassic Park*. Just like an aging actor, the old typeface was offered new roles. Whether consciously or not, *Jurassic Park* appeared to have transformed the type into an identity for curiously stereotypical representations of third world, African, or primitive subjects (such as on children's books and posters), not unlike how in the 1940s and '50s the bamboo novelty typeface Chop Suey (a.k.a. Far East Type) was wed to anything deemed Chinese.

S E E A L S O *Bauhaus, Art Deco Type, Expressionist, Novelty Type*

Designer: Rudolf Koch, Type specimen, 1923

NEW TYPOGRAPHY

Designer: Joost Schmidt
Advertisement, 1924

The New Typography was introduced in Germany, and subsequently to the rest of Europe's graphic designers, in the special "Elementary Typography" issue of *Typographische Mittelungen* (*TM*) (October 1925), a prominent Leipzig-based printing trade journal. Guest editor Jan Tschichold, a progressive young typographer from Cologne, was an avid follower of contemporary Russian, German, and Dutch typographic experiments that had grown out of the Modern art avant-garde. In this issue of the usually staid professional magazine, Tschichold collected what was at that time considered the

most audacious work of various avant-gardists. He hoped to influence German designers and encourage printers to adopt the functional, elemental, and dynamic new layout methods emanating from the Bauhaus, De Stijl, and other progressive schools and movements. Although these methods defied conventions, they nonetheless found a level of acceptability as the New Typography was introduced into the mainstream through advertisements, posters, magazines, and trade exhibitions that traveled throughout Europe. In 1928 Tschichold published the handbook *Die Neue Typographie*, which further codified the tenets of asymmetric page design for everyday applications. Eventually this and other manifestos on the New Typography had a huge impact on design practice.

The October 1925 issue of *TM* was not only an aesthetic deviation, it ignited political debate as well. The postwar twenties marked a critical period in German politics. The advent of the Weimar Republic gave rise to major polarities on the political spectrum among right-wing, centrist, and left-wing parties all vying for governmental dominance and popular support. Revolutionary Modern design was perceived as a product of the Left, and so Russian Constructivist, Dutch De Stijl, and German Bauhaus ideals were suspect for harboring political agendas. The Germans were rather unusual in allowing ideology to influence design as they did. It is nonetheless clear from the political broadsides and posters of the

Weimar period that sans serif typefaces did have a symbolic connotation and as the leftist critics of the day described it, "breathed the new."

Since *TM* was not just distributed to members of the Printer's Association, which was apolitical in nature, but rather to all printing and design professionals throughout Germany, Austria, and Switzerland, the inherent ideological issues caused some alarm. Throughout the twenties Austrian and Swiss designers eschewed this trend as qualitatively unacceptable. Only intense lobbying forced a sea change in design attitudes. Although *TM* never intended to lobby or radicalize the traditional design industries to change attitudes, the political side of the New Typography did wash over into literary publications and craft organizations that supported book design, such as the Social Democratic–leaning Büchergilde Gutenberg, which encouraged using sans serif and other novel-for-the-time typography in books. Aligning them-

Designer: Herbert Bayer
Currency, 1923

selves along political lines, different German publishers directed their in-house design departments to work either in the Modern or traditional manners.

To represent the new achievements Tschichold selected principal members of the group known as the *Ring Neuer Werbegestalter* (Circle of New Advertising Designers), who aggressively championed the New Typography as a cure for lackluster design that long prevailed in book and advertising centers throughout Europe. The Ring's adherents included typographers, photographers, and designers with established commercial advertising studios that wed fine to applied art. In Germany the leaders were Max Burchartz's Werbebau in Bochum, Walter Dexel's studio in Jena, and Kurt Schwitters' publication *Merz* in Hannover. Creative interplay was common, and Schwitters, for example, collaborated with foreign

artist-designers including El Lissitzky and Theo van Doesburg, each of whom further pushed the dynamic tension between type, picture, and color. Piet Zwart, Paul Schuitema, and László Moholy-Nagy perfected the practice of "typofoto," integrating type with photomontage. Schwitters was one of the missionaries of the new method and published his own private art and design periodical, *Merz*, to extol the virtues of Modern typography. In *Merz* 11 (1925) he reproduced a selection of advertisements for Pelikan Inks using only bold sans serif type and red and black bars and arrows as a substitute for traditional illustration. These ads were the quintessence of the New Typography.

Bauhaus typography is one subset of the overall New Typography style. Ironically, architect Walter Gropius, who became director of the Bauhaus in Weimar, Germany, in 1915, began his tenure with the mandate "not to propagate any style, system, dogma, formula, or vogue, but simply to exert a revitalizing influence on design." But a style—or at least a palette of recurring graphic traits—did emerge. After World War I, in 1919, typography and graphic design were introduced to the Bauhaus curriculum as integral workshop components, and from these classes emerged a stark geometric element of the New Typography. In accordance with its state charter, in 1923 the Bauhaus mounted its first major exhibition, *Staatliches Bauhaus in Weimar 1919–1923*, which revealed the seismic shift from traditional typography to the Constructivist model in both book and advertising media. The addition a few years earlier of Hungarian Constructivist László Moholy-Nagy to the Bauhaus faculty and the creation of a

preliminary typography course ushered in the experimental phase of Bauhaus typography, notable for its marriage of type and photography. For the Bauhaus catalog, in an essay titled "The New Typography," Moholy-Nagy stressed, "Typography is an instrument of communication. It must present precise information in a suggestive form. Clarity must be emphasized.... For legibility, the message must never suffer from *a priori* aesthetics. The letter types must never be forced into a preplanned form." Designers followed the "form follows function" dictum that

Designer: Jan Tschichold
Film poster, 1927

helped regiment and standardize modern typography.

About standardization, Tschichold wrote, "The aim of typography must not be expression, least of all self-expression. . . . In a masterpiece of typography, the artist's signature has been eliminated. What some may praise as personal styles are in reality small and empty peculiarities, frequently damaging, that masquerade as innovations." Yet the New Typography doctrine of asymmetry stood type on its ear in an effort to garner greater attention. The New Typography broke the conventions of placement and layout as it eliminated ornament and rigidly symmetrical composition. In place of the classical page were "constructed" sans serif typefaces and bold black and red rules designed to fragment the page and control the eye. During the 1920s it was viewed as an extraordinary departure from commonplace design; ultimately even the New Typography, which later influenced the Swiss International Typographic style of grid-based typography, became another set of stubborn rules against which to rebel.

SEE ALSO *Bauhaus, Constructivist, De Stijl, Futura, Helvetica, International Typographic, Modernist*

NEW WAVE

New Wave is a puzzling term. Presumably any novel art or design movement can be generically considered new wave. But this particular style was given the rubric for a collection of interrelated methods and manners. In fact, this New Wave was actually a bridge between late Modern and Postmodern styles that emerged during the digital age.

It surfaced in the late 1970s as a hybrid Modernism, a melding of European and Swiss International style precursors with a Punk sensibility that evolved from formal and personal experiments into a commercial trait. With international derivations, it took root in the United States and England. In Los Angeles and San Francisco it washed ashore as Pacific Wave, with the sprightly and colorful design of Michael Vanderbyl, Michael Manwaring, and Michael Patrick Cronan,

LEFT
Designer: John Van Hamersveld
Art Director: Leonard Koren
Magazine cover, 1980

RIGHT
Designers: David Sterling and Jane Kosstrin
Magazine cover, 1980

FE=T=SH

The Magazine of the Material World

Fall 1980

Synthetics

$2.00

Johnson on Johnson **Birthday Barbie** Lily Tomlin's
Betsey speaks **Unnatural Resources**

which symbolized the California aesthetic. The 1984 Olympics graphics designed by Deborah Sussman and Paul Prejza epitomized a carnivalesque modernity that fell neatly under one section of the New Wave umbrella. In England it took on an edgier aesthetic in Neville Brody's design for the *Face*, which transformed influences of twenties avant-garde Modernism into a resolutely contemporary vocabulary.

Just before this, the appearance of work in the United States by the Basel-educated American designers April Greiman and Dan Friedman was a marked departure from 1970s corporate Modern sensibilities. Eclectic typography and illustration and soft pastel colors, New Wave traits, were originally introduced by Push Pin Studios in the late '50s and early '60s. But Greiman's typographic contribution was less nostalgic than futuristic. In the early 1970s

Designer: Terry Jones
Photographer: Thomas Degen
Magazine cover, 1981

Greiman studied with Swiss designers Armin Hofmann and Wolfgang Weingart at the Gewerbeschule, and became one of the foremost interpreters of the Swiss grid-busting Weingart approach, though not a carbon copy. She too broke from the strict Swiss grids, but retained a disciplined sense of proportion. The bold sans serif Univers type used in her design for *WorkSpirit*, a newsletter for the furniture company Vitra—set in juxtaposed light and heavy weights with heavy accent rules, extreme leading, wide letterspacing, and layered over bright colored images—indicated a distinct break from the dominant Swiss International Typographic style and was a signpost for the new wave of typographic composition that followed. Friedman's 1975 redesign of the Citibank identity, with its graduating colors and differing weights of sans serif type, was a unique new way of addressing mainstream visual communications.

Friedman, who was schooled in both the science-based rationalism of Germany's Ulm school and the intuitive logic of Weingart's convention-smashing typogra-

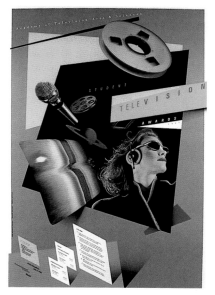

Designer: April Greiman
Poster, 1981

phy program at the Basel school, was an opponent of the Swiss School or International Style that dominated American corporate design. As a teacher at Yale and the State University of New York at Purchase in the early '70s, he introduced students to approaches that included linguistic and perceptual theory. Friedman challenged corporate Modernism in both theory and practice by creating an oeuvre that adapted original Modern humanist ethics while transcending its functional blandness. Abstract form and bright color typified his contribution to New Wave.

New Wave veered towards the new

Designers: April Greiman
and Jayme Odgers
Art Director: Leonard Koren
Photographer: Guy Webster
Magazine cover, 1979

technologies in early 1982, when Greiman was given early access to state-of-the-art video and digitizing equipment formerly used by Nam June Paik. With Jayme Odgers she began to integrate photomontage and type in posters and brochures that proffered a futuristic receptivity. The Macintosh was introduced in 1984 and by 1986 Greiman pioneered the marriage of text to digitized video images. The line between New Wave and other contemporary, digital methods found in Deconstruction and Grunge is vague. At a certain point the traits of one blend into the other and clear delineation of New Wave style becomes murky.

SEE ALSO *Deconstruction, Grunge, International Typographic, Modernist, Panter, Postmodern, Push Pin*

FIORUCCI'S PRINTED OUTPUT

Elio Fiorucci opened the first Fiorucci clothing store in 1967 in Milan, having built his reputation on shoes. The emphasis was on the outrageous, the overly fashionable, and the ever hip, and to that end, Fiorucci refused to advertise. Instead, his stores and clothing established a graphic identity through items such as their tags, stickers, and shopping bags in addition to the odd printed matter here and there. And the graphics were New Wave just ahead of and on its crest, their Day-Glo colors and constantly mutating logos making these supposedly throw items as desirable as the clothes, then popular among celebrities and the fashion elite. New Wave design was inherently commercial, combining the pyrotechnics, colors, abstractions, and absurdism of psychedelia with Art Deco type and rigidity and, in using floating geometric shapes, even dipping back to Constructivist ornamentation in bright, off-register colors.

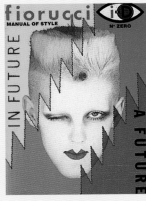

As Fiorucci did it, the style was all of that—and scantily clad women. At their more conservative, the Fiorucci images resembled souped-up Art Deco, its lines softened, colors brightened, spawning a neon line or two. Subjects of these graphics might be highways, flying saucers, and robots. The Fiorucci *Manual of Style*, however, takes it to the (two-color) hilt. Produced in conjunction with Terry Jones of that other New Wave fashion icon, *ID*, it alternates signatures of neon green, blue, pink, and orange, featuring tilted and tipped photographs of young artistes in Fiorucci clothes, surrounded by flying triangles and computer-like etched borders and graphics. Fiorucci's printed output may best be summed up on the final page: "Fuck art—let's dance." — D.N.

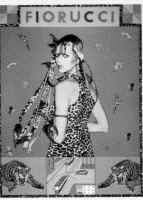

NOVELTY TYPE

Goudy Stout was designed in 1930 by Frederic W. Goudy, one of America's otherwise foremost type designers: "In a moment of typographic weakness I attempted to produce a 'black' letter that would interest those advertisers who like the bizarre in their print," Goudy admitted. "It was not the sort of a letter I cared for."

Even luminaries blunder when they succumb to the unpredictable tastes of the commercial marketplace, consequently in the name of style a rather long list of talented type designers have perpetrated typographic crimes and misdemeanors. Among them (though certainly subject to intense debate) are Hermann Zapf's Sapphire, Emre Reiner's Floride, Morris F. Benton's Hobo, J. Hunter Middleton's

Plastica, A. M. Cassandre's Acier Noir, and Roger Excoffon's Calypso.

Benton's Hobo, which was a best-selling press-type and Typositor film font for many years, aged poorly. When issued by the American Type Foundry and Intertype in the early 1920s, Hobo had fashionable, Art Nouveau characteristics that made it a viable advertising display face. Its vertical strokes and curved bars with the variation of stress on different letters gave it a quirky character and eye appeal; the elimination of all lowercase descenders saved on space. In the right designer's hands Hobo isn't half bad as a decorative alphabet, but used incorrectly, the results can be abominable.

Decorative, ornamented, or novelty typography dates from the early nineteenth century and the Industrial Revolution. A primitive form of print advertising replaced the tradesman as the primary hawker of goods. In *Printing Types: An Introduction* (Boston: Beacon Press, 1971) Alexander Lawson wrote: "Early in the nineteenth century English typefounders produced a variety of embellished types designed to emphasize their unique characteristics for the single purpose of attracting attention. Fat faces, grotesques, and Egyptians—decorative types when compared to the Romans that had undergone but minor changes since the Italian fifteenth-century period—were not flamboyant enough for the new requirements of advertising display."

Typefounders discovered that virtually any quirky design would be purchased by job printers for advertising, broadsides, and packages. Initially the ornamented types were inline or outline versions of the Didot, Bodoni, and Egyptian styles, but designers turned from altering existing faces to creating more unique and outlandish inventions. In the Victorian manner, letterforms mimicked the appearance of Gothic architecture and were intricately designed with filigree, like that applied to cast-iron industrial machines.

Concerning fashions in typefaces, the *Typographic Advertiser* (1879) offered the following: "We change, tastes change, fashions change. The special furor is now for bric-a-brac—antique pots and platters, Japanese oddities, and Chinese monstrosities. But fashion's rule is despotic, as so, yielding to her commands, we have prepared and show in this number some oddities to meet the taste of the times. . . . As printers no doubt desire to be in fashion, we trust they will approve our course by sending in orders for them, that their patrons also may catch the infection. . . ."

As the Victorian era came to an end the passion for extreme ornament also faded. A renewed interest in typography of classic origin contributed to the demise. In *The Practice of Typography* (1900) Theodore Low De Vinne offers this eulogy: "Printers have been surfeited with ornamented letters that did not

0792-1n
Allen Surreal O*M Vol.2 p.656

Has Anybody Seen Our Shi

1955n
Norton Nautical O*W*M Vol.2 p.702

It Might as Well Be Springti

1963-4n
Norton Noose O*W*M Vol.2 p.702

CHRISTMAS COMES BUT ONCE A YEAR

2454-3n
Hollyberry O*M Vol.2 p.706

CONFUCIUS SAY TAKES 2 TO MAKE QUARR

5229n
Governale Bamboo O*M Vol.2 p.707

CONIFEROUS - OR DO NOT FORGET TH

2025-2c
Rustic No.222 T*M Vol.2 p.707

PHOTO-LETTERING always has the Red Hot Alphabe

4597n
Flame Top O* '69 Yrbk p.1254

FAST FAST FAST RELIEF from type inflexibility

4595n
Speedway O* '69 Yrbk p.1254

STRIKE WITH A FLASH OF LIGH

6357n
Stan Flash O*

THE FIRE HAS NOT GONE OUT JOSEPH

1576-3n
Norton Chocolate Frosted O*W*M Vol.2 p.701

NAVAJOS ORGANIZE INDIAN CLU

3479-3n
Indian Clubs O* Vol.2 p.708

THE LIFE BLOOD OF THE FOUR

1831-4n
Newsboy O*M Vol.2 p.701

ornament and did degrade composi-tion, and that have been found, after many years of use, frail, expensive, and not attractive to buyers." However, De Vinne further notes that "more changes have been made in the direction of eccentricity than in that of simplicity. Fantastic letters were never in greater request, but they rarely appear as types in books. To see the wildest freaks of fancy one must seek them not in the specimen books of typefounders, but in the lettering made for displayed adver-tisements and tradesman's pamphlets."

At the turn of the century, designers working in the Art Nouveau style rejected the nineteenth-century excesses, but replaced them with "floriated madness," which was eventually rejected by those designers who sought yet another style. The vogue for the decorative letter was somewhat eclipsed during the 1920s by the canon of purity and functionalism espoused by the Bauhaus and Jan Tschichold in his book *The New Typography* (1928). However, despite the proliferation of functional sans serif types like Futura, advertisers required eye-catching type to appeal in an increasingly competitive market.

During the 1920s and '30s—the Art Deco era—quirky types were issued by the major German, American, English, Dutch, and French type foundries and promoted through extravagant type specimen sheets. Many of these faces symbol-ized modernity. Although type design has traditionally been based on past models, typographers today are routinely archaeologists digging through antique type books for faces suitable for revival or adaptation. While the revivalists pay homage to the past, the computer mavens are looking towards the future. But the future of quirky typography is *déjà vu*. Primitive, low-resolution bitmap forms have offered numerous possibilities for quirky typography equaling the worst produced during the nineteenth and early twentieth centuries, but in the right designer's hands, there is also an unlimited variety of fascinating concoctions.

SEE ALSO *Art Deco, Art Deco Type, Art Nouveau, Chantry, Cooper, Cuba,*

Emigre, Generic, Matchbox, Me-Too, Neuland, New Typography, Show-Card, Vegas, Victorian

see Object Poster

OBEY THE GIANT

Shepard Fairey created a style out of a face. Not his face, but the visage of a cult figure, André the Giant. André (a.k.a. André René Roussimoff, who was born in Grenoble, France, on May 19, 1946) was a seven-foot, four-inch, five-hundred-pound professional wrestler, who in the late '70s and '80s drew record crowds to his matches. But his second bout of fame came when Fairey, a Rhode Island School of Design illustration program student, borrowed and slightly altered his image as a high-contrast Kodalith and printed it on stickers that were pasted everywhere. Soon they became an enigmatic logo, a mark that raised the question "what does it represent?" According to the wily Fairey, the stickers were intended to be open to individual, often conflicting, interpretations. They could be taken as an Orwellian threat, an underground cult, or a sneaky sales ploy. Anyone who recognizes the face of the late André the Giant, who died in 1997 of a heart attack, might think it has something to do with wrestling mania. But the actual meaning, and the growing style that surrounds it, continues to evolve, even for its creator.

ABOVE
Designer: Shepard Fairey
Sticker, 1996

The first Obey the Giant manifestation was a sticker, black-and-white and about three inches square, printed at a Kinko's in 1989. Stickers have been a medium of choice for alternative

LEFT
Designer: Shepard Fairey
Poster, 2003

RIGHT
Designer: Shepard Fairey
Poster, 2005

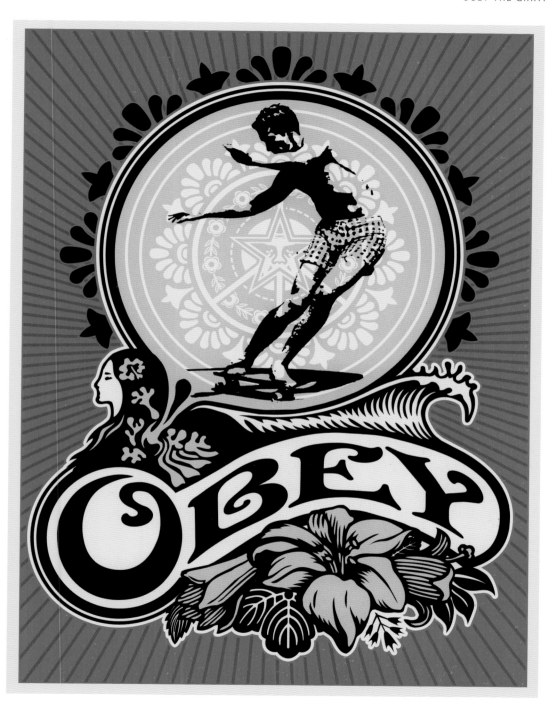

Greetings FROM IRAQ
"ENJOY A CHEAP HOLIDAY IN OTHER PEOPLE'S MISERY"

Designer: Shepard Fairey
Poster, 2005

groups since the '60s. Fairey's original artwork was a grungy photocopy made from a found newspaper ad. The text he used, "André the Giant has a posse," referred to Fairey's fellow skateboarders, who traveled in cliques called posses and decorated their boards with corporate logo decals and stickers. Fairey's satirically faux logo managed to catch on. Soon it grew into a "statement" with universal social implications.

By taking something absurd with no intrinsic value, "like an athlete from a bogus white-trash sport, and elevating it into an icon," explains design critic Michael Dooley about Fairey's intentions, "he's exposing consumer culture's susceptibility to propaganda." He prefers using an oblique approach because he hates stuff that's too self-righteous. "Rather than subject people to sloganeering, he wants them to have their own epiphany."

What started as an art school prank has turned into a style, and has become a single-minded obsession. Every weekend Fairey posts stickers, sprays on hand-cut stencils, and wheat-pastes posters that convey pitches that subvert common advertising. Billboards are a favorite venue for hijacking messages. He once "hijacked" a dozen Sprite "obey your thirst" boards up and down the California coast, obliterating everything but "obey" and turning them into Giant boards. He believes that any unadorned surface is fair game for his art, which pays homage to the Dadaists or Situationists.

What began as antiadvertising—Giant was a silent spokesperson without a product—has now become its own style and brand, complete with a line of T-shirts, hats, and backpacks. Fairey says, "People justify buying some new $80 shampoo because they need to wash their hair, even though they could get the same thing at the 99¢ store. But when they buy the Giant shirt it peels back all the veneers people use to shroud themselves in justification for all the other stupid stuff." He doesn't seem to worry about the contradictions inherent in transforming the antiestablishment into an establishment all its own.

SEE ALSO *Agit Retro, Chantry, Dada, Kodalith, Psychedelic, Skateboard*

OBJECT POSTER

In the beginning of the early nineteenth century commercial advertising relied on words because pictures were just too costly to reproduce. Ideas and messages were communicated through words set in wood or metal typefaces, printed in multiples, and posted on any empty surfaces. Walls, fences, and hoardings were covered with bold letters announcing miraculous patent medicines, derring-do entertainers, and honest-as-the-day-is-long political candidates. In fact, there were so many words that printers, the craftsmen fundamentally responsible for producing advertisements, could garner attention only by using the most raucous of letterforms. Larger, bolder, decorated letters were akin to screaming hawkers. But amid the cacophony of Tuscans, Latins, Egyptians, and novelty faces, a poster or broadside had to be more than just loud, it had to jump off the wall, onto the street, and into the public's consciousness.

Imagery was key. With the advent of chromolithography during the late nineteenth century a sea change in advertising and graphic design occurred. The reproduction of colorful tonal pictures gave birth to popular art that not only persuaded but entertained. With this new technology artists developed looser styles

Designer: Lucian Bernhard
Poster, 1914

consistent with painting. The resulting posters were large canvases filled with fanciful figures, mirthful metaphors, and chromatic colors, capped by artful letters. But artists being artists were not content to use one method alone, and so from the earliest academic renderings the visuals evolved into various graphic styles that became increasingly more complex—and then as a reaction, more simplified. An early-twentieth-century advertising movement in Germany

Designer: Lucian Bernhard
Poster, 1914

known as *Plakatstil* (poster style) was the umbrella for a submovement known for extreme simplicity known as *Sachplakat* (object poster).

Sachplakat's erstwhile inventor was an eighteen-year-old German cartoonist named Lucian Bernhard, who, in 1906, entered a poster competition sponsored by Berlin's Priester match company. The prize was fifty marks, a published piece, and a possible contract to do artwork for Hollerbaum & Schmidt, Germany's leading poster printer and advertising agency. As the story goes, Bernhard's first sketch was typically Art Nouveau (or Jugendstil): It included a cigar in an ashtray on a checked tablecloth with dancing nymphets formed by the intertwining tobacco smoke. Next to the ashtray were two wooden matches.

A friend mistakenly complimented Bernhard on the excellent *cigar* advertisement, which forced him to rethink the composition and one after another he eliminated the tablecloth, ashtray, cigar, and smoke, leaving only the two matches. Next, he enlarged the matches, painted them in red with bright yellow tips, and placed them on a dark maroon field. At the top of the image area he lettered *Priester* by hand in bold block letters.

The jury summarily discarded this entry as being much too spare. Yet

Designer: Lucian Bernhard
Poster, 1913

arriving late, the chief representative of Hollerbaum & Schmidt, Ernst Growald, retrieved Bernhard's work from the trash bin and announced that this was his winning choice. A big, boisterous man, Growald held sway over the other jurors asserting that this was the next wave of advertising. So Bernhard was given the cash award, the poster was printed and posted around Berlin, a contract was signed for additional work, and Sachplakat was born.

Art Nouveau met its demise not because of Bernhard's arbitrary invention, but because style was rapidly changing to meet new commercial demands. Industrialization, the growth of cities, the increase of vehicular traffic, and the fast pace of everyday life required that advertisers furiously compete for attention. Visual complexity no longer achieved the desired results. The industrial cities were too fast-paced for contemplative graphics. Growald understood this and Bernhard did too. The alternative was bright color, stark imagery, and bold headlines; usually the company's brand name was enough.

Designer: Niklaus Stoecklin
Poster, 1941

This was before the era of multinationals with diverse subsidiaries; one company produced one product, which may or may not compete with another company producing the same product. There may have been other match companies in Germany in 1906, but once the Priester poster was hung on the hoardings no other brand entered the consumer's mind. The same holds true for Steinway pianos, Manoli cigarettes, Frank coffee, and the many other products that Bernhard (and his Berliner Plakat cronies) advertised in this manner. The combination of word and image was invincible. The object poster was a verbal-visual sentence that worked best when hung in multiples of three or more consecutively in a long line, which created a visually rhythmic refrain—Priester, Priester, Priester. The concept is not unlike the constant barrage on radio or TV of repetitious

231

ABOVE
*Designer: Lucian Bernhard
Poster, 1914*

RIGHT
*Designer: Lucian Bernhard
Poster, 1913*

LEFT
*Designer: Lucian Bernhard
Poster, 1913*

jingles and slogans, but a well-designed row of Sachplakat posters was memorable without being annoying.

The object poster remained popular from 1906 to around 1914, when the Great War in Europe brought rampant commercialism there to a crashing halt. During the war wordy slogans and complex renderings sold patriotism as well as what few products remained. After the war advertising techniques shifted once again and a variety of new Modernist ideas began to take hold. Eventually it returned through artists like Niklaus Stoecklin.

SEE ALSO *Art Deco, Art Nouveau, Hohlwein, Modernist, Schutzmarken*

see Peignot

PANTER

Gary Panter's style has ratty line, eccentric yarns, and quirky characters. Jimbo, his postapocalyptic, neounderground comix hero of the late '70s, helped define the Los Angeles Punk aesthetic and is today a cult icon. Panter is nonetheless a master of disguise, one style today and another tomorrow yet each his own. His venues change too, from wall to page to stage to screen. He functions on his own terms, in his own space, and with his own esoteric inspirations from Japanese film monsters and Mexican magazine ads, to Dante, Boccaccio, Joyce, and Dick (Philip K., that is). "He certainly stays in touch with his inner nitwit and inner child, but he's clearly a thoughtful artist," says Pulitzer Prize–winner comics artist Art Spiegelman in an interview for *Metropolis*.

Panter's art is bolstered by moral and aesthetic contradictions. His drawing can be at once wretchedly grotesque and extraordinarily charming. He delights in the underbelly and revels in the prosaic yet the marriage of these opposites is incredibly resonant and genuinely exquisite. His pictures sometimes look as though they were rendered with a fork, but each line, mark, or splotch has an expressive pur-

pose. Panter's work is a dissertation of twentieth-century subcultures—how he fuses the likes of Godzilla and other sci-fi creatures with old American toys, Twiggy, Raquel Welch, Jim Morrison, Frank Zappa, Mama Cass, Elvis, Bruce Lee, monster trucks, Yul Brynner in *Westworld*, "Famous Monsters of Filmland," and really bad candy packaging is key to his art.

Designer: Gary Panter
Alphabet, 1999

Artist: Gary Panter
Comic book cover, 1997

Panter does not exploit the vernacular, but rather addresses its societal influence in multilayered narrative sequences that celebrate love and hate of consumer culture. He is the poet of postmodern maleness, this weird hidden energy that society denies whether it be in violence or sexuality. "As an underground cartoonist transgression is my business—and yea verily I have transgressed, mightily," Panter admits. "I really liked that there was once an underground in which you could seek for secret knowledge and maybe not find it all at once or easily. Now you just type in 'forbidden knowledge' [on a search engine]. It seems like the Internet may be destroying that filtering process. I would not want the clock turned back to before 'Ren and Stimpy,' but personally I would like to make something as wide-eyed and amazing as old Mighty Mouse cartoons."

When in the early 1970s he emerged as a comic strip artist the alternative cartoonists were following R. Crumb. Panter moved through the surreal end period of that time without any relation to drugs as catalyst. He created an interior landscape that touched down on reality. And he also forged a more-is-more approach to cartooning, the counterpoint to the benign less-is-more of, say, Charles Schulz. "Panter was revealing a new kind of visual density," says Spiegelman, "but the marks didn't look like Basil Wolverton [the '50s master of Byzantine intricacy]. It was more like Cy Twombly and a whiff of art school entering the cartoon planet. Here is somebody who had a knowledgeable interest in high art concerns."

In the '70s Panter started drawing "Jimbo" comic strips for *Slash*, the Los Angeles Punk magazine, and he made things crazier and uglier than anyone else. Jimbo is his most alter ego–like, unifying entity that has agelessly endured for almost thirty years. A transcultural enigma clad in a tartan loincloth with buzz-cut hair, Jimbo emerged fully formed in a cartoon story of 1974 called "Bowtie

Madness." Panter allows that Jimbo resembles "Joe Palooka, Alley Oop, Dennis the Menace, and my friend Jay Cotton." Jimbo will never be as popular as Homer or Bart Simpson (although bootleg T-shirts of Jimbo are in demand), but his character has emotional and philosophical depth, and his story, like life itself, is an odyssey with a past, present, and future. Like most ongoing comic book characters, readers can dip into Jimbo's life at any point along the continuum.

Jimbo is also the protagonist in Panter's most ambitiously transcendent comic strip, a reinterpretation of Dante's *Purgatorio*, titled "Jimbo in Purgatory." Panter drew a single panel each night (after putting his young daughter to bed) for three years in order to complete the twelve panels on each of the thirty-three *New York Times*–sized pages. Every page is devoted to a chapter or canto illuminated with a staggering array of densely composed characters and scenes, precisely built upon a stoic grid and hypnotically framed by intricate decorative ornament. Panter spent several years studiously comparing Dante and Boccaccio to find everything they had in common and then found countless additional literary and pop references to Dante, which he injects into the dialogue balloons of the reinterpreted cantos. In the original Dante is led by the Roman poet Virgil on a journey of the soul from chaos and ignorance to enlightenment using the imagery of the Catholic religion. As a stand-in for Dante, Jimbo (who in an earlier comic strip was imprisoned for resisting arrest) is guided by Valise, a parole-robot, who is a small ambulatory valise that resembles a miniature Corbusier house. And the rest is pure Panter both style and substance.

SEE ALSO *Comics Lettering, Do-It-Yourself, Underground Press*

PASTICHE

Since graphic design is rooted in common visual idioms, shared and altered tropes quickly become vernacular. Originality is secondary when messages must be quickly and efficiently communicated to a mass audience, therefore sampling is not only convention, it is a bona fide mannerism that includes pastiche as its defining characteristic.

PASTICHE: *a. A dramatic, literary, or musical piece openly imitating the previous works of other artists, often with satirical intent.*

b. A hodgepodge.

In a 2005 *New Yorker*, two full-page advertisements were done in a late 1930s and '40s American Streamline pastiche; each was heavily airbrushed and reminiscent of work by modernistic designers Joseph Binder, Otis Shepard, and Sacha Maurer,

known for their stylized travel, transportation, and ski posters. Although this is not the first time their respective styles have been reprised and composited for contemporary purposes, they conformed to a style known as Retro.

R E T R O *: Involving, relating to, or reminiscent of things past; retrospective: a fashion, decor, design, or style reminiscent of things past.*

Why would a designer use or, for that matter, a client, accept Retro or Pastiche? Retro certainly frees the designer from starting at zero. Borrowing existing mannerisms provides familiar codes with limited risk. Both of these *New Yorker* ads appear as though they were torn from vintage poster books. One for Amtrak's online reservation service and the other for Redwood Creek wine, both have logical albeit superficial conceptual links to their products, but neither service or product screams out to be treated as passé.

All brands need to appear new yet familiar. Retro design reconciles this paradox quickly if handled with care. Retro can give new brands instant heritage and old brands a chance to flag their origins and authenticity, even if none exist. Retro

Designer: Unknown
Advertisement, 2005

is one of the more dependable tools for sparking a certain kind of consumer interest—in certain products. The ad for Amtrak suggested that even in an age of high-speed travel (the campaign was launched before the Acela trains were ignominiously suspended) one can still enjoy a luxurious train ride, just like grandma and grandpa did. An ad for Redwood Creek transports the consumer back to the rustic elegance of old California mountain lodges seen in some late '30s noir films. These ads exude a sense of history and tradition, even if such never existed. And if nothing else, the look is a stylistic diversion from the contemporary.

But some argue that Retro Pastiche is not a design style at all but a marketing term invented by retailers, a catch-all used to label products inspired by the past (one hundred years ago or ten

Designer: Mark Michaelson
Magazine cover, 1988

years ago) and to inveigle products into consumers' consciousness.

Various top brands have developed limited-edition boxes and tins that look like vintage packages. Procter & Gamble's vintage Ivory soap package and Band-Aid's collector's edition set of tins featuring graphics from the 1950s and '60s touch an emotional chord. In this excessively high-tech age consumers seem to carry a special fondness for Retro facsimiles—everything from PT Cruisers to Jukebox DVD players—and the past is a safe haven for "creatives" afraid to test the boundaries.

Another reason for quoting the distant or recent past is appreciation of that past. Graphic design, like art itself, is assembled upon layers of history, sometimes a synthesis of, or even a reaction against previous methods and styles. Many designers who draw from historical references object to the Retro label as shallow and pejorative. Rather than rob tombs to create indulgent novelties these designers are sincerely influenced by various historical forms, which are integrated into their respective styles.

Historical styles are also perfect for telegraphing specific codes that are deliberately used to manipulate perception and trigger consumer response. Some key examples include:

Victorian = Historic

Russian Constructivism = Revolutionary

Bauhaus = Progressive

Art Deco = Elegant

Streamline = Speed

American Socialist Realism = Optimism

Psychedelic = Drugs

'50s Atomic and '70s Disco = Goofy

'80s = Hipster

Sometimes the tropes of stylistic periods are applied more or less in the actual spirit of the original, other times as strained reinterpretations. Sometimes they are used without a shred of irony, other times steeped in it.

For two decades, since around the same time that graphic design history courses began being taught in design schools, there has been an increase of Bauhaus-inspired and Russian Constructivist "New Typography" on ads, book jackets, posters, and CD covers (where relationships are tangential at best) and some have even been awarded medals in design competitions. Sometimes the only explanation is that the designer, recently introduced to the respective styles, has an

Designers:
Shadowplay Studios
Gareth Smith, Jenny Lee,
Ari Schter-Zelter
Movie titles, 2006

uncontrollable urge to copy them. Occasionally though these styles are cleverly reprised as in the music video for Franz Ferdinand's "Take Me Out," which pays loving homage to Dada, Surrealist, and Constructivist styles through ingenious animation of the most iconic graphic tropes in sync with the music, going beyond the clichéd reprises to a new inventive level.

To find the origin of Pastiche, however, it is necessary to go back to antiquity to find one culture borrowing ornament and architecture from another. In the late nineteenth century Pre-Raphaelites and the Arts and Crafts movement dug up the Gothic past for inspiration, just as in the mid-twentieth century Push Pin-ites returned to Victoriana, Art Nouveau, and Art Deco for aesthetic nourishment. One needn't be a devout nostalgist to reprise the past; designers known for their unequivocal Modernism have built graphic styles on historical form. Alvin Lustig's early 1950s book covers for Noonday Publishers composed almost entirely of Victorian slab serif and script wood typefaces reflect his interest in these letterforms, derived from an appreciation of typographic history and access to a trove of these fonts. His early metal type compositions where he constructed a series of abstract designs out of printer's furniture can be seen as a kind of Retro. Designs made from metal typecase and printing materials were common avant-garde tropes during the 1910s to '20s used by Futurist, Constructivist, and Bauhaus typographers as

Designer: Seymour Chwast
Brochure cover, 1988

the modern alternative to ornamental *fleurons*. In 1940, Lustig was proprietor of his own metal type shop in California and took metal furniture from his typecases to design abstract cover and chapter divider pages for the book *Ghost in the Underblows,* by Alfred Young Fisher, for the Ward Ritchie Press.

Styles developed in their own historical contexts for particular reasons. The early 1900s, for example, saw a throwback to nature and organic forms in stark contrast to the geometric shapes of the modern Industrial Revolution that was changing the world at the time. Art Deco was a means of bridging the bourgeois need for ornament and the Modernist disdain for it. Perhaps today the

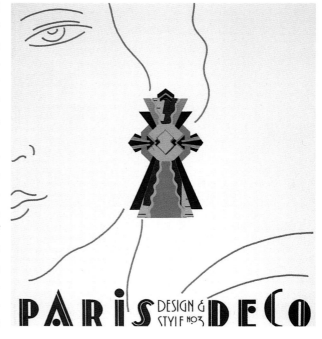

Designer: Ross MacDonald
Poster, 2001

technology revolution instead of the Industrial Revolution governs what is Retro Pastiche. Curiously, technology has no look and no form (and perhaps no politics) to inspire a visual movement. This lack leads to the perpetual question that designers from all disciplines constantly deal with: What should it look like? And it is in a stylistic vacuum like this that Retro Pastiche tends to be frequently used, and all too often abused.

SEE ALSO *Art Deco, Art Nouveau, Arts and Crafts, Bauhaus, Constructivist, Dada, Futurist, Modernist, Psychedelic Poster, Push Pin, Socialist Realist, Streamline, Surrealist, Victorian*

PEIGNOT

In the 1920s the future of typography rested on German experiments like Paul Renner's Futura (1927), the typographic emblem of modernity. In an attempt to outdo Renner, poster artist A. M. Cassandre and Deberny & Peignot proprietor Charles Peignot launched investigations that led to a sans serif face notable for its thick and thin body and the use of uppercase letters for its lowercase form, which Cassandre christened Peignot— a testament to his boss. The face was actually the offspring of two parents: the Bauhaus and the Renaissance. After many false starts, Cassandre and Peignot decided to follow traditional lines, while at the same time avoiding copies of what had been done before. "Copying the past does not create a tradition," wrote Peignot in *Arts et Métiers*

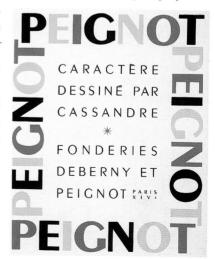

Designer: A. M. Cassandre
Type specimen, 1937

Graphiques. Cassandre had the idea of returning to the origins of letterforms. "Was there not something to be learnt from the semi-uncials of the Middle Ages?" queried Cassandre. "The idea of mixing the letter forms of capitals and lowercase seemed to us to contain the seed of new developments within traditional lines." The result was a quirky mixture of letters, which Peignot knew would require a period of adjustment for the public to get used to. In 1937 the typeface was launched as the official typeface of the World Exhibition in Paris, selected by Paul Valéry for inscriptions for the two towers of the Palace de Chaillot. A fabricator produced cardboard cutouts for making complete alphabets, and these were also used for murals and exhibition stands. The response to the type was overwhelming, and the face became widely used throughout France: it personified Art Moderne Paris. Like a proud father, Peignot kept tabs on how the face was used for the years that followed.

S E E A L S O *Art Deco, Art Deco Type, Bauhaus, Futura*

PICTOGRAM

The ISOTYPE (International System of Typographic Picture Education) was introduced in 1936 by Otto Neurath and his wife Marie as a set of pictographic characters used "to create narrative visual material, avoiding details which do not improve the narrative character," as Neurath wrote in a pamphlet explaining his creation. The Isotype was originally designed as an alternative to text, a starkly visual means for communicating information about directions, events, and objects, on the one hand, and complex relationships in space and time on the other.

Neurath believed that Isotype, also referred to as pictogram, icon, or symbol, could be the world's universal pictorial language and would transcend national

boundaries. Doing so it would decrease overall illiteracy through increased visual literacy. Neurath's method (also known as the Vienna School) was rooted in a simple graphic vocabulary of silhou-etted symbolic representations of every-thing from men and women to dogs and cats to trucks and planes. His collection of icons constituted a kit-of-parts that could be applied to solve any informa-tional or statistical problem. In addition

Designer: Gerd Arntz
Magazine cover, 1930

242

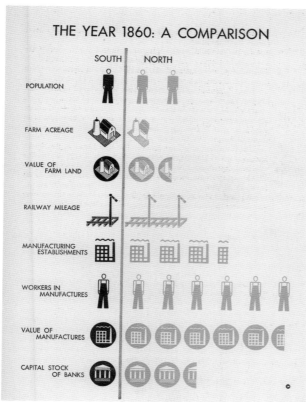

THE YEAR 1860: A COMPARISON

SOUTH NORTH

POPULATION

FARM ACREAGE

VALUE OF
FARM LAND

RAILWAY MILEAGE

MANUFACTURING
ESTABLISHMENTS

WORKERS IN
MANUFACTURES

VALUE OF
MANUFACTURES

CAPITAL STOCK
OF BANKS

*Designer: Rudolf Modley
Information graphic, 1937*

to generic human figures, Neurath's artists—notably Dutch symbol designer Gerd Arntz, and Viennese Augustin Tschinkel and Erwin Bernath—introduced clear descriptive characteristics to distinguish, for example, laborers, office workers, brides, grooms, soldiers, and police officers from other professions and stations. The silhouette was preferred for a dispassionate authority that eschews personal interpretation. The silhouette could further be viewed as a marker or signpost rather than a critique or commentary. To avoid objectivism Neurath ordered that his artists make silhouettes from cut paper or simple pen and ink drawings. Nonetheless, Arntz added a certain warmth (and humor) to the otherwise unaffected icons simply through gestures in the way a figure held a newspaper or carried a lunchbox.

Neurath's work influenced today's cartographic symbology and information graphics. He pioneered proportional symbols to represent comparative spatial information and prefigured other information specialists particularly in frequently published studies addressing demographic and social statistics in different countries, illustrating changes over the nineteenth and early twentieth centuries in a way that is designed to help the nonliterate or nonspecialist to understand social change and inequity.

Neurath and Arntz's theory of "statistical accountability" involved icons designed to appear next to one another in rows. "They could stand for quantities and thus be 'accountable,'" writes the contemporary information designer Nigel Holmes. In addition to conveying quantifiable data, the Isotype is the progenitor of today's common pictorial sign symbols found in airport terminals and restaurant doors. In fact, Neurath's colleague Rudolf Modley, whose *Handbook of Pictorial Symbols* (Dover Books, 1976), along with industrial designer Henry Dreyfuss' *Symbol Sourcebook* (McGraw-Hill, 1972), are the key references for their

inclusive compilation of symbols. Otl Archer's event symbols for the 1972 Olympic Games take the basic icons in a more streamlined direction. The American Institute of Graphic Art's system of fifty symbol signs, designed by Roger Cook and Don Shanosky in a collaboration between the AIGA and the U.S. Department of Transportation, has become the standard for pictograms in airports and other transportation hubs and at large international events.

S E E A L S O *Futurist, Instructional Guide, Modernist, Schutzmarken*

PLAYBOY

In 1953 Hugh Hefner published a magazine that would radically change the form and content of magazines and incite a cultural revolution—the Playboy revolution. *Playboy* was based on Hefner's belief that men had the right to be, or fantasize about being, libidinous rogues who listened to cool jazz, drank dry martinis, drove imported sports cars, and kept hip bachelor pads. Through the magazine he encouraged hedonistic and narcissistic behavior on the one hand and social and political awareness on the other. But Hef, as he was known, did not accomplish this alone. In fact, his message would not have been so broadly accepted (with a high of over seven million paid circulation) if not for *Playboy*'s innovative graphic approach. The magazine's format, typography, and illustration must not be underestimated in the calculus of success because with so much riding on *Playboy*'s premiere (Hefner invested his last dime and used his furniture as collateral to raise the initial $8,000), if it looked the least bit like a tawdry nudist magazine the project would be doomed.

Hefner, who studied art at the University of Illinois, hired former Chicago Bauhaus (Institute of Design) student Art Paul to become the magazine's

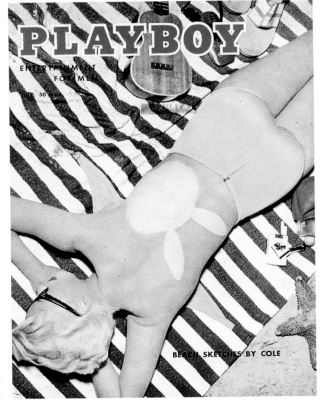

Designer: Art Paul
Magazine cover, 1955

mime. 3. Exercise or action intended for amusement or diversion; amusement; sport; frolic.

PLAYBOY *n.*

(plā′boi′). **1.** A sporty fellow bent upon pleasure seeking; a man-about-town; a lover of life; a *bon vivant.* **2.** The magazine edited for the edification and entertainment of urban men; i.e., in the June issue: "You Can Make a Million Today" by J. Paul Getty; a psychological portrait of Reno by Herbert Gold; five pages of color photography on the Grand Prix in Monaco with description by Charles Beaumont; cartoonist Shel Silverstein visits Hawaii.—**played out** (plād out), *pp.* Performed to the end; also, exhausted; used up.—**player** (plā′ēr), *n.* One who plays; an actor; a musician.—**playful** (plā′fool), -f'l), *adj.* Full of play; sportive; also, humorous.—**playmate** (plā′māt′), *n.* A companion in play.—**Playmate** (Plā′māt′), *n.* A popular pictorial feature in PLAYBOY magazine depicting beautiful girl in pin-up pose; shortening of "Playmate of the Month"; i.e., Austrian beauty Heidi Becker in June issue; hence, without cap., any very attractive female companion to a playboy.—**playock** (plā′ŭk), *n.* [Prob. dim. of *play, n.*] Plaything. *Scot.*—**playoff** (plā′ôf), *n. Sports.* A final con-

(1)
JUNE PLAYMATE

agree
singl
man
Pleas
ant,]
plain
the n
lively
adv.
cheer
n. St
agree
antr
Gaiet
ous s
laugh
plez′a
deligl
grou
chaic
plais
place
but a
assim
pleas
or of
emoti
ment
oppos
catiol
what
wish;
choice

founding art director; without him *Playboy* could have languished in a netherworld between pulp and porn. The initial title had been *Stag Party* and the dummy looked like a movie star magazine with cheesecake photos and puerile cartoons (a few of them drawn by Hef himself). It was not the style Hefner wanted.

"I was looking for a magazine that was as innovative in its illustration and design as it was in its concept," recalls Hefner in an interview. "We came out of a period where magazine illustration was inspired by Norman Rockwell and I was much more influenced by abstract art of the early 1950s and by Picasso. I was looking for something that combined less realistic and more innovative art with magazine illustration. The notion of breaking down the walls between what hung in museums and

what appeared in the pages of a magazine was very unique at that time."

Paul signed on but was put off by the *Stag* title and suggested that the name be changed, which Hefner did weeks before going to press, and only after *Stag*, a hunting magazine, threatened legal action for infringement. "We made up a list of names that suggested the bachelor life," Hefner explains. "'Playboy' was in disuse at that point and reflected back on an earlier era, particularly back on the '20s—I liked that connection." So with this detail out of the way Paul proceeded to develop a format that reconciled nude photography with the sophisticated fiction and nonfiction that became hallmarks of the Playboy formula.

Hefner wanted a mascot from the outset: *Esquire* and the *New Yorker* both had male symbols, Esky and Eustace Tilley, respectively. The notion of having an animal as a male symbol was a nice variation on the theme. The notion of putting a rabbit in a tuxedo seemed kind of playful, sexy, and sophisticated. The initial versions were fairly rough. By the third issue Paul's original drawing of the bunny in profile is what became the "empire's logo."

Sex was a significant part of the entire package, but it was not a sex magazine per se. Paul saw *Playboy* more as a lifestyle magazine, or as the subtitle said, "Entertainment for Men." Hefner wanted to present sex as commonplace, not taboo. A classy look was possible because photographs were exclusively shot for the magazine, rather than through stock providers.

Paul's contribution to the photography was to inject simple male-oriented objects, like a pipe or slippers in order to underscore a human element—or to give the girls "a smell," as painter Richard Lindner once said about *Playboy*'s photography. But Paul insists that he was less interested in nudes than the other aspects of the magazine where he made his more meaningful impact as an art director. This included feature page design and illustration.

Paul admired both Norman Rockwell and Michelangelo but admits a preference for the former, reasoning that fine artists like Michelangelo were in dusty art history books but the commercial illustrators like Norman Rockwell were on the shiny new covers of *The Saturday Evening Post*. As Paul became more professionally attuned he was increasingly perturbed by the distinctions made by critics between fine and applied art, which reduced illustration to uninspired formulas. He commissioned both fine artists and commercial illustrators to do work for *Playboy*. The marriage of the commercial and noncommercial artists' work gave *Playboy* a uniquely progressive edge among most publications at the time. Hefner notes that "while we were doing and after we did this, Andy Warhol did almost the opposite of that: He took commercial art and turned it into fine art, and we took fine art and turned it into commercial art."

Playboy art was resolutely eclectic, ranging from minimalist to maximalist, and drawing from Surrealist, Pop art, and post-Pop schools. The fine art alumni included such known painters and sculptors as Salvador Dalí, Larry Rivers, George Segal, Tom Wesselman, Ed Paschke, James Rosenquist, Roger Brown, Alfred Leslie, and Karl Wirsum. And Paul frequently published (and boosted the careers of) many top commercial illustrators, including Paul Davis, Brad Holland, Cliff Condak, Robert Weaver, and Tomi Ungerer, to name a few of the artists from the over three thousand illustrations Paul had commissioned.

Paul developed a feature article style that, although based on a strict grid, allowed for numerous variations and surprises, including a wealth of contoured type treatments and other typo-image experiments. The nineties were known for experimental tomfoolery but during the sixties and seventies Paul was in the forefront with his experimental use of artwork and paper special effects that injected a kinetic quality to the otherwise flat magazine surface. This unique creative technique

had a tremendous influence on contemporary magazine design and illustration.

Another influence is *Playboy*'s use of stereotypically plastic women, a projection that Paul admits "could be much better." He took some photographs himself that he called "designy nudes" —portions of bodies, like one of a nude foot with a high heel at the end of it. "Ultimately, I wanted strong images," he says. "But I was also concerned about being sensual." In the final analysis, though, *Playboy* merely raised the level of the pinup a few notches.

S E E A L S O *Conceptual Illustration, Magazine Cliché, Modernist*

POLISH POSTER

As a nation Poland resisted the occupying Nazis only to be occupied in 1945 by the Soviets, who presumably imposed the tenets of Socialist Realism on Polish arts. Yet Tadeusz Trepkowski's "Nie" was perhaps the first postwar Polish poster to suggest otherwise. The silhouette of a floating bomb framing the ruins of a devastated city was, in its own way, as expressive of the horrors of World War II as the numbing photographs of carnage published in *Life* and other American magazines. "Nie" was the first glimpse of how powerful Polish poster graphics were and a real sign that Polish art was alive and well. Thanks to conspicuous exposure in *Graphis* magazine, in the English-language *Poland* magazine, and in the Polish-language *Projekt* the world learned that not only was the Polish poster alive, it flew in the face of Soviet turgidity.

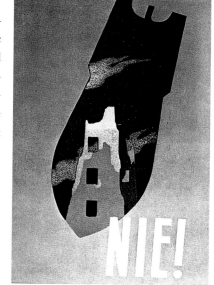

The Polish poster, with its Realist, Surrealist, and phantasmagoric imagery and violently hand-scrawled lettering, was the epitome of expressive *and* stylistic freedom. The Communist government recognized the power of posters; that a government that restricted its citizens with dictates and decrees would allow its artists to create a national graphic style rooted on individuality was ironic, though beneficial. In the United States graphic artists and designers were free to say virtually anything in print; commercial censorship was more injurious to

Designer: Tadeusz Trepkowski
Poster, 1953

creativity. American businesses imposed styles that would sell products in the competitive marketplace. But since the Polish poster sold cultural events and not product or ideology, they were pure poetry unfettered by agendas of state.

Polish artists were excited by the idea that visual language could subvert the state's tunnel vision. Their posters, many created to promote films under the patronage of Wydawnictwo Artystyczno-Graficzne (WAG), the state publishing agency, were exceptionally beautiful and the artists, including Henryk Tomaszewski, Roman Cieslewicz, Jan Lenica, Franciszek Starowieyski, and Waldemar Swierzy, created work that seemed as though the authorities were looking the other way. Surrealism and abstraction were means to circumvent strictures against free expression, and they caused new methods to emerge.

Designer: Franciszek Starowieyski
Poster, 1983

Such a poster tradition never emerged in the United States. While many exemplary posters were produced by talented artists—Milton Glaser, Seymour Chwast, James McMullan, Paul Davis, Ivan Chermayeff—by the 1960s television and magazine advertising reached many more people in less time than a poster. So, unlike France, for example, the U.S. never adopted the Polish model. But in 1970 the *New York Times* op-ed page began to reflect that a Polish vocabulary seeped into American design and illustration. The *Times* wanted to innovate a new illustration style—a more cerebral, symbolic, metaphoric approach—and rather than create something from whole cloth, it borrowed and reinterpreted for newspapers what the Polish artists had done for posters. Surrealism and fantasy were employed as a means to coyly comment on political and social issues without hitting the audience over the head. Like the Polish poster, the iconography alluded to, but did not directly articulate a controversial idea; graphic symbols were imbued with hidden meanings that could be decoded, or not.

Diverse talents contributed to the Polish Poster style (though latter-day practi-

tioners followed directly in the footsteps of the postwar masters). With frequent coverage in *Graphis* the style gained popularity outside of Poland, influencing work in other Soviet bloc countries. When some of the artists emigrated to the West, the style took root there too. Lenica and Cieslewicz settled in Paris and their tradition was adopted by the French political design collective Grapus. In the aftermath of Solidarity and democratization of Poland the style is less rigorously progressive than it was under the yoke of Communism.

S E E A L S O *Conceptual Illustration, Socialist Realist, Surrealist*

POSTMODERN

Postmodern is a broad rubric based on a wide range of aesthetic and formal issues. The ambiguous name served to represent the passage of the Modernist baton from one generation to the next, and marked the dismantling of the Modernist ethos, if only temporarily.

The slippery PM term implied stylistic diversity (and eclecticism) and the celebration of individual rather than universal design languages, although it also gave rise to a conformity of alienation. Postmodern graphic design started before the computer but nonetheless derives much of its forward thrust from the Macintosh revolution, which spawned the first wave of digital type design and later ad hoc fontography. Postmodernism, as taught in the progressive design schools Cranbrook, in Michigan, and Cal Arts, in Los Angeles, California, was an integration of theory, politics, and social relations into design practice. In the United States, Postmodern graphic design emerged around the mid-1980s and reached its stylistic zenith during the late '90s.

Designer: Higashi Glaser Design
Toy design, 1988

Deconstruction signified a particular Postmodern influence on design style, derived from a method of analyzing texts introduced by post-Structuralist critic Jacques Derrida that challenged the receiver of visual and textual messages to comprehend the complexity of meaning. In addition to theories of semiotics, linguistics, and semantics, in the late 1980s graphic design graduate students at Cranbrook Academy in Michigan embraced Deconstruction theory as a rationale for typographic compositions that broke the traditional grid. For some, Deconstruction was a means to see the printed page (or screen) anew, for others it was yet another contemporary code. Layering, distortion, and density are characteristics of design created as much to emote as to be read.

Postmodern was not monolithic. In addition to Deconstruction, other group-ings of stylistic theory were gathered under the single rubric. Most shared a few traits, but did not otherwise conform to one another's mannerisms. Proponents of New Wave (which Gary Panter called sterilized Punk), Grunge, post-Punk, Retro Pastiche, and Vernacular took pains to throw off the yoke (or grid) that Swiss Modernism (or International Typographic style) had imposed since the early 1950s and which still dominated much corporate identity design for multinational com-panies. In so doing the symbols of Modernism were replaced and typefaces like Helvetica were initially discarded in favor of eccentric ones like Template Gothic. *Emigre* and *Fuse* magazines, both digital type hothouses, led the charge against the old school, followed quickly by David Carson, first with *Beach Culture* and later *Ray Gun* magazines, his laboratory for antigrid, chaotic computer-driven design. Postmodern was characterized by complexity overshadowing simplicity, objectivity routing subjectivity, and ornament's defeat of austerity.

SEE ALSO *Deconstruction, Emigre, Grunge, Helvetica, International Typo-graphic, Modernist, New Wave, Panter, Pastiche, Ray Gun, Vernacular*

LED ZEPPELIN *PRESENCE* BY HIPGNOSIS

This 1976 cover and sleeve design for Led Zeppelin's album *Presence* has a single, nondimensional black object placed in various scenes of 1940s and '50s bliss, cre-ating a stark tension between it and the normative scene. It is stared at, enjoyed poolside, photographed atop a mountain, and exchanged as a gift, a literal acting out of presence—the word and the concept. The black shape has a presence as an object of obsession and a black hole in an otherwise normal image. In fact it speaks as much to modern alienation as to the totemic power a band has over its ardent fans. Creating a conflict between the nostalgic imagery and the abstract, mechanical object in service to a concept is a classic postmodern trope, and one given a commercial sheen in the case of *Presence*. — D.N.

PSYCHEDELIC POSTER

During the mid-1960s San Francisco was the vortex of the counterculture. Hippies prevailed, hallucinogenic drugs were plentiful, and rock music filled the air. Spanish-born, Brooklyn-raised Victor Moscoso stumbled into this milieu and soon became a contributing force in the distinctly American design style known as the psychedelic poster. Characterized by illegible typefaces, vibrating colors, and antique illustrations, psychedelia was a rebellious visual language created to communicate with a select community. Within a year it was usurped by entrepreneurs who fleeced it for its originality, turning it into a trendy commercial style that appealed to a new market full of youthful consumers. But before ceding the field to the so-called culture vultures, Moscoso created some of the most emblematic images of the '60s, of which the Blues Project poster is but one classic.

For most of over sixty posters Moscoso designed during a frenetic eight months in 1967, he rejected publicity photos in favor of found, public domain images. For the Blues Project poster he used a vintage photograph of a Salome-inspired

Designer: Victor Moscoso
Poster, 1966

nude. Following her contour, he hand-lettered the concert information in a typeface that Moscoso called Psychedelic Playbill (an adaptation of a Victorian wood type). Because he drew the letters out of negative space (whiting out all the areas between the bodies of the letterforms rather than drawing them directly), they look as if they were carved onto the page. The figure was printed in bright orange against an acid green background; the lettering was printed in process blue. The off-register trapping gave these letters a three-dimensional look and vibrating sensation produced by the juxtaposition of similar chromatic values.

The Blues Project poster defines more than the psychedelic style, it underscores the Moscoso style. While other leading contemporary poster artists

© 1967 NEON ROSE Photo: PAUL UBAC

(including Wes Wilson, Rick Griffin, Stanley Mouse, and Alton Kelley) had distinct visual personas, Moscoso's introduction of vibrating color was the most emblematic of all. As rule-busting as chromatic vibration was during the era of rationalist Modern design, it was nonetheless derived from strict Modern principles. Moscoso was schooled at Cooper Union in New York and Yale in New Haven before migrating West, and credits his Modern master Yale professor, Joseph Albers, for this key discovery. Likening Albers' famous Color Aid paper exercises to the futility of learning algebra in high school, Moscoso admits that color theory drove him crazy, but ultimately proved to be an invaluable resource. Albers' impact really didn't show until the psychedelic poster, when Moscoso found himself in a situation where all he had to do was reach back to his dusty shelf and pull out what he had learned.

Compared to rock posters by Rick Griffin and Mouse and Kelley, each of whom practiced an obsessively precisionist Gothic style, Moscoso was the master of (Modernist) simplicity. Despite what appears to be layers of graphic complexity, his visuals were strategically composed and purposefully designed. While being stoned may have added to the enjoyment of the Blues Project poster, the design was not drug-induced chaos. Moscoso was a highly disciplined rebel who was initially irked by this new poster style and its callous rejection of classical beauty, but he was also fascinated by its raw energy. Given all his formal training Moscoso thought he could do much better, but his first rock poster for The Family Dog dance hall, a picture of a gargoyle on the top of Notre Dame with psychedelic type overprinting the image, was a big flop. It lacked all the energy of the others. Like a wounded bear he crawled into his lair to lick his wounds, and to rethink what was going on. He realized that none of the self-taught poster artists were encumbered by the rules of good design. So Moscoso reversed everything he had formally learned. The rule that a poster should transmit a message simply and quickly became, instead, how long can you engage the viewer in reading the poster? Five, ten, twenty minutes? Do not use vibrating colors became use them whenever you can and irritate the eyes as much as you can. Lettering should always be legible was changed to disguise the lettering as much as possible and make it as difficult as possible to read.

Since there was no phototypesetting—and because Moscoso was intent on combining the lettering as an integral part of the design—it became necessary to invent a letter that was quick to draw. And since there was only about a 48-hour turnaround per poster, the entire lettering, drawing, and separating process had to be accomplished in nonstop sessions no longer than 8 hours. Moscoso developed a

LEFT
Designer: Victor Moscoso
Poster, 1967

method that allowed him to avoid rendering each letter separately, but rather draw the negative space between letters—which is indeed much faster.

Leaping farther from legibility with each poster, he nevertheless increased readability. As advertisements they could be read, or at least interpreted by the targeted audience. Although the deciphering gets harder from an outsider's standpoint, for the insider it was simply a matter of relearning how to read. The audience was in on the development all along, and part of the game was to keep the thing changing.

Key to the style was the appropriation and adaptation of various display and novelty faces into psychedelic lettering, including Alfred Roller's Secessionist alphabet and a late nineteenth-century face called Smoke.

Pressure to get the posters out ultimately took its toll on their creators.

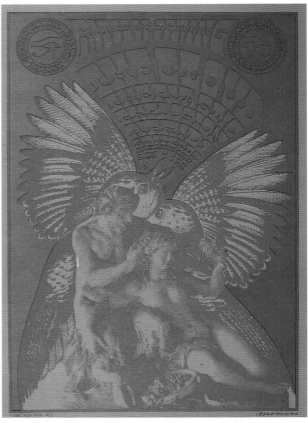

*Designer: Victor Moscoso
Poster, 1967*

Moscoso's involvement with the psychedelic poster was brief because he succeeded at what he wanted to do beyond his "wildest dreams." Psychedelic posters did not end when Moscoso stopped doing them in 1968. The style spread albeit diluted and crass, and was co-opted by young, would-be capitalists as well as mainstream entrepreneurs. Predictably, psychedelia became a cliché, viewed by some design critics as a brief commercial aberration. Moscoso's brilliance was momentarily eclipsed by this blanket condemnation of '60s kitsch. But like Lautrec, Chéret, Mucha, and Bernhard, poster geniuses of the late 1800s and early 1900s, Moscoso's posters transcend their stylistic era and stand out as virtuoso pieces of indigenous American typography and design.

SEE ALSO *Art Nouveau, Bauhaus, Handlettering, Modernist, Surrealism, Vernacular, Victorian*

MAN FROM UTOPIA BY RICK GRIFFIN

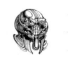

Rick Griffin's (1944–1994) brand of psychedelia tended toward concrete imagery: Christ, sailing, and cartoon icons, rather than the abstractions of some of his contemporaries. *Man from Utopia*, a 24-page oversized collection of images and cartoons, holds nearly all of the literary and graphic themes of psychedelia between two covers, as rendered by a single pen.

Griffin composed a symphony of imagery from the sacred to the profane: knives through hearts, scarabs, surfing, crucifixions, nudes, embryos, and Bob's Big Boy. Each piece in *Man from Utopia* relates to the others by sensibility and iconography alone: There are no captions or explanations of any kind. But Griffin's Art Nouveau and Surrealist influenced pictures tempt the viewer to look for a continuing story where there is none; just image after psychedelic image. As per the psychedelic artists' distortion of older graphic tropes, the cover includes an EC Comics–style character lineup (a Sambo stereotype, Jesus, and a character called The Monitor) set next to a tricked-out Donald Duck/Mickey Mouse hippie hybrid, playing the guitar while

riding a lion. The interior's stories are no less diverse, told in Griffin's hand-drawn type ranging from Deco swipes to nonsense script to his signature undulating letters. Psychedelia was an equal-opportunity style made coherent by, in Griffin's case, a mystic belief in unity. His efforts to make single images out of all this noise pushed psychedelic style into unusual narrative territories. Rather than telling a single story in *Man from Utopia*, Griffin uses a cast of thousands to convey his feeling: a pure, noncommercial psychedelia of the heart. — D.N.

PULP

Pulp magazines, so named because they were printed on cheap, uncoated rag or pulp newsprint paper, were once the red meat of mass culture. From the turn of the nineteenth century to the early 1940s hundreds of these nickel-and-dime serial periodicals—targeted directly at adolescent and adult males with titles like *War Birds*, *Horror Stories*, *Terror Tales*, *Weird Tales*, *Detective Tales*, *Famous Fantastic*, and *Imaginary Stories*—filled American newsstands with juicy art and lurid writing. Pulps had a graphic and prose sensibility all their own and typographically their style was defined by carnival-like tawdriness. In word and picture, pulps satisfied an urge among readers for vicarious sensation and hyperbole; athletes were stronger, heroes were nobler, and women were more luscious—with a pinch of taboo to spice things up. The page-turning intrigues of crooked coppers, cagey crooks, sinister spies, deranged dilettantes, and dangerous dames were written in steamy descriptive detail by many unknown but some destined-to-be-famous authors. Torrid covers by maestros of pictorial melodrama piqued appetites with vivid scenes of staged viciousness that appealed to prurient tastes. Some pulps were so scandalous that during the thirties New York's Mayor Fiorello LaGuardia attempted to ban them, as he did burlesque shows, but even "the Little Flower," as he was known, could not deprive a voracious readership of its regular diet.

Before comic books, paperbacks, and B movies, turn-of-the-century classic pulps were the mainstay of America's burgeoning escapist entertainment industry. With the advent of these other media, attention was swayed but pulps did not die overnight. Pulps continued the melodramatic formula yet evolved in the fifties into "sweat" magazines that further boiled the testosterone of their post-adolescent audience with tales and images of wanton behavior. Today the pulp and sweat covers remain as psychologically captivating and erotically stimulating as when first published. Pulp style has become a code for the American underbelly.

For all its hyperbole Pulp art was influenced by such notable American illustrators and painters as Winslow Homer, Howard Pyle, N. C. Wyeth, and even Edward Hopper. The Pulp art masters—among them Rafael de Soto, Norman Saunders, H. J. Ward, and Walter Baumhofer—understood the mystique and hypnotic allure of verisimilitude. Many of the Pulp artists were taught in the finest schools, which accounts for the art historical influences that one perceives.

While Pulp art was often more impressionistically than photorealistically representational, each artist stressed the importance of enticing details (such as torn blouses, visible garter snaps, silky stockings and slips, and windswept hairdos)

RIGHT
Illustrators: Unknown Magazine covers, c. 1937-1961

DOC SAVAGE Magazine

REG. U.S. PAT. OFF.
10 CENTS
DECEMBER

THE FANTASTIC ISLAND
A Book-length Adventure
Novel

25¢
JUNE
DIME DETECTIVE MAGAZINE

CASH WALE'S SECOND MASSACRE!
A NEW NOVELETTE by PETER PAIGE

TRAPPED BY THE LUST GODDESSES OF SERPENT ISLAND

MAN'S STORY

NARCOTICS
SQUAD COPS–
YOUR KIDS'
BEST FRIENDS

NOV.
35¢
PDC

THE VICE DOLLS
WHO BLASTED THE
INTERNATIONAL
WHITE SLAVERS

SOFT
FLESH
FOR FRANCE'S
MONSTER
OF AGONY

BOUND BEAUTIES OF NORWAY

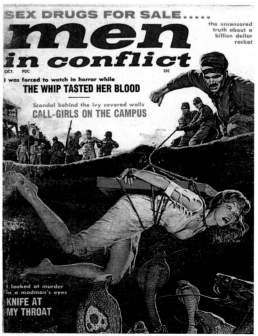

SEX DRUGS FOR SALE.....

men in conflict

the uncensored
truth about a
billion dollar
racket

OCT. PDC 35¢
I was forced to watch in horror while
THE WHIP TASTED HER BLOOD

Scandal behind the ivy covered walls
CALL-GIRLS ON THE CAMPUS

I looked at murder
in a madman's eyes
KNIFE AT
MY THROAT

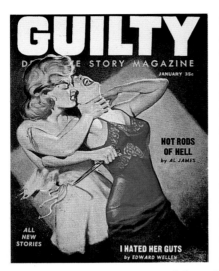

Illustrator: Unknown
Magazine cover, 1934

to make women far sexier than any comparable pinup by Petty or Vargas. The men in the paintings had two basic roles—heroic or villainous—but the painters' genius for fluid gesture gave them depth and breadth beyond their cardboard status. Even the most rigidly posed compositions were kinetic because to simulate motion was the essence of this art. While most facial expressions were limited to four emotions—anger, terror, shock, or surprise—each individual characterization spoke volumes about the respective narratives. Moreover, every nuance was expressed through eye contact with the reader.

The genre dripped with melodrama and stereotype (racial, ethnic, and gender), but Pulp artwork also tacitly reflected a nation's trepidations about an over-taxed economy, gangland lawlessness, isolationist fever, women's increasing rights, and threats of foreign (especially Asian) hordes invading American shores, among various alarming scenarios. Pulp images presented a wide range of imagined calamities, not least of which were alien invasions from earth and outer space. A striking example was H. Winfield Scott's 1941 painting titled "San Francisco Flames in the Night," from a magazine called *Click*, showing American women and children forcibly marching at bayonet point into a Japanese concentration camp located in occupied San Francisco. In its own skewed way, Pulp art like this was not unlike such paintings as Théodore Géricault's 1819 Romantic masterpiece, *The Raft of the Medusa*, which in its vivid and lurid depiction was the Pulp art of its day.

SEE ALSO *Generic, Heroic, Vernacular*

PUN

Considerable effort and remarkable skill are required to make letterforms humorous while avoiding the many pratfalls perpetrated by even the best designers in their quest for the cheap laugh. The visual pun is the most common form of humorous type play. Like its verbal counterpart, a visual pun is a single image that has two or more meanings—the obvious one and the surprising one—and a typographic pun likewise works on multiple perceptual levels.

Visual puns do not, however, usually evoke belly laughs yet they do stimulate attention and become mnemonics that prompt recognition. A vivid example of this is a poster advertising "MoMA" (1992) where the common abbreviation for The Museum of Modern Art in New York is transformed into a word-picture that conveys multiple planes of information. The "M" hangs like a painting in a picture frame while the vertical letters "oMA" simulate an individual observing the painting as though it were in a gallery. These graphic elements convey information that the four initials cannot impart. Moreover, since

a visual pun must not simply be an arbitrary transposition of disparate images the meaning must be logical, even if the overall image is somewhat absurd. In the case of MoMA, the vignette of the letters is logical and sublime.

Most humor is rooted in instinctual relationships between real and absurd. The designer for "MoMA," like most designers applying puns, doubtless came to this solution through trial and error—sketching out numerous visual relationships between the letters before settling on a serendipitous solution. It takes an acute observer to uncover the hidden secrets within such a design puzzle. Scores of other designers presented with these same four letters will invariably compose them in different ways but only a small percentage of them will stumble on the key that unlocks humor.

Sometimes a typographic pun is not self-evident, other times the letters naturally fall into predestined place. Some puns are natural, while others are seriously contrived. A form of type punning used to simulate a face (type-faces) is

rather common, but more than that, it is a veritable typographic toy. Virtually every letter of the alphabet can be somehow transformed into a body part. But randomly affixing letters in the shape of a face is not always easy. For a type-face to be truly witty it has to go for the laughs. It takes some manipulation to make all the letters fit into the scheme, but a type-face forces the viewer-reader to spend more time deciphering the work, which is the ultimate goal.

SEE ALSO *Conceptual Illustration, Modernist, Schutzmarken*

PUSH PIN

Push Pin Studios created a style that defined graphic design of the 1960s (and '70s). Although Push Pin Studios was not fanatically avant-garde, through its reinvention of discarded mannerisms it did spark profound shifts in commercial art away from the cold rationalism of the corporate Modern movement and the staid conventions of common commercial practice, and into new realms of pictorial expression. While exhuming Victorian, Art Nouveau, and Art Deco mannerisms (two decades before Postmodernism encouraged similar reappraisals of the past and the passé), Push Pin was not nostalgic or faddish and developed a markedly contemporary yet curiously Retro style.

Push Pin's principal cofounders, Seymour Chwast (b. 1931) and Milton Glaser

(b. 1929), two native New Yorkers who met while attending Manhattan's Cooper Union, brought distinct tastes and preferences to the development of their partnership. Chwast savored American comic strips while Glaser was passionate for Italian Renaissance painters. Despite their formal differences, both shared the conviction that postwar design and illustration should not be limited to prevailing practices—either sentimental realism or reductive simplicity. They rejected rote methods and rigid styles while concocting incomparable ways of transforming old into new.

Push Pin's disinct palette, typography, and imagery were bright, spirited, and

LEFT
Designer: Milton Glaser
Book cover, 1965

RIGHT
Designer: Seymour Chwast
Magazine cover, 1980

stylish compared to the strict asceticism of the Swiss School and International Style, which in the 1950s were methods of choice for most institutional design programs. But Push Pin's carnivalesque aesthetic was not undisciplined. For example, during an era when photography was becoming increasingly more popular among art directors than hand-rendered illustration, Push Pin stubbornly used paint, brush, and collage in expressionistic ways. Moreover, Push Pin revived the once seamless intersection of art and typography—illustration and design—deemed passé by Modernists who revered Machine Age tools and aesthetics. Illustrated posters with original lettering formed a significant part of Push Pin's repertoire. Yet contrary to appearances Push Pin was not solely about revivalism. Push Pin possessed a keen ability for achieving newness while avoiding the more dogmatic aspects of Modernism. Glaser's famous 1967 "Dylan Poster,"

Designer: Seymour Chwast
Poster, 1974

a harmonious marriage of Persian miniature ornament and a Marcel Duchamp self-portrait, is a characteristic example of transmuting two conflicting historical references into a single work.

In 1954, when Push Pin Studios hung its shingle, romantic realism continued to dominate illustration with only a few Expressionist blips appearing here and there. Illustration was patently literal and overly narrative (often images were taken verbatim from text passages decided upon by editors or art directors and then captioned to avoid any ambiguity). Push Pin's more conceptual and metaphorical image-making pried an opening in the conservative precincts of illustration, especially changing aesthetic attitudes toward book jackets and record covers, and spruced up advertisements, too. At the same time, however, postwar corporate Modernism had arguably become a predictable assortment of limited

typefaces and templates used for business reports and sign systems. Minimalist design wasn't all it was cracked up to be, and when it was applied to products that demanded variety, the public became indifferent. The original argument against decoration made some theoretical sense, but in extremis reductionism sacrificed the serendipitous quirks that gave graphic design its surprise factor. So in response to the status quo Push Pin exploited as many quirks as it could.

If any single factor should be credited for the uniqueness of the Push Pin style (aside from its principals' vision, of course), reference material is key. The slab serif Victorian, curvilinear Art Nouveau, rectilinear Art Deco, spiky German Fraktur, and other esoteric typefaces, as well as the bevy of cartouches, swashes, flourishes, and other vintage printers' rules, borders, and *fleurons* borrowed from old type catalogs were customized for the studio's use. Push Pin routinely created distinct motifs that defined its own look and influenced others. Chwast, for instance, was attracted to '20s decorative art, which he transformed into what he called "Roxy Style" before he knew it was Art Deco, which along with Glaser's variation on the same theme influenced the '60s Art Deco revival and morphed into psychedelic chic. Together they, and other studio members, created a style of their times that helped define the look of the '60s, but transcended it too.

SEE ALSO *Art Deco, Art Nouveau, Black Letter, Conceptual Illustration, Expressionist, International Typographic, Modernist, New Wave, Postmodern, Psychedelic Poster, Schutzmarken, Surrealist, Victorian*

Designers: Milton Glaser and Seymour Chwast Magazine cover, 1965

263

R

see Religious Message Board

RAY GUN

In the mid-1980s *Ray Gun*, an alternative rock-and-roll magazine, earned a repu-
tation for its radical graphic presentation, which so challenged the conventions of
legibility and readability that its words were reduced to textures on its pages. In
addition to reporting on young musicians ignored by the mainstream press, *Ray
Gun*'s riotous graphic design set the standard for a kind of hip generational style
of typographic tomfoolery which soon became the fashion with countless other

*Designer: David Carson
Magazine cover, 1992*

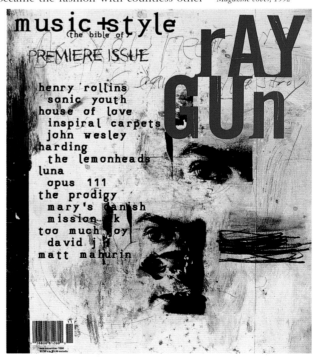

alternative culture publications and on
posters, packages, and music videos.

Between *Ray Gun*'s covers tradi-
tional type hierarchies (headlines, sub-
heads, body text, and page numbers)
were rejected for randomness (albeit
controlled randomness). In at least
one *Ray Gun* issue page numbers were
grotesquely blown up larger than the
headlines and positioned in the middle
of all the pages; in other issues text type
was allowed to bleed off the page in
the middle of a paragraph; and in yet
another an entire article was printed
backward in an otherwise illegible
typeface. Despite some protests from
irritated writers, the magazine was the
primary showcase for confounding lay-
out tricks made possible through the

Macintosh computer and assorted digital layout and font programs. *Ray Gun*'s founding art director, David Carson, and his small army of designers made pages that resembled Abstract Expressionist canvases. Instead of underscoring the writers' ideas, they created auras that exuded expression. Their methods paralleled a period of flux in graphic design when traditional methods were deemed unresponsive to the new generation's creative needs.

Ray Gun was not the first alternative culture magazine to test the limits of typographic tolerance, but like Dada journals for the generation of artists of the 1920s and psychedelic rock posters for the late 1960s, it was the harbinger of visual codes for the post–baby boom generation—and the Ray Gun style was adapted for mainstream television and print advertisements.

S E E A L S O *Dada, Me-Too, Psychedelic Poster, Underground Press*

RAZOR BLADE

Designers: Unknown
Razor blade wrappers, c. 1935

From the 1920s through the '40s razor blade wrappers were among the most sought-after ephemerally designed objects of consumer culture. The safety razor and blade were more convenient than the straightedge and strop, and caused fewer cuts too. Nonetheless the classic double-edge blade, made from thinly stamped steel and designed with slots on the front that could be snugly sandwiched between the tight-fitting layers of the razor, had not changed during much of the century, until the advent of the double- and triple-blade cartridges of today's "super" razors. At the outset, the key factor that distinguished one blade from another was the brand name and the package design.

Like cigarettes, razor blades were impressed with heroic, romantic, ironic, and nonsensical mnemonic names, such as Mac's Smile, Merlin, Super Gam, Seven O'Clock, Carezza, Honor, and Eclipse. Each was adorned with a mini-poster design—sometimes bold novelty typography, other times drawings

265

of elegant men, sensuous beauties, or goofy mascots. The blades themselves were made from white, blue, and gold steel, and were differentiated from each other with such superlatives as *extra*, *superior*, and *super extra*, although the same traits were really common to all. A few were touted as flexible, and at least one was said to be "magic."

Why were there so many brands and wrappers? During the '20s and '30s razor blades were fairly easy and inexpensive to produce so one company could issue half a dozen minibrands in the hope of hitting big with just one.

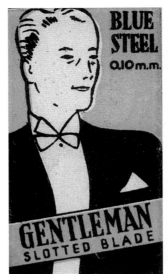 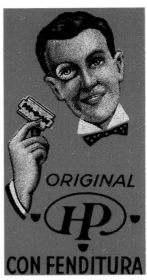

Designers: Unknown
Razor blade wrappers, c. 1935

Every basic safety razor model accepted the same double-edged blades, which would last for between five and ten shaves before turning dull, thus adding to the widespread need to replenish supplies. Since consumers were not necessarily loyal to any one blade it was incumbent on producers to distribute enough new products to maintain a sense of novelty that seduced most buyers.

Blade packs were anonymously designed by commercial artists in printing plants that specialized in this and other forms of consumer packaging. The format was obviously prescribed, but within the limitations anything was possible. Bold primary color was a requisite, and many blade wrappers were printed with metallic inks or multiple primary hues. Simplicity was the watchword for obvious reasons, yet a few brands, like Apollo No. 10, a German blade, was designed with an engraving of the Greek god framed by classical filigree, and Lama Italia, an Italian brand, had Novecento-styled graphic iconography. Most of the wrappers were as colorful as posters and as visually spirited as book jackets.

Blade wrappers range from commercially sophisticated to amateurishly naïve, like the Hamburg Ring Blade (made in Germany) featuring a distortedly drawn ocean vessel on a collision course with a life preserver that bears the brand name. But they all conformed to an overt—or loud—typographic and pictorial style that made the individual package appear larger than it was. By current standards all the specimens from this time frame are quaint remnants from a time when a truly engaging package design could shave a few contenders from the competition.
SEE ALSO *Generic, Show-Card, Vernacular*

RECORD COVER

Alex Steinweiss is the godfather of the illustrated album cover. He literally invented custom cover art for 78 rpm record albums and designed the basic package for the 33⅓ rpm LP. Without him this miniposter might eventually have come to pass, but speculating about what might have been is futile: Steinweiss was the first. He recognized a need and invented a major genre and style. It was as revolutionary in its way as sound was to film and color was to television. It added an entirely new dimension to the musical experience—and, not incidentally, the sales of recorded music. Being first had its advantages, too, because all competitors were judged against his standard, and in the beginning few stood up. Eventually, though, the genre grew more stylistically diverse and became one of the most creative graphic disciplines.

In the late 1930s Steinweiss stumbled into an industry that did not have a graphics tradition. Sheet music covers from the late nineteenth and early to mid-twentieth centuries were beautifully illustrated, but early record albums were noticeably bereft. In those days shellac 78 rpm records, which played for four or five minutes per side, were packaged in bulky albums of three or four records each in separate Kraft paper sleeves bound between pasteboard covers. They were referred to as "tombstones" because on display shelves they sat spine out in rows, differentiated only by colored bindings embossed with gold- or silver-leaf titles.

Designer: Alex Steinweiss
Record album cover, 1941

CBS Records was headquartered in Bridgeport, Connecticut, a gloomy industrial city that had no graphic arts suppliers, typographers, or designers. Yet Steinweiss was given a corner of a huge barnlike room, which he called "the ballroom," with a lone drawing table, tank of air, and his trusty airbrush. For the first six months he was the entire art department and mechanical staff. He designed scores of ads, posters, booklets, and catalogs for the classical, pop, and international lines. But he wasn't just mindlessly churning it out: "I put some style into it," he said—explaining the difference between his Modern influences and the virtual

nondesign of the other record companies.

After a few months, Steinweiss had what amounted to an epiphany: The generic plain paper wrappers were unattractive and lacked any appeal. Steinweiss announced to his boss that he wanted to experiment by designing a few covers with original art. Despite the fact that manufacturing costs would doubtless increase, he got the go-ahead. The very first album was for a Rodgers and Hart collection for which he rendered a theater marquee with the album title appearing in lights. Others followed and sales dramatically increased on the albums with the Stein-

Designer: Alex Steinweiss
Record album cover, 1944

weiss covers. Shortly after the first covers were issued, *Newsweek* reported that sales of Bruno Walter's Beethoven *Eroica* Symphony broke all records compared to the same release in a nonillustrated package.

Steinweiss was introduced to 1930s French and German posters through his teacher, Leon Friend, at Abraham Lincoln High School in Brooklyn, New York. Influenced by such masters as Lucian Bernhard and A. M. Cassandre, he developed a style using flat colors and Surrealist graphic elements isolated in space. He further believed that rather than show a portrait of a recording artist, musical and cultural symbols would stimulate the audience's interest more. He wed real and surreal elements together. He always maximized the limited image area of the cover by using poster elements—a strong central image, bold type and lettering, and distinctive color. Without type shops nearby he was pressured to hand-letter the titles himself, and so developed his own trademark script called the Steinweiss Scrawl, which in the early 1950s was licensed by PhotoLettering Inc. More problematic, though, since photoengravers did not work in four-color process, was that if he wanted color he had to give them tight key line drawings, which were broken down into the specified colors. All color was printed as a solid. These production limitations combined with his fine eye for graphic detail defined the 78 record style for years to follow.

S E E A L S O *Art Deco Type, Cappiello, Commercial Modern, Handlettering, Modernist, Object Poster, Surrealist*

RED SCARED

The stereotypes in anticommunist propaganda are so ludicrous it's hard to give them any credence. Yet postwar rhetoric about Godless Communism infused all media and invaded Americans' everyday life. Just the word Communism provoked irrationality. People truly believed that Reds were under the bed, in the water supply, and spying from space. The power of anticommunist propaganda was so effective (and perhaps seductive) that Americans relinquished rights and liberties so that the government could persecute its opponents. While this is not an apology for the real Soviet menace, it is an explanation of why anticommunist propaganda was virulent. Propaganda is based on the creation of recognizable stereotypes that oversimplify complex issues for the purpose of controlling mass opinion. The U.S. government encouraged Red-baiting and witch-hunting, as the Nazis did anti-Semitism, through print and film. It was the longest continuous propaganda campaign of its kind.

Illustrator: Unknown
Comic book cover, 1947–50

Americans were conditioned by politicians, businessmen, clergy, and the press to fear Communists. Editorial cartoons portrayed them as bomb-throwing thugs. The *New York Times* showed more respect for Mussolini than for Lenin or Stalin because Il Duce promised a social revolution that was more palatable to ruling-class Americans than the Soviet model. After the Russian Revolution, Communism was the dread of America's business and industrial leaders who feared labor unrest owing to their own exploitative practices. These same leaders forged secret alliances with racists, jingoists, and other America-first fanatics in spreading anticommunist propaganda throughout the nation.

Years before the American Communist Party was founded (in 1919) the word *Communism* was synonymous

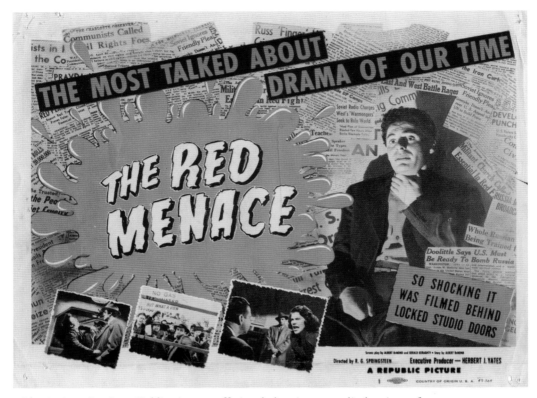

Designer: Unknown
Foyer card, 1949

with un-Americanism. Publications proffering bohemian or radical points of view, such as *The Masses*, were hounded by authorities who stupidly believed that these relatively small-circulation journals could alter American policy. After the 1917 Russian Revolution, the worst nightmare of American anticommunists was realized when Bolshevism became entrenched in Russian life. To add to officials' fears, in 1919 the American Communist Party was founded in Chicago. Refusing to recognize Lenin's government, President Wilson committed arms to the war against Bolshevism abroad and encouraged an increase in the level of anti-communist propaganda at home. By 1923, Communism had indeed become a force to be reckoned with, but the myth that a monolithic Communist vanguard was infiltrating America was still unfounded. Nonetheless America's misperception was based on Marxism/Leninism's promise of the eventual demise of capitalism.

During the Great Depression, Communism gained a foothold among American working and intellectual classes who opposed the policies of President Herbert Hoover (and Treasury Secretary Andrew Mellon) that plunged the nation into economic disaster. Owing to the New Deal's nod to socialism, acrimony between

diehard anticommunists and New Dealers continued throughout Franklin Roosevelt's presidency. The Nazis smashed labor unions and undermined democratic reforms while the New Deal strengthened them. FDR's Congressional opponents spent much of their time proposing bills that would limit immigration, free speech, and free assembly for suspected Communists, and deport foreign-born Communists in the bargain. Congress often flirted with the idea of legally prohibiting the Communist party, and that never came to pass.

By 1948 anticommunist militancy had swept the country. Joseph C. Goulden notes that "the American Legion, such newspaper chains as Hearst and Scripps-Howard, and any number of ad hoc business and 'patriotic' organizations were providing investigators with information on the Communist conspiracy." These entities were also contributing to the huge volume of anticommunist literature. The media was not always in the forefront of free expression neither on nor off the pages or screen. Many publishing houses gave ultimatums to their employees who were called to testify before Senator McCarthy's House Un-American Activities Committee: Cooperate or be fired. Others would not publish or buy work by suspected Reds. Executives supported the blacklist by subscribing to publications like *Red Channels*, a regularly updated list of known or suspected Communists.

The American Legion was also behind attacks on Reds, real or supposed, including a major assault on comic books during the mid-'50s. Typical of the mail in one Legionnaire newsletter was this: "We parents and the teachers and the principals do not like the horrors created by the comics. Are the Commies behind these books which appear in print by the thousands?" As a result of this forced hysteria the self-regulating Comics Code was instituted by the comics industry not only to prohibit horror and violence, but to uphold American values. Nevertheless, violence was the prescribed cure for Communism in comics sanctioned by the code.

The comic book turned out to be a popular medium for anticommunist groups. Typical of these was one published by the Houston-based Christian Anti-Communism Crusade, whose *Two*

Illustrator: Unknown
Editorial illustration, c. 1952

Faces of Communism was mailed free of charge to anyone sending in a self-addressed stamped envelope. The premise was predictable: Youth of America are oblivious to the Communist menace, but after thirty-six pages they are convinced by their elders to see things the way they really are, and to help others see the light by starting a Teens for America group. Another comic published by the Minneapolis-based Catechetical Guild Education Society titled *Is This Tomorrow?* offered a cautionary "this can happen here" scenario—perpetuated through pulp magazines and newspapers, too—which offered a prurient mix of evil Reds and imperiled babes. Violence and sex loomed large in this visual lexicon.

The Red-baiting style was cheesy but nonetheless a foolproof tactic for waging war against perceived enemies of the state. Justice William O. Douglas warned in 1952 that the "restriction of free thought and free speech is the most dangerous of all subversions. It is the one un-American act that could most easily defeat us." Still the ham-fisted graphic style that spewed fear and enmity reached down to the lowest common denominator and triggered fear and loathing on a grand scale.

SEE ALSO *Fear, Mushroom Cloud*

RELIGIOUS MESSAGE BOARD

There may or may not be one beneficent, all-knowing god, but there is one universal message board style for all the world's religions—great and small—at least on any thirty-block radius in Manhattan, New York, where on average there is one house of worship on every other block. Regardless of denomination, whether

Catholic, Russian Orthodox, Jewish, Presbyterian, Lutheran, Pentecostal, Moslem, or Baha'i, and despite their unique sacred tenets, customs, and rituals, each church, temple, mosque, and synagogue puts its faith in the standard quarter-inch grooved changeable letter board, also known as the "open face letter board." The height and width may vary, conforming to the simplicity or monumentality of the respective architecture; the messages present different homilies and greetings, the basic board adheres to a guiding, nondenomina-

LEFT AND RIGHT
Designers: Unknown
Message boards, 2005

Grace Church

GRACE CHURCH
IN
NEW YORK

THE REVEREND J DONALD WARING
RECTOR

THE REVEREND LINDA BARTHOLOMEW
ASSISTANT TO THE RECTOR

THE REVEREND ASTRID STORM
CURATE

DR PATRICK ALLEN ORGANIST & MASTER
OF CHORISTERS

SUNDAY

10 AM HOLY EUCHARIST IN THE CHURCH

CHILDCARE AVAILABLE AT 9·45 AM

6 PM HOLY EUCHARIST IN THE CHANTRY

WEDNESDAY

12·20 PM BACH AT NOON

6·00 PM HOLY EUCHARIST
CHANTRY

SUNDAY

CHURCH OPEN 1 PM THRU 5 PM

BRING THE KIDS

FOR MORE INFORMATION VISIT OUR WEBSITE
WWW.GRACECHURCHNYC.ORG

tional principle that information must be clear and legible from ten feet away.

The universality of these boards is not exactly a tip of the miter or yarmulke to ecumenicalism—although many signs do beckon "All Welcome"—but rather a practical acceptance of functionalism. "When you need to communicate information that changes regularly," states a Ghent Signboard brochure, "open face letter boards are perfect for you! These quick-change artists let you create signs easily. Changeable letter panels are available in black, blue, brown, & burgundy felt." While most rectors prefer black backgrounds to jazzier hues, there is scant consensus on what is the best typeface. While available sizes vary considerably, there are only three basic plastic type options—Gothic style, Roman style, and Helvetica style—available in standard 300-character assortments. Helvetica may get its own style classification apart from Gothic as a nod to the evangelical power of Swiss Modernism. But the majority of Roman Catholic (and Protestant) churches tend to use Roman, while most synagogues prefer Gothic. Only Baha'i seems to use the curiously bastardized Helvetica. And few mix Gothic and Roman. Usually only caps are used, even though lowercase is offered by the Dawson Quartet, a large supplier of plastic letters. There are, however, widely differing inch sizes (the point measurement is not used but rather Dawson advertises, "Available in three easy-to-read styles in sizes ranging from 5/16 to 3 inches"). And hallelujah, each character has precision-molded tabs to firmly grip the letter board surface.

SEE ALSO *Cheap Chic, Shadow Letter*

273

RIPLEY'S BELIEVE IT OR NOT

Walt Disney discovered gold in Anaheim, California, in the early 1950s, but he was not the first to cash in on cartoon creations. During the 1940s Robert Leroy Ripley gave his name to, and earned riches from, a chain of enticingly titled Oditoriums inspired by his popular cartoon, "Ripley's Believe It or Not!," a daily diet of odd and entertaining factual wonders that ran in hundreds of American newspapers.

Ripley had a lifelong passion for rooting out the bizarre and grotesque, the rare and uncommon that he discovered while on globetrotting expeditions that took him to 198 different countries. Dubbed "The Modern Day Marco Polo" by the Duke of Windsor, he recorded his findings in crayon using a realistic cartoon style that was decidedly surreal in its plumbing of the unusual. All irony was curiously suppressed as Ripley tested the public's capacity to believe the incredible.

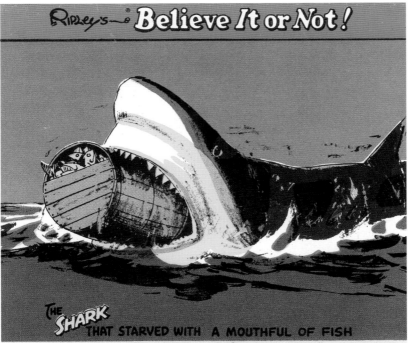

This shark was found dead in Jamaica in 1884, a barrelful of fish lodged in its mouth. Sharks' viciousness and greediness may be due less to "meanness" than to the great demands of their stomachs. As soon as they've eaten, sharks must be on the search for more food.

Illustrator: R. L. Ripley
Postcard, c. 1946

The cartoon had a distinctive character both from the lettering and drawing styles. The "logo" for Believe It or Not!, reminiscent of the typeface Cooper Bold with a shadow, was an unmistakable identifying mark. Real type was never used for body text, rather it was always Speedball-drawn handlettering. Nonetheless, the overall graphic impact was impeccable. Together all the elements got the message across and gave the work a singular personality. Had the cartoon looked any different—if the overpoweringly garish, signature red had been a soothing yellow instead—Ripley's graphic look might not have succeeded as it did.

A self-taught artist, Ripley reveled in oddities and lived the life of an eccentric. A millionaire a few times over, he filled his houses with artifacts from Europe, Asia, and South America. A colleague once said, "The most curious object in the collection is probably Mr. Ripley himself." Among his many quirks, he is said to have drawn his comic every morning without fail, always doing it upside down. He dressed in the brightest colors and most sensational patterns, wore bat-wing ties and two-toned spat shoes. He collected automobiles as though they were toys, but never learned to drive. Even though he often used complicated recording equipment for his broadcasts, apparently he was afraid to use a telephone for fear he would be electrocuted. A nonswimmer, he owned an odd assortment of boats including dugout canoes and even an authentic Chinese sailing junk. Such were the rewards and riches of cartooning that many others were inspired to seek riches plying the same trade.

Believe It or Not! was such a common household phrase that its potential as an advertising tool was well exploited. A tremendous backlog of cartoons was licensed for all promotional uses and for a modest fee, Ripley's unmistakably recognizable graphics could be licensed to represent everything from auto parts manufacturers to coffee shops.

Ripley's Believe It or Not! is an American cultural icon that has been exported around the world. Although the cartoon has ceased, the museums and Oditoriums continue to draw in crowds in Florida, Texas, and Missouri, as well as in Juarez, Mexico; Queensland, Australia; Lancaster, England; Kyonggi-do, Korea; Chonburi, Thailand; and elsewhere. Today, Ripley's is quaint given how current media offers exposure to the weird and ridiculous, but where else can one learn about "The Island Made of Soap," "The Hardest Working Stenographers in the World," or "The Accidental Soap Bubble by Which Ibn Al Haitam of Iraq discovered the Science of Optics"?

SEE ALSO *Comics Lettering, Novelty Type, Vernacular*

see Shadow Letter

SCHUTZMARKEN

German graphic designers (*Gebrausgraphikers*) working in Berlin and Munich from around 1910 through the '20s knew exactly how to make their marks: They did so simply, boldly, and with graphic force incomparable with anything in the rest of the industrialized world at that time. Commercial trademarks earned a special place in the practice of German commercial art. The leading makers included Peter Behrens (the father of corporate identity), Lucian Bernhard, F. H. Ehmcke, Konrad Jochheim, Louis Oppenheimer, Karl Schulpig, Valetin and Zietara, working for AEG, Manoli, Benz. Odol, among the leading corporations, pioneered a distinctly German abstract symbolic style that was omnipresent throughout the twentieth century (and influenced, among others, Otto Neurath's Isotype (or Pictogram) style of information design).

*Designer: Karl Schulpig
Logos, 1923–25*

The Schutzmarken style evolved in part from the medieval custom of embellishing every knight's weapon and from the wood engraving tradition exemplified by Northern Renaissance artist Albrecht Dürer (1471–1528). The modern Schutzmarken was an extension of the ancient monograms, signets, and crests from the early tradition of

printing. Add to these logical inspirations the stark and simple woodcuts of German Expressionism and the seeds of a graphic paradigm shift were planted. Nonetheless the trademark was not transformed into a Machine Age symbol overnight. German applied and fine arts were rooted in a romantic realist tradition, so simplification was not the most obvious path for designers to follow. Yet the demands of industry prior to and just after World War I altered many artistic attitudes. Before the war the introduction of the Object Poster as a response to the increased hustle and bustle of urban traffic was a key factor in the shift from complexity to economy, as was the avant-garde's radical rejection of bourgeois reliance on ornament and decoration. The public was also increasingly more accustomed to comprehending the witty little icons that stood for all manner of companies and goods.

Schutzmarken followed a fairly strict stylistic formula. Solid black silhouettes were preferred, usually simple forms like a round head on a body made by rectangles or squares. Other stark geometric shapes were championed—circles, triangles, parallelograms—and movement was encouraged: Karl Schulpig's logo for Bolle Dairy (which is still used) is a person's head and body formed by the letters "Bolle" with an additional arm ringing a bell. Most trademarks were solid black, but some were given the hint of color. Some stood on their own without any type, but many were integrated with bold sans serif letters that echoed the simplicity of the mark.

The modern trademark was promoted to designers and their clients through *Das Plakat*, the design magazine launched in 1910 as the official journal of the Verein der Plakat Freunde (The Society for Friends of the Poster), and later by *Gebrausgraphik*, founded in 1923, which became the leading international graphic design

and advertising journal. Both periodicals sought to expand the designer's role in business, and graphic identity was key. Nonetheless even the strongest trademarks demanded strategic attention.

The prolific trademark pioneer Wilhelm Deffke of Wilhelmwerk in Berlin explained in a 1929 book of his work, "Trademarks acquire their real worth and significance only through adequate usage. It is not sufficient to use them once in a while to designate certain products. They must be used systematically and frequently. The trademark will be the most likely to establish an inseparable bond between the user and the manufacturer." This was an idea that has certainly carried over into current branding and corporate I.D. strategies. But it was launched first in Germany.

SEE ALSO *Art Deco, Commercial Modern, Expressionist, Modernist, Object Poster, Pastiche, Pictogram, Pun*

SCREAMER TYPE

The typographical term "wood" is the jargon used by editors referring to so-called screaming headlines on tabloid newspaper front pages dating back to the late nineteenth and early twentieth centuries. Large sans serif wood types were common on advertising posters and broadsides because they grabbed attention without flourish or ambiguity. In 1919 the *New York Daily News*—the first American tabloid newspaper, started by Joseph Medill Patterson—used wood to announce with great fanfare the sensationalist (murder, sex, mayhem) story of the day. What distinguished the serious broadsheet from the scandalous tabloid was, in part, the

difference between elegant Roman and Gothic type. The conventions have not changed much, either. Tabloid wood may now be digital, but the goal is the same: to signal the big story (even if it's a nonstory) as if a billboard with flashing lights.

SEE ALSO *Novelty Type*

Designer: Unknown
Newspaper, 1990

278

SHADOW LETTER

Shadowed letters began as hand-drawn iterations of both classic and invented types and were introduced as metal typefaces as early as 1815, then popularized by such typefounders as Vincent Figgins, William Thorowgood, and Blake Garnett. Most shadowed types began as fat faces with typically thin stems and hair serifs that proved, at times, difficult to reproduce. Out of necessity, typefounders compensated by adding shadows to the more troublesome cuts—and they reveled in the surprising results. "It is as if the designers were absorbed in enjoying the ingenuity of their own invention," observed type historian Nicolette Gray in her book *Nineteenth Century Ornamented Type Faces* (University of California Press, 1977). Job printers quickly adopted these faces because regardless of the size they exploded off the page. In response to their surge in popularity, foundries issued wide selections of styles and sizes, including some quite awkward ones and others curiously elegant. Even literary giant Honoré de Balzac, the proprietor of his own Parisian type foundry, issued a lavish specimen catalog that included a varied assortment of Lettres Egyptiennes Ombrées—slab serif types with linear dimensional shading. Shadowed wood type was also in demand during the late nineteenth century,

Designer: Unknown
Advertisement, c. 1936

mostly used on posters designed to seize the eye of frantic passersby.

From their inception shadowed letters have toyed with viewers' perceptions. Whether framed by a subtle tint or bold silhouette, the shadow gives dimension, allowing words to rise monumentally and voluminously from an otherwise flat surface. Shadow faces offer a typographic trompe l'oeil based on real three-dimensional letters routinely placed on buildings that are made dramatic owing to the various ways in which light falls upon them, increasing or decreasing the depth of the shadow as the sun rises and sets, thus altering their shapes and proportions. This sculptural essence adds immensely not only to the letters' visibility, but also to their composition.

Designer: Unknown
Type specimen, c. 1898

Commercial sign painters mimicked these sculpted letterforms in hand-painted facsimiles that were rendered on glass, wood, and enameled metal. Although shadowed typefaces are more frequently used on small printed pages and posters, the finest—indeed most colorful—examples were found on late-nineteenth and early-to-mid-twentieth-century store windows and glass or enamel merchant's signs—all of which were created by hand with uncommon precision. Before the

explosion of neon in the early twentieth century, and even afterward, shadowed letters served as virtual illumination. Depending on the intensity of the artificial light source, hue of the silhouette, and color of the background on which they sat, the letters were often radiant. Years of hard-earned skill were needed to make these shadows work; ineptly rendered the letters could look unpleasantly grotesque.

A well-composed stack of luminescent shadowed letters on a poster can be as aesthetically satisfying as any beautifully designed object. Moreover, shadowed typefaces represent the nine-

Designer: Louise Fili
Photographer: William Duke
Book jacket, 1993

teenth century if Victorian lettering is used but can evoke the 1950s or 1990s or 2010, depending on the letter styles.

S E E A L S O *Commercial Modern, Novelty Type, Vernacular*

SHOCK AND ROLL

The generational dread of rock 'n' roll–influenced juvenile delinquents running wild in the streets (and the exploitation films that preyed on such feelings) contributed to the myth that rock 'n' roll was shock and roll. And despite efforts by the music industry to fend off criticism by schlocking up rock with clean-teen idols whose tepid pop covers of rock music prefigured the neutered sounds of Muzak, the real thing was never totally squelched.

Bubblegum notwithstanding, shock style was endemic to '60s rock. Sounds, lyrics, and album and poster art busted taboos and defined rock's aesthetic. Vivid misogyny and overt sexual perversion replaced the mildly graphic sensuality of earlier bachelor music. The Deviants' cover for their first album, simply titled *The Deviants* (1969), featured a photograph of a nun the likes of which might titillate even the pope. In the early '70s, Roxy Music took its graphic inspiration from girlie magazines with album covers (designed by Bryan Ferry) that were aimed at the masturbatory fantasies of adolescent record buyers. Sacred icons of American puritan culture were routinely defiled in the name of revolution. By the '70s, however, shock had become novelty and novelty soon wore thin. Alice Cooper resorted to live snakes on stage, Kiss put on Kabuki makeup and spit fake blood, while the Punks turned to body piercing, skinned heads, and ritual brawling.

Designer: Stefan Sagmeister
CD cover, 1994

Shock in rock moves its center from era to era and is really a quest for edge cutting. Since full-frontal nudity is fairly regular on prime-time TV, shockers must look to truly more distasteful imagery for inspiration. Where once shock had an element of sarcasm and satire, in-your-face disgust is more the state of the art. Pro-Pain's *The Truth Hurts* (Energy Records, 1994), designed by Stefan Sagmeister, is an

281

autopsy photograph while the cover of Sacred Reich's *Heal* (Metal Blade Records, 1996) is a photograph of a mysterious medical contraption by Max Aguilera Hellweg, taken from his book *The Sacred Heart*. Although difficult to decipher what exactly is going on, hands wearing surgical gloves hold a machine that appears to be inserted into a pulsating human heart. Compared to Sacred Reich's clinical depiction, Unsane's album art is more violently blood-soaked, but no more shocking. The cover for *Singles 89–92* (Matador Records, 1992) is an overview of a bathtub splattered with blood. The back cover showing a toilet stall is equally gruesome, and the CD graphic itself shows smeared blood. Songs with titles like "Urge to Kill," "Vandal-X," and "Blood Boy" reinforce the violent obsession.

Despite vain attempts to make rebellious statements using such tropes as erect middle fingers, bloody pieces of meat smeared on human heads, and even vivid scenes of enema application, shock style is schlock style. In an era when the verisimilitude of movie special effects has so numbed viewers to blood and guts, being truly shocking is a true challenge.

S E E A L S O *Fear, Grunge*

SHOW-CARD

In the early twentieth century most commercial artists learned about type and lettering through a graphic arts genre known as Show-Card writing. Schools were devoted to it, books were written about it, and livelihoods were made from it. Contemporary fabricators emerge from a long lineage of Show-Card makers, which in turn represents an outgrowth of nineteenth-century sign craft.

As the commercial art correspondence schools promised, students could "make $50 a week doing lettering" for stores, merchants, and businesses. All they needed was the know-how and tools. And so, for a small tuition fee these schools provided layout templates, typefaces, pens, brushes, and tricks galore—like how to dry paint quickly with the business end of a cigar butt.

Designer: Unknown
Show-card, 1932

To paint a Show-Card, the sign painter used slow-working oil colors or laboriously mixed his own colors from various pastes and powders. As the pace of industry and commerce quickened, the need for more elaborate Show-Cards and posters became proportionately greater. It soon became necessary to work with more speed and efficiency. To meet the demand, various artists began to specialize in specific genres and with certain media. Soon, new working methods, tools, and materials were introduced—specially prepared red sable brushes and Show-Card colors were manufactured.

A Show-Card letterer might not have known how to distinguish the nuances between one cut of Bauer Bodoni and another foundry's variation, but he was usually well versed in the best kinds of novelty brush letters that would grab the greatest attention. He also knew what quirky lettering combinations would liven up a store

Designers: Unknown
Show-card lettering, 1936

window or display case. He was also expert in the ABCs of card dynamics (such as where exactly to put those icicles for dynamic effect). The work extended to every facet of graphic arts: Show-Card makers were letterers, decorators, cartoonists, and copywriters (a good slogan made all the difference on a Show-Card).

With the growth of a widespread commercial culture during the late nineteenth century, Show-Card advertising became an economical means of announcing wares and selling products. In the early twentieth century with the advent of vaudeville and motion picture theaters, chain stores, smaller shops, and thousands of other business enterprises, Show-Cards rapidly became a big business.

Show-Card writing was never intended to be a hotbed of avant-gardism. It was simply an effective way of selling the goods, viands or violins, varnishes or vacations, to reach that much sought-after person, the man in the street. Scores of

books, booklets, and guides were produced for wanna-be Show-Card letterers providing them with countless pages of fetching options. Despite the standardized forms, it is interesting that Show-Cards were not usually a ready-made, or kept-in-stock product, but had to be made as required by the artist-workman.

Like that embarrassing second cousin who is best kept from the family reunion, Show-Card lettering will not be included in a standard graphic design history. Yet it was an aspect of design practice as consequential to commercial culture as the more sophisticated genres, movements, and schools celebrated today. What's more, it really took talent to do it well.

SEE ALSO *Art Deco Type, Cheap Chic, Comics Lettering, Handlettering, Novelty Type*

SKATEBOARD

Skateboarders have their own verbal and visual language. "Ollie," for example, is skater lingo for jumping. Most people think of skateboard graphics as just skulls and crossbones, but there is a complex weaving of signs and symbols that may not register with the uninitiated public. Skateboarding is a closed world, like some obscure fraternal order with secret handshakes, but it's also a big business that lures customers through intriguing graphics.

The range of styles stretches over decades and genres. Some look unapologetically nostalgic, borrowing heavily from '50s and '60s jazz album covers. Others tend towards Modern, modernistic, and just plain futuristic. Skaters are pretty traditional consumers: They buy based on brand image, which depends on how Punk, Hip Hop, East Coast, or bad-assed a skateboard company is, as well as who are the pros that ride for the company. The pros have a lot of sway and stylistic influence. And a pro's identity is often directly tied to a graphic aesthetic. There are so many companies with similar images that they all blur together. In the end it all comes down to unique graphics—that's why Ed Templeton,

(left)
Designer: Jim Phillips
Skateboard art, 1989

(middle)
Designer: Andy Jenkins
Skateboard art, 2005

(right)
Designer: Jim Phillips
Skateboard art, 1987

(left)
Designer: Jim Phillips
Skateboard art, 1999

(right)
Designer: Jim Phillips
Skateboard art, 1999

the owner/pro/artist of Toy Machine, thinks "about what would make me look at the board and notice it, or what would be funny on that board, what I'd laugh at if I walked into a shop. The whole purpose of a graphic is for that five minutes when a person comes into a shop and looks at it. Once a kid buys it, it gets wrecked anyway."

Boards are trashed quickly. Depending on how one skates, the board can easily be destroyed in a matter of weeks. Kids won't buy the same board twice—it is just not cool—so there is a constant need for new graphics. New boards are released in editions of one thousand or less every month. Once a series is sold out, the graphic is retired. It is good marketing strategy since stores keep buying new boards, figuring that kids purchase new ones just to have something different, even when they do not need a new board.

One of the most popular recurring motifs, however, is T&A, cartoony, violent-looking board graphics. Even skaters agree that "spread-eagled chicks" and the "bad-assed, sex and violence oriented images" make kids consumer crazy. The graphics shock for shock's sake because sex plus violence is an easy formula, and because aficionados agree skating is a "fuck with you" industry taking aim against adult standards, the status quo, and traditional mores of good taste.

Cease and desist orders are common in skateboarding graphics because many artists rip off corporate logos. Using trademarked material for graphics started as a cool way to engage in guerrilla attacks on corporations. Jason Lee's board graphic has his name sandwiched between the trademarked Burger King buns. Burger King was not amused and told him to cease and desist. But kids like logos, and skaters want to wear big Nike and Adidas marks, especially if they are skewed.

Skateboard style is not merely cool decoration. Artists like Jim Phillips and Andy Jenkins see skateboard art as a powerful way to communicate their ideas and philosophies. Some have eschewed cliché images of sexy chicks and violence in favor of images that explore issues of race and culture, such as the "emancipation board"

designed by Alyasha Owerka-Moore, that showed a black man shackled to a tree with "emancipation 1865–1995?" written underneath.

"It's impossible not to overanalyze the graphics and take them too seriously," says Jennifer Kabat, an online sports magazine editor. "The industry is shifting from its old model partly because fashions change, and the people creating them, building the industry, are getting older. Now, too, skateboard graphics are being taken seriously as 'art.' That changes the terms. Is it art, is it fun? What? It certainly is more than skulls and crossbones."

SEE ALSO *Club Flyer, Do-It-Yourself, Grunge, Obey the Giant*

SOCIALIST REALIST

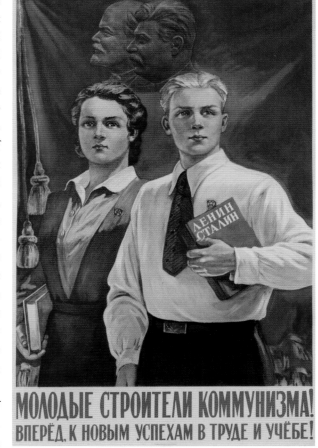

In order to survive, the totalitarian state must prohibit individualism. It must absorb the individual "into a communal scheme of life that tolerates growth and development of the personality only along narrowly prescribed lines," wrote Helmut Lehmann-Haupt in *Art Under Dictatorship* (Oxford, 1954). "Art is the expression of individual search, of experiment, of intuitive play, art that penetrates the surface of the visual world, that is prophetic, sensitive, apprehensive, art that challenges the individual, that demands concentration, effort… cannot be tolerated by the dictator." Art under the iron fist must give the illusion of authentication. In Nazi Germany, Fascist Italy, and the Soviet Union neoclassicism was perfectly suited to the needs of dictatorship. Its very nature and its revered historical root asserted validity, no matter how false.

Despite a brief but influential period of artistic progressivism in the USSR from around 1918 to 1922, the Soviet regime

ABOVE
Designer: Ludwig Hohlwein
Magazine cover, 1936

was suspicious of abstract art. Lenin believed that formalism—the focus on external forms and the deemphasis of content or meaning—excluded the proletariat as it was considered unduly concerned with style and unable to present communicable content. Moreover in formalism was found the expression of a doomed and decadent bourgeoisie.

Although the Constructivists and Productivists considered themselves revolutionary, in the USSR abstract art was inevitably labeled antidemocratic and antihumanistic. Lenin believed and Stalin later concurred that the artist cannot conceive or create artistic expression that is not a social and political statement. Yet paradoxically, the artist who consciously assumes the role of a true social critic is not tolerated in a totalitarian society.

In 1934 Stalin and author Maxim Gorky devised a new doctrine called Socialist Realism, which was presented at the first Soviet Writers' Congress. It started as a literary decree but quickly influenced the visual arts as well. Socialist Realism rejected formalism for its bourgeois influences on art. The Soviets abolished art (and eventually persecuted artists) suspected of harboring personal creative agendas. Ironically, what replaced abstraction in the USSR was a romantic and heroic style not all that pictorially different from American Social Realists' mural celebrations of worker, labor, and industry. But unlike American Social Realism fostered by the government-sponsored Works Progress Administration (WPA), Socialist Realism was imposed upon all Soviet artists, who were forced to belong to sanctioned artists' unions or become non-persons. In the ideological corruption of official Soviet art, those accused of being aloof from the daily struggle of the proletariat were removed from artistic life.

LEFT
Designer: Michail Solovjev
Poster, 1949

Artists had to espouse the ideas of Bolshevism: "Expressing the advanced ideas of the Soviet people, who at present represent the most advanced people of the

Designer: Norman Rockwell
Magazine cover, 1943

world, for they have built up socialism, the most advanced form of contemporary society," stated *LEF*, one of the official arts journals. "Soviet artists present the wholesome and integral art of socialist realism, expressed in profound artistic images reflecting true life, showing the struggle between the old and the new and the inevitable triumph of the new and progressive, an art mobilizing Soviet people for further victories."

Under Socialist Realism, which included painting, sculpture, graphic design, and photography, artists presented art created for the people, inspired by the thoughts, feelings, and achievements of the people, with the goal of enriching the people with its lofty ideas and noble images. The imagery was based on detailed, faux realistic depiction, which took the edges off the grit of reality, providing instead an ideal or heroic vision. In this way art exclusively served as unabashed propaganda.

Lenin once wrote: "Our workers and peasants are deserving of something more than circuses. They have gained the right to true, great art. For that reason we are first of all introducing the broadest popular education and training. It will lay the basis for culture, of course on condition that the question of bread is solved. On this basis a truly new, great, Communist art should grow up, which will create a form corresponding to its content."

All controlling measures were employed, stated Soviet minister of culture Anatoly Lunacharsky, "to regulate creative art, both proletarian and the art of those following the proletariat, and to put a stop to the artistic work among the direct enemies of the USSR." State control of the arts remained unchanged from the days of the Comintern through to Glasnost in the late 1980s. The style was also adopted in China immediately after the Communist Chinese assumed power in 1946, when it became integral to and remains the style of their propaganda posters and literature.

S E E A L S O *Constructivist, Heroic*

SPECTACULAR SIGN

France, Italy, and Germany were internationally celebrated in the early twentieth century for artful advertising posters that brightened the crowded boulevards of their great metropolises. Advertising art in Europe long relied more on enticing images than mere words, whereas American practice was based more on clever verbal slogans than pictorial concepts. Even roadside and urban billboards, the quintessential American advertising invention, were more headline-heavy, and without strong visuals, inferior to European output. But the U.S. did have a uniquely indigenous commercial sign style born of Thomas Alva Edison's incandescent revolution, the electric light display board or "spectacular." Paris may have been the "City of Light" but thanks to Times Square's "white light district," New York was the capital of commercial light, the wellspring of technologically progressive advertising or what the advertising impresario O. J. Gude called "the phantasmagoria of lights and electric signs."

Times Square was not the first Manhattan locale to introduce talking signs that telegraphed animated words and images for blocks around, but in 1916 it was the first urban environ given zoning rights to allow such a concentrated magnitude of

Designer: Douglas Leigh.
Photographer: John Vachon
Sign spectacular, 1943

white and eventually colored light, not simply for illumination but to project the nation's most influential brand names to the world. By 1922 the outdoor advertising business was booming and two years later national automobile, gasoline, soft drink, and cigarette manufacturers had taken the lion's share of available leases for most visible Times Square ad space.

Spectaculars—so named by Douglas Leigh, whose company conceived and with Artkraft-Strauss fabricated the majority of the lighting displays from the late '20s through the twentieth century—were nothing less than high-tech carnival midway attractions. They shook, wiggled, and blinked as they got increasingly bigger and bigger and saddled with more senses-capturing special effects in a desperate grab for public attention. Unlike a painted billboard or printed poster the spectacular was a semipermanent affair, so the concept had to have legs. The visual ideas had to last at least a year if not more. Stylistically they could not be ephemeral, but they did have to shed light on their times.

SEE ALSO *Commercial Modern, Vernacular*

STENBERG FILM POSTER

Most contemporary posters for feature films adhere to rigid formulas designed to capture the fleeting attention of the average pedestrian. Typically, they contain a strong central image—often a picture of the star or symbol of the plot—plus a bold title or logo, the stars' billing, a blurb or two, and a bank of scrunched-together credits, ratings, and other theater information. Given this cacophony, movie posters are rarely masterpieces of graphic design. But the genre was not always so artless.

From 1923 to 1933 the brothers Vladimir and Georgii Stenberg, Russian avant-garde graphic designers, created innovative posters that promoted the new Russian cinema and revolutionized graphic design. As proponents of a new radical art form called Constructivism, which was rooted in a marriage of technology and abstraction, the Stenberg brothers changed the look and feel of poster art and advertising. By introducing montage, the mechanical juxtaposition of disparate elements into a new entity, they created compositions of unusual grace and exceptional power. Using bold colors, simple geometry, and stark typography, their work caught the eyes of the largely illiterate Russian masses. Like the films they advertised, the Stenbergs' posters had a visceral effect on the viewer. Although the posters did not reveal the plot, they provided clues as to its nature and thus enticed audiences. Today they are just as powerful and continue to have influence,

RIGHT
Designers: Stenberg Brothers
Poster, 1928

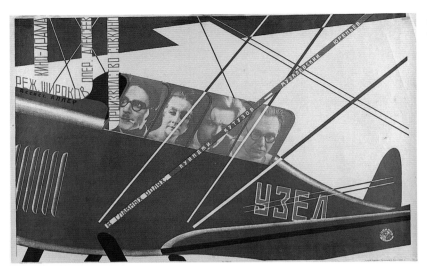

Designers: Stenberg Brothers
Poster, 1927

not so much on contemporary movie posters but on other forms of graphic design, including packaging, posters, and record and book covers.

Although their imagery illustrates specific films, when viewed together the posters exhibit a dominant visual style that draws as much attention to the designers as to the design. These posters may be artifacts of an eighty-year-old political, social, and cultural revolution which has since gone sour, but they have not turned into mere nostalgia in the same way that Art Nouveau and Art Deco have become quaint over time. The Stenbergs used a visual vocabulary and graphic wit that did not rely on fad or fashion. Remarkably, their ideas remain fresh.

The Stenbergs' primary goal was to startle. "We deal with material in a free manner . . . disregarding actual proportions . . . turning figures upside down; in short, we employ everything that can make a busy passerby stop in [his] tracks," they wrote in 1928. Theirs was a synthesis of avant-garde philosophy, theory, and eccentricity applied to promotional art. In a nation where strong iconography propagated the Soviet message, the Stenbergs rightly reasoned that graphic design was the best tool for reaching the proletariat. Constructivism and its utilitarian offshoot, Productivism, the primary avant-garde movements in the first few years following the Russian Revolution, were in large part serving commerce in ways that brought visual art to the greatest number of people. The Stenberg posters expanded this notion both individually and together with like-minded artists.

The brothers' emblematic style developed from 1918 to 1922, during the so-called Laboratory Period of Constructivism, when the leaders of the avant-garde—Aleksei Gan, Varvara Stepanova, and Alexander Rodchenko, among

them—founded the First Working Group of Constructivists and issued manifestos that pronounced the utilitarian purpose of art. Constructivism was typified by experiments that explored the kinetic quality of geometric and linear form and the compositional dynamism of two and three dimensions. In this spirit the Stenbergs constructed their posters by building up layers of visual material to a point where it appeared to explode on the poster's surface.

The Stenbergs introduced an array of abstract graphic devices including outlines, spirals, and concentric circles to imply movement, and mixed reality and fantasy into a single graphic image. To cap off their compositions, they used blocky sans serif Cyrillic letterforms to accentuate the mechanical quality of the posters.

The Stenbergs' graphic style has been widely reprised in contemporary graphic design. Although their work is probably largely unknown to young designers today, its influence on the early stages of Modern advertising was significant. Their pioneering efforts with photomontage, vibrant and vibrating color, and stark typography influenced the early Modernists and still echo in the work of computer generation designers.

The Stenberg brothers worked together intimately on the conception and design of every poster until Georgii's death in 1933. In 1934 Stalin instituted the doctrine of Socialist Realism, which effectively ended the experimental work of the Constructivists, forcing the leading experimentalists into a more official style of art. Vladimir adapted to the new dictates on art and design. He later held the post of Chief of Design for Red Square until 1964, during which time he collaborated on film posters with his sister and son. He died in Moscow in 1981.

S E E A L S O *Bauhaus, Constructivist, Modernist, Socialist Realist*

STREAMLINE

Streamline was a distinctly American Modern design style forged in the crucible of the social and economic turmoil of the 1920s and '30s. Overproduction for inactive consumer markets demanded radical measures and forced business into an unprecedented alliance with a new professional, the industrial designer. In an effort to stimulate consumption, these white knights of industry launched a crusade against outmoded industrial output that resulted in the application of new futuristic veneers that brought out the inherent machine-made attributes of products and commodities. Influenced by Modern art, which to a certain degree was inspired by the machine itself, the industrial designer was not like the nineteenth-century decorator, an apologist for or rebel against mass production,

but rather a visionary who understood that art should be of its time and products should represent the era in which they are produced.

Streamlining evolved in the United States from the practical need to minimize wind and water resistance in the design of ships, trains, cars, and planes. The functional teardrop shape (and other similarly practical designs) had aesthetic appeal and came to symbolize the mechanized tempo of daily life. By 1938 Streamlining was such a widespread practice that Sheldon and Martha Candler Cheney wrote in their important analysis of American industrial design, *Art and the Machine* (Whittlesey House, 1939), that "everywhere, there is . . . merchandise distinguished by the beauty that is peculiarly a product of artist and machine working together."

Industrial products themselves were not, however, the first to receive this Machine Age makeover. By the early '20s European Modernists had already worked to improve the look of everyday products, and this notion first filtered into American design in the form of magazine advertising. The term modernistic, or ersatz Modernism, is an accurate way to describe the style that developed. Although Modern characteristics were visible, modernistic design did not totally reject ornament but rather compromised between purism and bourgeois luxury. Modernistic graphics, characterized by sleek airbrushed veneers, framed and "dressed" otherwise quaint and timeworn products. In the early '20s the practice called "styling" had not yet been adopted for industrial wares.

But marketing strategists developed the illusion of progress by using progressive type and images that were seductively progressive, or what the industrial designer Raymond Loewy called MAYA, "most advanced yet acceptable." Even this pioneer of Streamlining realized that the public must be gradually introduced to progressive ideas one stylistic increment at a time.

The concept of obsoletism (later known as forced obsolescence) emerged as the capitalist tool and engine that propelled the Streamline movement. Industrial designers, like Loewy, Henry Dreyfuss, Norman Bel Geddes, Walter Dorwin Teague, and Donald Desky, believed it was their role to fulfill advertising's promises by designing and

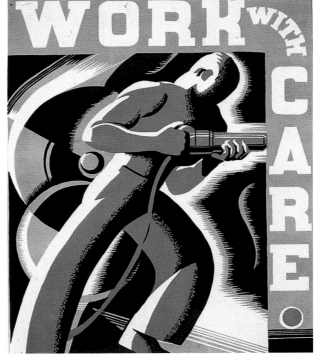

Designer: Robert Muchley
Poster, 1936

developing products that not only looked new but included substantial mechanical improvements. While the term Streamline implies a modicum of artifice, the application of aerodynamic and other progressive engineering principles to products and machinery significantly increased their efficiency. The paradigms of Streamline design are monuments of Machine Age retooling. Although not as pure in its rejection of ornament as the Bauhaus adherents would have liked, the Streamline ethos was nevertheless resolutely progressive within the limits of the commercial arena. Its primary exponents were dedicated to reviving the American economy and fervently believed that good design would do the job. Style was not arbitrarily affixed to products but was added to distinguish old from new and to encourage national pride through a distinctly American aesthetic.

That said, obsoletism encouraged excess, and the Streamline aesthetic was often carried to extremes. "It must be admitted," wrote modernistic design proponent Douglas C. McMurtrie in *Modern Typography and Layout* (Eyncourt Press, 1929), "that there have been numerous excesses and absurdities . . . in the use of type, masquerading under the guise of modernism." And Frank H. Young noted in his paean to contemporary design, *Modern Advertising Art* (Covici, Friede, 1930), "In

some instances enthusiasm for modernism has overshadowed good judgement and the all-important selling message is completely destroyed. The crash of the freakish layout will call attention only to itself and the reader will fail to react favorably to the message, if indeed he gets it at all."

The greatest testament to Streamlining was the 1939–40 New York World's Fair with its majestic Trylon and Perisphere designed by Wallace K. Harrison and J. Andre Foulihoux. The idealistic Democracity was suitably housed in the enormous Perisphere, a white futuristic temple that also served as the fair's indelible, architectural trademark. Perisphere was the largest "floating" globe ever built—180 feet in diameter and eighteen stories high, twice the size of Radio City Music Hall. The theme center emerged after more than one thousand sketches and models. Despite its unique form, it was not without design precedents, including references to the Bauhaus and Constructivism. Overall the fair, with its futuristic pavilions including General Motors' Futurama, was the most ambitious international exposition since the Crystal Palace housed the first New York World's Fair in 1853. Not just a trade show, it was endowed with mythic qualities; it was "The World of Tomorrow," and "The Dawn of a New Day." It was a masterpiece of showmanship, the epitome of stagecraft—a real-life Land of Oz indelibly etched in the memories of those who attended and in the imaginations of those who did not. It was more than a collection of exhibitions, it was a wellspring of innovation in corporate identity and graphic promotion. SEE ALSO *Art Deco, Bauhaus, Commercial Modern, Modernist, Shadow Letter, Spectacular Sign*

Designer: Joseph Binder Guide book cover, 1939

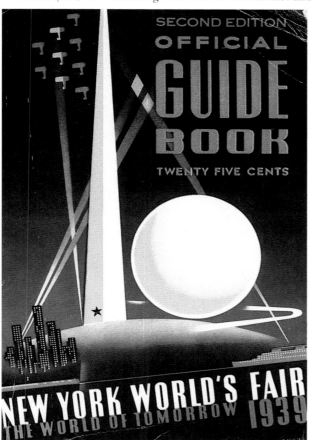

297

Designer: Randy Balsmeyer
Movie titles, 1991

STREET SIGN

No one knows the name of the first designer to use a common street sign as a design motif. In fact, no one knows who designed the first common street sign. Whoever was responsible launched one of the most ubiquitous of all design con-

ceits to be found on record, book, and magazine covers, and countless other graphic wares. Paul Rand, Saul Bass, and countless other moderns used it. It can be found on theater posters, book jackets, and magazine covers. During the mid-1920s the anonymous designer of a book jacket for the novel *9th Avenue* appropriately rendered the title as a lamppost sign. Similar iterations mimicked traffic and other directional signs. The copying of signs can be a form of parody; it also pays homage to recognizable vernacular (indeed street sign typography is about as vernacular as it comes). Some designs are quite

Designer: B. Middleworth
Book jacket, 2005

Designer: Unknown
Book jacket, 1927

clever applications, others are as mundane as the signs themselves. The film titles for Spike Lee's 1991 *Jungle Fever*, including all the actors' and filmmakers' credits, designed by Randy Balsmeyer (of Big Film), are harvested from an array of urban street signs (i.e. Stop, Yield, No Parking). More recently, B. Middleworth's (of Bats4bonesDesign) Photoshop-rendered jacket for the 2005 true crime exposé *Desire Street* was made from signs on a traffic light stanchion. The street sign motif never gets tired; perhaps because it is such a quick problem-solver, it will never be retired. S E E A L S O *Pastiche, Show-Card*

SURREALIST

The term *Surrealist* was coined in France in 1917 by poet Guillaume Apollinaire to describe an absurdist drama he had written. The Surrealist movement itself was codified in 1924 by writer André Breton, who authored its first manifesto declaring that the rights of man could be achieved through the liberation of the unconscious activity of the mind. Surrealism, Breton wrote, could recover control over human destiny. Surrealist ideas were originally applied to poetry in the form of automatic or subconscious writing, but soon the dreamlike language of Surrealism was manifest in the plastic arts. Surrealist images juxtaposed the irreconcilable, disrupted conventional expectations, and subverted traditional notions of beauty. About the Belgian painter René Magritte, whose 1928 painting *The False Mirror* is the quintessential Surrealist symbol, Breton said that "the visual image [was] systematically on trial."

Surrealism induced physical and mental vertigo that both stimulated and sabotaged perception. Yet surrealistic imagery was made long before the term Surrealism was coined. The macabre and nightmarish cartoons by French caricaturist J. J. Grandville in the early 1800s prefigured contemporary science fiction art. Others working with dislocated and dreamlike imagery paved the way for a language of Surrealism. Many artists and photographers anonymously explored

the psychology behind everything from lovemaking to war-making through surreal juxtapositions.

Perhaps no work exemplified the psychic disturbance of Surrealism better than that of Giorgio de Chirico. Though he was not officially a Surrealist his mental landscapes, with their multiple vanishing points that distorted Renaissance perspective, expressed the human traumas over which the movement obsessed.

André Breton urged artists to create objects that had appeared in dreams. Salvador Dalí's 1936 *Lobster Telephone* suggests an almost logical incongruity, while Meret Oppenheim's 1936 *Object* (her famous fur cup) reveals a Surrealist fixation with the erotic. At the 1938 Paris International Surrealist Exhibition many exponents had already trans-

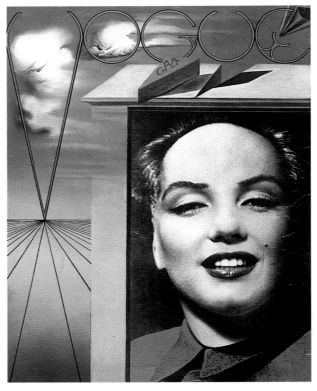

Designer: Salvador Dalí
Magazine cover, 1971

lated their dreams into photographs and cinema. The most chilling and classic film was *The Andalusian Dog*, a collaboration between Salvador Dalí and Luis Buñuel. Dalí also designed the dream sequence for Alfred Hitchcock's thriller *Spellbound*. To the dismay of the studio, Dalí had originally decided to cover the film's star, Ingrid Bergman, with ants.

By the late 1930s Surrealism had become a fashion, the vernacular for many commercial artists in various disciplines. Both mysterious and accessible, Surrealism provided a modern means to visually express complex as well as simplistic ideas and impart a sense of mystery and illusion.

Surrealist painters used realism as a means to dislodge the world of reality. Some collaged biomorphic forms to otherwise real objects or landscapes evoking an extraterrestrial sensibility. And others used collage as the means of making visual riddles. The graphic design of the 1940s evidences various Surrealist influences: Herbert Bayer's ad for nasal spray, 1940; Jean Carlu's advertisements for Container Corporation of America, 1943; and Alvin Lustig's collage and montage book jackets for New Directions publications, 1947.

Designer: Herbert Bayer
Advertisement, 1935

Historian Lucy Lippard calls Surrealism "housebroken Dada...Northern fantasy subjected to French lucidity." As commercial art, Surrealism was a benign tool not a revolutionary language. Nevertheless, graphic designers interpreted Surrealism effectively for various needs. During the '60s, René Magritte influenced many illustrators. By the '70s Surrealism was the perfect metaphor for an era in which multitudinous images bombarded the senses with shocking regularity. Among the most proficient contemporary Surrealists were the Japanese designers, such as Tadanori Yoko's poster for *Science Fiction Movies*, 1975. As a popular style, Surrealism's dreamy appeal continues to entice, and remains a viable means to convey complex themes in poetic, often abstract, ways.

S E E A L S O *Artzybasheff, Conceptual Illustration, Dada*

ROBERT JONAS' PENGUIN BOOK COVERS

Robert Jonas' paperback covers brought a mid-level Modernist aesthetic to middlebrow prose—a marriage made in heaven. Jonas, known by a lowercase Bodoni signature, was a paperback cover designer who spent much of his career working for Penguin and its various imprints. The best of his designs were in the 1940s, marked by a late Modern illustrative style that combined technical facility with dynamic compositions and a knack for subtle abstractions of figure and scale. He did not create floating abstract shapes or high-flown collage, he preferred more representational forms from which he could then safely riff. His style adapted Modernist mannerisms and made them commercial. Nevertheless, the concepts behind each image were clearly delineated and his covers are among the most striking in paperbacks. — D.N.

SUTNAR

Ladislav Sutnar (1897–1976) was a pioneer of information design, the man responsible for putting the parentheses around American telephone area code numbers when they were first introduced in the early 1960s. In the late 1950s and early '60s he developed a variety of sophisticated design programs for America's telecommunications monopoly, the Bell System, when it began a technological overhaul of its services. His functional typography and iconography made public access to both emergency and normal services considerably easier while at the same time they provided Bell with a distinctive graphic style.

Sutnar's contributions to information architecture are milestones not only of graphic design history but also of design for the public good. For a wide range of American businesses Sutnar developed graphic systems that clarified vast amounts of complex, usually ponderous, information. He transformed routine business data into digestible units through smartly designed catalogs.

As impersonal as the telephone area code design might appear, the parentheses were actually among Sutnar's signature functionally stylistic devices, one of many he used to distinguish and highlight information. As the art director of F. W.

Designer: Ladislav Sutnar
Advertisement, 1953

Dodge's Sweet's Catalog Service from 1941 to 1960, America's leading distributor and producer of trade and manufacturing catalogs, Sutnar developed various typographic and iconographic navigational devices that allowed users to efficiently traverse seas of data. His icons are analogous to the friendly computer symbols.

Sutnar also made common punctuation, such as commas, colons, and exclamation points, into linguistic traffic signs by enlarging and repeating them. Although he professed universality, he possessed a graphic personality so distinctive that his work did not even require a credit line, although he almost always took one. Nevertheless this personality was based on functional requi-

Designer: Ladislav Sutnar
Advertisement, 1955

sites, not indulgent mannerisms, and so never obscured his clients' messages.

"The lack of discipline in our present day urban industrial environment has produced a visual condition, characterized by clutter, confusion and chaos," wrote Allon Schoener, curator of Ladislav Sutnar: Visual Design in Action, a 1961 exhibition. "As a result the average man of today must struggle to accomplish such basic objectives as being able to read signs, to identify products, to digest advertisements, or to locate information in newspapers, books and catalogues. . . . There is an urgent need for communication based upon precision and clarity. This is the area in which Ladislav Sutnar excels."

Sutnar synthesized European avant-gardisms, which he said "provided the base for further extension of new design vocabulary and new design means," into a functional commercial lexicon that eschewed formalistic rules or art for art's sake. While he modified aspects of the New Typography he did not compromise its integrity the same way that elements of Swiss Neue Grafik or International Typographic style became mundane through continuous mindless use over time. He made Constructivism playful and used geometry to create the dynamics of organization.

Consistency reigned within an established framework, such as limited type and color choices as well as strict layout preferences, but within those parameters a variety of options existed in relation to different kinds of projects, including catalogs, books, magazines, and exhibits.

Although Sutnar's spoken English was fettered by a heavy Czech accent marred by grammatical deficiencies, he was nevertheless a prolific writer who articulated his professional standards in essays and books that were both philosophical and practical. *Visual Design in Action* (1961), which used his own work as an example, argues for future advances in graphic design and defines design in relation to a variety of dynamic methodologies. It is the most intellectually stimulating Modern design book since Jan Tschichold's 1928 *Die Neue Typographie.*

LEFT
Designer: Ladislav Sutnar
Book cover, 1950

Sutnar's fundamental thesis is found in these words: "Good visual design is serious in purpose. Its aim is not to attain popular success by going back to the nostalgia of the past, or by sinking to the infantile level of a mythical public taste. It aspires to uplift the public to an expert design level. To inspire improvement and progress demands that the designer perform to the fullest limits of his ability. The designer must think first, work later."

Sutnar and collaborator Karl Löndberg-Holm produced two indispensable graphic style guides for industry: *Catalog Design* (1944) and *Catalog Design Progress* (1950). The former introduced a variety of systematic departures in catalog design. The latter fine-tuned those models to show how complex information could be organized and, most importantly, retrieved. Over forty years after its publication *Catalog Design Progress* is still a paradigm of functional design.

Sweet's Catalog Service was a facilitator for countless trade and manufacturing publications that were collected in huge binders and distributed to businesses throughout the United States. Before Sutnar began its major redesign around 1941, the only organizing device was the overall binding. Löndberg-Holm had convinced Chauncey Williams, the president of F. W. Dodge, to order an entire reevaluation from logo (which Sutnar transformed from a nineteenth-century swashed word, "Sweets," to a bold "S" dropped out of a black circle), to the fundamental structure of the binder (including the introduction of tabular aids), to the

RIGHT
Designer: Steven Guarnaccia
Watch design, 1997

redesign of individual catalogs (some of which were designed by Sweet's in-house art department under Sutnar's direction).

But the most significant of Sutnar's innovations was the use of spreads. He was one of the first designers to design double spreads rather than single pages. A casual perusal of Sutnar's designs for everything from catalogs to brochures from 1941 on, with the logical exception of covers, reveals a preponderance of spreads on which his signature navigational devices force the users to go from one level of information to the next. Through spreads Sutnar was able to inject visual excitement into even the most routine material without impinging upon accessibility.

S E E A L S O *Bauhaus, Constructivist, International Typographic, Modernist, New Typography*

SWATCH WATCH

Swatch watches were introduced in 1982 in sleek boxes featuring its streamline logo abutting the traditional Swiss cross. The watches themselves were Swiss precision, yet they took a radical conceptual turn that transformed functional timepieces into a quintessential postmodern object. Rather than simply a watch it was designed as a commentary on the nature of watches. Commercially speaking, it expanded the role of the watch in contemporary culture. In 1985 Swatch launched its special, limited edition watches designed and decorated by prominent visual artists. Keith Haring and Kiki Picasso were the first to create watch faces in their trademark styles; they were followed by a diverse array of painters, photographers, designers, and illustrators including Kenny Scharf, David LaChapelle, J. Otto Seibold, Annie Leibovitz, and Steven Guarnaccia. The unifying element was a strong, usually humorous graphic style that told a story or symbolized an idea. The band and face were usually treated as a single unit, turning the watch into an unconventional object while still retaining the basic watch form. The Swatch style was known for its transparency—one approach was to show the gears through clear plastic and integrate the illustration into the components. Mostly, the Swatch style was an amalgam of many graphic styles resulting in a decidedly consistent identity. During the 1980s and early '90s watches became veritable canvases for designers and artists who played with the conventions of time-keeping. Swatch went a step further by using graphics to transform a permanent, often staid functional machine into a stylishly "ultracool" piece of ephemeral jewelry.

S E E A L S O *Conceptual Illustration, New Wave, Postmodern*

see Tijuana Bible

TEEN MAGAZINE

For pubescent girls growing up in the 1960s, *16 Magazine* was a dream machine of unattainable, yet imaginable lovers. For hormone-awakened boys it was a style guide to what the coolest cats were wearing, which, by extension, was what you should be wearing if you wanted to get to first base with the typical female *16* reader.

Gloria Stavers, who began at *16* as a lowly subscription clerk and miraculously rose to editor-in-chief (talk about the vicissitudes of fame) in just one year, knew that celebrity was a potent narcotic. Regardless of talent (or lack thereof), a familiar face and well-known name had untold seductive influence on impressionable young girls. Her theory of idol-making was simple: Identify already popular or rising personalities and hype the hell out of them through photographs and "exclusive" stories. The formula was not new: *Photoplay, Silver Screen, Movie Star,* and other '30s- and '40s-era pulp mass media fan magazines had preceded the current crop, but none were aimed at young teens. By 1957 when the first issue of *16* (with Elvis on the cover) premiered, the teen market was still in its infancy. Before World War II teenagers were in a netherworld between child- and adulthood, treated by commerce as one or the other, but never as an integral demographic.

Stavers devised a graphic style that

Designer: Unknown
Magazine cover, 1971

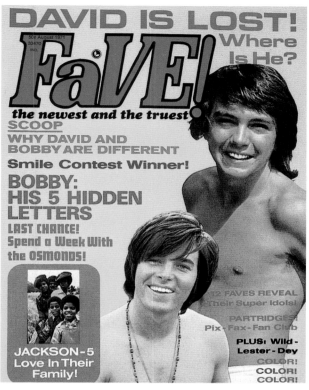

DAVID IS LOST! Where Is He?

50¢ August 1971
33470
IND.

FaVE!

the newest and the truest

SCOOP

WHY DAVID AND BOBBY ARE DIFFERENT

Smile Contest Winner!

BOBBY: HIS 5 HIDDEN LETTERS

LAST CHANCE! Spend a Week With the OSMONDS!

JACKSON-5 Love In Their Family!

12 FAVES REVEAL Their Super Idols!

PARTRIDGES! Pix - Fax - Fan Club

PLUS! Wild - Lester - Dey

COLOR! COLOR! COLOR!

Designer: Unknown
Magazine cover, 1971

was quickly adopted by other teen magazines, like *Tiger Beat* and *Rave*. Bright, garish cover colors, not unlike the appearance of raunchy adult pulps like *Police Gazette* and *True Confidential*. Also similar were the provocative declarative and questioning headlines—"David Cassidy's Truest Loves Revealed" or "How Does David Cassidy Stay So Loveable?"—set in screaming Gothic typefaces often framed by sunbursts, starbursts, and other graphic effluvia. The silhouetted heads of stars and starlets floated all over the cover, sometimes affixed, like at a carnival midway show, to the bodies of drawn or painted animals or strongmen.

Inside *16* cheaply printed black-and-white pages were filled with silhouetted publicity photos alongside candid shots. The layouts were full of pull quotes, tinted box sidebars, and widely leaded type. Nothing taxing, though filled to the gills with trivial information.

This teen (now called tween) style continues to this day, and has been borrowed for various other kinds of magazines. In the '80s, the silhouetted heads were appropriated by *SPY*, the sophisticated adult satiric culture and art magazine, designed in the late '80s by Stephen Doyle and Alexander Isley. Many of the Condé Nast lifestyle and celebrity magazines aimed at young adults and twenty-somethings, appear to have followed suit.

SEE ALSO *Magazine Cliché, Novelty Type, Vegas, Vernacular*

TIBOR

With his Barnum-like antics, rapier wit, genius for public relations, and radicalism from his days as an SDS organizer, by the late 1980s Tibor Kalman, who died on May 2, 1999, was unofficially dubbed (or perhaps dubbed himself) the "Bad Boy" of graphic design. Graphic design was Kalman's means to an end. Good design,

which he defined as "unexpected and untried," added more interest, and was therefore a benefit to everyday life. And since graphic design is mass communication, Kalman believed it should be used as an appeal to public awareness on a variety of issues. He urged clients to promote political messages and devoted M&Co's seasonal self-promotional gifts to advocate social causes.

Designer: Tibor Kalman
Watch design, 1983

Kalman believed that design was useless if it did not support a message leading to action. Even M&Co's most stylistic work must be viewed in the context of Kalman's challenge to the professional status quo. He once said about his clients: "We're not here to give them what's safe and expedient. We're not here to help eradicate everything of visual interest from the face of the earth. We're here to make them think about design that's dangerous and unpredictable. We're here to inject art into commerce." Kalman's critiques on the nature of consumption and production expanded the parameters of graphic and environmental design from business service to cultural force. He advocated that design should enhance the environment, not clutter it with unwanted messages or wasteful packages.

Kalman's style was rooted in various tenets; here are four:

One: Words convey meaning. Type is language. Typography is speech. These

are the ABCs of graphic design. And Kalman, who came to the United States from Hungary in 1957 without knowing a word of English, became enamored with the nuances of his adopted language and the means of its conveyance. He was acutely aware that letterforms and their placement on any surface was the foundation of mass communication, yet was insistent that Roman letters, the Western world's vernacular form dating back to ancient Rome, need not be slavishly traditional. Tradition, Kalman said, could suck the

Designer: Tibor Kalman
Advertisement, 1986

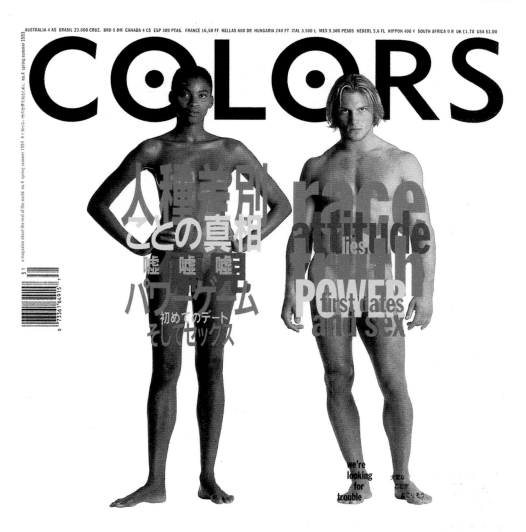

AUSTRALIA 4 A$ BRASIL 23.600 CRUZ. BRD 5 DM CANADA 4 C$ ESP 300 PTAS. FRANCE 16,50 FF HELLAS 600 DR HUNGARIA 240 FT ITAL 3.500 L MEX 9.300 PESOS NEDERL 5,6 FL NIPPON 400 ¥ SOUTH AFRICA 9 R UK £1.70 USA $3.00

C O L O R S

人種差別
ことの真相
嘘 嘘 嘘
パワーゲーム
初めてのデート
そしてセックス

race
attitude lies
truth
POWER
first dates
and sex

we're
looking
for
trouble

大変な
ことが
おこりそう

Art Director: Tibor Kalman
Magazine cover, 1993

life out of any message by rendering it bland or invisible, and therefore the tenets of typography existed to be upset.

Two: Legibility did not always equal readability; and readability did not always ensure accessibility. To communicate ideas, and particularly to convey meaning, demanded disruption of typographic convention. Reading was only a step toward memorability and to learn, the reader had to be inspired. Sometimes the words alone were not enough. Typography was a mnemonic that sparked interest and recognition.

Three: The detritus of commercial culture—the commonplace cereal packages,

take-out containers, restaurant menus, and store signs produced by commercial artists and craftspersons that are void of design school "sophistication"—is also good design. Kalman related best to the work of self-taught artisans who did not slavishly adhere to design fashions. He also found honesty in the purity of the "vernacular" or the ambient language of mass communications. Vernacularism was a tool to unhinge the dominance of cold Modernism and cool professionalism.

Four: Graphic design is a tool of social activism, a means to communicate directly with the public. Kalman urged clients to use the advertising that M&Co had created for them to promote political messages just as he devoted M&Co's seasonal self-promotional gifts to advocate support for the homeless. For Tibor Kalman there was no more important goal than to awaken a somnambulant public in whichever way he could.

SEE ALSO *Postmodern, Vernacular*

TIJUANA BIBLE

Tijuana Bibles are cheaply printed, pornographic eight-page minicomic books produced from the 1930s to the early '50s and clandestinely distributed through news shops and by street corner peddlers. Curiously naïve despite their copious hardcore depictions, these anonymously drawn indigenous American comics steal golden age cartoon styles from the likes of George McManus (Maggie and Jiggs), Bud Fisher (Mutt and Jeff), E. C. Segar (Popeye), Chic Young (Blondie), Rube Goldberg, and even Walt Disney, and are often drawn with the same witty expressiveness as the originals. Since old newspaper comics were produced as much for adults as children, many of these lascivious triple-X-rated versions are grownup speculations about forbidden behavior of real comic characters.

Tijuana Bibles were neither made in Tijuana, Mexico, nor resemble Bibles— they were also called "eight pagers," "two-by-fours," "Jo-Jo Books," and "Jiggs-and-Maggie Books," among their less salacious names—but the reference suggests the debauchery native to some of the seedier border towns made legend in the film *Touch of Evil*. Who invented, drew, printed, or distributed them is a mystery— although the sexologist Gershon Legman identified one cartoonist named "Doc" Rankin, who also drew for girlie magazines, and comics artist Art Spiegelman attributes some to Wesley Morse, who eventually drew Bazooka Joe bubblegum comics. In his introduction to *Tijuana Bibles: Art and Wit in America's Forbidden Funnies, 1930–1950*, Spiegelman notes that somewhere between 700 and 1,000 different versions were produced in various series or genres, and included famous

comic characters, movie stars and starlets (Mae West), sports figures (Lou Gehrig), gangsters (Al Capone), and dictators (Adolf Hitler, a.k.a. Herr Hipler). In its day Tijuana style was pervasive and profusely copied.

Tijuana Bibles were distinct from average porn styles for they were not entirely void of socially redeeming value insofar as in addition to presenting unrestricted graphic sexual activity (seen from all angles), they were wittily ribald. Rather than simply show the typical graphically unmitigated voyeuristic displays of copulation, the vast majority were wicked lampoons of uptight popular culture that obviously also served the voyeur's baser instincts. The basic 4 x 3 inch, stapled Tijuana Bibles adhered to conventional comics formats—splash panel title cover, panels with dialogue balloons and boxed narratives, often framed by heavy rules or sometimes filigree boxes. The drawings were surprisingly competent and a few so convincingly mimicked original strips that only the subject matter distinguished them from the mainstream. But they were very hardcore.

Designers: Unknown
Covers, c. 1930

MAD magazine artists of the early 1950s were certainly influenced by Tijuana Bibles. Although Harvey Kurtzman and Will Elder's stinging parodies of popular comics in *MAD* were less sexually overt, they were nonetheless just as sacrilegious when it came to skewering social proprieties. Later Underground comix in the '60s, definitely modeled on *MAD*, were clearly beholden to the Bibles too. Some of R. Crumb's sexually explicit lampoons of vintage strips and genres paid obvious homage, and ultimately through his and other Underground comix artists' strips and comix books, the Tijuana Bible model was raised up from the gutter into an alternative youth culture form and, more recently, now into certain mainstream comic book culture.

SEE ALSO *Comics Lettering, Show-Card, Underground Press, Vegas*

see Underground Press

UNDERGROUND PRESS

"'Underground' is a sloppy word and a lot of us are sorry we got stuck with it. 'Underground' is meaningless, ambiguous, irrelevant, widely imprecise, undefinitive, derivative, uncopyrighted, uncontrollable, and used up," exclaimed Tom Forcade, coordinator of the Underground Press Syndicate, in 1968 when the anarchic publishing movement known as the Underground Press had peaked in the United States. The rubric signified the surge of antiestablishment publishing from the early '60s through the early '70s. Initially termed "underground" because it represented a subculture that advocated organized disobedience in opposition to the Vietnam War and in support of the Civil Rights movement, eventually sex, drugs, and rock 'n' roll were added to the mix.

Underground publishing was a spontaneous rebellion of mostly urban middle-class kids and young adults against a power structure mired in the archaic status quo. The Undergrounds challenged propriety through word and picture. Written and visual obscenity was a prime weapon and style. Accepted notions of design were ignored entirely, which gave the newspapers their collective untutored look. The movement was a hotbed of functional naïveté. While historians often compare the Undergrounds to Dada, few of those

Designer: Felix Denis
Magazine cover, 1970

Illustrator: Hetty McGee
Magazine cover, 1967

involved in the Underground Press were familiar with it. Rather the editors and artists intuitively appropriated cheap layout and printing technologies to communicate efficiently and immediately.

The Undergrounds in look and content attracted anyone who felt alienated from mass society, but it was not a monolith. Comprised of many factions and editorial points of view, each Underground periodical had a distinct character (over 500 titles in the United States were accounted for by the Underground Press Syndicate by 1972). The papers had contrasting sociopolitical principles that loosely represented the far, middle, center, and neo-Left, including hippies, Leninists, anarchists, populists, Maoists, occultists, student guerrillas, Black Panthers, and rock 'n' rollers. Libertines were attracted to the soft-core porn and personal classifieds found in many of the publications.

Since journalism was defined as objective and dispassionate, the Undergrounds practiced the opposite. Since clean and rational graphic design was endemic to overground media, the Undergrounds purposefully looked as though they were slapped together in a dark cave. Although primitive when compared to mainstream newspapers and magazines, the Underground Press was nonetheless made possible with the advent of new technology. If not for inexpensive web-offset printing, the Varityper headliner and IBM MTST magnetic tape typesetting systems, and the Stat King photostat machine, printing and layout processes would be time-consuming and expensive (probably impossible). Typesetting and stat machines could be rented for a few dollars a day, and the average price for printing a

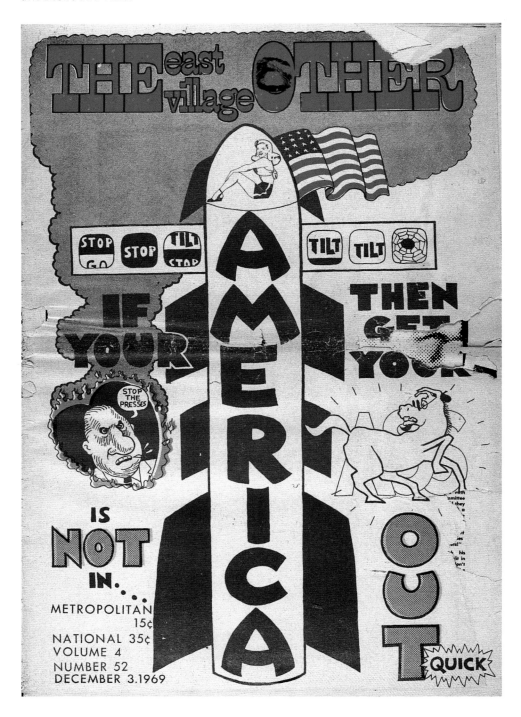

LEFT
Designer: Kim Deitch
Magazine cover, 1969

two-color tabloid was as low as $500 for 3,000 copies. Newsprint was cheap and so newsstand cover prices hovered between 15 and 35 cents. The medium determined the style, and style was cheap.

The Underground Press was not, however, so completely subterranean that it rejected mass newsstand distribution. This gave the most successful Undergrounds wider visibility and larger circulation: The major papers—the *East Village Other*, *Los Angeles Free Press*, *Seattle Helix*, and *Chicago Seed*—during their respective heydays boasted readers in the five figures. Yet to maintain a viable presence on the competitive newsstands, Undergrounds were compelled to up the volume of their graphics.

Underground "staff artists" were encouraged to experiment with any materials that could be collaged or photographed, although the more ideological papers were purposefully "undesigned," which meant that headlines, text, and pictures were haphazardly plunked down. Marshall McLuhan referred to the "new" graphic design when he wrote in the *San Francisco Oracle* (1966) that "the new media is too important to be left to the Peter Pan and Mother Goose executives, [and] can only be trusted to the new artists."

The Oracle (which began in 1966 and folded in 1967) was the short-lived clarion of the psychedelic movement, and the vanguard of Underground graphic revolution. It was also resolutely ad hoc. The psychedelic style was an amalgam of Victorian, Arts and Crafts, and Art Nouveau lettering, as well as ethereal, spiritual, and romantic drawing styles. The *East Village Other*, a weekly that premiered in 1965 in New York City as a radical alternative to the already proto-alternative *Village Voice* (cofounded in 1955 by Norman Mailer), was a wellspring of graphic experimentation, but of a different kind. Instead of being ethereal like the *Oracle*, *EVO* turned the notion of the newspaper inside out. Since the *Voice* was visually somber, *EVO* was jarring. The early issues of *EVO* took unconventional forms, including one issue as an eight-page accordion foldout that needed to be cut apart and then reconfigured. But eventually, *EVO* settled into a traditional tabloid that employed unconventional layout techniques such as intersecting vertical and horizontal columns, upside-down and sideways headlines, color surprints, and abstract graphic concoctions made from press-down ruling tapes.

In addition, *EVO* devoted many pages to a new phenomenon called Underground Comix. It even published a tabloid, *Gothic Blimp Works*, exclusively devoted to witty ribald narratives by R. Crumb, Spain Rodrigues, Gilbert Shelton, Kim Deitch, and others. These artists lampooned and assaulted the bland mass-market comic books that were sanctioned by the Comics Code Authority,

an industry censoring body, which emerged during the Red Scare in the mid-1950s.

By 1969 the Underground Press was beginning to experience a widespread loss of readership. The reasons vary: Youth culture was getting older; mainstream culture was co-opting it; rock and roll was becoming predictable; Vietnam protests were embraced by all social segments and ages. Whatever the cause, the effect was to turn to sex in order lure new readers. Sex stimulated the Underground but sapped its collective energy. Sales increased for the sex papers but the readership was no longer the politically, culturally, or socially minded. Despite the antiestablishment defiance inherent in publishing a sex paper (publishers were arrested on trumped-up pornography charges and endured lengthy trials, which they ultimately won), it was increasingly diffi-

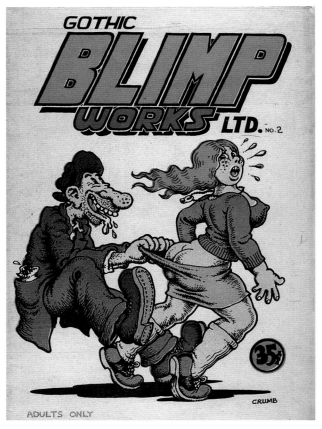

Illustrator: R. Crumb
Magazine cover, 1969

cult to maintain a serious political dialectic amidst the photos of orgies and reviews of kinky sexual gadgets. By the early '70s the Underground Press itself was no longer viable. What few papers remained became local or regional "alternative" or "free" papers produced in more or less traditional ways, dependent on profitable ad sales and supportable circulation. By the late '70s a new generation of alternative press emerged, spawned by the Punk music scene. The visual vocabulary was similar, but the sociopolitical content had given way to an emphasis on music and fashion. Punk didn't last long in the United States, and gave way to the decidedly design-driven culture tabloids of the early eighties.

S E E A L S O *Cheap Chic, Comics Lettering, Dada, Do-It-Yourself, Handlettering, Kodalith, Obey the Giant, Panter, Tijuana Bible*

THE EARLY '90S ZINE AESTHETIC

In the early 1990s, zines, like alternative music, became a genre rather than a statement of purpose. Small-scale publishing had been around for years, but the rise of

desktop publishing and the Kinko's copy-shop chain, as well as the popularization of underground culture, stimulated much activity in the arts. That era can be summarized by *Factsheet Five*, a bimonthly independent magazine that attempted to review every zine that came in the door, resulting in an exhaustive, newsprint zine crammed full of type. Like a nineteenth-century catalog, *Factsheet Five* simply attempted to cram in as much information as possible. Design beyond utilitarian readability was not a concern. The zines it reviewed were versions of that very resource. Though covering a variety of subjects, most shared a common format: Xeroxed black-and-white sheets of folded 8½ x 11 inch paper, held together by a staple or two.

Part of the impetus for making zines was to communicate with a community of readers outside of normal retail outlets. Mail order was the main form of distribution and so clarity and a low cover price were essential, further restricting the possibilities of zines while simultaneously offering a break from the commercial norm. *Cometbus*, one of the longest-running zines, consists of hand-lettered stories by the eponymous Aaron Cometbus between grainy, photographic covers. It's distinguished by crisp, orderly lettering, yet the style is essentially the same as *Beer Frame:* "The Journal of Inconspicuous Consumption" (left), a zine that reviews obscure products. That is, while *Beer Frame* is typeset and includes images, its undesigned, duotone style makes it akin to *Cometbus*. Both zines, like so many others, emphasized readability and ease of production—no fancy design tricks or any intention to design. The essence of the style is absence: absence of intrusive advertising, high cost, or interfering graphics. — D.N.

see Victorian

VEGAS

Take all the novelty typefaces ever designed, add neon, strobe, and blinking lights, blow up to monumental proportions, add a pinch of Hollywood glitz and Wild West kitsch and the result is something spectacular. Not spectacular as in marvelous, amazing, superb, but spectacular in the sheer breathtaking enormity of its tastelessness. The result is Las Vegas style circa 1950s through '80s (before the grand casinos and great capital simulacrum), a total design package that is so singularly and unrepentantly conceived to be a carnival midway on a mammoth scale that the critical mass of visual goo congeals into a tasty unified pudding.

Vegas evolved from Frontierland to Futurama to a Hollywood back lot—all to cash in on America's passion for unexpurgated design gaudiness. For the sophisticates who quibble over the typographic nuance of perfect Bodoni or Garamond the graphics that define Las Vegas are downright vile, unworthy of even the slightest iota of serious consideration. But for those who come together from all points on the map with all levels of taste, Vegas Style establishes the mood, sets the stage,

Designers: Unknown, c. 1969
Neon signs

and otherwise illuminates this Eighth Wonder. For designers able to suspend their belief in Modern purity this Mecca of slab serifs and bifurcated Tuscans is design purgatory, big apple of lust, and garden of creepy delights where designers can let their leading lapse and typefaces misalign.

SEE ALSO *Cuba, Novelty Type, Spectacular Sign, Vernacular*

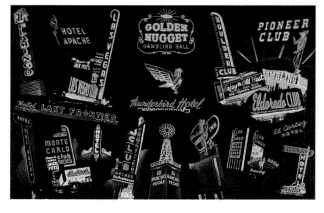

VERNACULAR

At the turn of the twentieth century a wedge separated the few exemplary type masters from the many common job printers. The former designed flawless pages of text, while the latter produced posters, bills, and flyers crammed with discordant type and ornament. Crass was for the mass, but fine was for the ages. By the 1920s a reevaluation of standards occurred when members of the Modern movement practicing the New Typography embraced classical ideals yet reflected contemporary, Machine Age times. Central-axis composition, for example, was rejected in favor of asymmetry, but even more significant was the mission of Modernist designers to expunge the mediocre, the vernacular types and typographies that appeared on signs, bills, and advertisements, and represented rote rather than sophisticated design thinking.

Designer: Unknown, 1932
Brochure cover

Vernacular style is comprised of comprehensible signs and symbols developed through trial and error, market testing, and focus groups. A Tide box, for instance, with its vivid sunburst motif and italic Gothic letters did not become the quintessential detergent package design through Darwinian natural selection, but rather because it simply succeeded in attracting mass consciousness through continual promotion and display on supermarket shelves and TV commercials. Throughout many years of continued, relatively unaltered use it developed into one of the most familiar and, therefore, vernacular, of all commercial designs.

By the mid-1980s tried and true vernacular was transformed from a common trait into a postmodern style. "Retro," the reprise of past and passé design fashions, became a popular component of the contemporary aesthetic, and a curious reverence for the commonplace emerged as a reaction to slick professionalism and austere

Designer: Tibor Kalman
Advertisement, 1985

Modernism. Vernacular (the term was coined by Tibor Kalman but had roots in Roland Barthes) was not viewed as the broad uber-language of graphic design, but rather as the distinct methods of sign painters, printers, and other graphic arts journeymen who produced the daily diet of billboards, banners, menus, and telephone book advertisements that actually lacked style.

Vernacular style made a distinction between mediocre "tutored" design (that of untalented design school graduates) and exemplary "untutored" design (that of tradespeople and craftspersons)—artifice versus no artifice. Of course, it is presumptuous to presume that sign painters and job printers are untutored; it takes considerable training to do this kind of work efficiently. But compared to design school graduates, sign shop art is in a different league—a kind of commercial folk art.

Vernacular style had various proponents in the mid-1980s, each with a distinct passion for different aspects of common commercial art. Art Chantry used common industrial parts catalogs and other graphics produced by craftspersons and naïfs. Tibor Kalman of M&Co employed the methods of typical coffee shop menus, restaurant signboards, and other standardized graphics. Paula Scher revived vintage commercial wood types, the commercial typography of nineteenth-century bills and posters. And Charles Spencer Anderson reprised job-printer's stock "clichés" of the '20s found on matchbooks, spot ads, and blotters. The lack of pretense of vernacular methods served to critique the overly polished professionalism that prevailed in the design competitions and annuals.

Kalman argued that vernacular was not an end in itself, but an ironic protest against the slickness of mannered

Designer: Unknown
Label, 1948

Designer: Bob Warkulwiz
Poster, 1987

and dishonest design (which sold bad products through good layouts). Yet for many designers applying primitive or street-smart typography in a professional context was little more than making hip veneers. At best it added dimension, at worst it was a formula. So even vernacular had its highs and lows.

The vernacular style evolved into its own standard practice: as pastiche and parody. The former is used to evoke a period aesthetic, the latter is used to satirize or caricature. In addition, for some designers vernacular is about celebrating (or exploiting) "found" visual materials—old clippings, postage stamps, twigs, matchbooks—for the sheer pleasure of playing with old forms and found objects.

SEE ALSO *Bonehead, Chantry, Chinese Calendar Girl, Dada, Grunge, Matchbox, Modernist, New Typography, Pastiche, Postmodern, Tibor*

VICTORIAN

The Victorian era—named for the 1837–1901 reign of England's Queen Victoria (1819–1901)—marked an eruption of eclectic design that exerted profound influence on architecture, furniture, fashion, and graphics at a critical juncture in technological, commercial, and social history. The term Victorian and all the stylistic manifestations it came to represent was not, however, exclusive to England but was used to describe analogous historical revivals in Europe and the United States during the second half of the nineteenth century. Moreover, although the Queen may be its namesake, in fact her beloved consort Prince Albert really defined the design tastes that characterized his times. He encouraged the Gothic revival style favored for churches, universities, and public buildings throughout England (notably Charles Barry and A. W. N. Pugin's Houses of Parliament). He favored the writings of John Ruskin, who influenced the shift in national taste from English Gothic to the Italian Gothic. And he conceived the Great

Designer: Unknown
Type specimen, 1897

Exhibition of Arts and Manufactures in 1851 with its landmark centerpiece the Crystal Palace, the protomodern engineering extravaganza that celebrated the Industrial Age and typified Victoriana.

During the Victorian era, engineering rose to the status of high art. It was also when graphic design (though not yet referred to as such) was drowning in layers of excessive revivalist (Byzantine, Romanesque, and Rococo) ornamentation that was both quaint and exciting.

The era bridged the Industrial Revolution and the Modernist twentieth century, and its distinctive graphic design is an enduring symbol of these times. Typeface and page design reveled in ornamental flourish that directly related to architectural aesthetics. Graphic stylists—from job printers to book makers—appropriated the decorative tropes of Victorian façades and monuments. Magazine and newspaper illustrations were minutely detailed with ornate filigrees, often with typefaces and customized lettering that appeared to be carved as though in stone. Considering the cumbersome wood and metal engraving techniques necessary to create these eccentric concoctions, the results are remarkably and intricately precise. As the typographic specimens attest, it appears precision was a greater virtue than any other Victorian aesthetic concern.

Victorian craftsmen challenged their media at every turn and the greatest endeavor for a typographer was to twist and contort the brass metal furniture to do unprecedented typographic feats. In addition, it was an age of fine draftsmanship, when artists took pride in bringing the most eccentric ideas to life. But the Victorian style was not limited only to the unconventional. Common job printers worked with the standard metal and wood types, but if they didn't have enough of one font they didn't think twice about including others together on one line of composition. The Victorian style of disparate faces on a single page derives from this banal necessity.

Designer: Unknown
Advertisement, 1896

Nonetheless wood, metal, and electrotypes produced during the Victorian era are known for eyecatching outrageousness and idiosyncrasy. Some were simply bastardizations of 1800s modern Romans introduced to England by John Baskerville and Robert Thorne. Nineteenth-century decorative and ornamented wood and metal let-

Designer: Unknown
Magazine cover, 1885

ters, flamboyantly designed for commercial use, prefigure the progressive ideas of functionality and economy. "The first modern faces designed around 1800 and 1810 are charming; neat, rational and witty," wrote Nicolette Gray in *Nineteenth Century Ornamented Types and Title Pages* (London: Faber & Faber, 1938). "But from that time onwards . . . types grow more and more depressing; the serifs grow longer, the ascenders and descenders grow longer, the letters crowd together." Anonymous type foundry draftsmen designed types such as Tuscans characterized by curled, pointed, bifurcated serifs, and slab serif Egyptians (developed in response to the fad from Napoleon's Egyptian campaign), in addition to other garish fat faces and sans serifs. They were given names like Phantom, Zig Zag, Elephant, Half Skeleton, and Rustic (a novelty face drawn to look like wooden logs), which may have been somewhat bizarre yet indicative of the growing need to communicate to the new masses. Decorating letters for the purpose of grabbing attention, with striped or arabesque patterns as well as open faces and shadows, was at its peak in the late nineteenth century. England was the wellspring of this, but widespread piracy and mimicry made hundreds of English-derived faces available in America.

Victorian trade journal and type foundry samplers provided panoplies of old and new designs as type foundries tirelessly met the demands of an increasingly literate population and growing consumerism. The growth of book and magazine publishing paralleled an explosion of printed advertising, which echoed the widespread availability of new products sold through a new wave of retail merchants. Technology allowed for large print runs of mass items without regard for aesthetic nuances.

SEE ALSO *Art Nouveau, Arts and Crafts, Novelty Type, Shadow Letter*

SEARS, ROEBUCK AND CO., 1897 CATALOG

American Victorian mannerisms were popularized in 1897, through the nearly 800-page Sears, Roebuck and Co. Consumers [sic] Guide (Catalog 104, to be exact) from Chicago. It was a virtual sample case of design excesses. Giant block type framed by printer's dingbats, standard in the publications of the time, screams: "Our 57-cent Princess Tonic Hair Restorer" and lengthy explanations written by Bart Sears. Intuiting that his

young company needed something extra to set it apart from the myriad other consumer goods firms, Sears entertained his customers with the copy—providing them not just with a catalog, but with a book. There are embedded jokes, sarcastic retorts, and salesmanship of the highest order. Pages overflow with minute type and engraved

depictions of all manner of novelties, hardware, clothing, fabrics, books, and so on. The catalog embodies baroque Victorian graphics in that no square inch of paper was left unfilled with stark engravings, block type of all kinds, border decoration, and nearly everything but the kitchen sink. Many of these conceits would resurface in the next century, from the clip-art craze of the '60's, to Push Pin's decorative impulses to McSweeney's updated Victorian copy. — D.N.

STANLEY MORISON COVERS FOR VICTOR GOLLANCZ

Victorianism made Modern is how to describe typographer Stanley Morison's covers for the Victor Gollancz publishing company in the 1930s. The entrepreneurial Gollancz had swift success publishing in the late 1920s and with the onset of the Depression launched an inexpensive paperback imprint, Mundanus, Ltd. Having decided on an emblematic yellow background, he employed Morison to make the books graphically distinctive. Morison, by then a well-established typographer, provided a unique combination of typographic wit and an eye for visual puns. Indeed, his wry use of type seems rooted in the broadsides and magazine covers of the Victorian era. But it's a firmly Modern vision via Morison's playful use of type-as-image, enabling him to describe the book in a visual prose. When listing the authors discussed in *The Intelligentsia of Great Britain*, Morison assigned each a different typeface, the sum being a typographical portrait of each author. That Morison was somewhat conservative in his approach, as opposed to his more avant-garde New Typography contemporaries, is perhaps owing to Gollancz's need to sell books—and as his design of New Times Roman for *The Times* of London indicated, Morison's own emphasis on clarity and wit in service to text above all else. — D.N.

W

see Wendingen

WARE LETTERING

Comic strip artist and publisher of the Acme Comic Library, Chris Ware is inspired by Victorian, Art Nouveau, and commercial display styles—specifically sheet music, old magazines, old magazine advertisements, record labels, and cigar labels. Never trained as a letterer, "I steal constantly from all sorts of things," he admitted in an interview, "especially when something emotionally affects me, either for reasons of color, composition, letter style—sometimes it's even something as simple as the ascender and descender width relative to each other. I'm sure that if I'd taken a class about this stuff I'd know much better why it all works the way it does, and I wouldn't have to fumble around in the dark so much."

LEFT
Designer: Chris Ware
Comics, 2005

RIGHT
Designer: Chris Ware
Comics, 2003

Designer: Chris Ware
Comics, 1997

Yet fumble, fiddle, or fidget, Ware has taken his lettering beyond mere pastiche into realms of reinvention and is the reincarnation of the master Show-Card letterers who effortlessly rendered one-of-a-kind alphabets for signs, windows, and labels. Of course, all comic strip artists worthy of the title must be skilled letterers, but Ware came to lettering after he had developed his narrative approaches during the late eighties, after he had been doing a regular strip for the student newspaper in Austin for a number of years. Up to that point, he considered type and lettering secondary to storytelling, some kind of additive decoration, at best a sort of mood setter, at worst, simply titles and logos.

But once he began studying early twentieth-century newspaper strips Ware noticed that the older style lettering radiated what he deemed "a warmth and a humanity" that contemporary lettering didn't, and that it had a potential as a primary "expressive element." He was smitten by the hand-done quality of that old stuff that had been lost, and he decided to learn the skills himself. Since he had self-consciously eliminated all words from his own comics for a number of years to try and communicate everything through gesture and rhythm, he was ready to try and bring words back into them, and wanted to get to the point where lettering was as, or more, important than the pictures were.

For many arduous years Ware copied from his grandfather's old Speedball manuals and paid more attention to the sections on display lettering, trying to learn how to use a ruler and a ruling pen. By his own account he struggled on hopelessly until one day, shortly after moving to Chicago, he came across a box of original advertising lettering art for Val-Mor. From this fountain of inspiration he instantly saw how the lettering process worked, what materials were used— ruling pens, brush, evening out the bottom of the letters with white ink—and what he had been wrestling with in his own strips suddenly clicked in his mind. Indeed Ware argues that his cartooning is not drawing; it's more like typography, a mechanical sort of "picture lettering."

SEE ALSO *Art Deco, Art Deco Type, Art Nouveau, Comics Lettering, Modernist, Pastiche, Show-Card, Vernacular*

WENDINGEN

Somewhere in the middle of the stylistic spectrum between Nieuwe Kunst (Dutch Art Nouveau) and De Stijl was a matchless Wendingen (Upheaval) style founded by Henrik Theodor Wijdeveld, a Dutch architect and graphic designer who trained under Walter Gropius and Frank Lloyd Wright. Wijdeveld showcased his method in the magazine *Wendingen* (published between 1918 and 1931), which

*Designer: H. A. van Anrooy
Magazine cover, 1918*

was so eclectic in design and content that it gave equal coverage to Expressionist, Modernist, and even bizarre mystical sensibilities. Wijdeveld produced a magazine (and style) that was unrepentantly decorative and devoutly geometric. Printed in an unprecedented square format (13½ inches) on high-grade paper, each page of *Wendingen* was one side of a sheet that was folded into two pages in a Japanese block-bookbinding process. Though it did not advance the New Typography, *Wendingen* published covers of some of the movement's principal designers— among them El Lissitzky for a special issue on Frank Lloyd Wright, and De

Stijl's Vilmos Huszar for a special on Diego Rivera. For Wijdeveld's own typo-
graphic concoctions he shared certain methods with Constructivists and Dadaists
using printer's materials to build quirky letterforms. His idiosyncratic aesthetic,
also referred to as the Linear School, barely influenced anything or anyone beyond
The Netherlands, but its importance to the design of that period is major.

Designer: H. Th. Wijdeveld
Typographic spread, 1926

Wijdeveld's distinctive architectonic layout was noted for its rectilinear type

design influenced by a wide range of
conceits from Art Deco to Javanese
ornament. Architects and graphic art-
ists alike were invited to design, illus-
trate, and compose covers that did not
conform to Wijdeveld's *Wendingen*
style but rather expressed different
schools and national or folk origins.
Wijdeveld's own covers, whether for
a series devoted to architects Wright
or Erich Mendelsohn, were rendered

Designer: S. L. Schwarz
Magazine cover, 1931

Designer: H. Th. Wijdeveld
Magazine cover, 1923

in his blocky emblematic typographic style that often came under harsh critique for illegibility. Despite (or perhaps because of) its excesses, *Wendingen* was "one of the most progressive magazines of its time, a work of art...It differed from other avantgarde publications such as *De Stijl* . . . in that it was a vehicle for the message rather than the message itself," wrote historian Alston Purvis in *Wendingen:*

A Journal for the Arts, 1918–1931 (Princeton Architectural Press, 2001). The magazine was a bridge between the disorder of the previous century and the new century's design. It advanced the grand notion of Gesamtwerk—that all art fed a common functional purpose yet was an alternative to the strict rationalism of orthodox Modernism.

SEE ALSO *Art Deco, Art Nouveau, Constructivist, Dada, De Stijl, Expressionist, Modernist, New Typography*

Designer: H. Th. Wijdeveld
Magazine cover, 1922

see Zanol

ZANOL

In 1931 Albert Mills, president and founder of the Zanol Products Company, issued a personal message to all the salespersons hawking his many household products and foodstuffs to the housewives of America. "I want you to know the ideals, principles, and business policy of The Zanol Products Company so that you will know more fully the kind of company you deal with when you buy Zanol Products," he wrote, assuring them that he stood behind every package with the highest concern for design that would attract customers. And so Mills and his art department created an identity for Zanol that was consistently identifiable by the customer.

Designers: Unknown
Advertisements, 1931

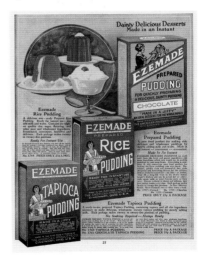

Zanol's labeling and packaging style is arguably the model for packages for the decade and beyond. The straightforward typographic and pictorial style was distinctive in its day: Neutrally colored packages (no more than two or three colors) with bold Victorian-inspired lettering, often accompanied by a detailed line illustration depicting the product's purpose—a woman baking a pie or washing dishes, a pair of stockings or shoes—or the type and a colorful background pattern were the only graphic attributes. Under the oval Zanol logo, however, each product was linked to the greater corporate identity, be it Soot Destroyer, Sticktite Liquid Glue, Fly Dope, Rat Dope, Roach Dope, Wizard Laundry Tablets, or Swish for Washing. Each label drowned in words—"Just Boil the Clothes That's All," or "Ready Prepared For Making Delicious Crispy Tender Doughnuts"—a contemporary designer's nightmare. But the strategy worked for Zanol, which though forgotten today, influenced other mainstream companies that borrowed (or stole) its style.

SEE ALSO *Commercial Modern, Generic, Shadow Letter, Vernacular*

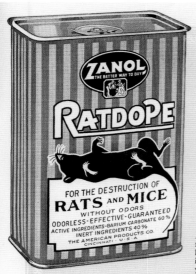

Rid Your Home of Rats, Mice, Roaches, Ants and Bedbugs

Zanol Rat Dope

The new, scientific, harmless discovery which helps to exterminate rats and mice without causing an odor. A formula recommended by the United States Department of Agriculture as one of the safest and best methods for use in the home. Kills them after they leave the premises in search of water, or in their holes---not in the home. Economical.

ZANOL Rat Dope is effective, economical and easy to use. It kills rodents of all sizes quickly, without causing the least odor, without any unpleasant after results. Rats and mice are mum- mified and dry up in their nests without producing any bad odor whatever. Put up in a large size, convenient, sifter-top can, containing enough Rat Dope to destroy hundreds of rats and mice.

No. 2492 PRICE ONLY 40¢

Zanol Roach Dope

A safe and harmless powder for destroying roaches, beetles, ants, water bugs and similar insects. Guaranteed to rid your premises of these pests if used according to directions.

Guaranteed Effective

Sprinkle ZANOL Roach Dope right from the can into cracks, crevices, corners and all places inhabited by the insects and where they are liable to breed. Kills them and destroys their eggs so completely that you will not be both- erd with these pests in the future. Safe to use throughout the home. Will not injure floor coverings, furniture or any fabrics with which it may come in contact. Use a little each week as a preventative---keep it on hand. Comes in large, convenient, big-value cans, ready for use.

No. 2494 PRICE ONLY 35¢

Zanol Bedbug Dope

A liquid preparation for destroying bedbugs. Sprayed regularly on bedsteads, bed springs, mattresses, linens, upholstery, draperies and in crevices, it destroys both bugs and eggs, preventing future appearance.

Guaranteed to kill bedbugs. Absolutely stainless and harmless. Kills both the bugs and their eggs. Keep a can ready to combat the first of these insects that show up. No home is immune---bedbugs may appear at any time. Bedbug Dope assures freedom. For best results, apply with ZANOL Hand Sprayer.

ZANOL Bedbug Dope will not stain wallpaper, bed clothing or even the finest of fabrics---dries out without leaving the slightest discoloration or odor. Large pint can for economical use. See below.

Bedbug Dope No. 2493 Pint Can PRICE ONLY 50¢

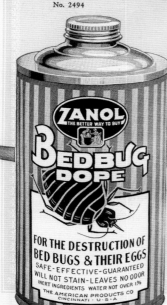

41

BIBLIOGRAPHY

Abrahams, Edward. *The Lyrical Left: Randolph Bourne, Alfred Stieglitz and the Origins of Cultural Radicalism in America.* Charlottesville: University of Virginia, 1986.

Ackland-Snow, Nicola, et al. *The Art of the Club Flyer.* London: Thames and Hudson, 1996.

Adams, Steven. *The Arts & Crafts Movement.* Secaucus, NJ: Chartwell Books, 1987.

Ades, Dawn. *Dada and Surrealism Reviewed.* London: Arts Council of Great Britian, 1978.

Aragon, Louis. *Treatise on Style.* Lincoln and London: University of Nebraska Press, 1991.

Barr Jr., Alfred H. *Fantastic Art, Dada, Surrealism.* New York: MoMA Press, 1946.

Baum, Stephen, ed. *Documents of 20th Century Art: The Tradition of Constructivism.* New York: Viking Press, 1974.

Baur, John I. H. *Revolution and Tradition in Modern American Art.* Cambridge: Harvard University Press, 1958.

Blackwell, Lewis. *The End of Print: The Graphic Design of David Carson.* San Francisco: Chronicle Books, 1996.

Bokult, John. *Documents of 20th Century Art. Russian Arts and the Avant-Garde.* New York: Viking, 1976.

Cabarga, Leslie. *Progressive German Graphics, 1900–1937.* San Francisco: Chronicle Books, 1994.

Cohen, Arthur. *ExLibris Catalog #6: Constructivism & Futurism: Russian and Other.* New York: TJ Art Inc, 1977.

DeNoon, Christopher. *Posters of the WPA.* Los Angeles: Wheatley Press, 1987.

Dluhosch, Eric, and Rotislav Svácha, eds. *Karel Teige 1900–1951: L'enfant Terrible of the Czech Modernist Avant-Garde.* Cambridge, and London: MIT Press, 1999.

D' Harnoncourt, Anne. *Futurism and the International Avant-Garde.* New Haven: Eastern Press, 1980.

Duncombe, Stephen. *Notes from Underground: Zines and the Politics of Alternative Culture.* London, New York: Verso, 1997.

Ford, Charles Henri, ed. *View-Parade of the Avant-Garde 1940–47.* New York: Thunders Mouth Press, 1991.

Foster, Stephen, and Rudolf Kuenzli, eds. *Dada Spectrum: The Dialectics of Revolt.* Madison, WI: Coda Press, 1979.

Fraser, James, and Steven Heller. *The Malik Verlag.* New York: Goethe House, 1983. An exhibition catalog.

Glessing, Robert J. *The Underground Press in America.* Indianapolis: Indiana University Press, 1970.

Gottschall, Edward M. *Typographic Communications Today.* Cambridge, MA, and London: MIT Press, 1989.

Gray, Camilla. *The Great Experiment—Russian Art 1863–1922.* New York: Abrams, 1962.

Hiesinger, Kathryn B., and George H. Marcus. *Landmarks of Twentieth-Century Design: An Illustrated Handbook.* New York: Abbeville Press Publishers, 1993.

Heller, Steven. *Design Literacy. 2nd ed.* New York: Allworth Press, 2005.

———. *Merz to Emigre and Beyond.* London: Phaidon Press, 2003.

———. *Paul Rand.* London: Phaidon Press, 1999.

Heller, Steven, and Seymour Chwast, *Graphic Style: From Victorian to PostModern.* New York: Harry N. Abrams, 1988.

Heller, Steven, and Louise Fili, *Euro Deco: Graphic Design Between the Wars*. San Francisco: Chronicle Books, 2005.

———. *Typology: Type Design from the Victorian Era to the Digital Age*. San Francisco: Chronicle Books, 1999.

Heller, Steven, and Julie Lasky. *Borrowed Design: Use and Abuse of Historical Form*. New York: Van Notrand Reinhold, 1993.

Hendricks, John. *Fluxus Codex*. New York: Harry N. Abrams, 1988.

Hollis, Richard. *Graphic Design: A Concise History*. London: Thames and Hudson, 1994.

Jean, Marcel, ed. *Documents of 20th Century Art: Autobiography of Surrealism*. New York: Viking Press, 1974.

Joffe, Hans L. C. *De Stijl*. New York: Abrams, 1971.

Julier, Guy. *The Thames and Hudson Encyclopedia of 20th Century Design and Designers*. London: Thames and Hudson, 1993.

Karyinov, German. *Rodchenko*. London: Thames and Hudson, 1979.

Kuenzli, Rudolf E., ed. *New York DADA*. New York: Willis, Locker and Owens, 1986.

Le Coutre, Martijn F. *Wendingen: A Journal of Arts 1918–1932*. New York: Princeton Architectural Press, 2001.

Lewis, Roger. *Outlaws of America: The Underground Press and Its Context: Notes on a Cultural Revolution*. New York: Pelican, 1972.

Lewis, Wyndham. *Blast #1* (reprint). Santa Barbara, CA: Black Sparrow Press, 1981.

———. *Blast #2: The War Number* (reprint). Santa Barbara, CA: Black Sparrow Press, 1981.

———, ed. *The Enemy #1*. London: Arthur Press, 1927.

Lippard, Lucy, ed. *Surrealists on Art*. Englewood Cliffs, NJ: Prentice Hall, 1970.

Lippard, Lucy R., ed. *Dadas on Art*. Englewood Cliffs, NJ: Prentice Hall, 1971.

Lista, Giovanni. *Le Livre Futuriste*. Rome: Panini Modena Editions, 1984.

Lupton, Ellen. *Mixing Messages: Graphic Design in Contemporary Culture*. New York: Cooper-Hewitt National Design Museum, Smithsonian Institution, and Princeton Architectural Press, 1996.

Marchand, Roland. *Creating the Corporate Soul: The Rise of Public Relations and Corporate Imagery in American Big Business*. Berkeley, Los Angeles, and London: University of California Press, 1998.

McAlhone, Beryl, et al. *A Smile in the Mind: Witty Thinking in Graphic Design*. London: Phaidon Press, 1998.

Meggs, Philip B., and Alston Purvis. *A History of Graphic Design*. 4th ed. New York: John Wiley & Sons, 2005.

Minick, Scott, and Jiao Ping. *Chinese Graphic Design in the Twentieth Century 1870–1920*. New York: Van Nostrand Reinhold, 1990.

Motherwell, Robert, ed. *The Dada Painters and Poets: An Anthology*. New York: Harvard University Press, 1951.

Peck, Abe. *Uncovering the Sixties: The Life & Times of the Underground Press*. New York: Pantheon Books, 1985.

Pile, John. *Dictionary of 20th Century Design*. New York: Roundtable Press, 1990.

Poggioli, Renato. *The Theory of the Avant-Garde*. Harvard, MA: Belknap Press, 1968.

Quilliei, Vieri. *Rodchenko: The Complete Works*. Cambridge, MA, and London: The MIT Press, 1986.

Remington, Roger R., and Barbara J. Hodik. *Nine Pioneers in American Graphic Design*. Cambridge, MA, and London: MIT Press, 1989.

Richter, Hans. *Dada: Art and Anti-Art*. New York: Harry N. Abrams, 1965.

Schrader, Barbel. *The Golden Twenties: Art and Literature in the Weimar Republic*. New Haven: Yale University Press, 1988.

Selz, Peter, and Mildred Constantine, eds. *Art Nouveau*. New York: MoMA Press, 1959.

Sembach, Klaus-Jurgen. *Style 1930*. New York: Universe Books, 1971.

Smith, Terry. *Making the Modern: Industry, Art, and Design in America*. Chicago: University of Chicago Press, 1993.

Steranko, James. *The Steranko History of Comics*. Reading, PA: Supergraphics, 1972.

Tashjian, Dickran. *A Boatload of Madmen: Surrealism and the American Avant-Garde 1920–1950*. New York: Thames and Hudson, 1995.

Thomson, Ellen M. *The Origins of Graphic Design in America*. New Haven and London: Yale University Press, 1997.

Thorgerson, Storm, and Aubrey Powell. *100 Best Album Covers*. London, New York, and Sydney: DK Publishing, 1999.

VanderLans, Rudy, and Zuzana Licko (with Mary E. Gray). *Emigre: Graphic Design into the Digital Realm*. New York: Van Nostrand Reinhold, 1993.

Washton, Rose-Carol, ed. *German Expressionism-Documents*. New York: Macmillan, 1973.

Whitford, Frank, ed. *The Bauhaus*. Woodstock, NY: Overlook Press, 1992.

Weiss, Jeffrey. *Popular Culture of Modern Art: Picasso, Duchamp and Avant Gardism*. New Haven: Yale University Press, 1994.

Wozencroft, Jon. *The Graphic Language of Neville Brody*. New York: Rizzoli, 1988.

ARTICLES

Heller, Steven. "Alex Steinweiss: For the Record." *Print* 46, no. 2 (1992).

———. "Do It Yourself: The Graphic Design of Punk Zines." *Baseline* 34 (2001).

———. "Introducing the First Digital Lettering Tool." *Baseline* 38 (2002).

———. "More than Wham Bang Boom." *Baseline* 35 (2001).

———. "Sho-Cards." *Baseline* 30 (2000).

Heller, Steven, and Barbara Kruger. "Smashing the Myths." *AIGA Journal of Graphic Design* 9, no. 1 (1991).